VOYAGE INTO MYTH

FRENCH PAINTING FROM GAUGUIN TO MATISSE FROM THE HERMITAGE MUSEUM, RUSSIA

This exhibition is under the high patronage of the Right Honourable Jean Chrétien, Prime Minister of Canada.

We also wish to thank His Excellency Vladimir Putin, President of the Russian Federation,
for having given this major exhibition due attention and all the assistance required to bring it to Canada.

An exhibition under the directorship of Guy Cogeval and Matthew Teitelbaum

CURATORS OF THE EXHIBITION
Nathalie Bondil, Chief Curator and Curator of European Art (1800-1945), Montreal Museum of Fine Arts
Michael Parke-Taylor, Associate Curator, European Art, Art Gallery of Ontario
With the co-operation of Albert Kostenevich, Curator of Modern European Painting, The State Hermitage Museum

EXHIBITION ITINERARY
Art Gallery of Ontario, Toronto: 12 October 2002 to 5 January 2003
The Montreal Museum of Fine Arts, Michal and Renata Hornstein Pavilion: 31 January to 27 April 2003

This catalogue is published on the occasion of the exhibition
'Voyage into Myth: French Painting from Gauguin to Matisse from The Hermitage Museum, Russia'.
This exhibition is organized by the Art Gallery of Ontario, Toronto, the Montreal Museum of Fine Arts, Montreal
and The State Hermitage Museum, Russia in association with the Hermitage Foundation of Canada.

ACKNOWLEDGEMENTS
This project would not have seen the light of day without the contribution of the professional
and technical staff of The State Hermitage Museum, the Art Gallery of Ontario and the
Montreal Museum of Fine Arts. Special thanks are also extended to Dr. Sean B. Murphy and Marianne Barbey, Barbara Butts,
Dawn Cain, Daniella Caruso, Mikhail Dedinkin, Claire Denis, Richard Field, Greg Humeniuk, Alexandre Kuznetsov, Betty Reitman.

The Montreal Museum of Fine Arts
P.O. Box 3000, Station H / Montreal (Quebec) / Canada / H3G 2T9
www.mmfa.qc.ca
Management
Guy Cogeval, Director; Nathalie Bondil, Chief Curator; Paul Lavallée, Director of Administration; Danielle Champagne, Director of Communications.

In Montreal, the exhibition is presented by Hydro-Québec in co-operation with SAP Canada.

The exhibition has also obtained major funding from the Volunteer Association of the Montreal Museum of Fine Arts and assistance from the Department of Canadian Heritage through the Canada Travelling Exhibitions Indemnification Program. The Montreal Museum of Fine Arts wishes to thank *La Presse*, *The Gazette*, Société Radio-Canada and 105.7 RYTHME FM, its media partners. Its gratitude also extends to Quebec's Ministère de la Culture et des Communications for its ongoing support.

The Montreal Museum of Fine Arts international exhibition programme receives financial support from the Exhibition Fund of the Montreal Museum of Fine Arts Foundation and the Paul G. Desmarais Fund.

CATALOGUE
MONTREAL MUSEUM OF FINE ARTS
CO-ORDINATION: Nathalie Bondil and Francine Lavoie
RESEARCH AND DOCUMENTATION: Sandrine Nicollier
RESEARCH AND PROOF-READING: Laurence Pollet
TECHNICAL SUPPORT: Majella Beauregard, Maryse Ménard
COPYRIGHTS: Linda-Anne D'Anjou

Also published in French under the title
L'Invitation au voyage : l'avant-garde française de Gauguin à Matisse de la collection du musée de l'Ermitage

© 2002 Art Gallery of Ontario
ISBN (English version): 1-894243-23-4
ISBN (French version): 1-894243-24-2

© 2002 The Montreal Museum of Fine Arts
ISBN (English version): 2-89192-994-2
ISBN (French version): 2-89192-993-4

© 2002 Hazan
Legal deposit: September 2002

Art Gallery of Ontario
317 Dundas Street West / Toronto (Ontario) / Canada M5T 1G4
www.ago.net
Management
Matthew Teitelbaum, Director and CEO; Dennis Reid, Chief Curator; Linda Milrod; Director, Exhibitions and Publications; Shawn St. Michael, Director, Development; Arlene Madell, Director, Marketing and Communications.

In Toronto, the lead sponsor of the exhibition is TD Waterhouse and the associate sponsor is SAP Canada.

This exhibition has been financially assisted by the Ontario Cultural Attractions Fund of the Government of Ontario through the Ministry of Culture. It has been supported by the Department of Canadian Heritage through the Canada Travelling Exhibitions Indemnification Program.

The Art Gallery of Ontario is funded by the Government of Ontario through the Ministry of Culture. Additional support is received from the Volunteers of the Art Gallery of Ontario, the City of Toronto, the Department of Canadian Heritage, The Canada Council, and from gallery members and many corporations, foundations and individuals.

EDITORIAL CO-ORDINATION HAZAN: Anne-Isabelle Vannier and Bernard Wooding

GRAPHIC DESIGN: Sylvie Milliet

TRANSLATION
Ch. 3, 4, 5 and 6: translated by David Wharry

PHOTOENGRAVING : Open Graphic, Paris
Printed in Belgium by Snoeck-Ducaju & Zoon, in Ghent, September 2002

VOYAGE INTO MYTH

FRENCH PAINTING FROM GAUGUIN TO MATISSE FROM THE HERMITAGE MUSEUM, RUSSIA

HAZAN

M
THE MONTREAL MUSEUM
OF FINE ARTS

Art Gallery of Ontario

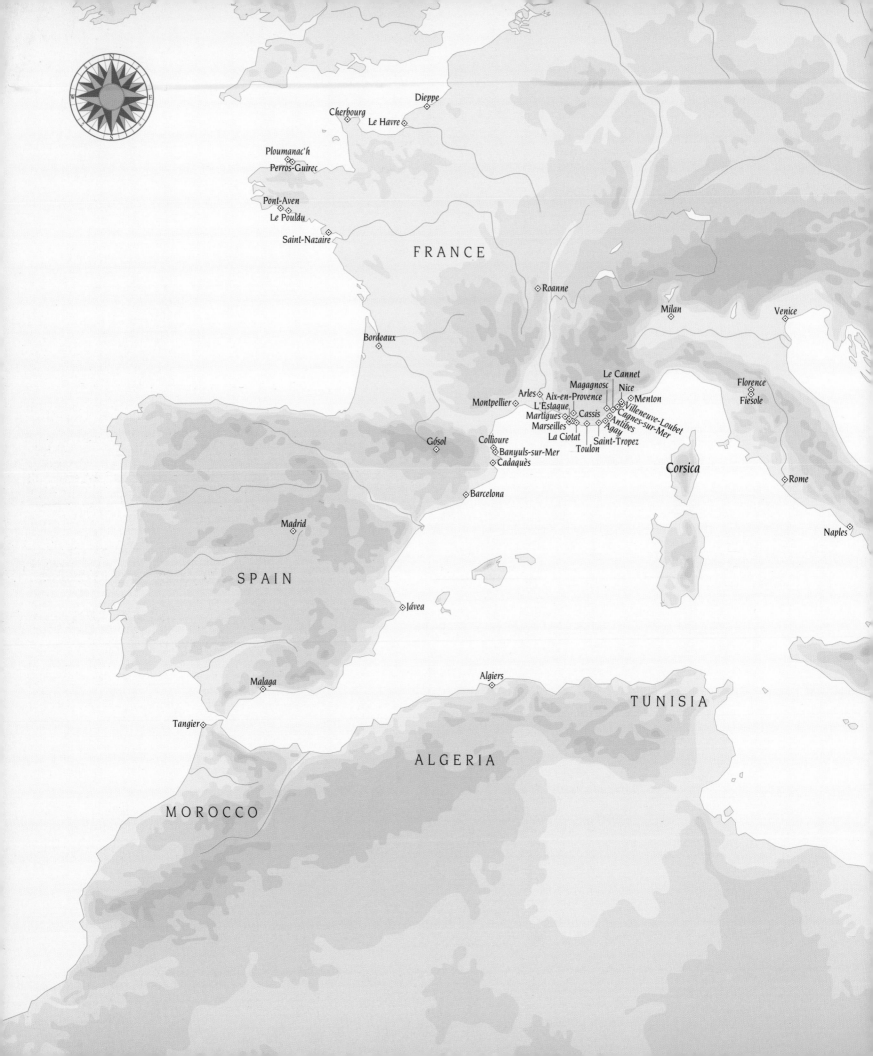

GREECE

TURKEY

Istanbul

EGYPT

Map: Edigraphie, Rouen

0 200 km

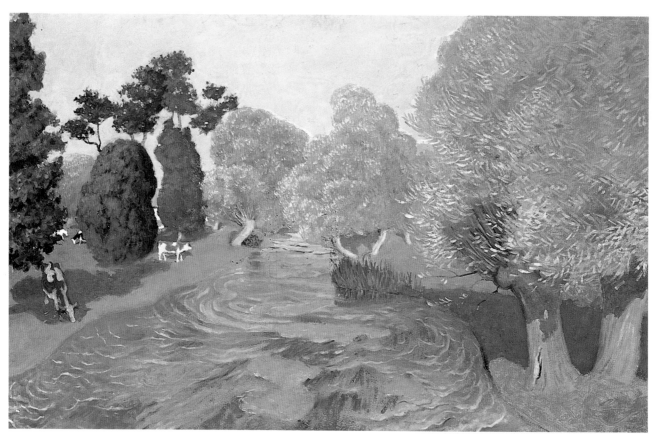

CAT. 1 FÉLIX VALLOTTON, *Landscape, Arques-la-Bataille*, 1903

CONTENTS

Under a historic loan agreement with The State Hermitage Museum, St. Petersburg – one of the most celebrated art institutions in the world, the Art Gallery of Ontario and the Montreal Museum of Fine Arts have jointly organised an exhibition to be shown exclusively in Canada. The exhibition consists of seventy-five masterpieces from the Hermitage's dazzling collection, ranging from Post-Impressionist through to early modern works. Until the mid-1950s, space restrictions forced the Hermitage to keep these unrivalled avant-garde works in storage, where they could be viewed only after special authorisation. In recent years, these seminal paintings by Cézanne, Gauguin, Matisse, Bonnard, Denis and Picasso have gradually become more accessible, and have made an essential contribution to an understanding of modern art. Now they are on view in Canada, thanks to our lead sponsors, TD Waterhouse in Toronto, Hydro-Québec in Montreal, both in association with SAP Canada Inc., in an exhibition that enables us to obtain a firmer grasp of their hidden connections.

Early in the twentieth century, the Moscow textile magnates Sergei Shchukin and Ivan Morozov brought together the finest and most remarkable collections of modern art ever assembled, in the process becoming leading figures in the world of art. These prosperous businessmen followed the Russian tradition begun by Peter the Great and Catherine II, opening up Russia to the art of Western Europe. On their frequent trips to Paris, Shchukin and Morozov discovered the innovative talents of Gauguin, Matisse and Picasso, among others. Not only did they buy paintings by these artists long before their works had made their mark in Europe, but the more adventuresome Shchukin commissioned Matisse to paint *The Dance* and *Music*, which are now considered two icons of modernism.

L'Invitation au voyage, the French title of the exhibition *Voyage into Myth*, comes from a poem by Baudelaire that longingly evokes a sensuous world of beauty and harmony, a Golden Age in the remote mythological past. The revival of classicism had been a leitmotif of Western art from the Italian Renaissance through the seventeenth-century paintings of Poussin and Claude Lorrain and on to the nineteenth-century work of Ingres and Corot. At the close of the nineteenth century, this tendency became widespread among French artists, who looked to the great tradition of French and Italian painting steeped in the legacy of classical antiquity. The generation of artists that flourished during the first decade of the twentieth century, one that included Matisse, Derain and Bonnard, also embraced the myth of the purity of the "primitive," which views the "classical taste" as a return to origins.

This exhibition demonstrates how two strains of influence – the resurgence of classicism and the impact of "primitivism" on Western culture – provide links between Symbolism, Post-Impressionism, Fauvism and the birth of modernism. Certain polarities generated by these two different strains – tradition versus innovation, Western versus non-Western culture, the timelessness of myth versus the experience of modern life – are driven by ideas that developed formalist parallels. We see these in the struggle between the figurative and abstract in art, and in the contrast between the pastoral idyll and the contemporary landscape.

Showcasing masterpieces by Bonnard, Cézanne, Denis, Derain, Gauguin, Matisse, Picasso and Rodin, *Voyage into Myth* makes an original contribution to art historical discourse. The exhibition will take the viewer on a journey of the imagination through the diverse landscapes of a mythological past, and through the exotic realms of Gauguin's Tahiti and the South of France found in the luminous paintings of the Fauves. One of the most potent myths that this exhibition addresses is that of the Mediterranean world as a new Arcadia, an earthly paradise sheltered from the materialism of the modern industrialised world, a place where dreamed of harmony is still attainable. Visitors will travel through worlds that exist somewhere between metaphor and reality, guided by artists who aim to transport them beyond the banalities of the here and now toward the contemplation of a nobler, purer and more perfect existence.

MATTHEW TEITELBAUM
Director and CEO of Art Gallery of Ontario

GUY COGEVAL
Director of The Montreal Museum of Fine Arts

The State Hermitage Museum is delighted to be showing once again a small part of its remarkable collections in Canada. This time we are presenting the magnificent French Post-Impressionist works assembled by the great collectors Sergei Shchukin and Ivan Morozov.

The exhibition, entitled 'Voyage into Myth: French Painting from Gauguin to Matisse from The Hermitage Museum, Russia', focuses on the ancestral symbolic and mythological elements of European culture that these works – some of which can at first sight appear to be purely decorative – all embody.

All these paintings – Odilon Redon's mystery-steeped visions, Paul Cézanne's landscapes and objects charged with an inner life, Maurice Denis's mythological scenes, Henri Matisse's tales overflowing with *joie de vivre*, Pablo Picasso's harsh poems, and many more – wrote an outstanding page in the history of art and also of the Hermitage. The presentation of Maurice Denis's Psyche series, which has rarely left our museum, is in itself a singular event.

The exhibition was organised by the State Hermitage Museum in collaboration with two superb Canadian museums, the Montreal Museum of Fine Arts and the Art Gallery of Ontario, and with the State Hermitage Museum Foundation of Canada, whose enterprising members love our museum and are helping it to develop. In some ways, the exhibition is an expression of gratitude to all our friends in Canada.

Our Canadian programme, which began with the exhibition 'Rubens and his Age' and continues today with 'Voyage into Myth', is set to continue with the exhibition of a larger part of the Hermitage collections. We are very grateful to all those in Russia and Canada who have made this exhibition possible.

MIKHAÏL PIOTROVSKY
Director of The State Hermitage Museum

It is not difficult to become attached to the Hermitage Museum. This magnificent home of 2.8 million works of art, collected over the past 300 years by Russian imperial families, is truly a world heritage site. The Hermitage has survived wars and revolutions. Its collections have twice been evacuated in advance of invading armies. It has known both an elegance such as we can now only imagine and times of want such as only a few can ever fully fathom. Throughout all of this, the Hermitage has stood out as a symbol of the strength, courage, and conviction of the Russian people, and also of the enduring role of culture in our lives. We at The State Hermitage Museum Foundation of Canada Inc. are proud to be associated with this eminent institution and its distinguished Director, Dr. Mikhaïl Piotrovsky. The Foundation is dedicated to the preservation of the collections of the Hermitage and, in so doing, to the enrichment of generations the world over.

'Voyage into Myth: French Painting from Gauguin to Matisse from the Hermitage Museum, Russia' is the second of three exhibitions that we have had the privilege to help bring to Canada along with our partners the Art Gallery of Ontario and the Montreal Museum of Fine Arts. This collaboration is the first of its kind between these two important Canadian institutions.

We would like to thank Mikhaïl Piotrovsky for making this exhibition possible and for his support of the Foundation. We also thank the Rt. Hon. Ramon John Hnatyshyn, our Honorary Chairman, for his leadership and guidance, as well as the distinguished members of our Board of Directors who volunteer their time and expertise on the Foundation's behalf.

Executive: The Rt. Hon. Ramon John Hnatyshyn, P.C., C.C., C.M.M., C.D., Q.C.; Prof. Mikhaïl Piotrovsky; Robert Kaszanits; William Teron, O.C.; Michael Bell; Joseph Frieberg; William B.G. Humphries;

Board Members: Kenneth R. Bartlett; Lawrence A. Brenzel; Guy Cogeval; Anna Dan; John Edwards; A. J. Freiman; Nance J. Gelber; Hon. Jean-Pierre Goyer, P.C., Q.C.; Hon. Senator Jerry S. Grafstein, Q.C.; Malka Green; Catherine Johnston; Hon. Robert P. Kaplan, P.C., Q.C.; Bernard Lamarre, O.C., O.Q.; Anne Leahy; Sean B. Murphy; Grant L. Reuber, O.C.; Paul R. St-Amour; Matthew Teitelbaum.

A special thanks goes to the volunteers of the Canadian Friends of the Hermitage, the education and membership arm of the Foundation, for bringing the Hermitage to schoolchildren and universities across Canada.

Executive: Doris M. Smith; Gerald Glavin; Nancy Scarth; David Wait; Joan McNabb;

Members-at-large: Anne-Marie Hall; Jean-Marie Joly; Judith Parkes; Patricia Simmermon; John Skeggs.

Few of us get an opportunity to travel to Russia to see these wonderful paintings first hand. It is our hope that Canadians will take advantage of this rare opportunity to experience for themselves these treasures from the Hermitage.

ROBERT KASZANITS
President of The State Hermitage Museum Foundation of Canada Inc.

Hydro-Québec is proud to sponsor 'Voyage into Myth: French Painting from Gauguin to Matisse from the Hermitage Museum, Russia', a major exhibition to be held at the Montreal Museum of Fine Arts. Consisting of a large group of works from the Hermitage Museum in St. Petersburg, the show will give museum-goers an opportunity to appreciate the immense talent of the artists who in large measure paved the way for the advent of modern art.

These early twentieth-century artists, who include Paul Cézanne, Paul Gauguin, Henri Matisse, and Pablo Picasso, will make world travellers of us all, transporting us to the beaches of Tahiti or the Riviera, or to the African continent, as they invite us to accompany them on their travels, form our own impressions and embark upon this most beautiful of journeys ourselves.

The exhibition will give a large number of Quebecers a chance to see and explore works by some of the greatest artists of the nineteenth and the twentieth century. Enabling the public to encounter such creative genius is the constant theme underlying Hydro-Québec's support of Québec's cultural institutions.

Hydro-Québec wishes to congratulate the staff of the Montreal Museum of Fine Arts for their extraordinary creativity in making 'Voyage into Myth' the pre-eminent cultural event of 2002-2003. We are confident that the presentation of these exceptional works of art will attract a large number of visitors from here and elsewhere, and will reinforce Montreal's reputation as a world-class centre of culture.

Hydro-Québec wishes you an unforgettable voyage!

JACQUES LAURENT
President of the Board of Directors

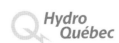

Invitation to the Voyage

CHARLES BAUDELAIRE

My child, my sister, dream
How sweet all things would seem
Were we in that kind land to live together,
And there love slow and long,
There love and die among
Those scenes that image you, that sumptuous weather.
Drowned suns that glimmer there
Through cloud-dishevelled air
Move me with such a mystery as appears
Within those other skies
Of your treacherous eyes
When I behold them shining through their tears.

There, there is nothing else but grace and measure,
Richness, quietness, and pleasure.

Furniture that wears
The lustre of the years
Softly would glow within our glowing chamber,
Flowers of rarest bloom
Proffering their perfume
Mixed with the vague fragrances of amber;
Gold ceilings would there be,
Mirrors deep as the sea,
The walls all in an Eastern splendor hung –
Nothing but should address
The soul's loneliness,
Speaking her sweet and secret native tongue.

There, there is nothing else but grace and measure,
Richness, quietness, and pleasure.

Fig. 1 Henri Matisse, study for *Luxe, calme et volupté*, 1904

See, sheltered from the swells

There in the still canals

Those drowsy ships that dream of sailing forth;

It is to satisfy

Your least desire, they ply

Hither through all the waters of the earth.

The sun at close of day

Clothes the fields of hay,

Then the canals, at last the town entire

In hyacinth and gold:

Slowly the land is rolled

Sleepward under a sea of gentle fire.

There, there is nothing else but grace and measure,

Richness, quietness, and pleasure.

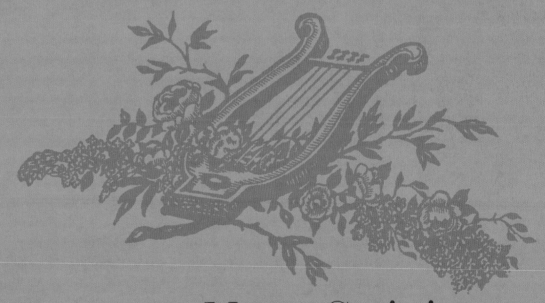

New Spirits
and Sacred Springs

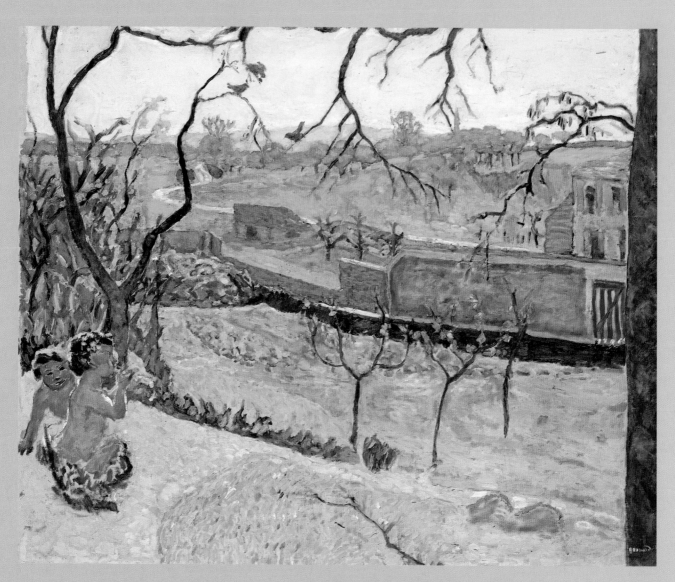

CAT. 2 PIERRE BONNARD, *Early Spring (The Little Fauns)*, 1909

New Spirits and Sacred Springs: Modern Art in France at the Turn of the Century

KENNETH E. SILVER

'WHAT CHANCE HAS . . . JUPITER AGAINST THE LIGHTNING ROD AND HERMES AGAINST THE CRÉDIT MOBILIER?'
KARL MARX, INTRODUCTION TO *GRUNDRISSE: FOUNDATIONS OF THE CRITIQUE OF POLITICAL ECONOMY*, 1857-58

After the radical innovations of the years immediately preceding World War I, a form of modern classicism swept through the Parisian avant-garde. Picasso's Greek maidens-at-the-well, *maternités*, and bathers are the most obvious examples of this neo-antique trend of the early 1920s. Picasso's Synthetic Cubism of the period, as well as the classicised modernism of Gris, La Fresnaye, and Léger also typify this trend, along with the art of the Purists, Amédée Ozenfant and Le Corbusier. Their magazine, L'*Esprit nouveau*, founded in 1920, was a journalistic demonstration of the enduring 'classic' principles that Ozenfant and Le Corbusier believed were fundamental to modern, Machine Age visual form. In their seminal essay 'Purism,' they declared: 'Logic, born of human constants, and without which nothing is human, is an instrument of control, and, for him who is inventive, a guide towards discovery.'[1] And in 'The Lesson of Rome,' they wrote: 'So they invented methods of construction and with these they did impressive things – *Roman*. The word has meaning. Unity of operation, a clear aim in view, classification of the various parts.'[2] The visual vocabulary of Purist painting, the architectural language of Le Corbusier, and Picasso's neo-classical art

were all expressions of this new, post-World War I, French *rappel à l'ordre* (to use Jean Cocteau's phrase), in which the modern and the classical were brought into striking realignment.

Beginning with John Golding and Christopher Green's 'Léger and Purist Paris' exhibition and catalogue for the Tate Gallery, in 1971, the classicising subtext of early-twentieth-century modernism has been investigated in numerous exhibitions, catalogues, and books. My own E*sprit de Corps: The Art of the Parisian Avant-Garde and the First World War, 1914-1925* demonstrated how wartime ideas of French classicism, in contradistinction to presumed German 'barbarism,' came to dominate Parisian cultural life, powerfully transforming the art of most of the leading figures of the period.[3] In 1990, the Tate mounted another major exhibition, with accompanying catalogue, 'On Classic Ground: Picasso, Léger, de Chirico and the New Classicism, 1910-1930', curated by Elizabeth Cowling and Jennifer Mundy, which extended the classicising moment backward to the pre-war years and broadened its scope to include modernist classicist currents in Spain and Italy. In 1996, the Öffentliche Kunstsammlung Basel and the Kunstmuseum Fondation Paul Sacher, Basel, presented 'Canto d'Amore:

Modernité et Classicisme dans la Musique et les Beaux-Arts Entre 1914 et 1935', with an important catalogue edited by Gottfried Boehm, Ulrich Mosch, and Katharina Schmidt, in which, along with painting and sculpture, music and ballet were considered in an international context. In the exhibition 'Antiguitat/Modernitat', of 1990, which she curated for the Fondació Joan Miró, Barcelona, Gladys Fabre took a chronologically broader look at the subject by including numerous contemporary, postmodern artists. Picasso's classicism, in particular, has been the subject of several monographic exhibitions, including 'Picassos Neoklassizismus: Werke von 1914-1934', organised by Ulrich Weisner in 1988 at the Kunsthalle Bielefeld; 'Picasso and the Mediterranean', organised by Steingrim Laursen in 1996 at the Louisiana Museum of Modern Art, Copenhagen; and 'Picasso, 1917-1924', organised by Jean Clair at the Palazzo Grassi in Venice, in 1998.

Our exhibition, 'Voyage into Myth: French Painting from Gauguin to Matisse, from the Hermitage Museum, Russia', extends the investigation of classicism in avant-garde French art even further back in the modern period, to the *fin de siècle* and the first decade of the twentieth century. With this chronological adjustment we arrive at *la source*, the wellspring of modern classicism, as the etymology of the term *l'esprit nouveau* suggests. It was neither entirely their own nor altogether new when the Purists proclaimed a controlled, classicising 'new spirit' just after the *Grande Guerre*. Guillaume Apollinaire, in his 1917 essay, 'L'Esprit nouveau et les poètes', invoked the term: 'The new spirit which we can already discern claims above all to have inherited from the classics solid good sense, a confident sense of criticism, a wide view of the world and the human mind, and that sense of duty which limits or rather controls displays of emotion.'[4] This sensible, reasoned attitude, bequeathed by classical civilisation, was, for the poet, a specifically French way of thinking, a 'sublime expression of the nation.' In fact, the term was no more an invention of Apollinaire's than of the Purists. Rather, it had first been launched, as Debora Silverman has shown, more

than twenty years before, during the period of 'Voyage into Myth.' In 1894, Eugène Spuller, who had been Gambetta's close collaborator, and was now minister of public instruction and beaux-arts under Prime Minister Jean Casimir-Périer, wrote: '*L'esprit nouveau* is the spirit that tends, in a society as profoundly troubled as ours, to draw all Frenchmen together around the ideas of good sense, justice, charity. These ideas are necessary for any society that wants to endure. It is a spirit that aspires to reconcile all citizens.'[5] Spuller's new spirit was more than vague, high-flown rhetoric. It was a specific reference to the political programme known as *ralliement*, whereby the Catholic Church and the monarchist Right could, finally, be reconciled to the Third Republic in the wake of recent papal recognition. Spuller was calling, in turn, for the tempering of long-standing liberal anti-clericalism. The spirit of compromise, this *esprit nouveau*, in which modernity and tradition are reconciled, is the ideological link between the aesthetics of the turn of the century and that of the early 1920s. As we shall see, it was during the period covered by 'Voyage into Myth' that there emerged in France a constellation of 'spiritual' artistic revivals, of which a reinvented classicism was among the most significant.

As Ekkehard Mai has reminded us, 'No period of modern art's beginnings seems to have been as disconcerting, protean and complex in its artistic manifestations as the decades between 1880 and 1910.'[6] The extraordinary group of talented individuals and influential movements that followed in rapid succession during these years comprises the current exhibition. Included among the artists are Rodin, Puvis de Chavannes, Cézanne, Gauguin, Denis, Bonnard, Signac, Matisse, Derain, and Picasso. The movements in which many of them took part include Impressionism, Neo-Impressionism, Symbolism – as well as its sub-groups the Synthetists and the Nabis – Fauvism, and Cubism. But even the degree of talent and astonishing variety of approach indicated by these names and designations fails to indicate the complexity of this period, because the *fin de siècle* is characterised not only by the clearly demarcated

aesthetic positions of remarkable artists, but also by changes in direction, shifting alliances, and critical misinterpretation. Cézanne, for instance, considered himself first, last, and always an Impressionist, but members of the younger generation, including Maurice Denis, saw him as something quite different – as a classicist; perhaps that was because Denis himself became a classicist, having begun his artistic life as a Synthetist, influenced by Gauguin, and allied with the Nabis.[7] Bonnard, on the other hand, was a Nabi who, at least according to some, moved *backwards* towards Impressionism. Matisse was first a naturalist of the Impressionist kind, then briefly a Neo-Impressionist, before gaining celebrity as a Fauve, a designation that he shrugged off only a few years after he had been one of the movement's founders. Picasso was a Symbolist and a classicist before he was a Cubist, and Derain was a Fauve, then a proto-Cubist, then a 'Gothic' modernist before becoming a classicist.

Yet the rhetorical incoherence that the end of the nineteenth century and the beginning of the twentieth begat testifies to a moment of extraordinary artistic self-consciousness, in the best sense of the term. Whether it was referred to as *l'art moderne*, *l'art contemporain*, or *l'art vivant* (the word 'modernism' was not yet in use), it was clear to artists, critics, dealers, collectors, and the public at large that the intensity of artistic endeavour had turned Paris into a kind of creative laboratory with, by the turn of the century, a powerful recent history all its own. Unquestionably, the two great modern artistic currents by the 1890s were Impressionism and Symbolism. We are used to thinking of Symbolism as the introspective, private, spiritualised answer to Impressionism's extroverted, public, painterly materialism, and that is not altogether inaccurate. It is true that nothing could be less like Impressionism, an art founded on modern life and *plein air* painting, than Gauguin's exotically rendered *Ave Marias*, Denis's archaising *Visitations* (cat. 11, 46) or Matisse's nymphs and satyrs (cat. 40). But, all of these Symbolist – ideal, ideational – manifestations were made by artists whose

intensely hued palettes were deeply indebted to Impressionist luminosity and whose various *mises en scène* bear striking traces of Impressionism's on-the-site observation, even if these have been exaggerated in the name of 'expression.' Indeed, as Richard Shiff has shown, Symbolism and Impressionism were not at first considered antithetical. To the contrary, in 1892, Albert Aurier, who first defined Symbolism as the 'painting of ideas,' specifically *praised* Manet, Degas, Cézanne, Monet, Sisley, Pissarro, and Renoir for their 'attempts at expressive synthesis.' The 'naturalists', of whom Aurier disapproved for their materialism, lack of soul, and conventional technique, were the academic artists, or *pompiers* – Béraud, Bouguereau, and Detaille.[8] Moreover, if the Impressionist visual legacy was amply exploited by the Symbolists, there are aspects of nascent Symbolism – an interest in classical myth, religion, and the cultivation of subjectivity – which were both anticipated and exploited by the Impressionists. Renoir's first classicising foray of the mid-1880s – his large *Bathers* (*Baigneuses*), now in the Philadelphia Museum of Art – comes to mind, as do Monet's pictures of Rouen Cathedral of the early 1890s, as well as his retreat to Giverny, and Cézanne's to Provence, both of which could be interpreted as forms of introspective withdrawal from Paris and *la vie moderne*.

It is nonetheless true that, as time went on, Impressionism was slowly reconfigured as Symbolism's opposite. Robert Rey points out that it was Denis who first considered the art of Gauguin and his friends as marking 'the beginning of the reaction against Impressionism.'[9] Rey himself refers to the Impressionists as 'superficial' and 'scientific,' irremediably exiled from the 'mysterious centre of thought.'[10] By the last decade of the century there was a widespread reaction against the entire Realist tradition – even on the part of some of the Impressionists – stretching all the way back to Courbet. It was he who famously said 'Show me an angel and I'll paint one' and wrote that 'painting is essentially a concrete art and can only consist of the representation of real and existing things. It is a completely physical language, the words of which consist of all

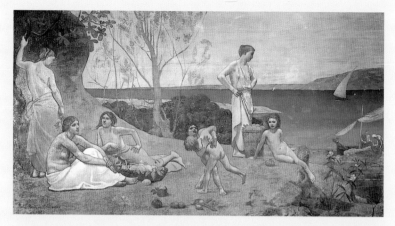

FIG. 2 PIERRE PUVIS DE CHAVANNES, *Pleasant Land* (reduced version), c. 1882

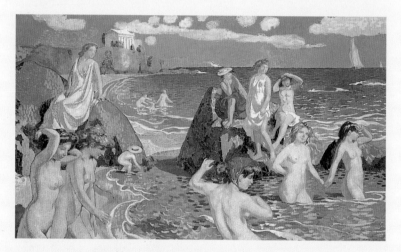

FIG. 3 MAURICE DENIS, *Beach with Small Temple*, 1906

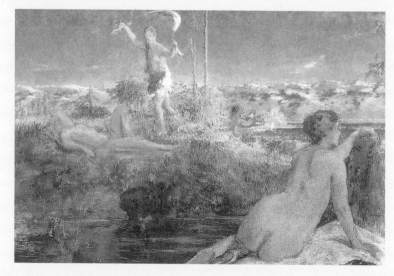

FIG. 4 KERR-XAVIER ROUSSEL, *The Cape of Antibes*, c. 1928

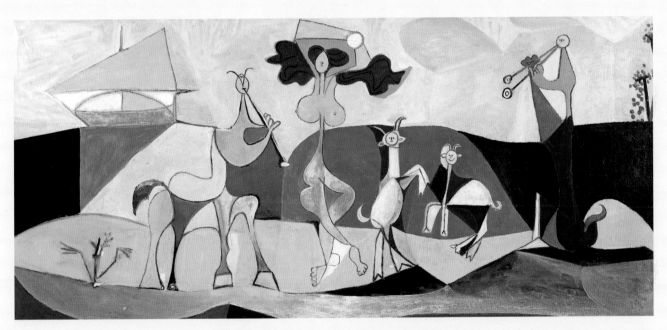

FIG. 5 PABLO PICASSO, *La Joie de vivre* or *Antipolis*, 1946

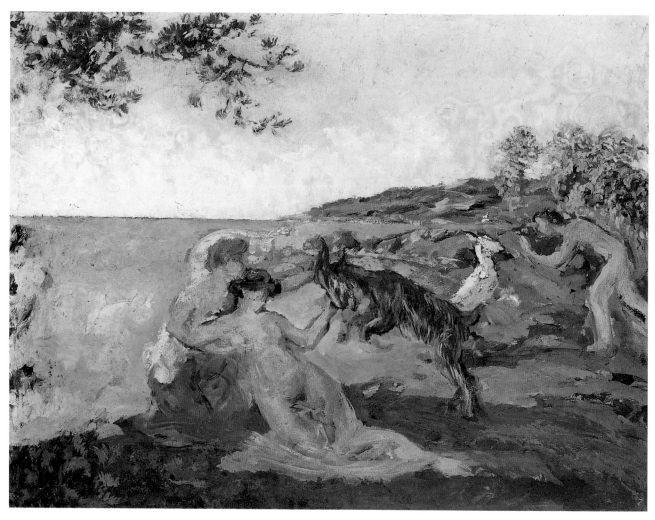

Cat. 3 Kerr-Xavier Roussel, *Mythological Scene*, c. 1903

Cᴀᴛ. 4 Mᴀᴜʀɪᴄᴇ Dᴇɴɪs, *Bacchus and Ariadne*, 1907

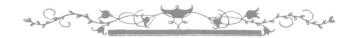

visible objects; and an object which is abstract, not visible, non-existent, is not within the realm of painting.'[11] In much the same spirit, Flaubert had said slightly earlier that 'the leading characteristic of our century is its historical sense. This is why we have to confine ourselves to relating the facts.'[12]

'Voyage into Myth' demonstrates how willing the *fin-de-siècle* generation was to stray from facts and history and to re-engage with 'non-existent' mythic subject matter, even if most of the works in the exhibition strike a balance between the two, powerful, informing currents of Impressionism and Symbolism. Although they are locked in the most earthbound of embraces, Rodin tells us that his marble lovers of 1905 are none other than *Cupid and Psyche* (cat. 35), and Denis's *Story of Psyche* (1908, cat. 62–73), created for Ivan Morozov's palace in Moscow, and composed of eleven narrative scenes and two borders, is an update of Italian Renaissance versions of the myth by way of overripe Synthetist colours. Fantin-Latour's young beauty in the waves, of 1896, could be any daring young woman taking a dip without her clothes, except that he tells us she is a naiad; Roussel, although his work of 1911-13 exhibits a revived Impressionist, or post-Fauve, painterly brilliance, depicts a *Triumph of Bacchus* (*Rural Festival*) (cat. 5) complete with classical drapery and musical accoutrements. (A cultural news item of 1904 relates: 'Who would have believed it? Poussin is becoming fashionable. Walking through the room in the Louvre, formerly deserted . . . it isn't rare to see several young men and women copying either his *Bacchanalia* . . . or his noble classical landscapes.')[13] And Bonnard's *Early Spring* (*The Little Fauns*) (1909, cat. 2), with its exquisite palette of pale mauves and soft yellows, recalls the most subtle of Pissarro's or Monet's *plein air* landscapes, except for the two fauns at the lower left, who herald the new season with most un-Realist aplomb. That same year, when Denis was also completing work on his *Story of Psyche*, he published an article in *L'Occident*, in which he took note of all of the classicizing activity around him: 'Like their elders, the young have made a resolute return to classicism. We have seen the new generation's infatuation with the seventeenth century, Italy and Ingres:

Versailles is fashionable, Poussin is praised to the skies, Bach concerts are packed, and Romanticism is ridiculed. In literature and politics, young people have a new passion for order. This return to tradition and discipline is as unanimous as the cult of the self and the spirit of revolt was when we were young.'[14] Classicism, order, discipline, tradition – *l'esprit nouveau*.

When Karl Marx, in the *Grundrisse*, pondered the relationship between modernity and myth in the form of a rhetorical question – 'What chance has . . . Jupiter against the lightning-rod and Hermes against the Crédit Mobilier? . . . is Achilles possible with |gun| powder and lead? Or the *Iliad* with the printing press?' – his answer was to be expected: the techno-logical world 'demands of the artist an imagination not dependent on mythology.' But he hedged his bets, which was a clever thing to do given the recrudescence of myth which we recognise in the works in our show: 'But the difficulty lies not in understanding that the Greek arts and epic are bound up with certain forms of social development,' he asserted. 'The *difficulty* |emphasis mine| is that they still afford us artistic pleasure and that in a certain respect they count as a norm and as an unattainable model.'[15] Of course, as Guy Cogeval has reminded us, 'the rediscovery of mythology' at the end of the nineteenth century was not, in fact, new. Mythological subject matter had been the business-as-usual iconography – the *norm*, in Marx's formulation – of the academic painters, who had drawn upon it 'mainly as a source of more or less literal learned references, to be cluttered in a welter of archaeological detail' whereas the Symbolists had been 'concerned with looking afresh at myths and systematically rereading them in an objective manner.'[16] The same, in fact, may be said for religious art. It continued to be produced, usually by academic painters, throughout the nineteenth and early twentieth centuries, but the Symbolists looked at it anew, hoping to restore – by various distancing mechanisms – some of its ancient mystery and power. Gauguin's was the most radical proposal: transpose the New Testament to Polynesia, where the scenes he had learned as a boy to contemplate with such

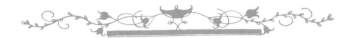

intensity at Bishop Dupanloup's seminary in Orléans might be reinvested with the innocent, uncorrupted faith of the 'noble savages' who functioned as his *dramatis personae*.[17] Gauguin's *Women by the Sea* (*Maternity*) of 1899 (cat. 39), and *Te Avae No Maria* (*The Month of Mary*) of 1899 (cat. 38) all have the added advantage of what is now called, in the political arena, 'deniability': they may be viewed as religious works, or, for the non-believer, as cultural (i.e. ethnographic) images, since the action which unfolds in each is non-specific enough to tolerate a certain degree of ambiguity. This is part of their 'renewal' of innocence, as if the various virgins, mothers, and children depicted by Gauguin are only dimly aware of the role that they may (or may not) play in the tragic and glorious story to come. Denis, who, as a critic and theorist was central to much that transpired in advanced Parisian art at the turn of the century, turned, for his religious paintings of the 1890s, to an *art primitif* closer at hand: the Italian primitives. In *The Meeting* (*The Visitation*), c. 1892, cat. 11 and *The Visitation* (1894, cat. 46) he was inspired by the late medieval, early Renaissance work of Giotto, Fra Angelico, and Masaccio. In contradistinction to the hyper-naturalism of the Christian art of his contemporaries, like that of Lhermitte or Béraud, Denis's style is ostentatiously naïve – flattened forms and stiff poses are rendered with a minimum of chiaroscuro and in a restrained palette.[18] As in Gauguin, Denis's Marys and Elisabeths inhabit a chronological and narrative framework that is ambiguous, in this case syncretist, at once contemporary and pre-modern; and, as in the art of his mentor, Denis's dramas require a leap of faith only for those who are susceptible to the exertion. Much later, Denis would take a more instrumental approach to Christian art, after the establishment in 1919 with Georges-Olivier Desvallières of the Ateliers d'Art Sacré, dedicated to the training of young artists in the methods necessary for modern religious decoration.

These two iconographies – the classical and the Christian – took on ever-increasing relevance in the context of turn-of-the-century French political life. The Dreyfus Affair, which lasted more than a decade – from the French Jewish captain's conviction of espionage in 1894 to his exoneration in 1906 –

brought to the fore most of the major questions of authority that had been first unleashed by the Revolution a century earlier: monarchy versus republic, army versus civil authority, landed aristocracy versus industrial bourgeoisie, religious versus secular culture, Frenchmen versus foreigners (France versus Germany, Catholics versus Jews), each of these antagonisms in synecdochical relationship to all the others. In this context, the classical and the Christian – linked by way of Rome specifically and the Mediterranean more generally – were fraught. For the extreme Right, like Charles Maurras and his *Action française* (and for Maurice Denis), legitimate authority was vested in these 'twin' traditions: 'Latin culture' was shorthand for the obedience and control associated with the Roman Empire, and for the deep faith of Christianity. Only a restored monarchy, according to Maurras, could reinstate these traditions, and return France to an earlier, natural, harmonious whole.[19] (When Le Corbusier, at the end of his book, *Urbanism*, of 1926, said of Louis XIV: 'Homage to a great town-planner – This despot conceived great projects and realised them' he was worried enough about the associations between ultra-Right politics and *la France classique* to add a note: 'This is not a declaration of the *Action française*.')[20] For the extreme Left, the classical and the Christian were mostly anathema – twin forms of oppressive obedience to authority, and both, *pace* Marx, 'mythic' – although the Mediterranean could also, as in the case of Paul Signac, be the setting for a harmonious environment of the anarchist-socialist kind, 'in contrast to the cities and the lives of workers contaminated by the degradation of work in a corrupt society.'[21] His largest and most important painting, *In the Time of Harmony* (*Au temps d'Harmonie*, 1893-95, fig. 20), which now decorates a staircase of the town hall of Montreuil, is a picture of wholly integrated work and play, set on the bluffs above Saint-Tropez's Graniers beach. Its subtitle, *The Golden Age has not Passed; It is Still to Come* (*L'âge d'or n'est pas dans le passé, il est dans l'avenir*) coined by the anarchist Charles Malato, indicates that the nostalgia of those who typically invoked golden age themes could also be turned in the other

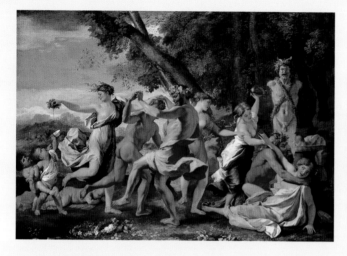

FIG. 6 NICOLAS POUSSIN, *Bacchanal before a Herm*, c. 1634

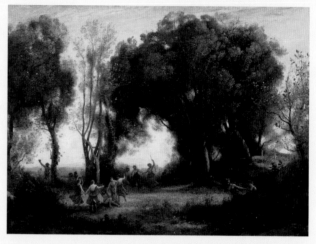

FIG. 7 JEAN BAPTISTE CAMILLE COROT,
Morning, the Dance of the Nymphs, c. 1850

FIG. 8 WILLIAM BOUGUEREAU, *The Education of Bacchus*, 1884

CAT. 5 KERR-XAVIER ROUSSEL, *The Triumph of Bacchus (Rural Festival)*, 1911-1913

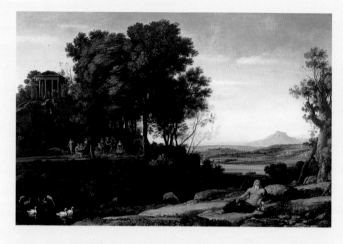

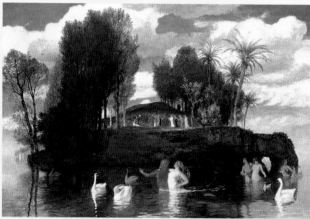

FIG. 9 CLAUDE GELLÉE called LE LORRAIN,
Landscape with Apollo and the Muses, 1652

FIG. 10 ARNOLD BÖCKLIN, *The Island of the Living, 1888*

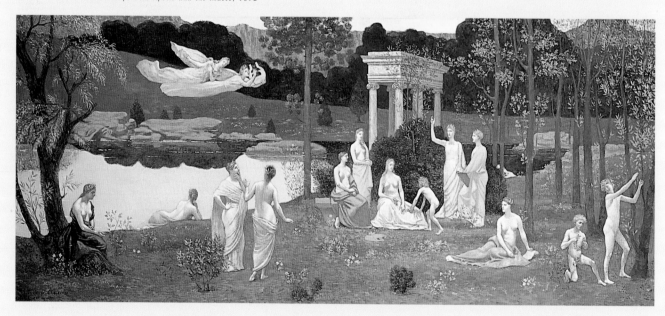

FIG. 11 PIERRE PUVIS DE CHAVANNES,
The Sacred Grove, Beloved of the Arts and Muses (reduced version), 1884-1889

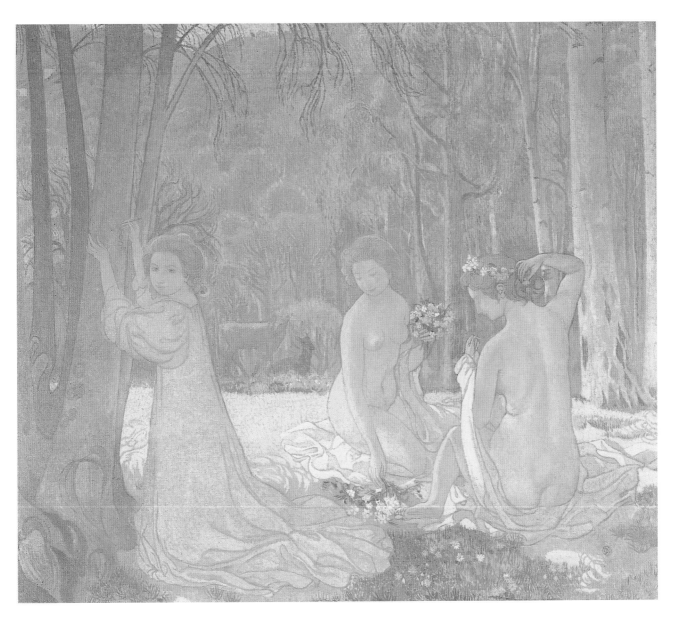

CAT. 6 MAURICE DENIS, *Figures in a Spring Landscape (The Sacred Grove)*, 1897

direction, towards a utopian future. Signac's painting of Marseilles's Vieux Port, *Port of Marseilles* (1906-7, cat. 17), with its old-fashioned, triple-masted schooner rendered in the modern, 'scientific' divisionist technique he had learned from Seurat, reconciles the out-of-date and the up-to-date, on behalf of *le peuple*, in the brilliant light of the Midi. Let us keep in mind that Spuller's *esprit nouveau* was aimed at both the Left and Right.

Escape from cities – and from Paris in particular – had special relevance for artists interested in either the classical tradition or Christian subjects. Of course the classical meant the south, which, thanks to the PLM (Paris-Lyon-Mediterranean railway), could be easily reached from the capital from the 1860s. The Impressionists had already popularised artistic displacement by means of the railway, usually to the Parisian suburbs and to the Channel coast resorts. By the end of the century, *la France méridionale*, and especially the south east coast – the Côte d'Azur – became ever more popular with artists, especially for those in search of an idyllic, Arcadian setting.[22] The Fauves and their friends worked both in the south west, at Collioure – where in 1905 Matisse painted a *View of Collioure* (cat. 23), looking out over the rooftops of the town, in brilliant reds,

blues, pinks, and oranges – and along the Côte d'Azur: at Cassis, where Derain's *Mountain Road* (1907, cat. 22) signalled a shift in his art away from the typical Fauvist high-keyed palette towards a more normative, Cézanne-inspired range; at Menton, where Marquet painted the port; and at Saint-Tropez, the small fishing port that gradually became an art colony (thanks to Signac, whose house there, La Hune, was a gathering place for visiting Parisian artists). Manguin painted a contemporary Arcadia (cat. 24), with a view across Canoubiers Bay, and his wife and two sons lounging in the grass at the lower right, near Saint-Tropez, at the Villa Demière, in 1905; four years later, as Manguin's guest there, Bonnard got his first idea for the central panel of his triptych *Mediterranean* (1911, cat. 74), commissioned by Morozov for his staircase. Without recourse to mythological intrusion, Bonnard projects an Eden-like image of total complicity between man and nature: set in a sun-dappled garden near the sea, a woman plays with a cat at the lower left, infants crawl around in the centre, and a mother and young child converse at the lower right – a kind of Three Ages of Woman by-the-sea.

All of these works were predicated on a notion of classicism quite distinct from that of France's conservative spokesmen.

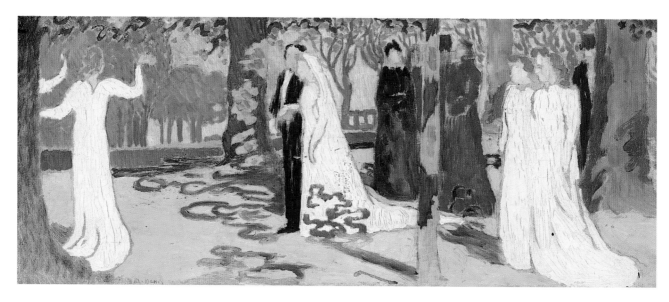

CAT. 7 MAURICE DENIS, *Wedding Procession*, c. 1892

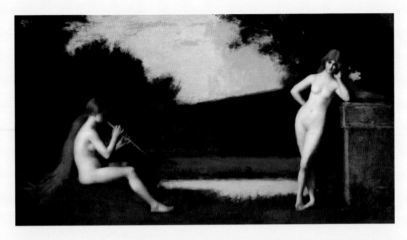

Fig. 12 JEAN-JACQUES HENNER, *Eclogue*, 1879

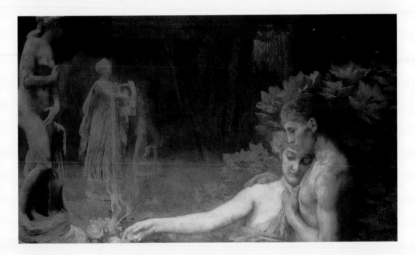

Fig. 13 JANOS VÁSZARY, *The Golden Age*, 1898

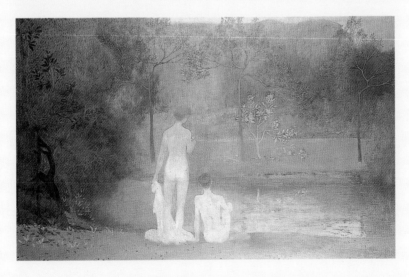

Fig. 14 CONSTANT MONTALD, *The Garden of Eden*, 1904

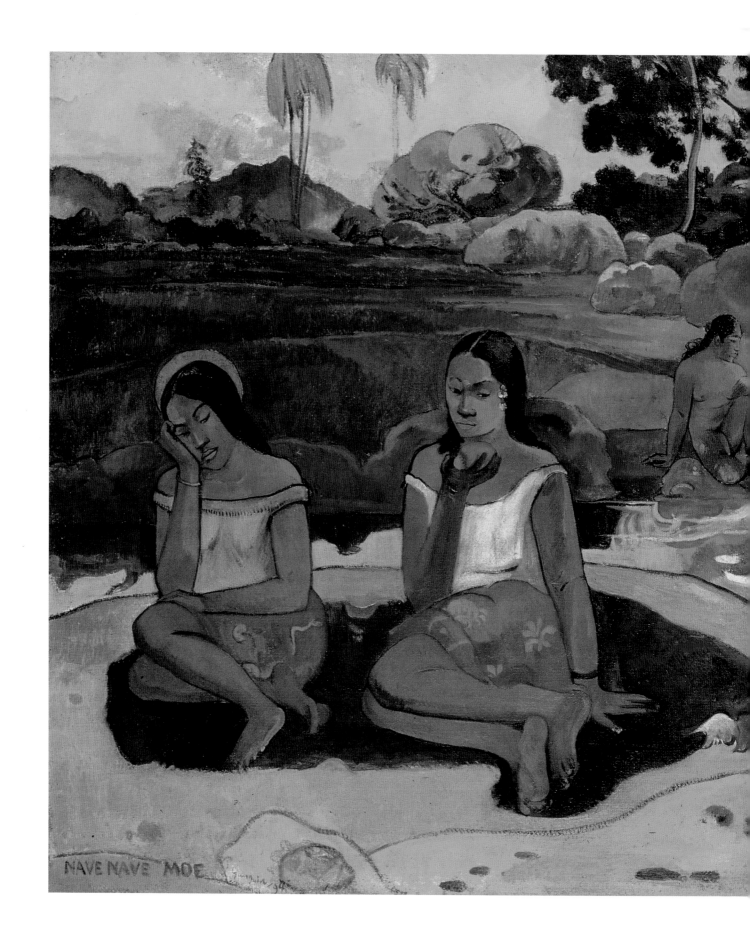

CAT. 8 PAUL GAUGUIN, *Nave Nave Moe (Sacred Spring / Sweet Dreams)*, 1894

FIG. 15 JACOB BOUTTATS, *The Paradise*, c. 1700

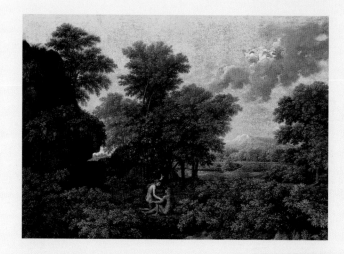

FIG. 16 NICOLAS POUSSIN, *Spring or the Earthly Paradise*, 1660-1664

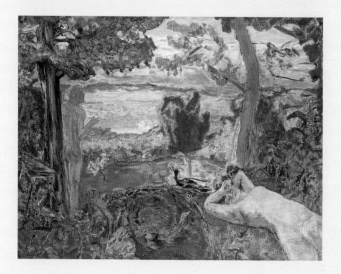

FIG. 17 PIERRE BONNARD, *Earthly Paradise*, 1916-1920

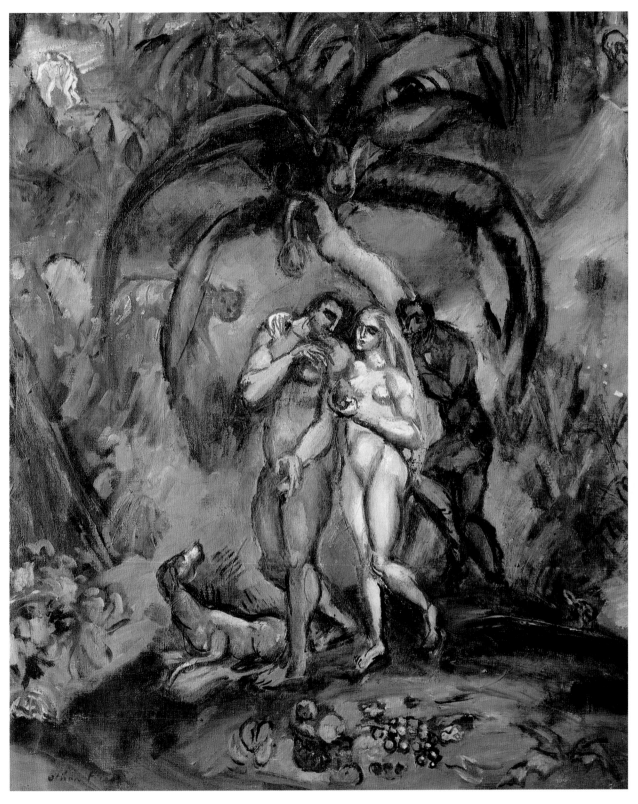

CAT. 9 ÉMILE-OTHON FRIESZ, *Temptation (Adam and Eve)*, c. 1910

In typical French artistic parlance, *l'art classique* comprised not only antiquity and the Italian Renaissance, but also the court art of François I at Fontainebleau, the art of Poussin and Claude Lorrain during the *grand siècle*, the art of Ingres, the great representative of *le style classique*, and of Corot, in the nineteenth century. Now, though, the classical south, and the Arcadian imagery that was its human coefficient, were being rendered by modern means, with the palette and direct observation of the Impressionists and their pictorial descendants. This made them difficult for the radical Right to recuperate, even if their modernism was tempered by an obvious reference to traditional golden age imagery. What James Herbert has said of Fauvism can also be extended to many of the paintings in 'Voyage into Myth': 'In such works the present moment, not the absolutist seventeenth century, seemed the inevitable product of the cultural and political heritage flowing from Athens and Rome to Paris. The Latin heritage, according to these paintings, belonged to modern France... Nationalist tools were brought to bear on a cause other than nostalgic regret: the ratification of the republican status quo.'[23]

Part of the evolving national profile of the Third Republic during the 1890s was cultural decentralisation, which mostly worked from the outside in: the Regionalist movement, which challenged Parisian hegemony, experienced significant gains during the decade. For any number of figures of varying political persuasion, the capital city was increasingly seen as dangerous and corrupting. As Anne-Marie Thiesse has pointed out: 'In the rhetoric of the time, Paris, capital of power, business, trade and the luxury goods industry, was the modern Babylon on which to pour anathemas,'[24] with a net gain for the provinces: 'The violent attacks against "Parisian" culture, declared decadent and morbid, went hand in hand with a celebration of the provinces as the bedrock of a healthy, rich and authentic culture in which France could find its Renaissance.'[25] The two most important regions for this emerging profile of the nation were Provence, 'a direct descendant of Virgil and the Graeco-Latin world,'[26] and

Brittany. 'The Bretons were thought of as pure-blooded Celts,' Catherine Bertho has written, 'as kinds of anthropological fossils that had survived intact down the ages and whose characteristic traits had remained stronger than those of their neighbours ... The region's significant economic backwardness also reinforced the impression of an archaic world ... The French provinces in general were reputed to be wild, Brittany wilder ... The French provinces in general were supposed to be Catholic and conservative, Brittany more Catholic and more conservative.'[27] Artistically, Brittany since mid-century had been depicted as simple, hardworking, and devout by peasant painters like Jules Breton. By the 1880s, Gauguin and Bernard devised a neo-primitive style that was the corollary of this already well-established local Breton iconography, a style which, in turn, was the basis for works like Denis's *Sacred Spring at Guidel* (1905, cat. 10). We have already taken note of Denis's interest in the Italian primitives; now he was turning his attention to a form that was native to France. Here, the locals, in traditional costume, gather to drink the healing waters from *la source*, in front of rich grazing land (frequented by two healthy-looking bovines), only metres from the shoreline. This was the kind of thing that the regionalists could applaud, an image of 'healthy, rich, authentic' provincial life and a source of French regeneration.

But whether the revivifying waters were to be found in Brittany or in Tahiti, as in Gauguin's *Nave Nave Moe* (*Sacred Spring / Sweet Dreams*) of 1894 (cat. 8), they were equally far, in spiritual terms, from the 'decadent, morbid' capital. Distancing oneself from the here-and-now, represented by Paris, took the form of both real and metaphorical voyages at the turn of the century. Not only did artists regularly travel to Brittany, the South of France, and to many other places near and far, but traversing cultural and political terrain became a kind of literary trope as well. Maurice Barrès is the foremost example of this: having started out, around 1890, as a sceptical, aestheticised, Symbolist writer, famous for his formulation of the *culte du moi*, by 1900 he had become a fervent nationalist and regionalist

(calling for *revanche* against Germany in order to restore his native Lorraine to France), devoted to 'the self-within-the-group defined by *la terre et les morts*, the organic foundations of inescapable affinities.'[28] If Barrès's conversion was extreme, it was nonetheless the prototype for related intellectual, moral, and political journeys of the era, especially for trajectories from radical youth to conservative maturity. Maurice Denis saw the history of recent French art in just this way: *Théories (1890-1910): Du Symbolisme et de Gauguin vers un nouvel ordre classique* was the title of his highly influential collected essays. Signac, of course, saw things otherwise, but the title of his 1899 collection of essays nonetheless also took the form of a trajectory (one *away* from myth, perhaps, and towards science): *D'Eugène Delacroix au néo-impressionnisme.*

But whatever form their art and theory took, and although most of them continued to live in or near Paris (at least part-time), the city no longer exerted the kind of hold on the artistic imagination that it had a decade or two earlier. Urban imagery, a staple of advanced French art of the 1870s and 1880s, is almost wholly absent from 'Voyage into Myth'. There are works which invoke the seasons – Rodin's *Eternal Springtime* (c. 1900, cat. 33), Van Dongen's *Spring* (1908, cat. 14), Puy's

Summer (1906, cat. 25), and Friesz's *Autumn Work* (1907, cat. 27) – and works about fecundity – from Gauguin's *Man Picking Fruit in a Yellow Landscape* (1897, cat. 47) and his various *maternités*, to the rich assortment of fruit to be found in the still-life paintings of Cézanne, Derain, Matisse, and Picasso. There are images that speak to the question of civilisation's early development – like Matisse's *Game of Bowls* (1908, cat. 41) or Valtat's *Little Girls Playing with a Lion Cub (Children's Games)* (c. 1905-6, cat. 57) – and there are images of more advanced development, like the harbour paintings of Signac, Marquet, and Derain. But not until the very end of 'Voyage into Myth' do we begin to see anything, in thematic terms, that invokes the modern and the urban, and these are just glimpsed in Picasso's *Brick Factory at Tortosa* (1909, cat. 28) and Sonia Delaunay's *The Prose of the Trans-Siberian and Little Jehanne of France* (1913, cat. 31). Indeed, Cubism would mark a very distinct re-engagement with modern, urban life, a not insignificant aspect of its newness after 1910. For the two decades of our exhibition, one at a century's end and the other at a century's beginning, the artists of the Parisian avant-garde were mostly *en route* – to places real and mythic – for which only nature herself could provide the assurance of authenticity.

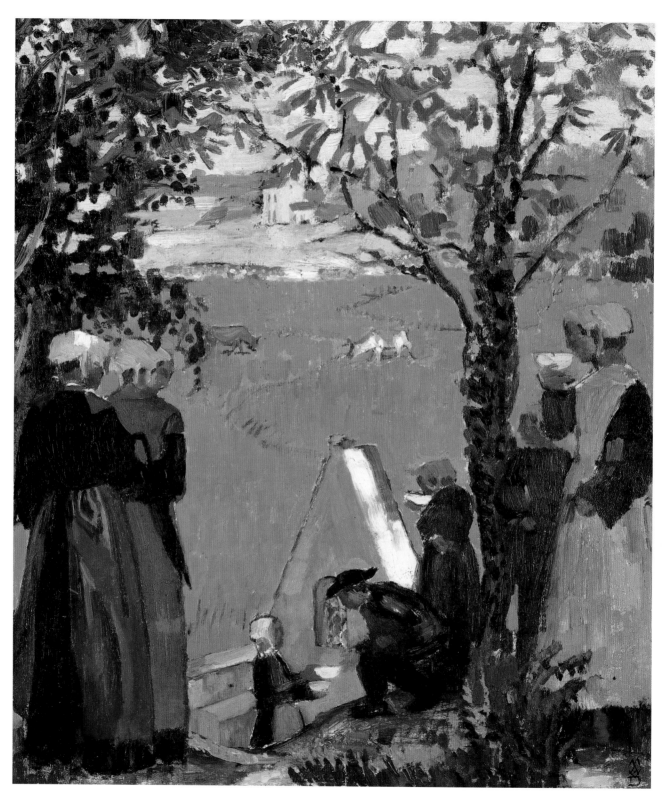

CAT. 10 MAURICE DENIS, *Sacred Spring at Guidel*, c. 1905

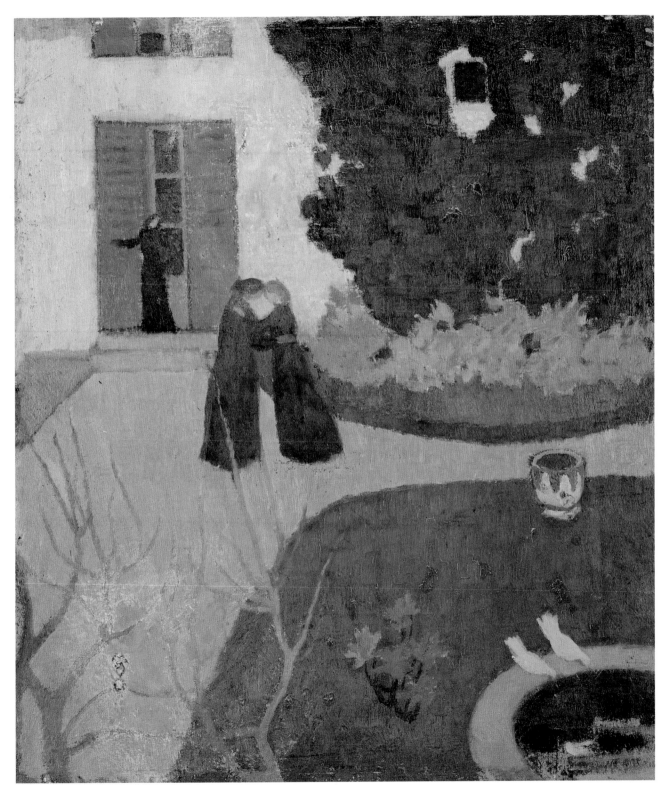

CAT. 11 MAURICE DENIS, *The Meeting (The Visitation)*, c. 1892

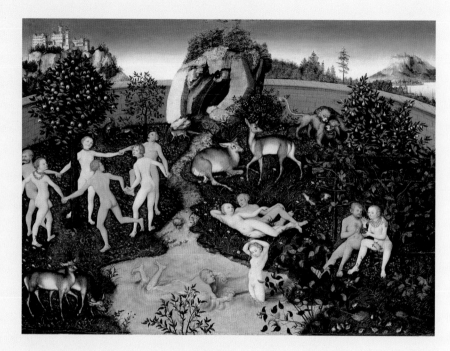

FIG. 18 LUCAS CRANACH THE ELDER, *The Golden Age*, c. 1530

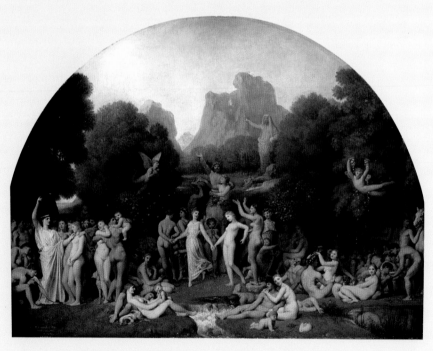

FIG. 19 JEAN AUGUSTE DOMINIQUE INGRES, *The Golden Age*, 1862

FIG. 20 PAUL SIGNAC, *In the Time of Harmony*
(The Golden Age has not Passed; It is Still to Come), 1893-1895

FIG. 21 ANDRÉ DERAIN, *The Golden Age*, 1905

Notes

1 In Robert L. Herbert, ed., *Modern Artists on Art* (Englewood Cliffs, NJ: Prentice Hall, 1964), pp. 59-60. In French: 'LA LOGIQUE, dérivée des constantes humaines, sans laquelle rien n'est humain, est un instrument de contrôle et, pour celui qui sait inventer, un guide de découverte,' in Amédée Ozenfant and Charles-Édouard Jeanneret (known as Le Corbusier), 'Le Purisme', *L'Esprit nouveau* no. 4 (January 1921); reprint: Da Capo Press, New York, 1968, p. 369.

2 Quoted in English in *Towards a New Architecture* (New York: Frederick A. Praeger, 1946), p. 146. In French: 'Alors ils ont inventé des procédés constructifs et ils en ont fait des choses impressionnantes, romaines. Le mot a un sens. Unité de procédé, force d'intention, classification des éléments,' in Le Corbusier, 'La leçon de Rome', *Vers une architecture* (Paris: Éditions Arthaud, 1977), p. 127. The original edition of this work was published in 1923 under the title *Vers une architecture* by Editions Crès et Cie, Paris.

3 *Esprit de Corps: The Art of the Parisian Avant-Garde and the First World War, 1914-1925* (Princeton: Princeton University Press, 1989). Published in French in 1991 as *Vers le retour à l'ordre*.

4 Guillaume Apollinaire, 'L'Esprit nouveau et les poètes', (1917), *Œuvres complètes de Guillaume Apollinaire*, ed. Michel Décaudin, 3 (Paris: Ballard et Lecat, 1966): p. 900 'L'esprit nouveau qui s'annonce prétend avant tout hériter des classiques une solide base de bon sens, un esprit critique assuré, des vues d'ensemble sur l'univers et dans l'âme humaine, et le sens du devoir qui dépouille les sentiments et en limite ou plutôt en contient les manifestations.'

5 Eugène Spuller as quoted in English in Debora Silverman, *Art Nouveau in Fin-de-Siècle France* (Berkeley: University of California Press, 1989), p. 48. In French: 'L'esprit qui tend, dans une société aussi profondément troublée que celle-ci, à ramener tous les Français autour des idées de bon sens, de justice et de charité qui sont nécessaires à toute société qui veut vivre,' in Jean Mayeur, *Les Débuts de la IIIᵉ République, 1871-1898* (Paris: Seuil, 1973), p. 212.

6 Ekkehard Mai, 'Abstraction et synthèse: Confrontation des textes de Maurice Denis avec la réflexion théorique en Europe', *Maurice Denis: 1870-1943*, exh. cat. (Musée des Beaux-Arts de Lyon, 1994), p. 31. 'Aucune période des débuts de l'art moderne ne semble avoir été aussi déconcertante, protéiforme et complexe dans ses manifestations artistiques que les décennies qui se sont écoulées entre 1880 et 1910.'

7 Theodore Reff convincingly argues that Cézanne never said that he wanted to 'do Poussin again after nature' as is usually claimed, and, further: 'If Poussin was a model for Cézanne, he was one among many, neither the most important throughout his career nor of the same importance in its several aspects or phases; if, on the contrary, he is often represented otherwise, that that is the product of an accumulation of distortions and projections whose origin is in his early commentators, not in the artist himself,' amongst whom he names Bernard, Denis, and Gasquet. Reff, 'Cézanne and Poussin', *Journal of the Warburg and Courtauld Institutes* 23, nos. 1-2 (January to June 1960), pp. 150-74.

8 Richard Shiff, *Cézanne and the End of Impressionism: A Study in the Theory, Technique and Critical Evaluation of Modern Art* (Chicago: The University of Chicago Press, 1984), pp. 7-8. The article by Albert Aurier he cites is 'Les Peintres symbolistes' (1892), in *Œuvres*, pp. 306, 297.

9 'Le début de la réaction contre l'impressionisme', Robert Rey, *La Renaissance du sentiment classique: La peinture française à la fin du XIXᵉᵐᵉ siècle* (Paris: Les Beaux-Arts, 1931), p. 80.

10 'Le centre mystérieux de la pensée', in Rey, op. cit., pp. 63-64.

11 Quoted in Linda Nochlin, *Realism* (New York: Penguin Books, 1978), p. 23. In French: 'Je tiens aussi que la peinture est un art essentiellement concret et ne peut consister que dans la représentation des choses réelles et existantes. C'est une langue toute physique, qui se compose, pour mots, de tous les objets visibles, un objet abstrait, non visible, non existant, n'est pas du domaine de la peinture,' in Pierre Courthion, *Courbet raconté par lui-même et par ses amis*, vol. 2 (Geneva: Pierre Cailler, 1950), pp. 205-6.

12 Quoted in Nochlin, *Realism*, p. 23. In French: 'Nous sommes avant tout dans un siècle historique. Aussi faut-il raconter tout bonnement, mais raconter jusque dans l'âme.' Letter to Louise Colet (22 April 1854) in Flaubert, *Correspondance*, vol. 2, ed. Jean Bruneau (Paris: Éditions Gallimard, 1980), pp. 556-57.

13 Cited in Reff, 'Cézanne and Poussin', p. 167. In French: 'Qui le croirait, Poussin commence à devenir à la mode ? En traversant la salle du Louvre, jadis déserte . . . il n'est pas rare de voir plusieurs jeunes gens ou jeunes filles copier soit ses bacchanales . . . soit ses nobles paysages classiques,' in Georges Dralin, 'Propos', *L'Occident*, no. 30 (May 1904), pp. 235-39.

14 'Autour de ses aînés, la jeunesse est revenue résolument classique. On connaît l'engouement de la nouvelle génération pour le XVIIᵉ siècle, pour l'Italie, pour Ingres; Versailles est à la mode, Poussin porté aux nues, Bach fait salle comble; le romantisme est ridiculisé. En littérature, en politique, les jeunes gens ont la passion de l'ordre. Le retour à la tradition et à la discipline est aussi unanime que l'était dans notre jeunesse le culte de moi et l'esprit de révolte.' Quoted in Ellen Oppler, *Fauvism Reexamined* (New York: Garland Publishing, 1976), p. 267. This was Oppler's 1969 PhD dissertation for Columbia University and it marked a true turning point in Fauvism studies by putting the movement in contemporary critical context; John Elderfield's excellent *The 'Wild Beasts': Fauvism and its Affinities* (New York: Museum of Modern Art, 1976) relies heavily on it, as do all serious subsequent Fauvism studies, as well as the present essay.

15 Karl Marx, *Grundrisse*, trans. by Martin Nicolaus (London: Penguin Books, 1993), pp. 110-111.

16 Guy Cogeval, 'The Waning of Culture', *Lost Paradise: Symbolist Europe*, exh. cat. (Montreal: Montreal Museum of Fine Arts, 1995), p. 25. In French 'Le recours à la mythologie . . . son utilisation littérale en a fait un manuel de références plus ou moins savantes, recouvertes de l'épais manteau d'un fatras archéologisant . . . Le symbolisme, en revanche, s'investit dans une revisitation des mythes ; il en opère systématiquement la relecture critique,' in Guy Cogeval, 'Le crépuscule de la culture', *Paradis perdus: l'Europe symboliste*, exh. cat. (Montreal: Musée des Beaux-Arts de Montréal, 1995), pp. 25-26.

17 For the background to Gauguin's Catholicism see Debora Silverman's recent *Van Gogh and Gauguin: The Search for Sacred Art* (New York: Farrar, Straus and Giroux, 2000).

18 For an overview of Denis's religious art in the context of nineteenth-century French religious painting, especially in relation to Naturalism, see Michael Paul Driskel, *Representing Belief: Religion, Art, and Society in Nineteenth-Century France* (University Park, Pennsylvania: The Pennsylvania State University Press, 1992).

19 See Eugen Weber, *Action Française: Royalism and Reaction in Twentieth-Century France* (Stanford, California: Stanford University Press, 1962).

[20] Quoted in English in Reyner Banham, *Theory and Design in the First Machine Age* (New York: Praeger, 1960), p. 256. In French: 'Hommage à un grand urbaniste – Ce despote conçut des choses immenses et il les réalisa . . . ceci n'est pas une déclaration d'Action française,' in Le Corbusier, L'*Urbanisme* (Paris: Les Éditions G. Crés & Cie, 1926).

[21] Robert L. Herbert, 'An Anarchist's Art', *The New York Review of Books* XLVIII, 20 (20 December 2001), p. 25.

[22] The Côte d'Azur has been the subject of several exhibitions in the last several years, with important catalogues: *1918-1958: La Côte d'Azur et la Modernité*, exh. cat. (Paris: Réunion des Musées Nationaux, 1997); Kenneth Wayne, et al. *Impressions of the Riviera: Monet, Renoir, Matisse and their Contemporaries*, exh. cat. (Portland, Maine: Portland Art Museum, 1998); Françoise Cachin, *Méditerranée de Courbet à Matisse*, exh. cat. (Paris: RMN, 2000), and my own *Making Paradise: Art, Modernity, and the Myth of the French Riviera*, exh. cat. (Cambridge, Mass., and London: The Portland Museum of Art and MIT Press, 2001).

[23] James D. Herbert, *Fauve Painting: The Making of Cultural Politics* (New Haven: Yale University Press, 1992), p. 7.

[24] 'Paris, capitale du pouvoir, des affaires, du commerce, de l'industrie du luxe est dans la rhétorique du temps la moderne Babylone sur laquelle pleuvent les anathèmes,' in Anne-Marie Thiesse, *Écrire la France: Le Mouvement littéraire régionaliste et de langue française entre la Belle Époque et la Libération* (Paris: Presses Universitaires de France, 1991), p. 49. I am grateful to Ed Berenson, director of the Institute of French Studies, New York University, for leading me to Thiesse and the literature on Paris and regionalism at the turn of the century.

[25] 'Les attaques violentes contre la culture "parisienne", declarée décadente et morbide, se doublent d'une célébration de la province comme fondement d'une culture saine, riche, authentique, où la France peut trouver sa Renaissance,' in Thiesse, op. cit., p. 48.

[26] 'L'héritier en droite ligne de Virgile et du monde gréco-latin,' in Thiesse, op. cit., p. 24.

[27] 'Sortes de fossiles anthropologiques arrivés intacts du fond des âges et dont les traits caractéristiques auraient gardé plus de forces que celles de leurs voisins . . . Enfin, le réel retard économique du pays a renforcé l'impression d'un monde archaïque . . . Lorsque la province française dans son ensemble est réputée sauvage, la Bretagne paraît simplement plus sauvage . . . lorsque la province française tout entière est censée être catholique et conservatrice, la Bretagne est plus catholique et plus conservatrice,' in Catherine Bertho, 'L'Invention de la Bretagne, genèse d'un stéréotype' (1980), quoted in Thiesse, op. cit., p. 40. I had the pleasure of meeting Bertho (now Bertho Lavenir) when she spoke at a symposium, 'En Route: On Travel and Tourism in France' organised by Shanny Peer, Susan Carol Rogers, and myself at the Institute of French Studies, NYU, in 1998. I am grateful to my co-organizers, and the conference's participants, for helping me to think more broadly about issues of French travel and tourism.

[28] Eugen Weber, *France, Fin-de-Siècle* (Cambridge, Mass.: The Belknap Press, 1986), p. 25.

The Myth of the Midi

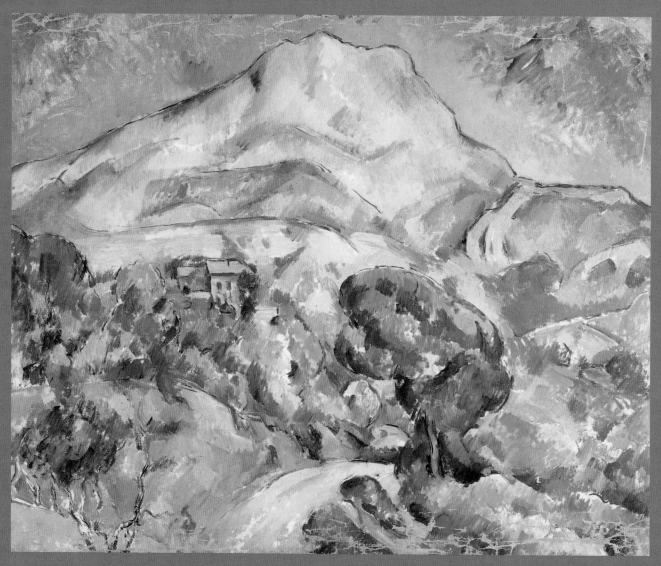

CAT. 12 PAUL CÉZANNE, *Mont Sainte-Victoire*, C. 1896-1898

THE MYTH OF THE MIDI:
LANDSCAPE AS EARTHLY PARADISE

MICHAEL PARKE-TAYLOR

In mid-nineteenth-century France, the Decadent writer Charles Baudelaire (1821-1867) admonished the reader of his poem *L'invitation au voyage* to dream of a journey to a land where, 'There, there is nothing else but grace and measure, Richness, quietness, and pleasure.'[1] By shortly after the turn of the century, many artists of the French avant-garde had travelled to the South of France, a place that is today firmly associated in our minds with luxury and pleasure, if not calm and order. And when Henri Matisse borrowed the line *Luxe, calme et volupté* (fig. 1) as the title of his ground-breaking painting made in Paris (figs. 1, 26), but inspired by the summer of 1904 at Saint-Tropez, Baudelaire's dream voyage to an earthly paradise, the South of France, and the modernist triumph of imagination over nature became inextricably linked.

With nature as the starting point, the notion of transporting the viewer to distant, often mythic, realms was a particular challenge for Matisse and other early modernists. Their voyages of artistic discovery encompassed both dream journeys and real places, and thus paralleled the experience of travel as described by travel writer Norman Douglas, who observed, 'It seems to me that the reader of a good travel-book is entitled not only to an exterior voyage, to descriptions of scenery and so forth, but to an interior, a sentimental or temperamental voyage which takes place side by side with the outer one.'[2] For the early modernist painters, the description of place went hand in hand with the evocation of a powerful interior experience, which occurred when a picture triggered memory or stimulated imagination. Mythmaking was often not far behind.

Travel can serve many purposes for artist and audience, and it was an aspect of the search for an earthly paradise, which was a recurring theme of much late-nineteenth and early-twentieth-century painting. The quest begins when the artist flees from the city, that locus of modernity, to create a parallel modernity in a place where history can be invented. The experience of travel, so the myth goes, frees the artist to develop in emotional and intellectual ways that are commensurate with the distance from civilisation left behind and the exoticism of the new locale. The quintessential modernist example is Paul Gauguin, who attempted to find his paradise on earth by visiting Tahiti, where he yearned for the simple life of nature and tried to 'go native.' He wished to invent an exoticism for the representation of native Tahitian culture, which he observed had already been corrupted by colonisation. Gauguin thus perpetuated the myth that he had escaped a diseased civilisation to find a new world where he might be renewed through contact with primitive culture.

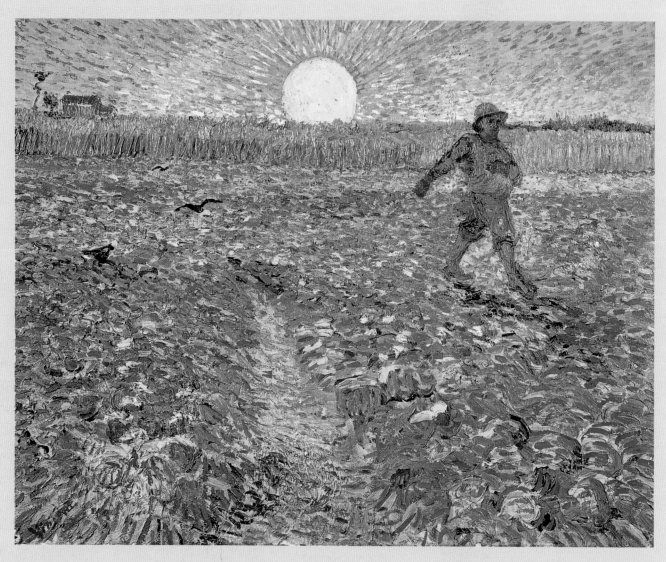

FIG. 22 VINCENT VAN GOGH, *The Sower*, 1888

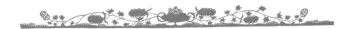

The idea that travel can encourage a voyage into mythmaking with therapeutic benefits for the artist may also be extended to the viewer, who participates vicariously in the experience. In his oft-quoted 'Notes of a Painter,' Matisse wrote in 1908: 'What I dream of is an art of balance, of purity and serenity, devoid of troubling or depressing subject matter, an art that could be for every mental worker, for the businessman as well as the man of letters, for example, a soothing, calming influence on the mind, something like a good armchair that provides relaxation from fatigue.'[3] Taken out of context, this statement misrepresents Matisse and his art as facile and hedonistic, when in fact his sentiment was probably directed to his Russian patron Sergei Shchukin (1854-1936), who had recently suffered great personal loss and tragedy.[4] Jack Flam has noted that Matisse, who also endured hardship during the early years of his career, wrote for Shchukin's benefit by suggesting that painting could be a psychological haven from a tortured, tragic life.[5] Art as a therapeutic flight from reality was understood by Shchukin as 'living in' the landscape paintings that were installed to enhance his opulent Moscow residence.[6] Not only did the paintings act as a soothing restorative by conveying him to distant realms, but Shchukin also hoped that his fellow Russians might participate in such an experience after 1909 when he opened his home each weekend as a museum for the general public.

As early as 1903, before Matisse was important to him, Shchukin had discovered Gauguin, amassing the finest collection of the artist's work by 1910. Stimulated by the exotic elements in Gauguin's Tahitian paintings, which reminded him of his own exotic travels to India, Palestine, and Egypt, Shchukin hung his Gauguin collection in his dining room so that every visitor could not help but be overwhelmed on first sight. A contemporary noted, 'The pictures are tightly arranged, and at first you do not notice where one ends and the next begins: the impression is of one mighty fresco before you, one iconostasis.'[7] If Gauguin's paintings had the power to transport Russians to the South Seas, so his example set the stage for French artists

to seek an earthly paradise in the South of France. As Kenneth E. Silver has observed, 'Paul Gauguin, or rather his myth, embodied nearly everything – art, beauty, escape, and sex – that would encourage France's southeast coast to be re-imagined as a home-grown version of the South Pacific. And without the potency of that myth, in both its contradictions and the ways in which it spoke to real desire, it is unlikely that the Côte d'Azur would have assumed the particular cultural shape it did.'[8] How then was the Midi (defined as the regions bordering on the Mediterranean from Languedoc-Roussillon to Provence-Alpes-Côte d'Azur) shaped by mythic elements from the past and present, and how were these translated into contemporary landscape paintings?

That the South of France was intimately connected to a classical heritage was self-evident from the archaeological remains of Greek and Roman rule there, and by dint of France sharing the Mediterranean as a common body of water with its Latin neighbours. The task for French artists was to take the timelessness of the classical past based on ancient Greek and Roman occupation and make it current and contemporary. Certainly tourists by the turn of the century were presented with the south as an alternative destination to holidays in the north (Normandy and Brittany). And a holiday in the sun could be a veritable trip to Eden, or so it was considered in travel accounts of the day, where real time and mythical time might be conflated into a classical idyll of timelessness. 'Perhaps the most potent myth of all is that of the Mediterranean world as Arcadia – an earthly paradise protected from the sordid materialism of the modern industrialised world, free from strife and tension, pagan not Christian, innocent not fallen, a place where a dreamed-of harmony is still attainable.'[9]

When Vincent van Gogh journeyed to Arles in 1888, he sought to find a place of personal refuge and creative renewal for his art, away from the debilitating pressures of the Parisian art world. His goal was to establish a community of artists – a so-called 'studio of the South' with Gauguin at its head. Unlike his contemporaries, van Gogh did not perceive the South as a

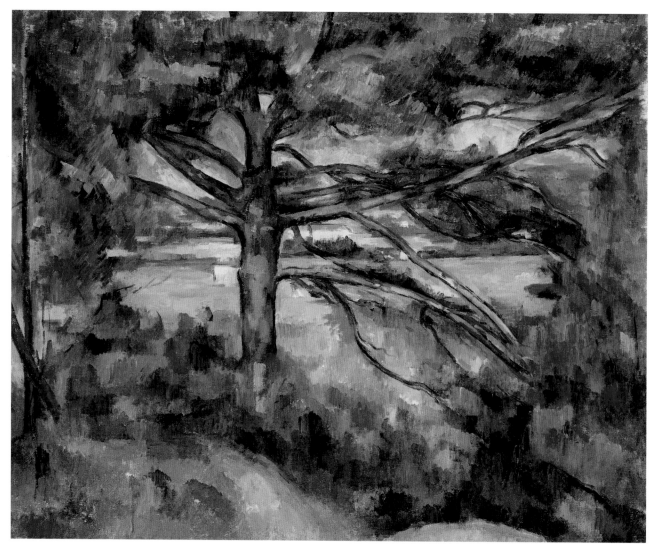

Cat. 13 Paul Cézanne, *Large Pine Near Aix-en-Provence*, c. 1895-1897

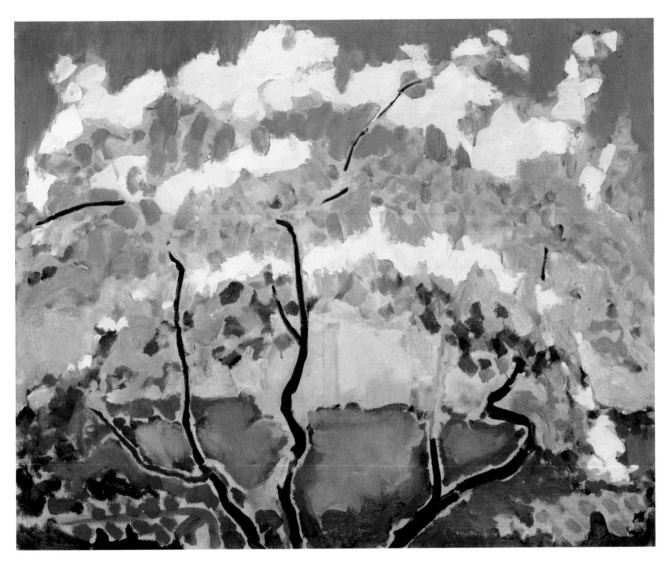

CAT. 14 KEES VAN DONGEN, *Spring*, 1908

CAT. 15 PAUL GAUGUIN, *Fatata te Mouà (At the Foot of the Mountain)*, 1892

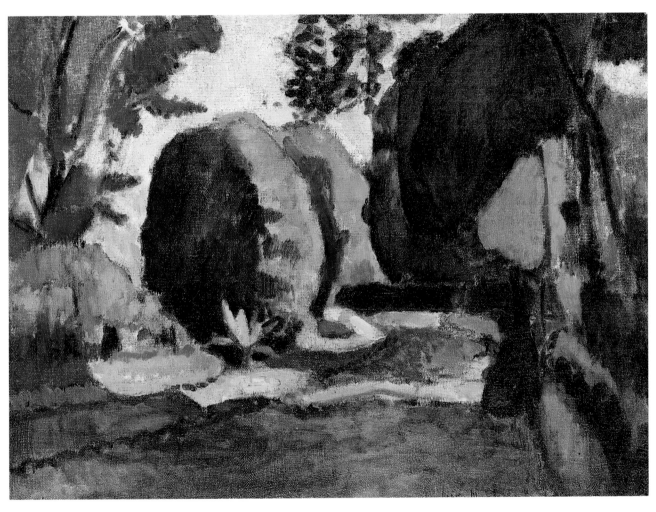

CAT. 16 HENRI MATISSE, *The Luxembourg Gardens*, C. 1901

classically inspired Arcadia, but arrived there with the preconceived notion that everything would look like Japan. 'His first vision of the Mediterranean further convinced him that the South was a simulacrum of Japan, and that he had already acquired 'a more Japanese eye' – sensing colour differently, drawing quickly, simplifying feeling – that abetted the exaggeration of colour he had been thinking about for some time.'[10] In a letter to Émile Bernard (June 1888), van Gogh described his struggle to come to terms with the light and colour of the South in his painting *The Sower* (*Le Semeur*, fig. 22) noting that ultimately he could not care less what the colours were in reality.[11] He finished the painting in the studio with bright, vivid colours, thus demonstrating his indifference to actual local colour and helping to create a myth about what the light of a sun-baked Southern landscape should look like. When Gauguin joined Vincent in Arles shortly after, the experience of painting landscapes with van Gogh furthered Gauguin's fantasy that a mythic, primitive Arcadia could yet be found.

Gauguin's continued flight from civilisation reached fulfilment when he arrived in 1891 in Tahiti. There he settled on the south coast of the island near the village of Mataiea, where he painted *Fatata te Mouà* (*At the Foot of the Mountain*; cat. 15). Unusual in his oeuvre as an almost pure depiction of the landscape, the picture features a magnificent mango tree that dominates the centre of the composition. Gauguin clearly struggled with the unfamiliar light and colour of Tahiti as he sought to express his observations on canvas. 'I began to work: notes and sketches of every sort. But the landscape, with its pure, intense colours, dazzled and blinded me. Previously always in doubt, I searched from noon until two o'clock . . . It was so simple, however, to paint what I saw, to put a red or a blue on my canvas without so much calculation! Golden forms in the streams enchanted me; why did I hesitate to make all of that gold and all of that sunny joy flow on my canvas? Old European habits, expressive limitations of degenerate races!'[12] Gauguin did not want to misrepresent the colours he saw before him, but at the same time he considered that the

restraints he felt in approaching the saturated colours of Tahiti had been imposed upon him by the circumscribed rules and artistic theories formulated by the art world he had fled.

At the same time, Paul Cézanne was painting landscapes *en plein air* around his native Provence. Unlike van Gogh, a northerner who did not understand the light of the South, Cézanne spent his life in the environs of Aix-en-Provence trying to create an art that might combine an acute observation of nature with a compositional structure based on his knowledge of the history of art. Rejecting the Impressionist concern with capturing transient effects in nature, Cézanne wanted to make an art that was current, yet looked to the past. Émile Bernard described Cézanne as 'a bridge . . . which brought Impressionism back to the Louvre.'[13] From the mid-1880s, Cézanne looked to the classicism of the seventeenth-century French painter Nicolas Poussin for inspiration as his own sense of cultural identity with Provence and its Greco-Roman roots became stronger.[14] The topographical feature near Aix he adopted as his favourite subject to express a balance of perception and conception – the eye and the mind – was the iconic Mont Sainte-Victoire. The painting *Mont Sainte-Victoire* (cat. 12) shows carefully juxtaposed planes of colour built to give the landscape a solid material existence in a palpable light. In fact, Cézanne took liberty with nature's data. A photograph taken of the site by John Rewald demonstrates that the artist brought the mountain closer to the viewer than it would have been if governed by the rules of linear and aerial perspective.[15] The effect makes the mountain grander and more massive than otherwise – a permanent symbol of nature, and now art, as something fixed, immutable, and indestructible.

The Post-Impressionist artists we have discussed thus far – van Gogh, Gauguin, and Cézanne – all contributed to the late-nineteenth-century crisis of Impressionism that led to its ultimate demise. Each artist wished to create an art that was timeless yet based upon an intimate knowledge of nature. Because of its preoccupation with ephemeral effects based on a direct empirical transcription of nature, Impressionism was

found wanting because it was more preoccupied with ephemeral effects based on a direct empirical transcription of nature than with issues of universal meaning or truths that might transcend time. The Neo-Impressionist artists Georges Seurat and Paul Signac sought to combine empirical observation and timelessness. Their solution, based on various nineteenth-century colour theories, advocated the judicious juxtaposition of small dots of colour on the canvas to produce an optical effect that might give a sensation of nature viewed objectively. In practice, Neo-Impressionist theory, which was based on the physics of light and colour, proved to be a pseudo-science and no more 'truthful' to nature than Impressionism. However, Signac (who carried the torch for Neo-Impressionism following the early death of Seurat in 1891) is a significant figure in the shift from Post-Impressionist to early modern painting. He was one of the first artists to distinguish between the light of northern France as 'colourful' and the light of the South of France as 'luminous,' and to tackle the problem of how the light and atmosphere of the South actually affected colour. Reacting to a negative review of paintings he executed at Cassis, Signac posited: 'Yet I think that I have never done paintings as "objectively exact" as those of Cassis. In that region there is nothing but white. The light, reflected everywhere, devours all the local colours and makes the shadows appear grey . . . Van Gogh's paintings done at Arles are marvellous by their fury and intensity, but they do not at all render the "luminosity" of the South. Under the pretext that they are in the South, people expect to see reds, blues, greens and yellows . . . While it is, on the contrary, the North – Holland, for example – that is "coloured" (local colours), the South being "luminous."'[16]

By the time Signac came to paint *Port of Marseilles* (cat. 17) in 1906-7, he had long abandoned the necessity of working directly on site, preferring to paint from notes, watercolour sketches, and memory. Signac's canvas of the entry to the Old Port recalls an earlier work by the artist from 1898 that was also painted from recollections of a visit to Marseilles.[17] Signac's memory may have been topographically accurate in general, but not quite up to date, since he failed to include in the Hermitage picture the major architectural landmark of the *pont transbordeur* (transporter bridge) that had been built as recently as 1905 but would not survive World War II (fig. 29). What is more important here is that Signac constructed his painting through the lens of convention provided by the example of seventeenth-century seascapes by Claude Lorrain (fig. 27). Signac and other artists of his generation were so conditioned by their training to see the landscape through Claude's eyes that the framing architectural elements flanking a compositional centre of interest were adopted without having to think consciously of any particular Claudian prototype.

The classical ideal of Claude and Poussin exerted a profound influence on late-nineteenth and early-twentieth-century French landscape painting. The pictorial organisation of their paintings constituted a kind of formula that defined the way artists looked at the landscape. Indeed, they helped codify the compositional exigencies of the 'classical picturesque,' which generally included *repoussoir* trees in a well-defined foreground leading the eye to a middle-ground of ruins and a distant panorama of mountains. This convention, which formed the French *grande tradition*, was passed from one generation of artists to the next, thereby making Claude and Poussin the major links in the chain of landscape painting between the Renaissance and the early twentieth century.

Richard Thomson has demonstrated that the connection of the Mediterranean landscape to Claude and classicism enjoyed a long history and is not a *fin de siècle* phenomenon. 'What Claude had developed in the seventeenth century to evoke an ideal of the ancient mythological Mediterranean could be redeployed to articulate a nineteenth-century ideal of France's southern coast, the picturesque changelessness that garnered greater authenticity by its Claudian inflection.'[18] By the turn of the twentieth century, it was not necessary to include fauns and nymphs in a landscape to convey Hellenic associations. Simply painting a picturesque Mediterranean

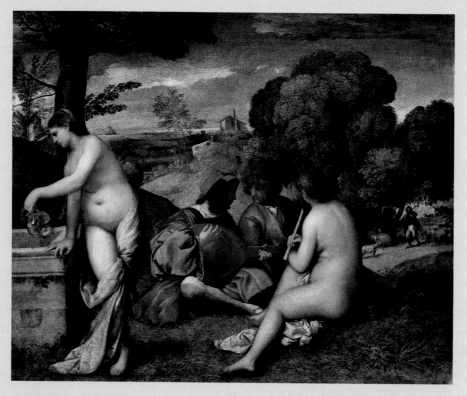

FIG. 23 GIORGIONE, *Pastoral Concert*, 1510-1511

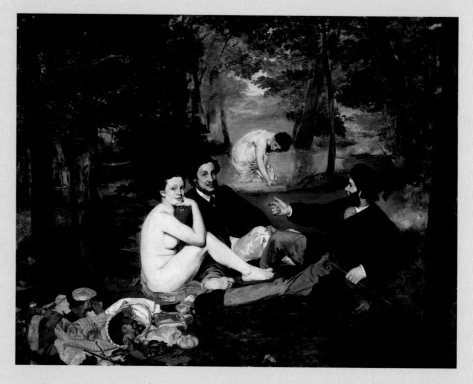

FIG. 24 ÉDOUARD MANET, *The Luncheon on the Grass*, 1863

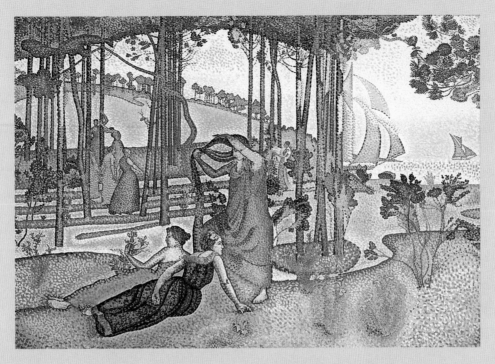

FIG. 25 HENRI-EDMOND CROSS, *Open Breeze* or *L'Air du soir*, 1893-1894

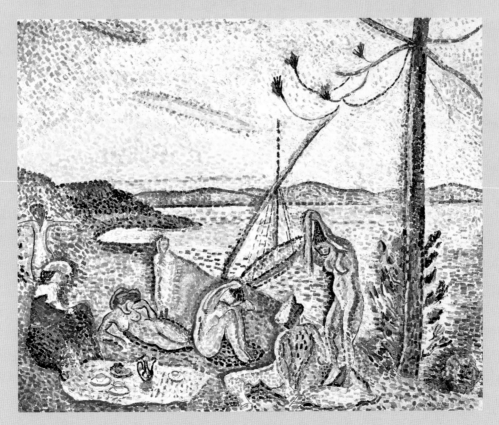

FIG. 26 HENRI MATISSE, *Luxe, calme et volupté*, 1904

landscape carried with it all the meaning required to be connected with a Latinate cultural heritage. The geometric structure of Poussin and the picturesque qualities of Claude meant that landscape could be conceived as something permanent and timeless like the heroic or mythic Arcadian subjects of their paintings. For artists of Matisse's generation, recuperating Poussin and Claude Lorrain was the required antidote to transient effects and seeming compositional deficiencies in Impressionist painting.

The summer of 1904 at Saint-Tropez proved to be a critical testing ground for Matisse in the company of Signac. Although the 'scientific' method of Neo-Impressionism was anathema to his fundamental belief that art is not derived from theory, Matisse nonetheless experimented with a quasi-divisionist facture in the now famous sketch for *Luxe, calme et volupté* (fig. 1). Fellow painter Henri-Edmond Cross's description of him that summer as 'anxious . . . madly anxious' testifies to Matisse's uncertainty in the face of Signac's encouragement. Matisse felt it necessary to work his way through Neo-Impressionism in order to press forwards to a new conception of painting. *Luxe, calme et volupté* is a significant marker of his ability at this point to create a work both timeless and contemporary. The unlikely subject of a family picnicking in the company of nude bathers on the beach at Saint-Tropez triggers a multitude of associations from the history of art, including the pastoral ideal of Giorgione/Titian's *Pastoral Concert* (*Concert champêtre*; fig. 23), the rococo otherworldliness of Watteau's *The Embarkation for Cythera* (*L'Embarquement pour Cythère*; fig. 28), and the modern life of Manet's *Luncheon on the Grass* (*Le Déjeuner sur l'herbe*; fig. 24). All this is presented in Matisse's painting, layered with the title taken from Baudelaire's stanza, to evoke a golden age – a mythic and classical earthly paradise of sensual pleasure.

Matisse's experience with Signac set the course for the new direction that his art would take the following summer at Collioure, a little fishing village on the Mediterranean coast near the Spanish border. With fellow painter André Derain, he forged a new conception of colour in landscape painting that was later dubbed Fauvism. Both artists had known each other from around the turn of the century, a time when they frequented the Louvre to make copies after Old Master paintings.[19] Their knowledge of classical landscape painting conditioned the way they approached the landscape. Roger Benjamin notes that '[Matisse's] attachment to the classical landscapes of Poussin or Claude is bound up with his need to go beyond the mimetic element in Impressionist art, to find a new application for the museum art he admired. In addition, the supposedly Mediterranean but pre-eminently generalized and utopian "no-places" proposed by classical landscape corresponded with Matisse's cosmopolitan and peripatetic sensibility.'[20] Collioure was a perfect Mediterranean 'no-place' where myth might be invented and a new approach to light and colour might be advanced.

The 1905 summer at Collioure posed a challenge for both Matisse and Derain as they attempted to come to terms with the whiteness of the Mediterranean light. Derain wrote that he was 'grinding away' with Matisse, who was going through a crisis. The challenge was to respond to the natural world yet replace it with an emotional response to nature that rejected imitative colours. Rather than contrast tones, Matisse sought to re-create transmitted light by contrasting hues of colours. Large brushstrokes of red, green, blue, and yellow were applied so that the spaces between them and the white of the untouched primed canvas might impart an appearance of luminosity. Derain wrote of their discoveries to his fellow painter Maurice de Vlaminck:

1. A new conception of light consisting in this: the negation of shadows. Light, here, is very strong, shadows very bright. Every shadow is a whole world of clarity and luminosity which contrasts with sunlight: what are known as reflections. Both of us, so far, had overlooked this, and in the future, where composition is concerned, it will make for a renewal of expression.

2. Noted, when working with Matisse, that I must eradicate everything involved with the division of tones. He goes on, but I had my fill of it completely and hardly ever use it now. It's logical enough in a luminous, harmonious picture. But it injures things that owe their expression to deliberate disharmonies.[21]

Derain's response to the problems he articulated at Collioure was the Hermitage painting, Harbour (1905, cat. 21). He gives us a scene with moored boats that is not site specific but could represent any number of fishing villages dotted along the Mediterranean coast. The picture looks deliberately unfinished, so that untouched bare canvas might play a positive role in generating the successive flash of white light that characterises the southern midday sun. The painting appears spontaneous, elemental, and simple, like the unsophisticated art of children, which Derain and Matisse both admired. Brilliant hues of colour denote contour, which is sometimes filled in with crude brushwork. The canvas is a quintessential example of Fauve painting.

Notwithstanding Derain's example, John Elderfield has done much to debunk certain myths about Fauve painting and has arrived at three important conclusions with respect to Matisse: 'First: although Fauvism is commonly considered a spontaneous style and Collioure its crucible, it is clear that Matisse either worked somewhat infrequently or spent longer on each of his works than their effect of spontaneity suggests. Second: although Fauvism "was something only painting can do," most of Matisse's works that summer were drawings. Third: the inventory shows that too many canvases by Matisse are currently attributed to that summer in Collioure. A significant number were painted later.'[22]

For all its look of improvisation, a close examination of Matisse's View of Collioure (1905, cat. 23) reveals otherwise. Infrared photography demonstrates that the picture began with a detailed pencil drawing that denotes the compositional substructure. Paint was added later, suggesting that Matisse may have finished the painting in the fall of 1905 in Paris. It would seem that colour added after the fact in View of Collioure was not based on empirically derived data, but achieved by wilful distortion for emotive purposes. On the other hand, the structure of the picture is a classically inspired Poussinesque composition with well-defined foreground, middle-ground, and background planes, even if it is essentially site specific. Topographic accuracy is apparent from a comparison with Albert Marquet's 1912 painting (fig. 32) from almost the identical vantage point, looking towards the Chapelle Saint-Vincent and the distant Pyrénées.

While Matisse toiled with Derain in Collioure during the fateful summer of 1905, Marquet worked in Saint-Tropez and then made his way east along the Côte d'Azur to Menton near the French/Italian border. That Marquet's painting Menton Harbour (1905, cat. 19) is faithful to the landscape depicted is evident by examining a stereoscopic photograph from the same period (fig. 31). Both show the tower of the seventeenth-century cathedral of Saint-Michel close cropped at the upper left, although Marquet has taken a certain artistic liberty by exaggerating the curving sweep of the harbour.[23] Even though Marquet was associated with Fauve painting by exhibiting in the 'cage aux fauves' at the infamous 1905 Salon d'Automne, he never matched the chromatic intensity or daring brushwork of Matisse or Derain. Nevertheless, Marquet's conservative maritime views are linked to the same classical legacy that informed their work, as witnessed by his Bay of Naples (1909, cat. 18). Here the view of Mount Vesuvius is a reminder of the classical past simply by virtue of the depiction of this famous Italian landmark. A stereophotograph of the Bay of Naples demonstrates that photographers were subject to the same conventions as painters in 'constructing' the landscape through the lens of Claude (fig. 27). The Claudian conceit of the framing tree at the left to mark the foreground only serves to enhance the stereoscopic effect of the panorama.

Returning to the summer of 1905, we find Henri Manguin, another Fauve artist, also painting at Saint-Tropez in the same locale as Marquet. Both artists were likened by art critic Louis Vauxcelles (who later dubbed them among 'les fauves,' the wild beasts) to migrating birds who had flown to the South in

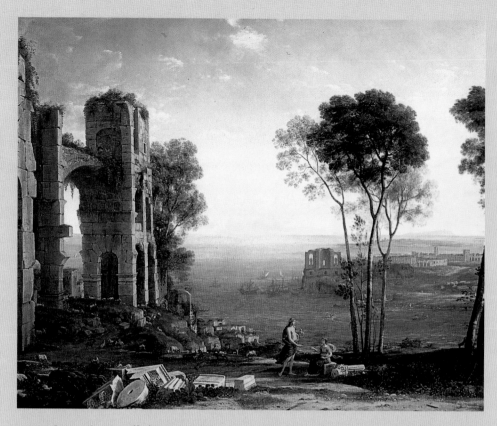

FIG. 27 CLAUDE GELLÉE called LE LORRAIN, *The Harbour of Baiae with Apollo and the Cumaean Sibyl*, c. 1646-1647

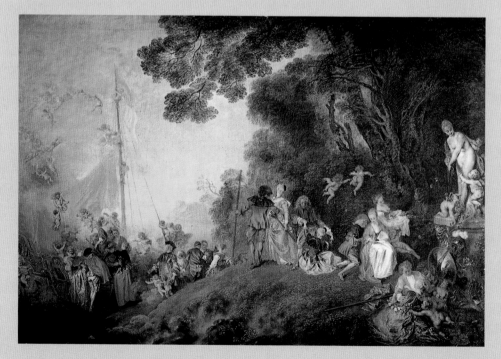

Fig. 28 ANTOINE WATTEAU, *The Embarkation for Cythera*, c. 1718-1719

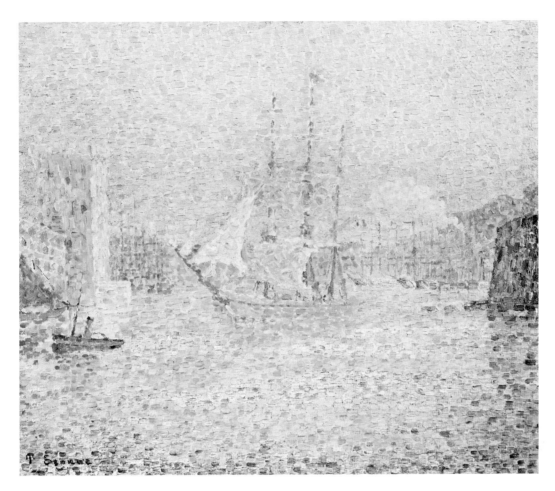

CAT. 17 PAUL SIGNAC, *Port of Marseilles*, 1906-1907

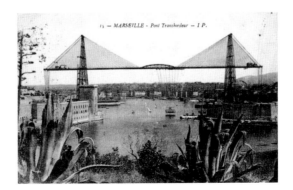

FIG. 29 *Entrance to the Vieux-Port and the transporter bridge,*
Marseilles, c. 1919

Cat. 18 ALBERT MARQUET, Bay of Naples, 1909

Fig. 30 Keystone View Company Meadville,
Vesuvius and Beautiful Naples from Posilipo Heights, Italy

CAT. 19 ALBERT MARQUET, *Menton Harbour, 1905*

FIG. 31 BENJAMIN WEST KILBURN, *The harbor and city, Menton, France, 1903*

search of a 'pays enchanté.'[24] While Marquet's palette became less heightened as Fauvism developed, Manguin is associated with high-keyed colours that he used to paint the sun-drenched landscape of the Villa Demière at Malleribes (near Saint-Tropez). There he looked for secluded spots where he might sometimes pose his wife in the nude away from the prying eyes of the local fishermen. *Path in Saint-Tropez* (1905, cat. 24) is a typical Manguin painting of the period showing his wife Jeanne and their sons not altogether harmoniously integrated into a decorative landscape setting. Indeed, Manguin's brand of Fauvism seems more related to a generic type of decorative Impressionism/Post-Impressionism where 'place' is not the issue. Vauxcelles noted at the time that Fauve painting was not about the faithful transcription of nature, but rather the site as the means to 'seeing decoratively.'[25]

Like Manguin, Kees van Dongen also exhibited in the 1905 Salon d'Automne's 'salle des fauves'. However, his connection with Fauvism is more tenuous than the other artists under discussion here, because he tended to focus more frequently on figurative subjects in the manner of Toulouse-Lautrec. Nevertheless, like those of Manguin, the landscapes he produced during the Fauve era are based on similar decorative structures allied with the spontaneity of Impressionism. While the painting *Spring* (1908, cat. 14) betrays the influence of the sinuous tree branches in studies that Matisse had made for his landmark *The Joy of Life* (*Le bonheur de vivre*; fig. 44), van Dongen deploys a highly original composition by means of a vantage point that crops the branches at the bottom centre of the picture plane.

In the following spring of 1909, Pierre Bonnard painted *Early Spring* (*The Little Fauns*) (cat. 2) at Vernouillet, a small village about eighty kilometres from Paris. Here he conceived the northern French landscape as a specific setting in which we find a local farmhouse. What makes the picture remarkable are the two figures at the lower left, who have been transformed from children into flute-playing, Pan-like mythological creatures. They shift the painting from the present to the past – or at least they blur the line, as Matisse had done in *Luxe, calme et volupté*

(fig. 26), between the eternal and the contemporary. In a sense it was natural for Bonnard to ponder things mythological given the interests of his Nabis brethren, including Kerr-Xavier Roussel, who frequently populated his pictures with Dionysian dancing nymphs and fauns (see cat. 5).

A few months later, in June 1909, Bonnard made his first trip to Saint-Tropez, where he stayed with Henri Manguin at the Villa Demière. He wrote to his mother that the Mediterranean struck him 'as a spectacle from *A Thousand and One Nights*.'[26] He returned to Saint-Tropez several times over the following two years, meeting Signac there in 1910. Like other artists of his generation, Bonnard found it difficult to come to terms with the intense light of the South. Some years later he noted: 'In the light experienced in the South of France, everything sparkles and the whole painting vibrates. Take your picture to Paris: the blue turns to gray . . . Therefore one thing is necessary in painting: heightening the tone.'[27]

No doubt this was on Bonnard's mind when he returned in 1911 to Manguin's villa in Saint-Tropez with a big project in hand. The Russian collector Ivan Morozov (1871-1921) had commissioned him in 1910 to make a major decoration for his home in Moscow. An immense triptych measuring over thirteen feet high with each panel separated by a half-column was envisaged at the top of Morozov's grand staircase (fig. 91). Like his compatriot Sergei Shchukin, Morozov surrounded himself with art that might transport the viewer into mythological realms. Maurice Denis had already supplied a multi-panelled sequence of fourteen-foot canvases on the theme of *The Story of Psyche* (figs. 62-73) for Morozov's music room. Thanks to their scale and subject, Morozov's grandiose commissions commanded the viewer to participate in a voyage into myth that might rival the experience of seeing at Shchukin's a large number of paintings by Gauguin in the dining room or Matisse's large-scaled *Dance* (*La Danse*) and *Music* (*La Musique*) in the stairwell (figs. 63, 64).

The result of Morozov's commission to Bonnard was the decorative tour de force *Mediterranean* (1911, cat. 74).

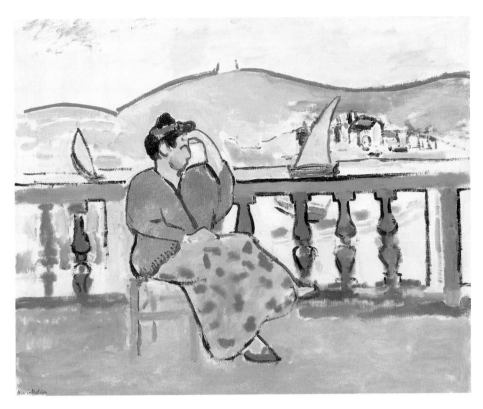

CAT. 20 HENRI MATISSE, *Lady on a Terrace*, 1907

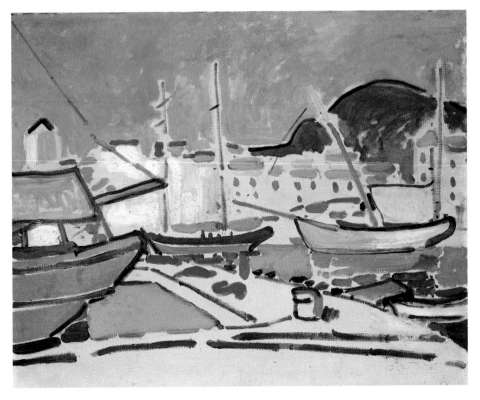

CAT. 21 ANDRÉ DERAIN, *Harbour*, c. 1905

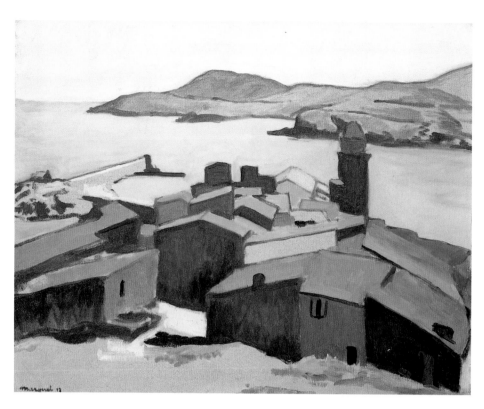

FIG. 32 ALBERT MARQUET, *View of Collioure*, 1912

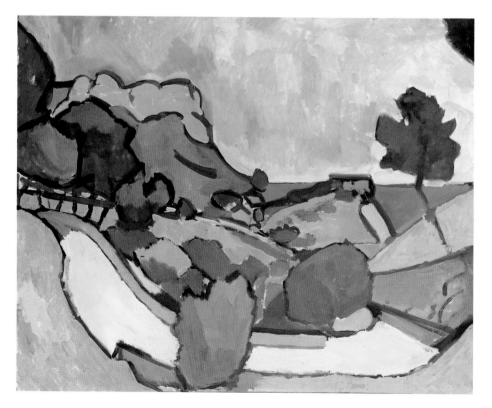

CAT. 22 ANDRÉ DERAIN, *The Mountain Road*, 1907

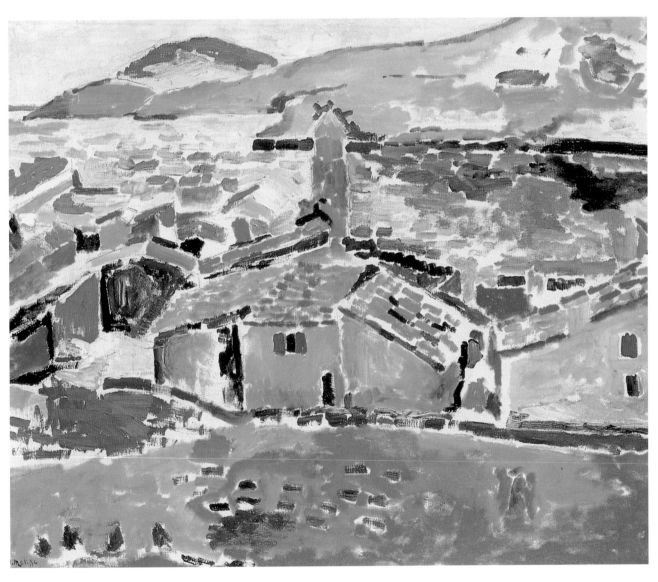

CAT. 23 HENRI MATISSE, *View of Collioure*, c. 1905

It comprised three painted panels flanked and separated by Ionic order demi-columns that offered a Greek architectural setting to enhance any classical connotations that might be found in the triptych (fig. 92). Bonnard paralleled this with a composition that is classical in terms of a coherent and geometrically balanced relationship of figures to landscape. That he generally placed all of his figures in shadow is noteworthy given the problem of 'vibrating' light that the artist observed in the South. No fauns or nymphs are required to establish an idyllic setting linked to a mythological past. As Gloria Groom has observed, 'What is "southern" about them [Bonnard's panels] is not so much a set of specific references to the classical past as the artist's association of his Mediterranean subject with relaxation, luxuriant well-being, and an overwhelming sense of warmth and tranquillity.'[28] The painting is thus evocative of an earthly paradise where time slows down and one may enjoy life for its simple pleasures.

From Bonnard, who was contributing to a large-scale decorative aesthetic that went beyond the conventions of easel painting, we return to André Derain to examine how his work developed after the Fauve summer of 1905. He continued to visit the South of France each summer and in 1907 could be found painting in Cassis on the coast east of Marseilles. In comparison with his Collioure pictures, colour in *The Mountain Road* (1907, cat. 22) covers the entire surface leaving no exposed white canvas to represent light. Derain now deployed muted colours with natural greens, ochres, and blues to define simplified forms bound by thick black contours. It is as if his interpretation of landscape is mediated by the example of Cézanne, reduced to flat volumes and locked into simple colour units. If light was no longer Derain's primary concern, the influence of Picasso may have prompted a desire to structure the landscape into interlocking abstract forms.

At this time both Derain and Picasso looked to their common forefather, Cézanne, who was leading Fauvism and Cubism along different paths. Picasso's painting *Brick Factory at Tortosa* (1909, cat. 28) is set in a small Spanish village near the Mediterranean coast about one hundred miles south of Barcelona. The tropical palm trees and the geometry presented by architectural elements in the landscape offered a structure that could be transposed from site specificity into nascent Cubism. Elizabeth Cowling notes the connection of Cubism with a 'classicist impulse . . . for its typical subjects are traditional and stereotyped, and treated in a suggestive, non-anecdotal and emotionally neutral way; the accent is on structure and form, both being determined by rationally conceived systems based on geometry; colour is subordinated to line and to composition; handling is impersonal, even anonymous; the effect sought is generally harmonious and contemplative.'[29] While Derain never took the Cubist plunge, Cowling's argument might be applied equally to the direction Derain's art took shortly after his 1907 Cassis landscape. By the summer of 1913, he had returned to one of his favourite fishing villages in the South of France, located at Martigues, just to the west of Marseilles. There he painted *Martigues* (*Harbour in Provence*) (1913, cat. 30), which superficially demonstrates a similar concern to Picasso's simplification and geometric order of composition. Yet ultimately the picture demonstrates Derain's debt to Claude and the classical exigencies of the 'paysage composé.' This is more pronounced than ever here, with the carefully constructed composition of the Claudian tree at the left framing the bird's-eye view of the town and distant mountain. While the block-like houses of Martigues provided the inspiration for Derain's picture, the scene is generic, uncomplicated, and a seemingly naïve depiction of place.

Against Derain's conservative vision immediately pre-World War I can be juxtaposed a more adventurous evocation of travel staged at the forefront of the avant-garde. While Derain was in Martigues, Sonia Delaunay was in Paris working on illustrations for a poem by Blaise Cendrars, *The Prose of the Trans-Siberian and Little Jehanne of France* (1913, cat. 31). The text was based on Cendrars's personal experiences in Russia from 1903-7. Both Sonia and her husband Robert Delaunay were painters concerned with the contrast and placement of colours

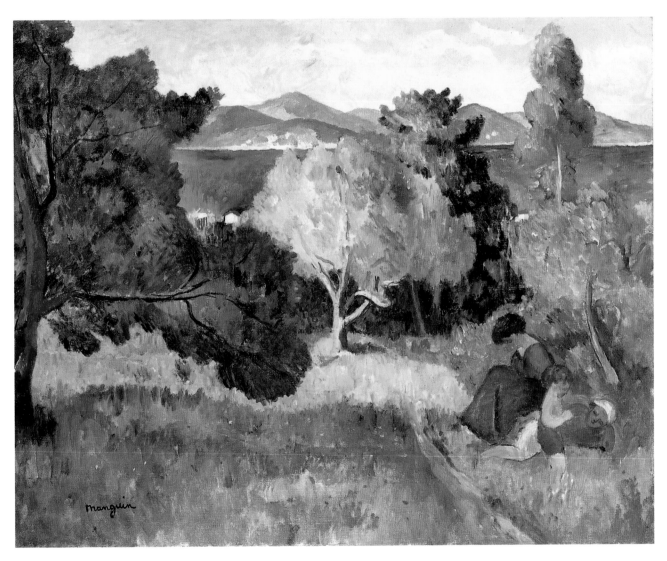

Cat. 24 Henri Manguin, *Path in Saint-Tropez*, 1905

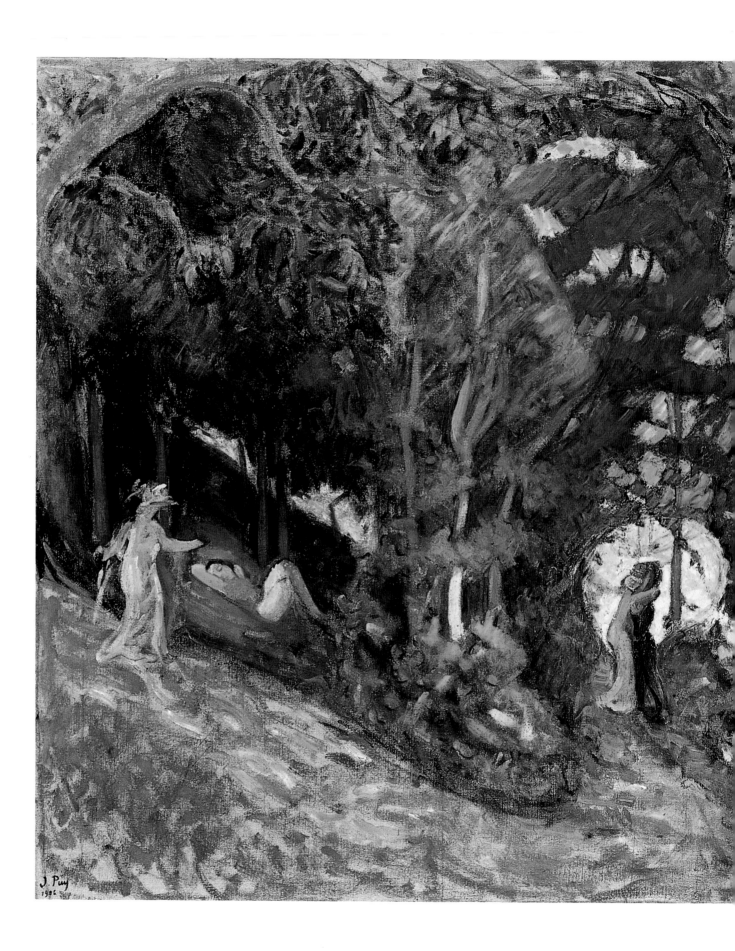

CAT. 25 JEAN PUY, *Summer*, 1906

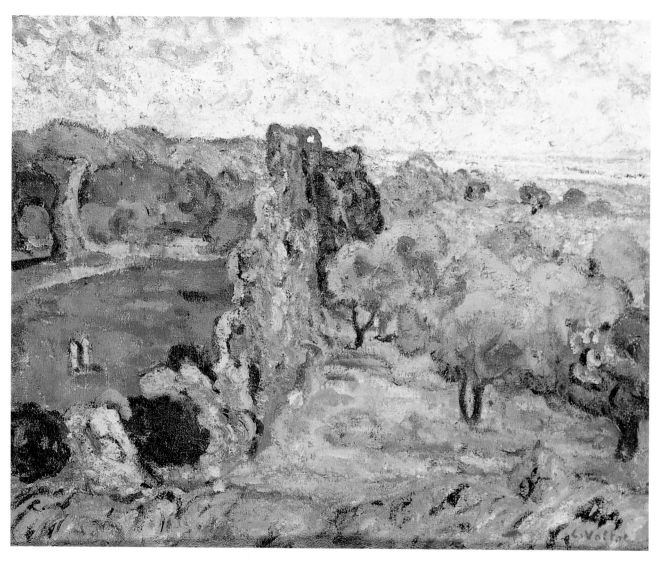

CAT. 26 LOUIS VALTAT, *Landscape in the South of France*, C. 1908

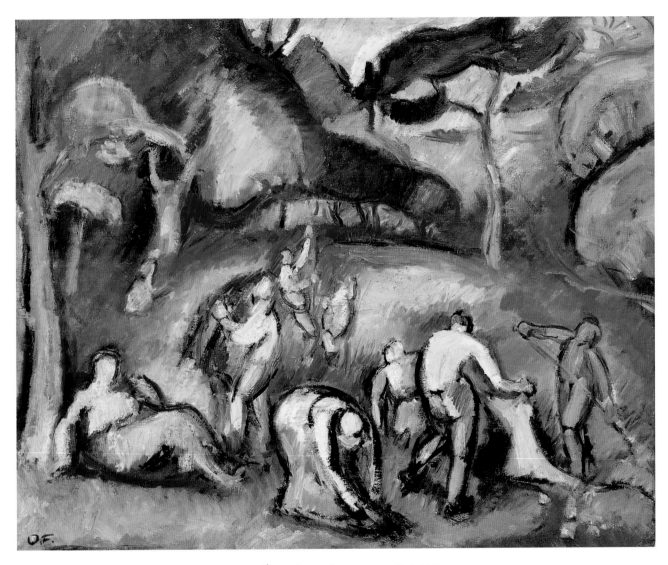

Cat. 27 Émile-Othon Friesz, *Autumn Work*, 1907

to create light, movement, and form independent from objects. Together they developed a new language for abstract painting based on Eugène Chevreul's nineteenth-century theory of the harmony and contrast of colours. Just as Cendrars brought together place names in his modernist poem to evoke different dimensions of time and place, so Delaunay used 'simultaneous' dynamics of colour to express a sense of excitement with regard to the modern world – a world in which distant places could be linked rapidly, not only in the mind but also in reality, with the advent of closer global connections through exhibitions, publications, and train and air travel.

The poem with Delaunay's stencils consists of four joined sheets that measure almost six and a half feet from top to bottom. Richard Thomson likened Delaunay's work to a journey, 'a matter of incidents, passing visual signs and colours, the perception of dynamic movement, and of jumbled impressions of sight and sound . . . As a series of visual effects, her chromatic forms need – like the text – to be experienced over a passage of time, to assist in the building up of perceptions, sensations and memories.'[30] Sonia Delaunay's illustrations of Cendrars's poem embody a modernist voyage presaging the future rather than embracing the classical past. But historical events were to change the world and the course of art. The Russian collectors Shchukin and Morozov found their attempt to find paradise and sanctuary in the confines of their collections abruptly terminated with the loss of their personal property and wealth during the Russian Revolution. The unspeakable horror and carnage of World War I contributed in its aftermath to a desire for a renewed classicism and a so-called 'return to order' that informed the work of many artists, notably Picasso and Derain. Avant-garde classicism assumed a new dynamic in postwar France as the Côte d'Azur became a playground for the rich. And so history repeated itself.[31] The South of France in the Roaring Twenties once again became a haven for artists – a place where rejuvenated efforts to locate paradise on earth might be found through the agency of a voyage into myth.

Notes

Any one who treats the topic of myth and Fauve landscape is indebted, as I am, to James D. Herbert's *Fauve Painting: The Making of Cultural Politics* (New Haven: Yale University Press, 1992)

[1] 'Là, tout n'est qu'ordre et beauté/Luxe, calme et volupté.' Baudelaire's poem 'L'invitation au voyage' was published on 1 June 1855 in the *Revue des deux mondes* in a collection of writings titled *Les Fleurs du mal*. Translation by Richard Wilbur, *The Flowers of Evil: A Selection*, ed. Marthiel and Jackson Mathews (New York: New Directions, 1958), pp. 53-54.

[2] Norman Douglas as quoted in John Elderfield, 'Matisse in Morocco: An Interpretive Guide', in *Matisse in Morocco: The Paintings and Drawings, 1912-1913*, exh. cat. (Washington, DC: National Gallery of Art, 1990), p. 201.

[3] 'Ce que je rêve, c'est un art d'équilibre, de pureté, de tranquillité, sans sujet inquiétant ou préoccupant, qui soit, pour tout travailleur cérébral, pour l'homme d'affaires aussi bien que pour l'artiste des lettres, par exemple, un lénifiant, un calmant cérébral, quelque chose d'analogue à un bon fauteuil qui le délasse de ses fatigues physiques.' Henri Matisse in 'Notes of a Painter' as quoted in *Matisse on Art*, rev. ed., Jack Flam, ed. (Berkeley and Los Angeles: University of California Press, 1995), pp. 42 (English translation) and 240 (original French text).

[4] In 1905 Shchukin was shaken by the suicide of his son Sergei. This was followed by his wife Lydia's death in January 1907 and the suicide of his brother Ivan the following January 1908. The tragedy continued in 1910 when his son Grigory committed suicide.

[5] Jack Flam, 'Matisse Revisited' symposium, Denver Art Museum, 14 April 2000. Cf. Jack Flam, ed., *Matisse on Art*, rev. ed. (Berkeley and Los Angeles: University of California Press, 1995), p. 35.

[6] Beverly Whitney Kean, *French Painters, Russian Collectors: Shchukin, Morozov and Modern French Art 1890-1914*, rev. ed. (London: Hodder and Stoughton Ltd, 1994), p. 130.

[7] Yakov Tugendkhold, 'The French Collection of S. I. Shchukin', *Apollon* 1-2 (1914), p. 6; as quoted in Albert Kostenevich, *French Art Treasures at the Hermitage: Splendid Masterpieces, New Discoveries* (New York: Harry N. Abrams, Inc., 1999), p. 25.

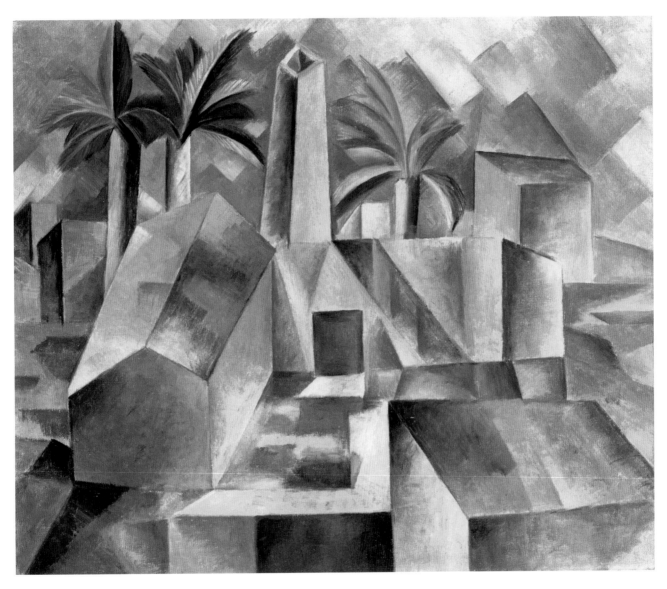

CAT. 28 PABLO PICASSO, *Brick Factory at Tortosa*, 1909

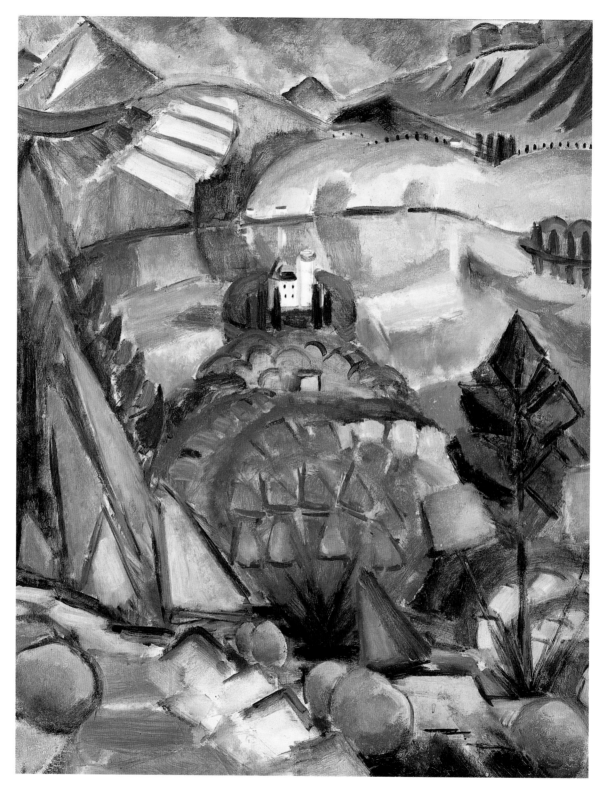

CAT. 29 HENRI LE FAUCONNIER, *The Lake*, 1911

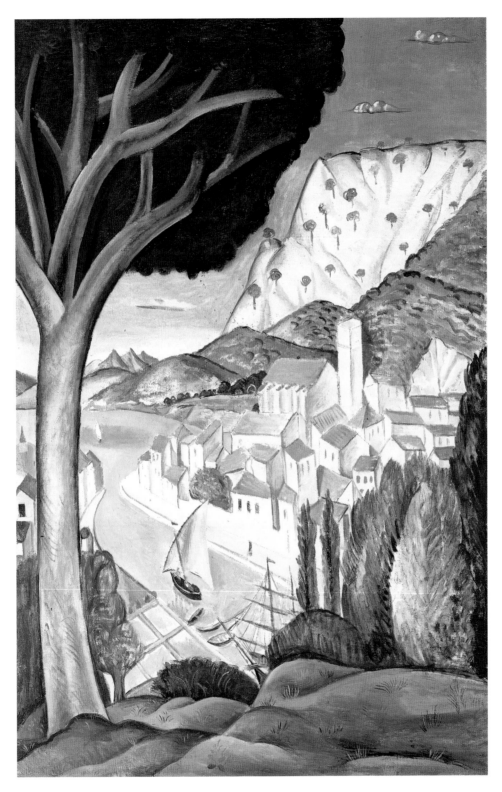

CAT. 30 ANDRÉ DERAIN, *Martigues (Harbour in Provence)*, 1913

[8] Kenneth E. Silver, *Making Paradise: Art, Modernity, and the Myth of the French Riviera* (Cambridge, Mass. and London: MIT Press, 2001), pp. 103-4.

[9] Elizabeth Cowling and Jennifer Mundy, *On Classic Ground: Picasso, Léger, de Chirico and the New Classicism 1910-1930*, exh. cat. (London: Tate Gallery, 1990), p. 12.

[10] Douglas Druick and Peter Kort Zegers, *Van Gogh and Gauguin: The Studio of the South*, exh. cat. (New York: The Art Institute of Chicago and Thames and Hudson, 2001), p. 109.

[11] Van Gogh to Bernard (18 June 1888), quoted in Druick and Zegers, op. cit., p. 115.

[12] Gauguin in *Noa Noa* (Louvre ms, p. 43), quoted in English in Richard Brettell et al., *The Art of Paul Gauguin*, exh. cat. (Washington, DC: National Gallery of Art, 1988): p. 248. French text in *Gauguin*, exh. cat. (Paris: Galeries Nationales du Grand Palais, 1989): p. 249. 'Je commençais à travailler, notes, croquis de toutes sortes. Tout m'aveuglait, m'éblouissait dans le paysage. Venant de l'Europe j'étais toujours incertain d'une couleur, cherchant midi à quatorze heures . . . Cela était cependant si simple de mettre naturellement sur ma toile un rouge et un bleu. Dans les ruisseaux des formes en or m'enchantaient. Pourquoi hésitais-je à faire couler sur ma toile tout cet or et toute cette réjouissance de soleil? Probablement de vieilles habitudes d'Europe, toute cette timidité d'expression de nos races abâtardies.'

[13] Émile Bernard as quoted in English in Richard Verdi, *Cézanne and Poussin: The Classical Vision of Landscape*, exh. cat. (London: National Galleries of Scotland and Lund Humphries, 1990), p. 35. In French: 'Cézanne est un pont jeté au-dessus de la routine, par lequel l'impressionnisme retourne au Louvre et à la vie profonde,' in P. M. Doran, ed., *Conversations avec Cézanne* (Paris: Macula, 1978), p. 80.

[14] Cézanne's famous quote on Poussin was recorded by Émile Bernard: 'Imaginez Poussin refait entièrement sur nature, voilà le classique que j'entends.' See Doran, op. cit., p. 80. For a full discussion of Cézanne and classicism, see Terence Maloon et al., *Classic Cézanne*, exh. cat. (Sydney: Art Gallery of New South Wales, 1998).

[15] The photograph is reproduced in John Rewald, 'The Last Motifs at Aix', *Cézanne: The Late Work*, exh. cat. (New York: The Museum of Modern Art, 1977), p. 85. An earlier photograph of the same site taken by Erle Loran is found in Erle Loran, *Cézanne's Composition: Analysis of His Form with Diagrams and Photographs of His Motifs* (Berkeley and Los Angeles: University of California Press, 1950), p. 98.

[16] Signac journal entry for 29 September 1894, as quoted in English in Marina Ferretti-Bocquillon et al., *Signac 1863-1935*, exh. cat. (New York: The Metropolitan Museum of Art and Yale University Press, 2001), p. 142. In French: 'Je crois que je n'ai jamais fait des tableaux aussi "objectivement exacts" que ceux de Cassis. Il n'y a dans ce pays que du blanc. La lumière reflétée partout mange toutes les couleurs locales, et grise les ombres . . . Les tableaux de Van Gogh faits à Arles sont merveilleux de furie et d'intensité, mais ne rendent pas du tout la "luminosité" du Midi. Sous prétexte qu'ils sont dans le Midi, les gens s'attendent à voir du rouge, du bleu, du vert, du jaune . . . Or au contraire c'est le Nord - la Hollande par exemple - qui est "coloré" (couleurs locales), tandis que le Midi est "lumineux,"' text in *Signac*, exh. cat. (Paris: Musée du Louvre, 1963), p. 33.

[17] See Signac, *Port of Marseilles*, 1898 (Kröller-Müller Museum, Otterlo) in Françoise Cachin, *Signac: Catalogue raisonné de l'œuvre peint* (Paris: Gallimard, 2000), no. 322.

[18] Richard Thomson, *Monet to Matisse: Landscape Painting in France 1874-1914*, exh. cat. (Edinburgh: National Gallery of Scotland, 1994), p. 78.

[19] Matisse and Derain's training, respectively with Gustave Moreau and Eugène Carrière, was very much in keeping with standard academic practice, which included drawing after plaster casts of Greco-Roman sculptures. Matisse would have been familiar with Poussin and Claude when studying under Moreau at the École des Beaux-Arts. Derain is known to have sketched Poussin's *L'Été* (*Ruth et Boaz*). For issues around the important role copying played for the future Fauves, see Roger Benjamin, 'Recovering Authors: the Modern Copy, Copy Exhibitions and Matisse', in *Art History* 12 (June 1989), pp. 176-201; and Michael Parke-Taylor, 'André Derain: les copies de l'Album fauve', in *Cahiers du Musée national d'art moderne* 5 (1980), pp. 363-77.

[20] Roger Benjamin, 'The Decorative Landscape, Fauvism, and the Arabesque of Observation', in *Art Bulletin* 75, no. 2 (June 1993), p. 307.

[21] Derain to Vlaminck, from Collioure (28 July 1905) as quoted in English in Judi Freeman, *The Fauve Landscape*, exh. cat. (Los Angeles: Los Angeles County Museum of Art and Abbeville Press, 1990), pp. 15-16. French text in André Derain, *Lettres à Vlaminck* (Paris: Flammarion, 1955), pp. 154-55.

[22] John Elderfield, *Henri Matisse: A Retrospective*, exh. cat. (New York: The Museum of Modern Art and Harry N. Abrams, Inc., 1992), p. 51.

[23] Roger Benjamin is critical of the methodology of art history since the 1980s, which accounts for a landscape painting solely by means of its close relationship to the site depicted. He asserts that such an interpretation does not account for the 'transformative work that the painting performs' and ignores the 'complex process of imaging landscape' that is based on historical ways of seeing (i.e. through the eyes of Claude and Poussin). See Benjamin, op. cit., p. 295.

[24] Louis Vauxcelles, *Gil Blas*, 17 October 1905, as quoted in John Elderfield, *The 'Wild Beasts': Fauvism and its Affinities*, exh. cat. (New York: The Museum of Modern Art, 1976), p. 62.

[25] Louis Vauxcelles, *Gil Blas*, 20 March 1906, as quoted in Benjamin, op. cit., p. 297. Benjamin (pp. 307-8) understands the Fauves' decorative conception of landscape as the key ingredient of Fauve painting. He characterises Fauve procedure as the 'arabesque of observation' to describe the artificial structuring of the composition for purposeful distortion. He proposes that the Fauves went 'beyond the classical system where the arranged took precedence over the observed, developed an emphatic rhythmical interpretation of the seen, [and introduced] a reinvigoration of the palette along non-normative lines in a determined, expressionistic manner.'

[26] Bonnard to his mother (June 1909) as quoted in English in Gloria Groom, *Beyond the Easel: Decorative Painting by Bonnard, Vuillard, Denis, and Roussel, 1890-1930*, exh. cat. (New Haven and London: Yale University Press and The Art Institute of Chicago, 2001), p. 182. In French: 'J'ai eu un coup des *Mille et une nuits*,' in *Bonnard*, ed. Sasha M. Newman, exh. cat. (Paris: Centre Georges Pompidou/Musée National d'Art Moderne, 1984), p. 254.

[27] Pierre Bonnard, 'Observations sur la Peinture' (1946) as quoted in English in Sasha M. Newman, ed., *Bonnard: The Late Paintings*, exh. cat. (Washington, DC: The Phillips Collection, 1984), p. 70. In French: 'Dans la lumière du Midi, tout s'éclaire et la peinture est en pleine vibration. Portez votre tableau à Paris: les bleus deviennent gris. Vus de loin, ces bleus, aussi, deviennent gris. Il existe donc en peinture une nécessité: hausser le ton,' in Newman, op. cit., p. 203.

[28] Groom, op. cit., p. 147.

[29] Cowling and Mundy, op. cit., p. 23. Cowling (p. 24) notes that early apologists of Cubism 'stressed its opposition to Impressionism, its dependence on Cézanne, and its classical foundations, even while insisting on its innovative character.'

[30] Thomson, op. cit., p. 128.

[31] The post-World War I conception of earthly paradise held by artists working in the South of France is discussed in Kenneth E. Silver's *Making Paradise*.

CAT. 31 SONIA DELAUNAY, *The Prose of the Trans-Siberian and Little Jehanne of France*, 1913

Fin de Siècle Nostalgia
and Primitivism

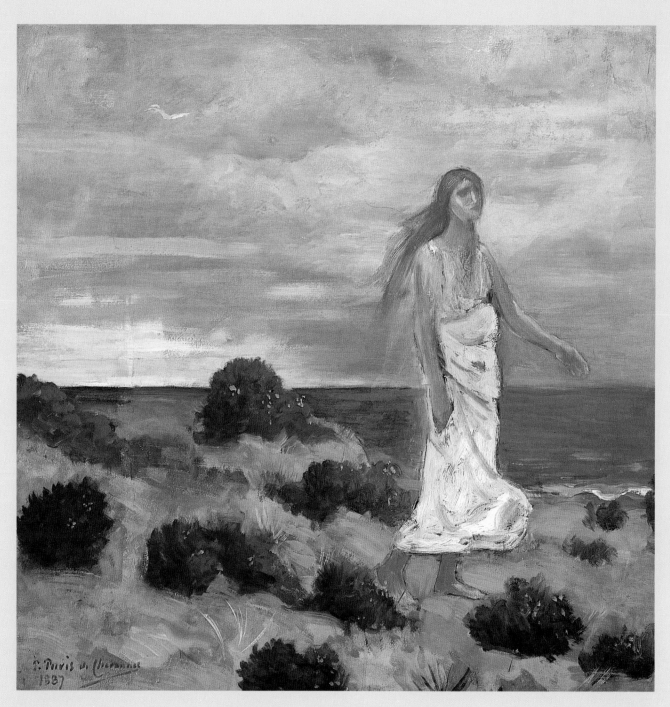

CAT. 32 PIERRE PUVIS DE CHAVANNES, *Woman by the Sea*, 1887

Fin de Siècle Nostalgia and Primitivism: Ancient Brother or New Man?

NATHALIE BONDIL

'Mythology, as we have seen it exploited for the last thirty years, will be the shame of the French School. And religious painting, which at least expressed two or three primordial sentiments, seems irremediably distorted and misrepresented. It all had to be replaced, something else found, the nobility of ancient models matched.' Ary Renan was certain Pierre Puvis de Chavannes held the keys to this paradise regained, 'to a golden age, an ideal Utopia in which everyone, rich and poor alike, would want to act and dream.' Ingenuousness, simplicity, and faith were the keywords of this aesthetic journey that turned the artist into 'a philosophical innovator.'[1] Faced with the impasse of the academic studio model, whose worn-out, corseted canon epitomised urban and therefore tainted society (within the banal but inescapable turn-of-the-century conflict between town and country), the body uncovered itself. Free to do as it pleased, in its Edenic simplicity it embodied the nostalgic urge for a return to nature. The artist (in this case Puvis de Chavannes; cat. 32, fig. 2) invented the canon of a new mankind. 'Here, then, parading before us is the happy people of earthly legend, which surpasses others in magnitude and contains their germ. Here is man in his regal nudity, perhaps our better but no different to the one we rub shoulders with daily . . .

he is an earlier brother, a beautiful organism whose passions are as limpid and expressive as Homeric or Virgilian legends.[2]

How does one represent this quintessence of the human, living in such harmony with nature that it eludes the anecdote of individualisation? How does one depict this natural, quasi-original state in which people become the pictograms of an original humankind? Long before Georges Braque and Pablo Picasso, artists saw the primitive as a solution, as the guarantee of an authenticity unadulterated by academic teaching. Throughout the nineteenth century, the notion of primitive art referred neccessarily to an initial truth supposedly altered by progress.[3] The thirst for innovation drove artists to search ever further afield. Although at the turn of the century the term 'primitive' had a vague meaning, encompassing arts that are today completely differentiated, it still had the same meaning for the artist: it was an immemorial, barbarous, and authentic art, above all one that testified to an antique era peopled by genuine, unperverted human beings.

The aim here is not to undertake a comprehensive overview or definitive synthesis, but rather to pick a few flowers from among the works exhibited. A small bunch as composite as the turn of the century, whose flowers have rich, sometimes gaudy colours, those of artists who blossomed in different gardens

yet had a common bond, a certain diffuse and profound pantheism equating a nostalgia for our origins and man's harmony with nature. In this great pantheist communion, the artist did not copy a model nor even refer to one: Puvis de Chavannes created in parallel with nature, Odilon Redon shut himself up inside it, Paul Gauguin entered into it. It was a return to our origins and a return to the land of our ancestors. From now on, in order to create, the artist had to go back to his primitive roots through an authentic way of life that was proof of the sincerity of his art. To do this he left the city, a spatial displacement akin to stepping into a time machine, which took him back into another age.

But the garden of our beginnings was a protean one. Each artist imagined different roots for himself, and so envisioned a mankind of a different race or type. In a France that was in conflict with Germany, this original people was an antique, Mediterranean, Latin, national one. The ancient man also embodied the new man, one who had taken up a life closer to nature, in which sports and the bicycle transformed the body, a more natural life, far from the artifices and pollution of the city. Some believed the original man to be the missing link, an indeterminate state midway between man and beast, even one oscillating between the vegetable and animal kingdoms. This primitive man lived on in far-flung corners of the world and the imagination. But beyond these caricatured divisions, everything mingled and intertwined. The fact was that all these artists imagined a mankind closer to nature, more authentic, and in so doing invented new canons that eluded the individualisation and anecdote that naturalism could not avoid.

'A Gentle Mythology Came Back to Life with French Grace'

In 1891, abandoning Symbolism, Jean Moréas published his manifesto in Le Figaro announcing the birth of a French 'Roman School.' Co-founded with Charles Maurras, it upheld Greco-Roman tradition and sought to revive national roots and the French spirit of clarity and classicism. At the heart of this manifesto lay a nostalgia for a Virgilian France such as Kerr-Xavier Roussel (cat. 5) celebrated. The critic Marius-Ary Leblond noted that 'Roussel painted idyllic Theocritian and Virgilian visions in which a gentle mythology came back to life with French grace.'[4] For Leblond, the 'pantheism of light' of this 'dreamer of France' revealed a French art with the purest of racial qualities . . . This faunlike, nymphal mythology had a native feel about it, of the Île-de-France in particular, the artist's favourite region. Puvis de Chavannes, to whom Roussel was compared, was subjected to the same kind of analysis. Yet nowhere was there a bacchanalia to be seen in his work. In L'Élite, Georges Rodenbach's assessment of this timeless harmony with nature, totally oblivious to sensuality, is enlightening: 'And what a dream! One of a superior mankind, of a humanity that should have been, or will be. A mystical and mythical humanity, but never a mythological one. His women are not goddesses but the women of an Eden in which the Original Sin either never existed or doesn't anymore.'[5] For Rodenbach, it was absolutely clear that Puvis de Chavannes was an artist of 'very national stock' whose figures were directly related to Poussin's higher order of humanity.

Around 1895, Cézanne's fame was buoyed by the emergence of the reactionary Provençal movement. Influenced by Frédéric Mistral, it advocated the renewal of a Mediterranean literature that was essentially classical and national. In conflict with the decadence of Parisian Symbolism, it reaffirmed the vitality of man in contact with nature. Cézanne's vision of his native Provence was a nostalgic one, of the golden age[6] of his idyllic childhood spent swimming and reciting poems in nature. Gauguin described him as a man who spent his days on mountain peaks[7] reading Virgil and contemplating the sky. And Cézanne, who admired Ingres's Golden Age (fig. 19) and Poussin's Et in Arcadia Ego, would certainly have reflected on Provence's Virgilian and Arcadian dimension.

From Antiquity to the Mediterranean: Sculpture in the Open Air

For artists, the Mediterranean basin had long been the gateway to antiquity, an antiquity living on not only in statues but also in the peoples who lived there. The Mediterranean peoples were the depositaries of a timeless beauty, one that could only be found there, truth being in Nature. Already, during their travels, Delacroix and then the Orientalists had discovered that this biblical humanity still existed unchanged. An artist's Mediterranean origin was in itself considered as guaranteeing success in recovering this classical spirit. The lapse into nationalism was only a step away. Maurice Denis wrote about his friend Maillol: 'By birth, by race, he belongs to the South of France . . . It was some Greek, an ancestor of his, who brought to our southern coasts, along with the worship of beauty, that of Pallas Athena, that is, classical Reason. With his well-built forehead, straight nose and stiff beard, he himself resembles a warrior on the pediment of Aegina!'[8] Convinced that the artist depended on his environment, Maillol wrote: 'Of course, I admire Negro sculpture; but I believe that, to make Negro sculpture as it may be done, one has to be a Negro, live like a Negro and believe in what Negroes do.'[9]

Maillol's trip to Greece in the spring of 1908 was a pilgrimage to the sources that he felt confirmed his belonging to the Mediterranean world.[10] He wanted above all to see Greek sculpture in front of the sea, not to learn but to confirm his own works, 'to see a Greek temple, marble columns in the sun, even sculpture outside, real sculpture in the open air . . . I will see marble in the sun, art in nature.'[11] Rodin was of the same mind.[12] The sculpture that made Maillol famous, *Méditerranée*, shown at the 1905 Salon d'Automne, was a hymn to his native Arcadia, the Roussillon. '*Young Woman in the Sun* was the name I first thought of giving her . . . Then one beautiful day she appeared so alive to me, so radiant in her natural atmosphere that I baptised her *Méditerranée* . . . My idea in sculpting her was

to create a young, luminous, noble figure. And isn't it exactly that, the Mediterranean Spirit?'[13] For Maillol, any reference to modernity had to be made through the body of the female nude. *L'Île-de-France* was a Parisian sportswoman,[14] but he preferred the robust and radiant canon of the southern French peasant woman, who, he explained to Octave Mirbeau, 'lives intensely, normally in nature, of which she is in a certain sense the symbol of joy and health.'[15] Beyond classical harmony, Maillol's sculpture achieved a certain primitivism.[16]

Auguste Rodin (cat. 33-35) never tired of visiting Italy, but didn't discover Rome until 1912. 'One has an impression of grandeur, an imposing grandeur, of nobility, of sovereignty. Even the modern Roman has style. The priest officiating at the altar in Catholic churches, for example, does so with august gestures, like a senator in the Capitol. The gestures of a passer-by, of the simple man in the street, who talks more with his hands than with his mouth, also have style. The working-class woman has no coquetry. I know the plasticity of Roman women for having had many of them as models: they are beautiful and powerfully built.'[17] Although Rodin, like most artists of his generation, professed a worship of antique art, towards the end of his life he grew to appreciate more primitive forms, or at least more exotic ones such as Egyptian and Far Eastern art. His personal collection reflected his interest in the Archaic period of Greek art, but he emphatically did not want to copy antiquity. 'If you want to understand this work (a kneeling woman in the Naples Museum of Art), don't copy it but turn your back on it and take some woman passing by and get her to repeat the same gesture and look closely: every muscle moves in turn and in a flash will show you beauty.'[18]

In her study of Rodin, Valentine de Saint-Point[19] examined his work in the light of a pantheism revealing the aspirations of the time. Rodin, an artist of divine naïvety, reinvented the human body. He showed its original oneness with nature, exposed its share of noble animality, in short, turned it into one of the living pillars of nature. Like the primitives, he had the eyes of a child. Comparing him to the Assyrian stone

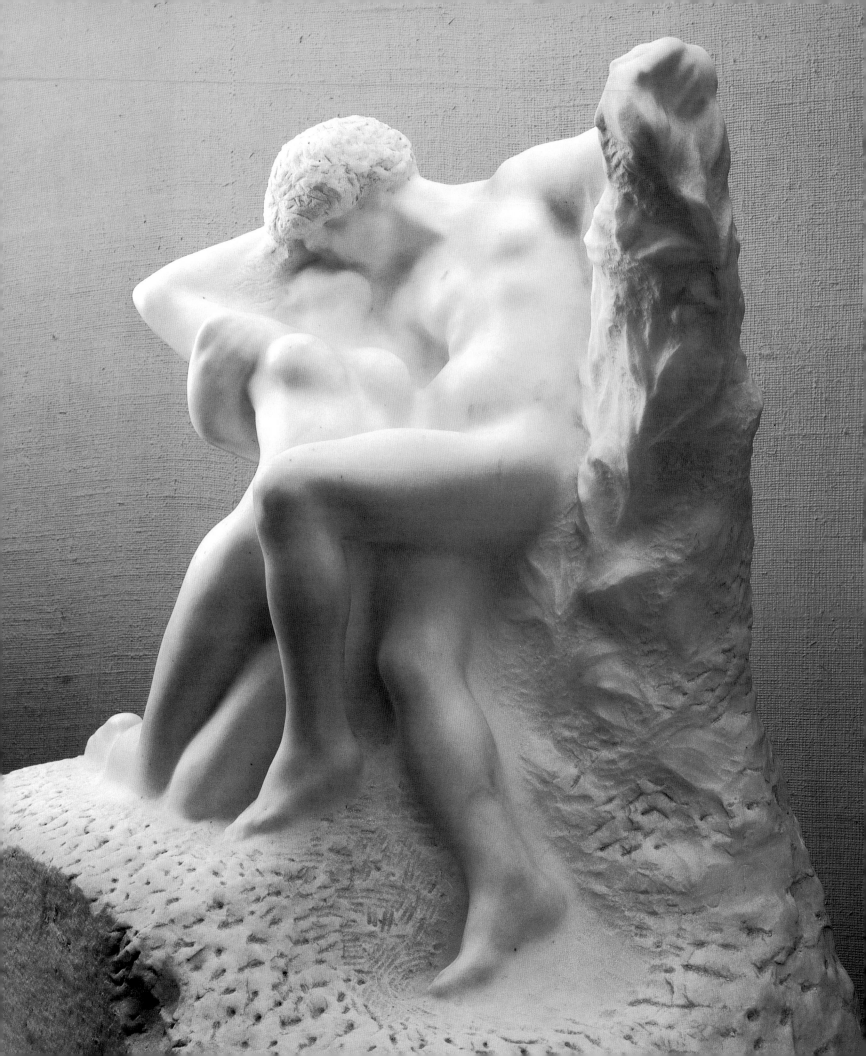

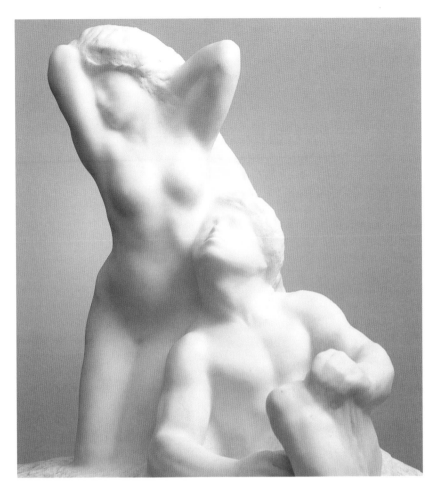

CAT. 34 AUGUSTE RODIN, *The Poet and The Muse*, c. 1905

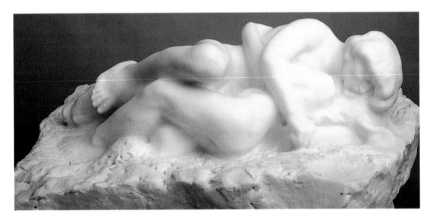

CAT. 35 AUGUSTE RODIN, *Cupid and Psyche*, 1905
CAT. 33 AUGUSTE RODIN, *Eternal Springtime*, c. 1900 (left)

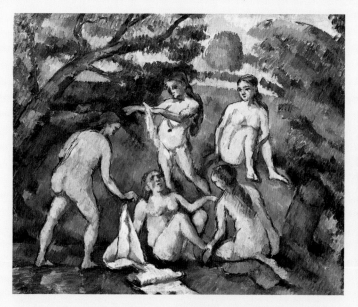

FIG. 33 PAUL CÉZANNE, *Five Bathers*, 1879-1882, formerly collection of Pablo Picasso

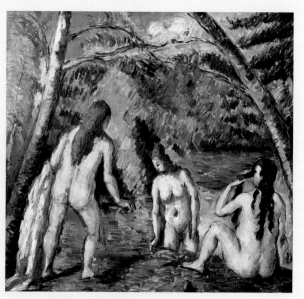

FIG. 34 PAUL CÉZANNE, *Three Bathers*, 1879-1882, formerly collection of Pierre Matisse

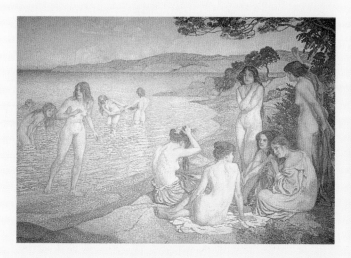

FIG. 35 THÉO VAN RYSSELBERGHE, *The Burnished Hour*, 1897

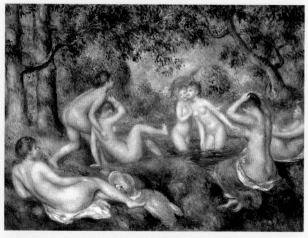

FIG. 36 PIERRE-AUGUSTE RENOIR, *Bathers in the Forest*, c. 1897

carvers, she refers to the lost secrets of archaic art: 'Just as the Orientals composed their pantheon out of the deified life of animals, Rodin fashioned an endless gallery of man's primal forces out of form . . . In him, we see the same love of movement which in the prehistoric caves characterised the wonderful art of primitive reindeer hunters, a strange art which captured the most extraordinary poses of fleeting, galloping animals.' A demiurge of modern times, 'the statue translated there, in static immutable matter, a human figure, an anthropomorphic feeling of nature . . . The analogy between the human figure and the surrounding landscape strikes one in a strange and intense fashion.' Hence, Rodin's sculptures become architectures of the earth: 'The majority of these works, when placed at random in the countryside, har-monise *naturally*, one could almost say *instinctively*'[20] in the spontaneous harmony of their union with nature. The author concludes on the *astral body* of these sculptures: 'The very sure distribution of light and shade, of half-tones . . . produces here new harmonies, which create a rhythmic movement of light around the statue. The contours are prolonged by this rhythm instead of remaining hard and precise; they mingle with the ambient light, melting into the vibration which in reality surrounds bodily organisms. Thus the statue is alive.'[21]

A poet of desire and of woman, Valentine de Saint-Point also evokes Rodin's 'sensual mysticism.'[22] Natural forces appear to him in nature in sexual form. His is the triumph of animality and desire after a long period of mortification of the flesh. 'This neo-pagan renaissance – already acknowledged in various forms of art – which has its brutal equivalent in the gradual thrust of life in the open air, is already to some extent given genius by Rodin.' She imagines his sculpted bodies, writhing with lust but never obscene, as 'fantastic bridges thrown across the chasm in which man teems, dies, and is born again; like strange arches of flesh proclaiming the triumph of Pan reborn.' She pursues this dual and complementary nature of the body - carnal flower, woman-female – that has become, by an artistic prodigy, biologically inseparable. Taking the example of *Centauress*, she writes: 'By the meticulous observation of a principle of balance, allied with an absolute respect for nature, in this statue, in which there is the effort of a headless horse and a woman without a body, [Rodin] comes close to primal forces, the source of all ideas. And in so doing reveals the fundamental nature of his materialist-idealist genius!'[23] It is the rite of spring, then, which is exalted. That primordial union between man and nature is symbolised by the gallery of hybrid beings, half-man, half-beast, of Greco-Roman mythology, 'and everything is permeated by the great religious rut of the Garden of Eden.'[24] In L'*Après-midi d'un faune*, Nijinsky himself was faunlike: the short, stocky model of his body seemed simian, and therefore primitive, in Rodin's eyes. Celebration of spring, religion of nature, dance itself became a bacchanal. This free effusion of the senses became the Matissian joie de vivre that affirmed an organic, global nature, the collective body rather than the individual.

THE BATHER: MODERN ICON OF JOIE DE VIVRE

The invention of the open-air nude reflected the climate of the times. Holidaying, lounging around, even naturism were in fashion. Games, sports, and leisure pursuits were recom-mended for good health and education. Cycling and English sports, increasingly popular, sculpted a new body. Baron de Coubertin bestowed sport with every virtue. Through the taste for the open air and physical effort, it brought men closer to nature, drew them away from the 'literary cancer' and the 'complication of industries.' Muscle no longer symbolised manual labour but rather an organism in perfect health. The podgy figure of the bourgeois was no longer fashionable. Far from urban pollution, women went on beauty cures in the sun or at the water's edge. Due to the influence of the dancer Isadora Duncan, rhythmic gymnastics appeared. 'Woman has a right to the normal exercise of her muscles and nerves,' said

FIG. 37 GUSTAVE COURBET, *The Woman in the Waves*, 1868

FIG. 38 ARISTIDE MAILLOL, *The Wave*, c. 1898

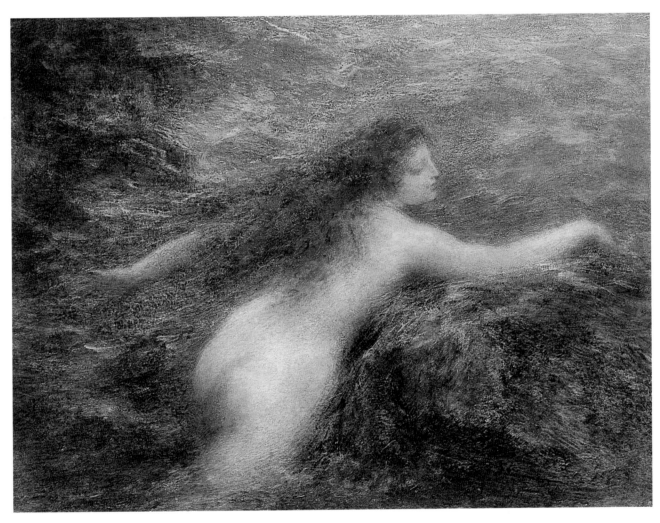

CAT. 36 HENRI FANTIN-LATOUR, *Naiad*, c. 1896

FIG. 39 MAURICE DE VLAMINCK, *The Bathers*, 1908

FIG. 40 ANDRÉ DERAIN, *Bathers*, 1908

FIG. 41 ÉMILE-OTHON FRIESZ, *The Bathers of Andelys*, 1909

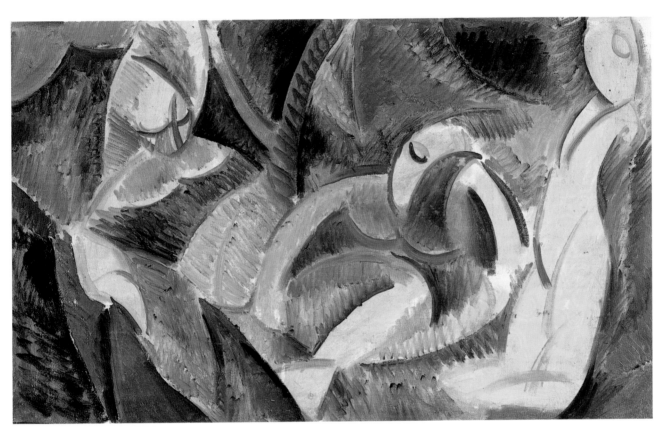

CAT. 37 PABLO PICASSO, *Bathing*, 1908

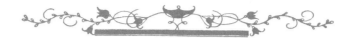

the newspapers, 'she has the right to air her body, to a healthy physique, to the joy of her entire physical organism. Only then is she elegant, healthy, and well balanced, no longer the creature of sin and sensual delight that centuries of mortifying Catholicism has prepared for us.'[25] To roam in the nude or almost, to free one's body from the fetters of fashion and the corset, to bathe at last, to be like a mermaid in the sea, a fish in water, it was this classical harmony that the modern bather renewed in nature (figs. 35, 36).

Let out of the harem and tepidarium, the new bather became one with nature. She was the wave itself for Courbet (fig. 37), Paul Gauguin, and Maillol (fig. 38). For Fantin-Latour, she was a naiad in the deep, a daughter of the Rhine, still a mythological creature (cat. 36). Then she became a very contemporary siren, swimming in her bathing costume, her body losing itself in the water's concentric ripples, in a definitive fusion with it. The bather became associated with the depiction of the new leisure activities and the genre scene. Daringly early on, Frédéric Bazille depicted naked men in the countryside. But it was Cézanne who definitively established the bather (figs. 33, 34), male and female alike. These works painted in the twilight of his life, which he considered capital, show his painterly will to integrate the nude into nature. Nothing could be more classical in proposition; it is his resolution which is completely novel: with no qualifier, the scene becomes timeless, the bodies faceless. Cézanne 'thought' his figures. Complaining about the provincial propriety that prevented him from painting from the model, he said, 'An invalid old man posed for all these women.'[26]

The motif of the nude in nature revived an original simplicity, the nudity of Adam and Eve in their earthly paradise before Original Sin (cat. 40, 41; figs. 44, 45). Modern painters,[27] from the Fauves to the Cubists, immediately understood the potential of these male and female bathers. In 1907 and 1908 it was the obligatory motif for symbolising joie de vivre and the pleasure of the senses. Picasso (cat. 37), Henri Matisse, and André Derain reintroduced the figure into the landscape. Matisse painted *Luxe I* and *II* and *Bathers with a Turtle* (fig. 46), while Derain painted

sculptural *Bathers* (figs. 40, 42) with copper-tinted skin. Reminiscent of Cézanne and Gauguin, his exotic Eves, whose faces evoke primitive masks, seemed to have come out of some antediluvian forest. 'It's mind-bogglingly, frighteningly expressive. But there is a double motive for this excess of expression: these are forms born out of the open air, out of the full light and destined to manifest themselves in the full light of day,'[28] wrote Maurice de Vlaminck, himself a painter of *Bathers* (fig. 39) in the same year.

Gauguin's Ancient Eve: 'It Doesn't Reek of the Model'[29]

Rousseau maintained *that society corrupts the original goodness of man in his natural state.* With Bougainville, dream became reality when he described Tahiti and its good savages, unaltered by civilisation. The Tahitian myth aroused in man the hope of being reborn in a new and pure world.[30] Tahiti was an Eden because of the lushness of its nature, a new Cythera because of the beauty of its women and the importance placed in sensuality, and a Utopia because of the kindness of its men and their society.

When he left for the islands, first Martinique, then Tahiti, and finally the Marquesas, Gauguin (cat. 38, 39) wanted above all to be able to live without money, to lead an idealised primitive life in a kindly climate.[31] He wanted to doff his civilised man's getup and find his true self. 'My feet, in permanent contact with stones, have hardened, become familiar with the ground; and my body, almost constantly naked, no longer suffers from the sun. Civilisation is slowly leaving me . . . I have all the pleasures, animal and human, of the free life. I am escaping the artificial, entering into nature.'[32] Gauguin considered himself to be part wild due to the Indian ancestry he prided himself on, enlisting contemporary determinist theories for his own ends. Although he often mixed several artistic influences (such as Khmer and Egyptian) to reinforce the primitive expressiveness of his art, he

CAT. 38 PAUL GAUGUIN, *Te Avae No Maria (The Month of Mary)*, 1899

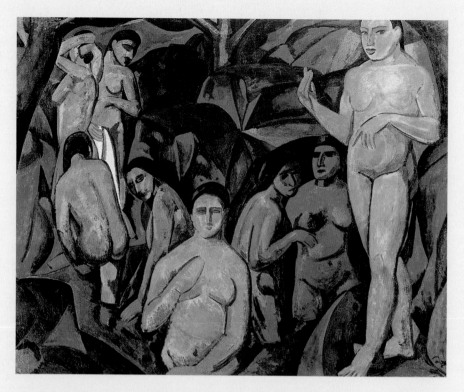

FIG. 42 ANDRÉ DERAIN, *Bathers*, 1908

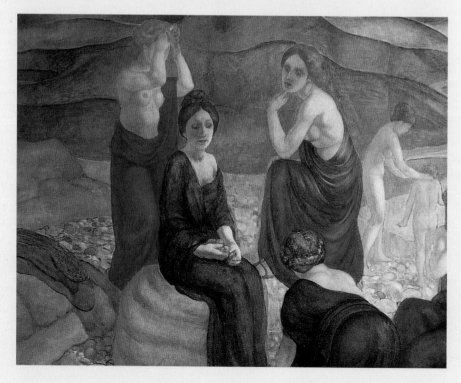

FIG. 43 KUZMA PETROV-VODKIN, *The Shore*, 1908

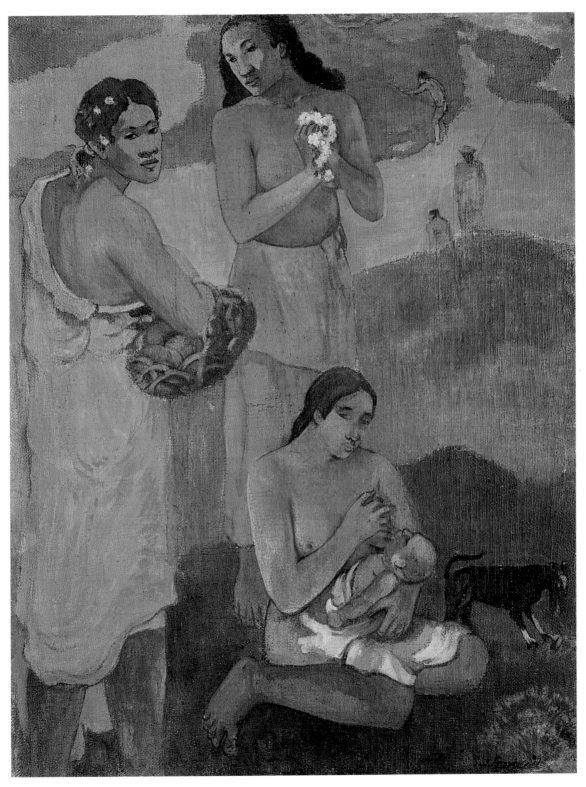

CAT. 39 PAUL GAUGUIN, *Women by the Sea (Maternity)*, 1899

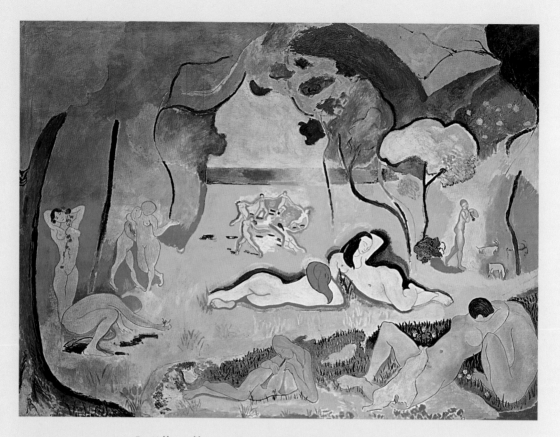

FIG. 44 HENRI MATISSE, *The Joy of Life (Le bonheur de vivre)*, 1905-1906

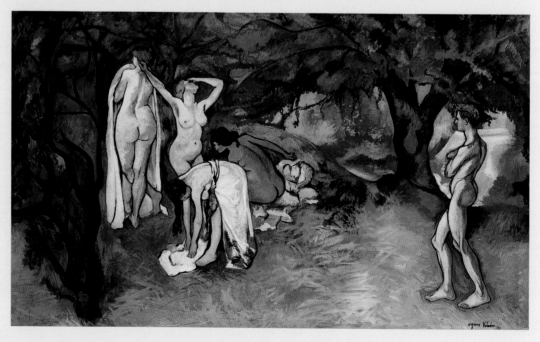

FIG. 45 SUZANNE VALADON, *The Joy of Life*, 1911

perceived the classical character of the islanders' bodies, the product of a racial antiquity that had given them their timeless beauty. This is why he often drew on Puvis de Chavannes and Ingres in his figures. He noted: 'What distinguishes the Polynesian woman from all other women and the reason why she is often mistaken for a man, are the proportions of her body. She is a Diana, a huntress with broad shoulders and a narrow pelvis . . . The Polynesian woman's leg descends from hip to foot in a lovely straight line. The thigh is large but not in width, which makes it very round and avoids that gap which leads to the comparison of some women in our country with a pair of tongs. Their skin is a golden yellow, of course, which some find ugly, but everything else, especially when she's naked, can hardly be said to be ugly. And they give themselves for almost nothing.'[33]

Here Gauguin seems to be echoing Stendhal who, asking himself 'Where can one find the Ancient Greeks?' replied: 'Not in some obscure corner of a vast library, stooped over mobile desks laden with an endless file of dusty manuscripts, but rifle in hand, in the forests of America, hunting with the Indians in the Ouabache. The climate isn't as good but that's where today's Achilles and Hercules are to be found.'[34] Like Gauguin, Redon revealed the classical beauty of the savage. When he saw Fuegians from Patagonia, whom Darwin had described as particularly primitive, exhibited in the Jardin d'Acclimatation in Paris he was, on the contrary, struck by their beauty:[35] 'A group of several sublime barbarians from Tierra del Fuego, proud, haughty, cruel, powerful, grotesque beings, gave me a kind of dream of primitive life, a nostalgia for the pure and simple life of our beginnings.' He continues, 'Here is the animal, its all-powerful instinct, its certainty, the uncorrupted beauty of its physique; for these limbs, so firm and shapely, are cast in antique bronze.' Contrasting them with the ugliness of the bourgeoisie, he writes further on: 'Their nudity comes out of the earth like a tropical flower, blooming, luxuriant, harmonious, and immobile in the splendour of its radiant and mute existence. These taut physiques should be seen among lianas in the shadows of a virgin forest, or stretched out on the golden sands

of some immaculate, deserted shore. What poetry there is in such a perfect organism, emerging from the primeval mud to stammer along with us the first verses of a universal anthem!'[36]

Gauguin wrote: 'The ancient Eve, who in my studio scares you, may well one day smile at you less bitterly. This world, which no Cuvier or botanist will perhaps ever find, is a paradise that I will have merely sketched in.'[37] He dreamed of the ancestor-gods of the Maori race. He didn't believe in their Malay origin; for him they were Oceanian and therefore insular and much purer. But he was aware that this 'race' was an endangered species. Victor Segalen echoes this: 'Neither white, yellow or black, the Maoris, when painted, even with words, must not be compared to any other species of man. In the sun, they don't have dullness of the European nude . . . One must, therefore – and the painter [Gauguin] has magnificently undertaken this – contemplate them in their wild enigma, the one they will take with them to their foreseeable end.'[38] Gauguin soon realised that his Romantic vision was repressed by the colonial culture, hence his flight from island to ever wilder island. A year before he died, sick, impoverished, isolated, and above all disenchanted, he wanted to return to Europe. But he had become, by a cruel twist of fate, prisoner of his own myth. His Arcadian quest had taken him to a heaven on earth. He no longer belonged to the world of the living. Monfreid wrote to him: 'You are now that unprecedented, legendary artist who, from the depths of Oceania sends the disconcerting, inimitable, and definitive works of a great man who has as it were disappeared from the world . . . In short, you are enjoying the immunity of the great dead, you have passed into *art history*.'[39]

TO THE ROOTS OF THE FAMILY TREE

One has to study nature to understand its laws, that is, examine the relationships each organic object has with its parts, explained Puvis de Chavannes: 'I need only to study a willow,

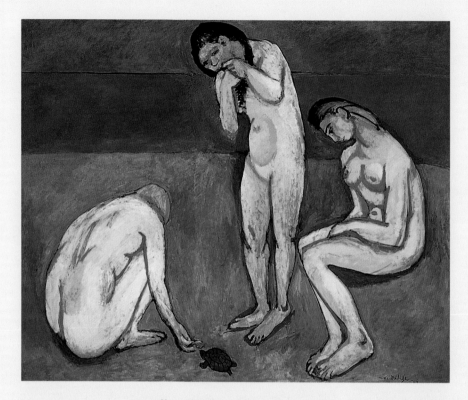

FIG. 46 HENRI MATISSE, *Bathers with a Turtle*, 1908

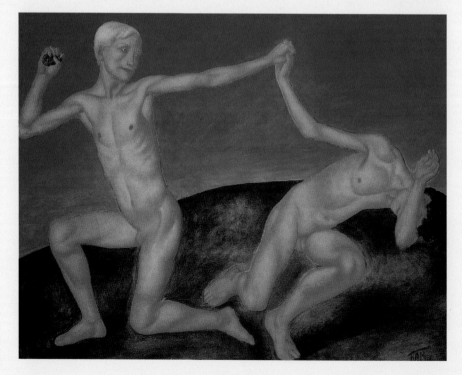

FIG. 47 KUZMA PETROV-VODKIN, *Boys*, 1911

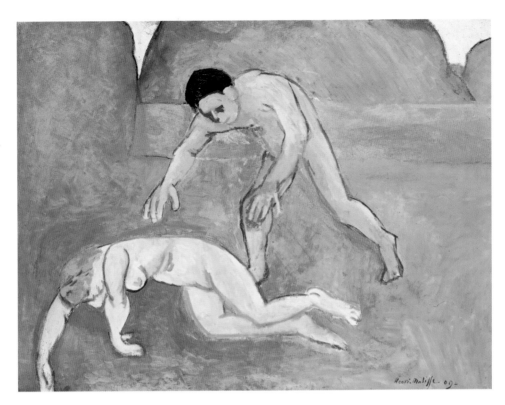

CAT. 40 HENRI MATISSE, *Nymph and Satyr*, 1908-1909

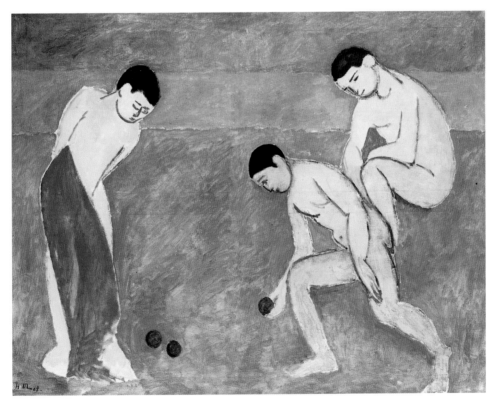

CAT. 41 HENRI MATISSE, *Game of Bowls*, 1908

CAT. 42 PABLO PICASSO, *Naked Youth*, 1906

cypress, pine, or laurel branch in order to draw forests.'[40] This original fusion was translated into a new formal pantheism. His women's bodies are as 'supple and straight as the stalk of a flower, with the slender flank of a lily and, as smooth and magnificent as a lily, the torso springs from the embrace of the drapery.'[41] They are 'strange visions, very real, robust even, with the infinite peace of these forests within them.'[42] This association of the female body with the vegetable realm flourished in Art Nouveau.[43]

The indeterminacy of genres owed as much to evolutionism as it did to fantasy. When Redon 'shut himself up in nature', he sought to draw forms that he saw as quivering and ambiguous.[44] Darwinian thought influenced the whole Symbolist generation, for whom there was no radical difference between man on the one side and nature on the other, since man is integrated into its very process.[45] Hence the resurgence at that time in the form of a spiritual Darwinism, of beliefs in an archaic pantheism (cat. 44). A friend of Redon, the progressive botanist Armand Clavaud sought 'that intermediary life between animality and the plant, that flower or being, that mysterious element which is animal for a few hours of the day and only under the action of light.'[46] The scientist initiated the artist into his work, notably into new theories of vegetable physiology, which diminished the boundaries with the human. Certain plants have a nervous system and organs enabling them to smell and feel. Redon's 'women-flowers'[47] were inspired, whether consciously or not, by the Darwinian idea of the inferiority of women, considered to be lower down the evolutionary ladder and therefore closer to primitive nature. Redon's aesthetic pantheism can also be explained by his belief in metempsychosis.[48] This appeal of the primitive, symbol of a communion between man and nature, was primordial for him, and although he travelled little he had his own *terra incognita* where he drank at the source of his childhood, Peyrelebade, between the pine forests of the Landes and the Atlantic ocean. Yet Redon's description of it likens it more to some lost archipelago on which lands an unlikely Robinson Crusoe. . .[49]

This 'Daphneisation' of women, as Pierre Schneider so aptly put it, continued with Matisse when he discovered springtime Tangier. 'It is through the gateway to the East,' he explained, 'that the painter discovers an Eden, the garden of happiness in the Koran.' Dazzled by the luxuriance of the vegetation, Matisse painted women like flowers; the young Moroccan from the Rif (cat. 50) and the mulatto woman Fatmah both remind him of the green of meadows in spring. The faces are expressionless therefore timeless; Oriental indolence reduces them to a life that is 'if not vegetable at least vegetative.' Matisse botanised his way of working. He needed to feel the vegetable essence of the human being in order to approach the decorative and the abstract. For him, 'floralising the human is purifying it: – When I see, when I study women, I often think of flowers, but never vice versa.'[50] He added: 'The Renaissance makes it very difficult to bring the animal and vegetable closer to one another,' which implies, in Schneider's view, that on the other hand the decorative Orient facilitates it. 'Look at a tree: it's like a human being,'[51] Matisse explained, 'When you draw a tree, you must have the feeling of going up with it.'

BACK TO THE TREES! . . . BACK TO NATURE![52]

Nostalgia was one of the driving forces of modernism, despite the usual view of the history of the progressive avant-gardes. This nostalgia for a pre-academic order, a prehistoric lifestyle, was a common theme for artists and writers, as well as for paleontologists and explorers. Picasso, like Gauguin, wanted to flee from civilisation when he retired to the mountains at Gósol in 1906. The myth persisted of a pocket of original nature surviving intact in some unexplored corner of the world, still inhabited by the missing link, half-great ape, half-man.[53] This regression to a primitive lifestyle found a particular echo among the German Expressionists of the Die Brücke group (fig. 49). Critical of indus-

CAT. 43 PABLO PICASSO, *Dryad*, 1908

trial society and taking van Gogh and Gauguin as their models, they wanted to return to a natural state and live as an artistic community. During their numerous excursions with their models to the sea and lakes at Moritzburg from 1909 to 1911, they depicted a pacific mankind living in the midst of nature. Enthusiastic about the art from the South Seas they discovered in the anthropological museum in Dresden, they considered that these peoples had a still-pure lifestyle, at one with nature, the lifestyle they sought in their community life. Emil Nolde, then Max Pechstein followed Gauguin's example and left for the Palau Islands.

The fusion of the body and nature, the dissolution of matter in light, the new formal paths for representing this archetypal mankind stemmed therefore from thought rooted in tradition. The conception of the archetypal nude, purified by nature and absolved of guilt by the return to the original state, was an Edenic nudity and, when displaced historically and geographically, a primitive one, the nudity of sculptural indigenous bodies and of the timeless masks of their faces. The body no longer had a humanist or individual beauty but reflected the ideal state of man in nature, both treated equally (figs. 50-52). Woman-flower and man-trunk, dryad or bather, the body was reified. It became an architectonic component of the landscape. The human being no longer lent his form to the allegories of nature: nature imposed its image on him.

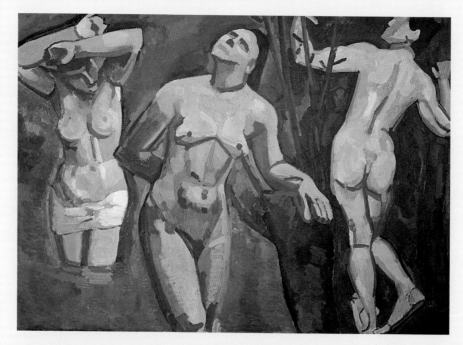

FIG. 48 ANDRÉ DERAIN, *Bathers*, 1907

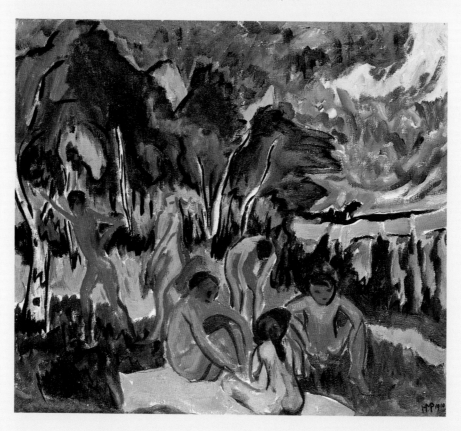

FIG. 49 MAX PECHSTEIN, *Open Air (Bathers in Moritzburg)*, 1910

FIG. 50 PABLO PICASSO, *Landscape with Two Figures*, 1908

FIG. 51 FERNAND LÉGER, *Nudes in the Forest (Nude Figures in a Wood)*, 1909-1910

FIG. 52 SVYATOSLAV VOINOV, *Sleep*, 1915

Notes

1 Ary Renan, 'Puvis de Chavannes', in *La Revue de Paris* 1 (15 January 1895), p. 441.

2 Ibid., p. 441.

3 It is well known that the avant-garde – the Barbus in David's studio, the Nazarene artists in Germany, and the Pre-Raphaelites in England – in order to escape imposed artistic models, sought renewal in a return to art's sources.

4 Marius-Ary Leblond, 'Roussel' in *Revue illustrée* 2 (1907), p. 420. Vollard told the following anecdote: 'One day, passing a large canvas by K. X. Roussel, his *Triumph of Bacchus*, which M. Morosoff (sic) from Moscow had just bought, Degas stopped and began stroking the picture: Who painted this? – Roussel – It's noble!' Quoted in K. X. *Roussel* (Saint-Tropez: L'Annonciade, Musée de Saint-Tropez, 1993), p. 114.

5 Georges Rodenbach, *L'Élite* (Paris: Fasquelle, 1899), pp. 220-21.

6 Paul Smith, 'Joachim Gasquet, Virgil and Cézanne's landscape – "My beloved Golden Age"', in *Apollo*, vol. CXLVIII (October 1998), pp. 11-23.

7 The importance Cézanne attached to the Mont Sainte-Victoire and its red colour recall Aix's Roman origins. According to a local legend, a Roman general defeated barbarians from the north there, and their blood coloured the stone red.

8 Maurice Denis, 'Aristide Maillol', in *L'Art moderne* 35 (2 September 1906), pp. 278-79.

9 Unsigned, 'Maillol speaks', in *The Arts* (July 1925), p. 36.

10 On Maillol's return from Greece, when someone asked him, 'So, Maillol, the Parthenon, I bet that was quite a blow,' he replied, 'No, a kiss.' An anecdote by Roussel in 'Fragments du journal de Paul Signac', in *Arts de France*, no. 18 (1947), p. 79.

11 Cécile Vincent, 'Maurice Denis et Maillol', in *L'Information d'histoire de l'art* 5 (November-December 1970), p. 213.

12 This idea directly evokes what Rodin said about the contemplation of a sculpture in front of the *Victory of Samothrace* during a visit to the Louvre with Paul Gsell: 'In your mind, move her to a golden shore from where one saw, beneath the olive branches, the sea, with its white islands, sparkling in the distance! Antique sculpture needs to be in the open air. In our museums they are weighed down with too-strong shadows: the reverberation of the sunlit Earth and the nearby Mediterranean bathed them in dazzling splendour.' Quoted in Rodin, *L'Art. Entretiens réunis par Paul Gsell* (Paris: Bernard Grasset, 1911), pp. 174-75.

13 René Puig, 'La vie misérable et glorieuse d'Aristide Maillol', in *Tramontane* 483-84 (1965), p. 26. Quoted in *Maillol* (Saint-Tropez: L'Annonciade, Musée de Saint-Tropez, 1994), pp. 76, 80.

14 Maillol expressed his interest in the male body: 'I have recently conceived a project, and I have made many drawings in search of a type of young man which would express the present tendency towards athleticism.' He notes: 'The modern athlete cannot be expressed in the terms of the Greek or Roman athlete. I have my own type.' Unsigned, 'Maillol Speaks', in *The Arts* (July 1925), p. 37. In 1928, invited by his patron, Count Kessler, in the German Olympic stadium, Maillol admired the athletes, who reminded him of the exploits celebrated by the Greek poets. Maillol's work was appreciated in Germany since it refers to the *Sehnsucht* (nostalgia) the Mediterranean Eden represents for northern Europeans. In particular, Kessler's enthusiasm for Greece corresponded to the idea he had of an enlightened society, which enabled one to freely live a homophile sensuality. See Sabine Walter, 'Le Comte Kessler, Maillol et Hofmannsthal en Grèce', in *Aristide Maillol*, ed. Ursel Berger and Jörg Zutter (Paris: Flammarion and Musée des Beaux-Arts de Lausanne, 1996), pp. 145-50.

15 Octave Mirbeau, 'Aristide Maillol', in *La Revue* (April 1905), pp. 327-29. Quoted in *Maillol* (Saint-Tropez: L'Annonciade, Musée de Saint-Tropez, 1994), p. 90.

16 Maillol preferred Archaic Greek art, considered more primitive. 'Classical in spirit and not to the letter, Maillol passed for an archaic. His work was said to be derived from the Egyptians, Etruscans, and sixth-century Greeks. But he was the first to understand that statuary had to go back to its sources. He gave form back its weight, density, and plasticity. Maillol was undoubtedly a primitive by his economy of means and by his respect for the material he used, but he in no way adopted the historical styles. Too many artists have believed they could recover the freshness of vision by imitating the Gothic, Aegean, and Khmer artists.' Waldemar George, 'Un sculpteur classique français – Maillol', in *L'Art vivant* 3 (1 February 1925), p. 2.

17 Jean Lefranc, 'Rome vue par Rodin', in *Le Temps* (20 February 1912). Quoted in *Rodin et l'Italie*, ed. Antoinette Le Normand-Romain (Rome: Edizioni de Luca, 2001), p. 21.

18 Rodin, 'La leçon de l'Antique', in *Touche à tout* 10 (October 1909), p. 499. Quoted in *Rodin et l'Italie*, ed. Antoinette Le Normand-Romain (Rome: Edizioni de Luca, 2001), p. 132.

19 Valentine de Saint-Point (1875-1953) studied painting under Alphonse Mucha and published collections of poems. This tragedian, a specialist in Sophocles, was also a theorist of dance and theatre. Influenced by Nietzsche, she questioned the carnal dimension of the body. She invented an abstract form of dance called 'Métachorie.' She is one of the rare women in French Futurism whose manifestos on women and lust sparked violent debate. Attracted to esotericism, she finally settled in Egypt, converted to Islam, and defended the cause of Arab nationalism. She was also a muse and model for Rodin, who considered her study interesting and important.

20 Saint-Point (de), 'La double personnalité d'Auguste Rodin', in *Nouvelle Revue*, 28th year, vol. XLIII (November-December, 1906), pp. 33-36.

21 Saint-Point (de), part I, p. 41.

22 Saint-Point (de), part II, p. 193.

23 Saint-Point (de), part II, p. 199.

24 Félicien Fagus in *La Revue blanche* (1 June 1902). Quoted in 'K. X. Roussel', in *L'Art Moderne*, vol. 2, Bernheim-Jeune (1919), p. 54.

25 H. Béranger, 'Les Jeux de la femme', in *La Revue des revues*, 1900. Quoted in Dominique Paquet, *Miroir, mon beau miroir – Une histoire de la beauté* (Paris: Gallimard, 1997), p. 77.

26 John Rewald, *Cézanne* (Paris: Flammarion, 1986), p. 222.

27 The models are nude outside, even if the Fauves revived working in the studio. Henri Manguin had one key advantage over his friends, since he was able to count on his young wife, Jeanne, because it was not always easy to find a conciliatory model. On this subject, Paul Signac recalls his expedition in 1892 to the island of Port-Cros, where he and his friends wanted to paint the nude from a hired model: 'Her name was Mathilde, but after a few days, we nicknamed her "the cholera" because she was so unbearable ... She also refused to pose under the pretext that there were too many mosquitoes,' 18 June 1932, archives, Musée d'Orsay.

28 Letter from Derain to Vlaminck dated 7 March 1906, in *Lettres à Vlaminck suivies de la correspondance de guerre*, ed. Philippe Dagen (Paris: Flammarion, 1994), p. 173.

29 *Lettres de Paul Gauguin à Georges-Daniel de Monfreid* (Paris: Éditions Georges Crès & Cie, 1918), p. 201.

30 On the subject of the Tahitian myth, see Daniel Margueron, *Tahiti dans toute sa littérature* (Paris: Éditions de L'Harmattan, 1989).

31 See Isabelle Cahn, *Gauguin et le mythe du sauvage* (Paris: Flammarion and Arthaud, 1988).

32 Gauguin, *Noa Noa – Séjour à Tahiti* (Paris: Éditions Complexe, 1989), p. 48.

33 Gauguin, *Oviri – Écrits d'un sauvage* (Paris: Gallimard, 1974), p. 325.

34 Stendhal, *Histoire de la peinture en Italie – Autour de Michel-Ange* (Paris: Seuil, 1994), p. 10.

35 These anthropological exhibitions of natives proved to be highly lucrative enterprises. On this subject, see *Zoos humains*, ed. Nicolas Bancel, Pascal Blanchard, Gilles Boëtsch, Éric Deroo, and Sandrine Lemaire (Paris: Éditions la Découverte, 2002).

36 Redon, *A Soi-même – Journal 1867-1915* (Paris: Librairie José Corti, 1961); reprinted 1989, pp. 84-85.

37 Letter to August Strindberg, n.d. (5 February 1895) in Gauguin, *Lettres à sa femme et à ses amis* (Paris: Éditions Bernard Grasset, 1946), p. 267.

38 Tribute to Victor Segalen, in *Lettres de Paul Gauguin à Georges-Daniel de Monfreid* (Paris: Éditions Georges Crès & Cie, 1918), p. 36.

39 Letter from Monfreid dated 14 November 1902, in *Lettres de Paul Gauguin à Georges-Daniel de Monfreid* (Paris: Georges Falaize, 1950), p. 233.

40 Paul Guigou, 'Puvis de Chavannes', in *La Revue du siècle* 56 (January 1892), p. 8.

41 Paul Guigou, 'Puvis de Chavannes', in *La Revue du siècle* 56 (January 1892), p. 10.

42 Paul Guigou, 'Puvis de Chavannes', in *La Revue du siècle* 56 (January 1892), p. 15.

43 The reference books by the botanist Professor Christopher Dresser and the Darwinian biologist Ernst Haeckel had a decisive influence on Art Nouveau.

44 Émile Bernard described Redon's drawings as follows: 'They generally depict imprecise visions, beings being formed, miasmas developing, human beings in plasma, wandering monads. In this case Darwin's theories are acknowledged by Redon, who takes us through all the humiliations of our supposed genesis.' To which Redon, the subject of the eulogistic article, soberly retorted in the margin: 'I don't know where I drew miasmas. I'm not a Darwinian since my work isn't science.' Disagreeing, he insisted: 'The supernatural doesn't inspire me. I only contemplate the exterior world, and life.' And he concludes wryly: 'I've kept my feet on the ground. And my works are true despite what people may say. And hooray for a good game of tennis!' Émile Bernard wrote the article in Cairo in 1903 and it was published in *L'Occident* in May 1904. The version annotated by Redon was commented on by John Rewald in 'Quelques notes et documents sur Odilon Redon', in *La Gazette des beaux-arts* (November 1956), pp. 81-124.

45 See Barbara Larson, 'La génération symboliste et la révolution darwinienne', in *L'Âme au corps – Arts et science 1793-1993*, ed. Jean Clair (Paris: RMN, Gallimard, and Electa, 1993), pp. 322-41.

46 Redon, op. cit., p. 18.

47 See Gloria Groom, 'The late work', in *Odilon Redon 1840-1916* (London: The Art Institute of Chicago and Thames and Hudson, 1994), pp. 306-52. See also in the same book, on the dream of the primitive life, the essay by Douglas W. Druick and Peter Kort Zegers, 'In the public eye', pp. 120-74.

48 Revealed by Édouard Schuré in 1889 in *Les Grands Initiés*, the Pythagorean doctrine of metempsychosis (or palingenesis) also reports the multiple existences of the *Psyche*.

49 'Soulac, Soulac is the long-awaited cry at last heard by the traveller washed up on an unknown beach. He sees nothing at first: a wide and moving carpet of sand, large pines on the crumbling dunes. He is alone, almost lost; the surprised native comes closer. A few rare bathers will also be there at the arrival to see the newcomer or friend. One is so alone there, *at the end of the earth*, it is also the only impression one will have in the half-dead, wild land, lifeless, with no culture, almost confined to the Ocean.' Redon, op. cit., pp. 49-50.

50 Pierre Schneider, 'La charnière marocaine', in *Matisse au Maroc: peintures et dessins, 1912-1913* (Paris: Adam Biro, 1990), p. 27.

51 Schneider, op. cit., p. 37.

52 Roy Lewis, *The Evolution Man or How I Ate My Father* (New York: Vintage Books, 1994).

53 Around 1880-90, the pygmies were discovered in the forest of Africa. Legendary since antiquity, they were considered by anthropologists to be the living remnants of an extremely ancient phase in human evolution.

Sergei Shchukin
and Ivan Morozov

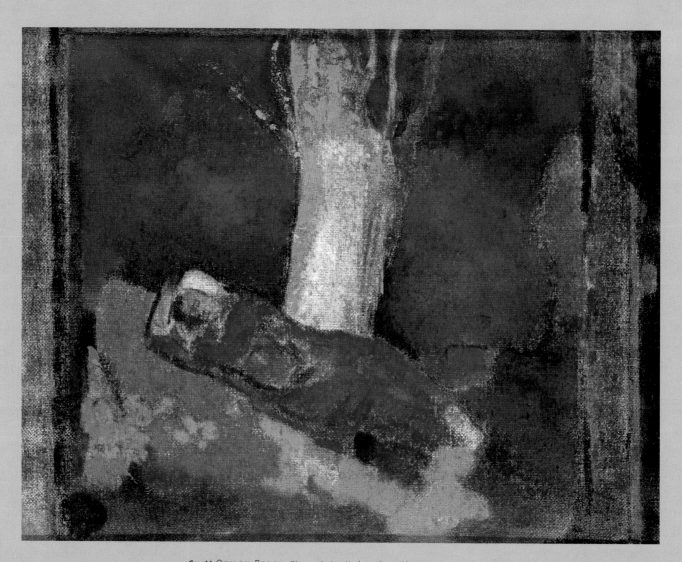

CAT. 44 ODILON REDON, *Woman Lying Under a Tree (The Dream)*, 1900-1901

Sergei Shchukin and Ivan Morozov: Two Legendary Collectors

ALBERT KOSTENEVICH

Sergei Shchukin and Ivan Morozov were active as collectors at the dawn of the twentieth century, at a time when initiatives in the field abounded. Yet even today, almost a century later, the achievements of these two Russian collectors are still just as amazing. A great many of the canvases by Monet, Cézanne, van Gogh, Gauguin, Bonnard, Matisse, Picasso, and Derain that they acquired are now considered masterpieces of the new art that emerged in France. Paradoxically, these extraordinary collections were assembled by people totally alien to the European art world, living far from Paris, and having received no particular training. Moreover, the milieu they frequented – Moscow's merchant class – was largely indifferent, or even hostile, to art. Moscow, that original but half-'Asian' city, was a far cry from brilliant St. Petersburg, Russia's only 'window onto Europe.'

However, it was not by chance that Shchukin, Morozov, and other famous admirers of the new French painting appeared in Moscow. There were no such connoisseurs in St. Petersburg, whose merchant class was too intent on imitating the tastes of high society in the capital to produce such a thing as a great independent collector. Many St. Petersburg aristocrats had large collections of old masters, but in the second half of the nineteenth century they rarely attempted to enlarge them, and when they did, it was generally because they had succumbed to the temptation of having their portrait painted by some Parisian Salon celebrity.

The fabulously rich St. Petersburg merchant Eliseyev, giving in to his wife's artistic tastes, may have decorated the rooms of his sumptuous mansion on Nevsky Prospect with Rodin sculptures, but these marbles had none of the aspirations of the Parisian avant-garde. Another St. Petersburg trader, Haasen, had a passion for a distinctly more 'advanced' art. He owned canvases by the Nabis, Marquet, and Manguin, albeit far less radical than those Shchukin had shipped to Moscow. This representative of a Swiss chocolate firm had, moreover, remained fundamentally a Russianised foreigner. Contrary to St. Petersburg merchants, Muscovites were generally considerably more independent in their artistic tastes.

Sergei Ivanovich Shchukin (1854-1936) belonged to an old family of Muscovite merchants. In his youth, no one could have predicted a brilliant future for him, either in business or in the cultural domain. Yet it was to him that his father, director of I. V. Shchukin and Sons, a major player in the Russian textile business, left his mansion, once the palace of

FIG. 53 Sergei Ivanovich Shchukin [1854-1936]

FIG. 54 Shchukin's house in Moscow, 1913

FIG. 55 Sergei and Lydia Shchukin in India (n.d.)

FIG. 56 Sergei Shchukin at Epidaurus, 1908

the Trubetskoy princes. Only the third son in line, a frail and stuttering child, no one could have seemed less likely to step into the shoes of Ivan Vassilyevich, a figure of considerable authority in the business world. Sergei had such a terrible stutter that his parents, loath to send him to school, hired tutors to teach him at home. He spent his childhood and youth deprived of the company of boys of his own age, which had its effect on his character development. He grew up into an independent young man capable of overcoming his hesitations and, when he had to, going against preconceived ideas. It was this well-forged temperament, combined with a developed sensitivity, that made him a great collector.

Sergei Ivanovich Shchukin's large family was an extraordinary clan with connections in the cultural world. It had blood ties with several prominent Muscovite families, in particular the Botkins and the Tretyakovs, whose extraordinary art collections the six Shchukin brothers would have been familiar with. Ivan Vassilyevich, who had never received an education, was determined that his sons should have a foreign 'veneer' – a seemingly unrealisable goal as far as Sergei was concerned given the boy's terrible stutter. Nevertheless, when he was nineteen, his father took him to Germany for treatment. Although this was far from successful, Sergei did make sufficient progress to be able to enrol at the Academy of Commerce at Gera in Thuringia. He pursued his studies in France for a time then, when he returned to Moscow at the end of 1878, became a director of the family firm alongside his father.

The stuttering Sergei soon proved he had far more flair for business than of any of his naturally more favoured brothers. With time, his knowledge of textile production, his expertise in commercial transactions, and his innate understanding of both the home and foreign markets earned him the nickname 'minister of commerce' in finance circles. In 1912, he was appointed head of the Moscow Merchant's Council. For a long time he had had a reputation as an enterprising and daring businessman, acquired in particular during the 1905 General Strike. During

the wave of panic that had swept through the business world, he had bought up every textile mill he could and then, after the revolution had been put down, raised prices.

Curiously, though, for quite a long time Shchukin's success in business seems not to have aroused any desire to spend his wealth on works of art, or at least no more than was expected of a well-established industrialist. He seems not to have begun collecting until he was around 40, by which time his brothers were already recognised collectors. The eldest, Piotr, had been acquiring rare books, documents, and domestic objects in great quantity for a long time. Even Sergei's younger brothers had begun collecting before him. Dmitri, for example, had the finest collection of Old Masters in Moscow before the revolution.

Each brother had a link with art in his personal life, but unlike the eldest, who were inevitably expected to work in the family business, Ivan, the fifth son, had been allowed to choose his own vocation. After studying at the faculty of history and philology at Moscow University, in 1893 he moved to Paris where for fifteen years his apartment in avenue Wagram became a rather special gathering place for the Russian community. In a letter to his wife, Chekhov described Ivan Ivanovich Shchukin as an interesting personality, adding that he had lunch with him whenever he was in Paris. Degas, Renoir, Rodin, Redon, Huysmans, and Durand-Ruel were also regular visitors to his apartment. He fed on their conversations about art and took advantage of exceptional opportunities to buy works by the great masters with whom he had the opportunity to exchange a few words from time to time. And as he knew Durand-Ruel, he could 'recommend' his elder brothers. In 1898, he took his brother Piotr to Durand-Ruel's gallery. Piotr was already the venerable director of a museum he had created himself. Following this visit, his museum-residence in Moscow began filling up with pictures by Monet, Renoir, Degas, Picasso, and Sisley.

Sergei bought his first Impressionist paintings at the same time as Piotr, who had no doubt himself also heeded the

FIGS. 57 AND 58 Paintings by Monet, Renoir, Le Douanier Rousseau, Denis, Degas,
Derain, Puy, among others, c. 1913
Below, the music room

advice of their Parisian brother. By that time, he was already an experienced collector. It is hard to say precisely when he had begun collecting pictures: possibly in the early 1890s. They were canvases by Russian realist painters belonging to the Wanderers movement, which he later parted with. In 1896-97, his tastes began to veer towards the West. 'Shchukin's first acquisitions at the end of the 1890s,' wrote one of the collector's close friends, the critic Yakov Tugendkhold, 'were landscapes by Thaulow, Paterson, Cottet, Simon, and *The Spanish Woman* by Zuloaga, middle-of-the-road painters who steered clear of the impetuous mainstream of modernity.'[1] These painters still reflected a Romantic and banal attraction for second-rate art and had ill-defined aims. The artists – a Norwegian, a Scotsman, a Spaniard, and two Frenchmen – came from a range of countries, even though all the pictures had been bought in Paris.

A year or two went by before Shchukin decided to limit himself to a single school – French painting, then sovereign throughout Europe – although it took him a little while to develop a reputation as a collector with an infallible eye. Who today remembers the painters Guilloux and Maglin, whose work Shchukin bought in Paris in 1898? At the time, he had been attracted by their mysteriousness. Yet, that same year, at the Galerie Durand-Ruel, he bought his first masterpiece of the French avant-garde, Claude Monet's *Cliffs at Belle-Île* (1886, Pushkin Museum of Fine Arts).

Shchukin soon demonstrated what would be his characteristic trait as a collector: his constant desire to remain on the crest of the contemporary artistic wave. To do so he had first to catch that wave or, more precisely, the movement's latest phases – no easy matter for a Russian art lover at the end of the nineteenth century. The painter and art critic Alexandre Benois, the greatest connoisseur of the time, wrote, 'Until the 1890s Impressionism was essentially an "underground" phenomenon, known only to a very select few . . . The masses hardly ever heard about painters such as Manet, Degas, Monet, and Renoir, and then only on an ad hoc basis, and if these names were mentioned or cited in a critique, it was always with a hint of irony or indignation. For the vast majority, these today undisputed representatives of "France's glory" were madmen or charlatans. France's incontestable celebrities were, on the contrary, Gérôme, Benjamin-Constant, J. P. Laurens, Henner, Meissonier, Bonnat, Bouguereau, Roybet, Jules Lefèvre, et al.'[2]

Although enlightened society denounced the Impressionists as charlatans, the vast majority howled even louder at anyone who dared to collect their pictures. In 1914, at a time when the memory of the early days of Shchukin's collection was still fairly fresh, Yakov Tugendkhold wrote: 'The first landscapes by Monet that Shchukin brought back were greeted with indignation, just like with Picasso today. It was not without good reason that one of Shchukin's guests scribbled on a painting by Monet in protest.'[3]

From the outset, one major characteristic of Shchukin's approach was not his obsessive search for exhaustiveness but his desire to concentrate on the most important works. He came to the conclusion that the main figure of the Impressionist movement was Monet. But hardly had Muscovite society got used to Monet's Impressionism than Shchukin was preparing to deal it a new blow. The painter Leonid Pasternak – father of Boris, the writer and future Nobel prize winner – recalled in his memoirs, 'One day, Serov and I found ourselves alone with Shchukin at his house: "I've got something to show you, just look at this," he said. He drew back the heavy window curtains and brought out his first Gauguin (*The Maori Venus with a Fan*). Laughing and stuttering, he added, "Look wha-wha-what a madman painted a-a-and a-another madman bought."'[4]

By around 1903-4 he had caught up with the most daring innovators and from then on the enrichment of his collection kept pace with the lightning development of French painting. With the exception of his very first purchases, Shchukin's activity as a collector can be divided into three periods: the

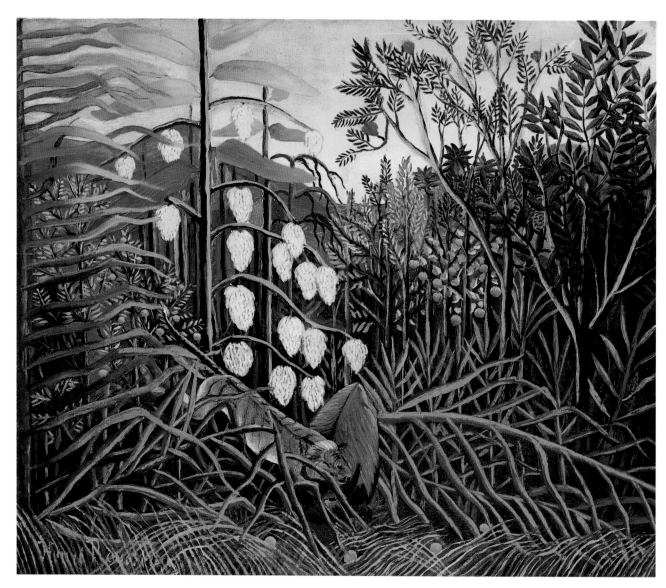

CAT. 45 HENRI ROUSSEAU, *Combat of a Tiger and a Bull (In a Tropical Forest)*, 1908

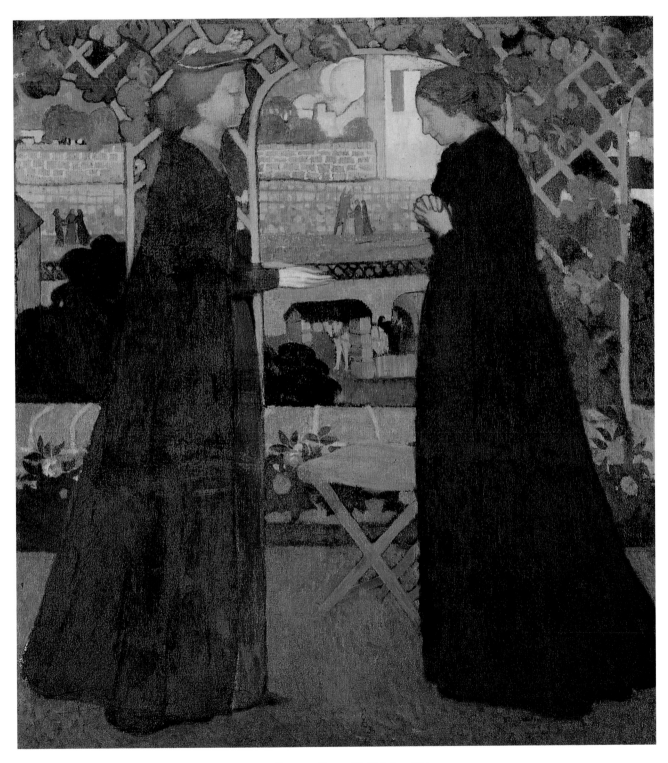

CAT. 46 MAURICE DENIS, *The Visitation*, 1894

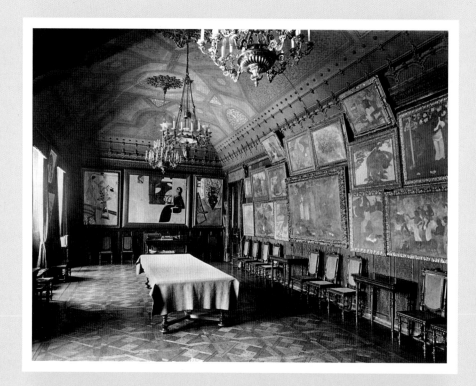

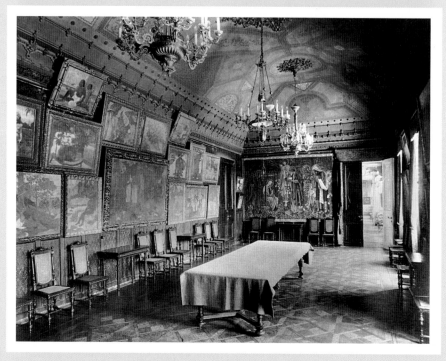

FIGS. 59 AND 60 Shchukin's dining room with his collection of Gauguins. Top, on the far wall, *Conversation* by Matisse, c. 1913

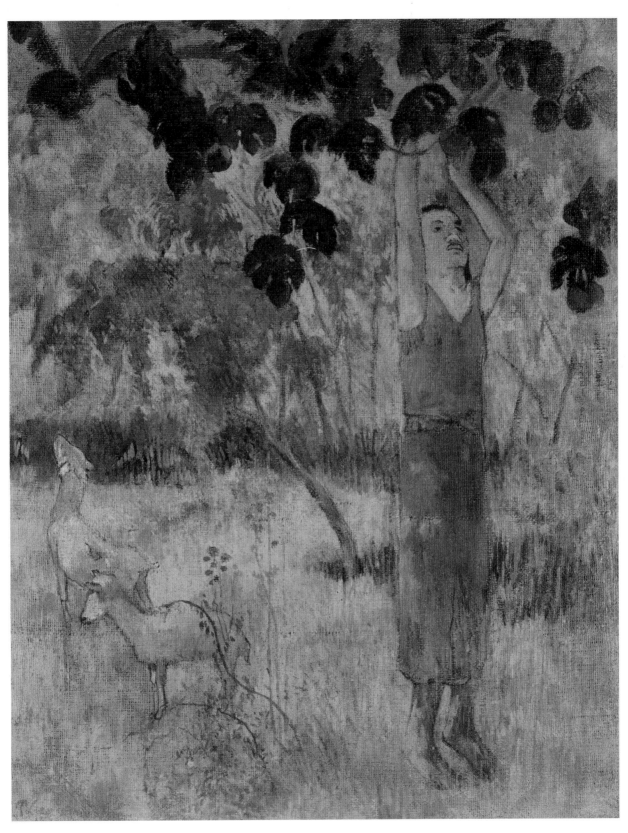

CAT. 47 PAUL GAUGUIN, *Man Picking Fruit in a Yellow Landscape*, 1897

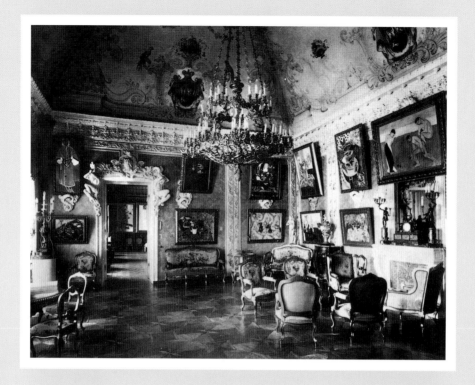

FIGS. **61** AND **62** Shchukin's Matisse drawing room, c. 1913

CAT. 48 HENRI MATISSE, *Still Life with Blue Tablecloth*, 1909

CAT. 49 HENRI MATISSE, *Pink Statuette and Pitcher on a Red Chest of Drawers*, 1910

first, from 1898 to 1904, when he sought above all Monets; the second, from 1904 to 1910, which was the period of Cézanne, van Gogh, and Gauguin; and the last, from 1910 to 1914, which was linked with the names of Matisse, Derain, and Picasso. Moreover, one should note that the first Gauguin and Cézanne canvases appeared in his home in 1903, well before these artists were widely known. It took him only a few years to amass what was to become the finest Gauguin collection in the world.

In 1904, Shchukin bought one of Cézanne's most remarkable works, *Mardi Gras* (1888, Pushkin Museum of Fine Arts), as well as his *Flowers in a Blue Vase*, previously in the collection of Victor Chocquet, a faithful comrade-in-arms of the Impressionists and Cézanne. He always drew a distinction between the Aix master and the Impressionists and, contrary to Monet, Degas, and Renoir, whose works he rapidly ceased collecting, always kept an eye on what he was doing. He considered him the *dernier cri* in European painting, but also perceived the artist's wider cultural resonance. Matisse recalled, 'In Paris, Shchukin's favourite pastime was visiting the Egyptian antiquities in the Louvre, in which he saw parallels with Cézanne's peasants.'[5]

Similarly, what attracted him in Gauguin's work was not only its decorative beauty and the alluring exoticism of faraway Tahiti (to which this tireless traveller, who had roamed India, Palestine, and Egypt, was certainly not indifferent), but also its profound links with diverse strata of world culture, from the European Middle Ages to the ancient East. For Shchukin, the ensemble of sixteen Gauguin canvases to which he had devoted the main wall of his reception room (figs. 59, 60), a room almost as large as the music room, where Monet's paintings hung in state (figs. 57, 58), was in a certain sense akin to the ensembles of icons in Russian cathedrals – regular visitors to his gallery of course also noticed this. Shchukin hadn't decided to exhibit the Gauguin 'iconostasis' straight away. An astute businessman, he foresaw that his artistic acquisitions would be considered extravagant, and began by hanging his canvases by French masters in rooms not open to visitors.

With paintings by Cézanne, Gauguin, and van Gogh now alongside the Monets and the other Impressionist works, the collection had become one of the most important of its kind in Europe, compelling Shchukin to envisage its imminent transformation into a full-blown museum.

The sudden death of his wife Lydia spurred him into more concerted action. During the night of 4 January 1907, he drew up a will in which he left his collection to the city of Moscow – more precisely to the Tretyakov Gallery. The tragedies that beset him – the death of his son Sergei, who had thrown himself into the Moskova River a year earlier, the loss of his wife, his brother Ivan's suicide followed by that of his youngest son, Grigory – might have broken anyone. They certainly altered not only the collector's vision, but also his way of serving art. He decided to open his collection to the public free of charge on a regular basis. Beforehand, famous artists had been able to see it, but from this point on, every Sunday, his mansion was open to all.

The gallery's influence very quickly made itself felt. In 1908, even though it hadn't yet acquired its definitive configuration, or its most radical pictures, Pavel Muratov rightly noted, 'S. I. Shchukin's picture gallery in Moscow belongs among the most remarkable Russian collections. For a long time now, it has benefited from notable and deserved fame in artistic circles and among enlightened friends of art. What is more, this gallery has exercised a crucial influence on the destiny of Russian painting over these last years. It is set to become the most powerful vector in Russia for the European artistic trends so brilliantly expressed in the works of Monet, Cézanne, and Gauguin which belong to him.'[6]

At the time this was written, Shchukin had already established a special relationship with Matisse, who had become, after Monet, Cézanne, and Gauguin, the focus of a new infatuation on his part (figs. 61, 62). Echoes of the scandal caused by the Fauve section at the 1905 Salon d'Automne had already reached Russia, but the first Russian Revolution had just broken out, art lovers had other preoccupations and news of

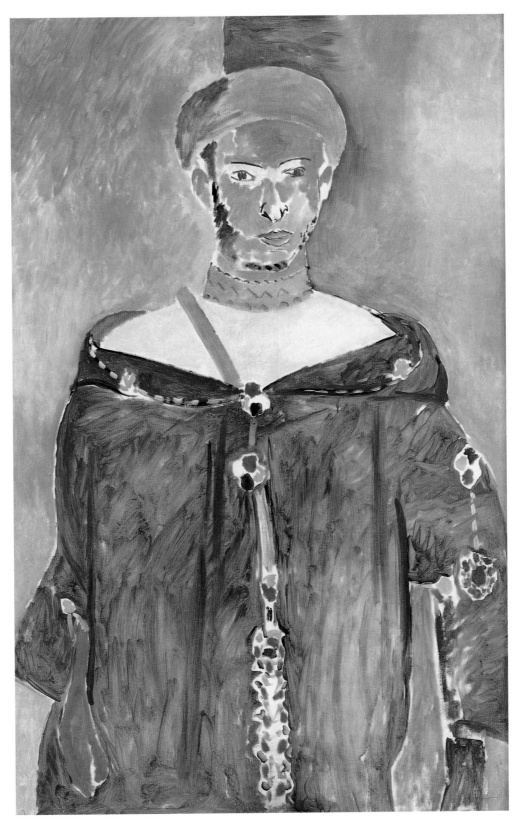

CAT. 50 HENRI MATISSE, *Standing Moroccan in Green (The Standing Riffian),* 1913

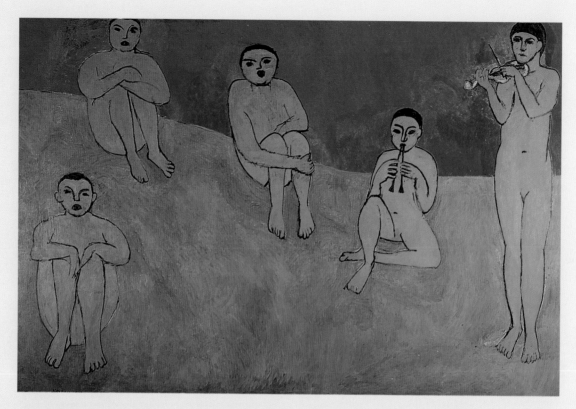

FIG. 63 HENRI MATISSE, *Music*, 1910

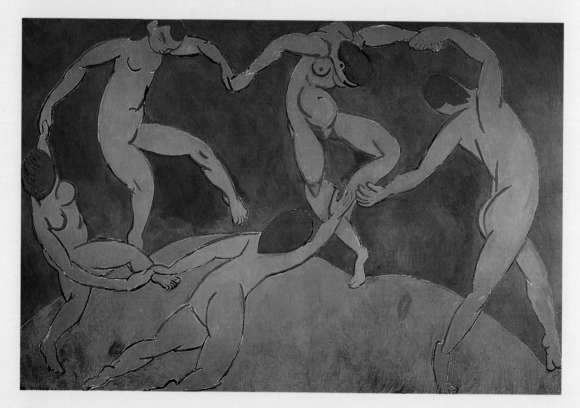

FIG. 64 HENRI MATISSE, *Dance*, 1910

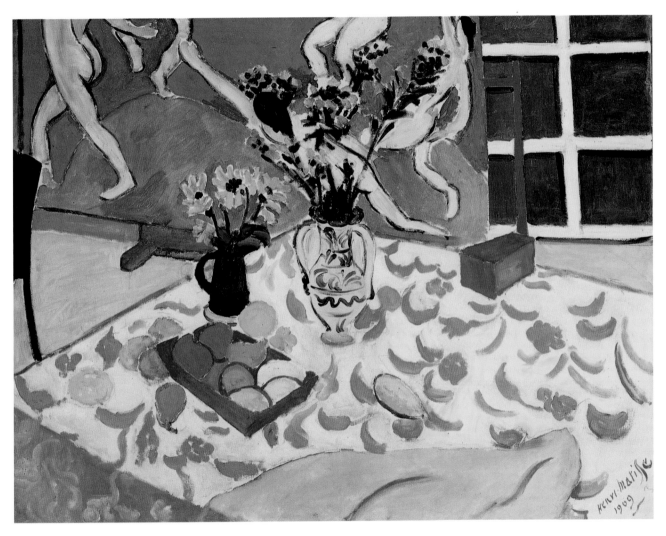

Cat. 51 Henri Matisse, *Fruit, Flowers, and the panel 'Dance'*, 1909

the Salon took time to spread. Shchukin, though, continued to keep abreast of events in the art world. In May 1906, he asked Vollard for Matisse's address.[7] Shortly afterwards, Matisse told Manguin that he had sold Shchukin a large still life, which the latter had discovered on the mezzanine of his studio.[8] The collector had been attracted by Matisse's ability to give his own interpretation of Cézanne's artistic principles, just as, a little later, he would be won over by the way in which Matisse adapted those of Gauguin in the Luxembourg Gardens. When they first met, he had seen Matisse more as the talented heir to the great Post-Impressionists. But he very soon realised that, far from being a successor, he was a profoundly original painter, destined to become the founder and leader of a new movement.

The Muscovite collector, like the American Stein family, then living in Paris, and the German Karl-Ernst Osthaus in Hagen, aimed at a large audience – French as well as Russian – far outreaching the circle of connoisseurs. He believed in Matisse surprisingly quickly, and thanks to him, Russia became the first country to 'import' his works. In 1908, he bought a key work, *Game of Bowls* (cat. 41), which Matisse had only just finished, as well as a series of still lifes from different periods.

Matisse, for his part, quickly saw Shchukin as a man of outstanding artistic flair. Ilya Ehrenburg recorded these highly significant words by the painter about him: 'Shchukin began buying my painting in 1906. At that time, few people in France had heard of me . . . It is said that some painters have an infallible eye. Shchukin had just such an eye, even though he was a collector not a painter. He always chose the best. Sometimes, if I didn't want to part with a canvas, I would say, "I didn't bring that one off, I'll show you another one." He would look and then finally say, "I'll take the one you didn't bring off."'[9] Shchukin gave Matisse precious support during the years when he most needed it. It is no exaggeration to say that their association was the catalyst for a great many major works. To 'wager' on Matisse, one had to have Shchukin's flair. Far-sighted in every domain, he distinguished himself by his

firm-handedness and decisiveness. Through his commissions, Shchukin effectively became Matisse's patron.

It took a great deal of courage in 1908 to show the *Game of Bowls* in one's home, and even more to commission Matisse, who had discussed his projects with him, to paint the 'decorative canvas for the dining room' that was to become *Harmony in Blue*. The 'harmony' was essential for Shchukin: the blue had to go with the golden yellow tones of the Gauguins that reigned over the room. So after Matisse painted over *Harmony in Blue*, he hung *The Conversation*, also blue (fig. 59), in its place. He expressed not the slightest disappointment – blue would have better matched the decoration of the large dining room – when he received *The Red Room* instead: on a sudden impulse, the painter had entirely repainted the canvas. Shchukin immediately understood that the new 'harmony' represented a spectacular leap forward, a genuine shock for contemporary art. He immediately replied to Matisse, '*The Red Room* pleases me immensely.' The picture defied all previously established artistic conventions, despite having obviously been created not to 'dazzle' but to find a totally new kind of harmony corresponding to the spirit of the new century that had just begun.

The appearance of *The Red Room*, *Game of Bowls*, and *Nymph and Satyr* (cat. 40) in Moscow transformed Shchukin's gallery into the repository of the most daring initiatives of the European avantgarde. But Shchukin didn't intend to stop there. For his mansion's main staircase he immediately commissioned *Dance* and *Music* (figs. 63, 64), which were to be the culmination of their collaboration. He should be given as much credit as Matisse for creating this ensemble, which was to have extraordinary repercussions throughout European painting. When, later, someone asked the painter's son Pierre, who had become one of the most important art dealers of the time, whether his father would have painted such monumental canvases if it hadn't have been for Shchukin, he merely said, 'Why? For whom?'[10]

Shchukin incontestably gave Matisse the ideas for several of his major canvases – notably the still lifes *Seville*, *Spain*, and

Family Portrait. Matisse's artistic development, from the first still lifes to the Moroccan cycle, including the decorative and symbolic works (*Game of Bowls*, *Nymph and Satyr*, *Dance*, and *Music*), could not but influence Shchukin. His tastes as a collector developed gradually, in reaction to diverse phenomena in avant-garde art, and he was very influenced by his contacts with Matisse, who, in all his manifold facets, had undoubtedly become more completely 'Shchukinian' than any other painter in his collection.

Shchukin knew intuitively that it was to Matisse and Picasso that one had to look, not for the umpteenth new fad with pretensions of originality, but for an authentically new vision. He was full of admiration for the creative imagination of these two geniuses. After receiving *Arab Café*, Shchukin wrote to Matisse that he looked at the painting every day for at least an hour and that he preferred it to all the others.[11] But that did not necessarily mean he rated *Arab Café* above the others. In his letters to the painter, he often said how dear his pictures were to him and how he admired them every day.

He did make other kinds of remarks though. In a letter to Matisse telling him that *Dance* and *Music* had arrived, he wrote, 'Your canvases have arrived and been put in place. The effect isn't bad. Unfortunately, in the evening, under electric light, the blue changes a lot. It becomes almost gloomy, black almost. But on the whole I find the canvases interesting and I hope I will like them one day. I have great confidence in you. The public is against you, but the future is yours.'[12] A remarkable avowal, beneath which one senses an inner struggle between mind and heart. 'I find the canvases interesting': one perceives doubt here, a tinge of ambiguity in his reaction. But from experience Shchukin knew that one's aesthetic sense, when it is alive, never remains immutable. He left the matter in Matisse's hands, sensing that through his painting passed one of the major paths of contemporary art.

The artist and art historian Alexandre Benois paid tribute to Shchukin, although he in no way shared his convictions, or those of Matisse, giving the following account of the then still recent story of the acquisition of *Dance* and *Music*: 'What didn't this man have to put up with for his hair-brained ideas. For years he was considered a madman, a maniac who poured money down the drain and was taken for a ride by Parisian swindlers He surrounded himself with things whose slow and constant action revealed to him the true contemporary artistic state of affairs, which taught him to take delight in what was authentically thrilling in our time. His final exploit was the acquisition of two decorative canvases by Matisse which had caused an outrage in Paris the previous autumn . . .

This feat was a source of great suffering to Shchukin. He had already decided against the purchase but, on his return to Moscow, found, to his own surprise, that he 'missed' the works, and immediately had them transported to Russia. He no longer regretted his audacity but friends and connoisseurs, even most of those who habitually supported him, threw in the towel, more perplexed than ever.'[13] When he bought his first paintings by Picasso (cat. 52-54), he followed his intuition in exactly the same way, and likewise had to suffer the consequences. Tugendkhold wrote a few years later: 'For now we will follow the example of Shchukin who, even when he doesn't understand Picasso, says, "It's certainly he who is right and not me."'[14]

For the Muscovite collector, the prophetic meaning in the art of this Spaniard settled in Paris came as a revelation. It was apparently Matisse who introduced them, when he took Shchukin to the Bateau Lavoir in September 1908. Increasingly conscious of the significance of Picasso's art, whose latest developments he followed attentively, the Russian patron began buying his early work – something he would not have done for an artist of lesser standing. He did the same for Derain, the third of the trio of young contemporaries, with Matisse and Picasso, whom he saw as the most important painters of the time.

In the autumn of 1909 Shchukin acquired *Woman with Fan* (1909, Pushkin Museum of Fine Arts). 'Shchukin bought one of

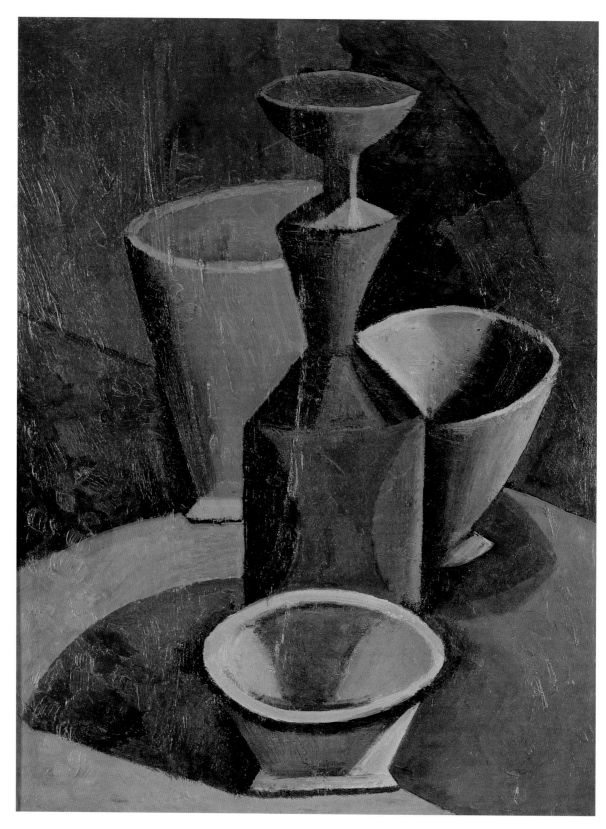

CAT. 52 PABLO PICASSO, *Carafe and Three Bowls*, 1908

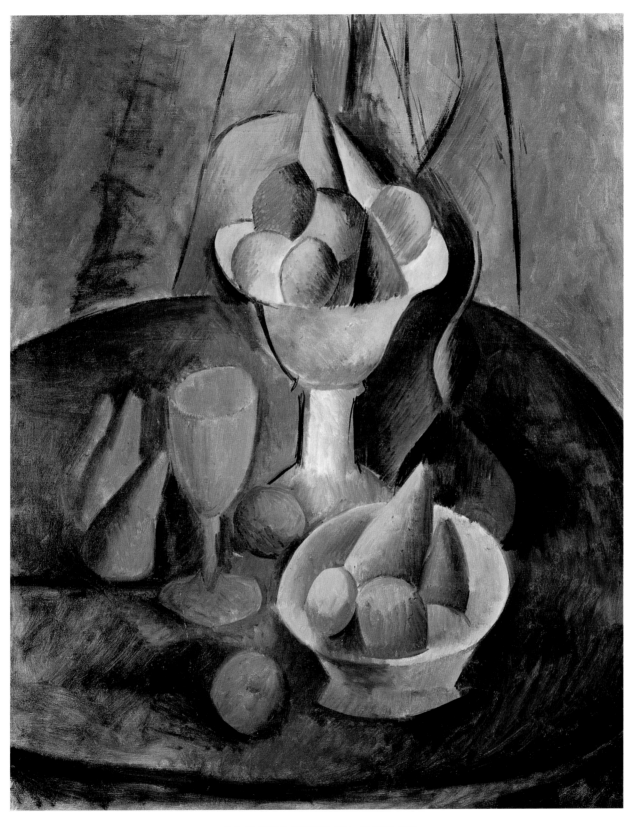

Cat. 53 PABLO PICASSO, *Vase with Fruit*, 1909

my paintings chez Sagot, the portrait with a fan,'[15] Picasso wrote in a letter to Gertrude Stein in mid-September 1909. Having just moved into a new flat in Boulevard de Clichy, he immediately announced an event that was unquestionably important for him, not only because Shchukin had a reputation as an exceptional connoisseur of avant-garde art, but also because he 'put his money on' Matisse, whom Picasso saw as his principal rival.

Shchukin saw Picasso as the antithesis of Matisse, both temperamentally and formally. Matisse exuded joy and tranquillity. In Picasso's pictures, the collector saw hellish visions, an eternal sadness, and an inexorable tragedy, but also catharsis, purification through suffering. After the personal tragedies he had endured, Shchukin sought in Picasso reminders of death. With his transition to Cubism, the painter renounced the figurative principles and psychology of the Blue Period. Reducing the world's diversity to primal geometric forms in paintings such as *Bathing* (cat. 37), *Dryad* (cat. 43), *Small House in a Garden* (cat. 54), and *Carafe and Three Bowls* (cat. 52), he revealed the impersonality of the period and its hostility to nature. He did not reject the tragic, but rather transposed it onto a different plane.

Shchukin had only one real rival among Russian collectors: Ivan Morozov. It was in fact a very particular kind of rivalry, one tinged with a certain camaraderie. Matisse, who knew this, wrote to Shchukin to tell him about the pictures he was painting for Morozov. The two collectors had radically different personalities and totally opposite temperaments, but when they were in Paris they would go to exhibitions together. And even if Shchukin, who was older and whose collection was far more advanced than Morozov's, sometimes had a tendency to look down on him, this did not create the slightest friction between them. Both were conscious that they were working together to initiate the Russian public and Russian artists in the breakthroughs of the French avant-garde.

Matisse himself said of their unique tandem effort: 'Out of the collectors who took an interest in my work from the outset, I must mention two Russians, Shchukin and Morozov. Shchukin, who imported oriental fabrics to Moscow, was around fifty, a vegetarian, and extremely reserved. He spent four months of the year in Europe, travelling just about everywhere. He loved profound, serene pleasures . . . Morozov, a Russian colossus twenty years younger than Shchukin, had a factory with three thousand employees and was married to a dancer.'[16]

Ivan Morozov's genealogy was unusual in some respects. In 1797, one of his ancestors, a serf by the name of Savva Morozov, was granted permission by his master to open a small silk ribbon factory. His initial capital was five roubles, his wife's dowry. By 1820 he had amassed enough money to buy his and his family's freedom and, seventeen years later, he bought a property near Orekhovo-Zuyevo from his former masters. Savva Vassilyevich and his descendants laboured so successfully that by the end of the century the family and its numerous branches had become one of Russia's most powerful dynasties of merchants and industrialists. The path that led Ivan Morozov to become a collector was traced by his elder brother Mikhail, who became fascinated with the new French painting very early on, just after or at the same time as Sergei and Piotr Shchukin.[17] Mikhail Morozov (1870-1903) was an eccentric even by Moscow standards: erudite historian, journalist, novelist, collector, bon vivant, gambler, gentleman, energetic *mujik*, partygoer who threw money to the wind, merchant who quibbled over the slightest kopek because his principle was to buy everything at a reduced price – he was all these things. The sociable and hospitable Mikhail became friends with Muscovite artists, most of them of his generation, such as Sergei Vinogradov, who was only a few years older than him, Valentin Serov, and Constantin Korovin. His magnificent mansion on Smolensk Boulevard soon became a showcase for remarkable works by Vrubel and Serov, which were later joined

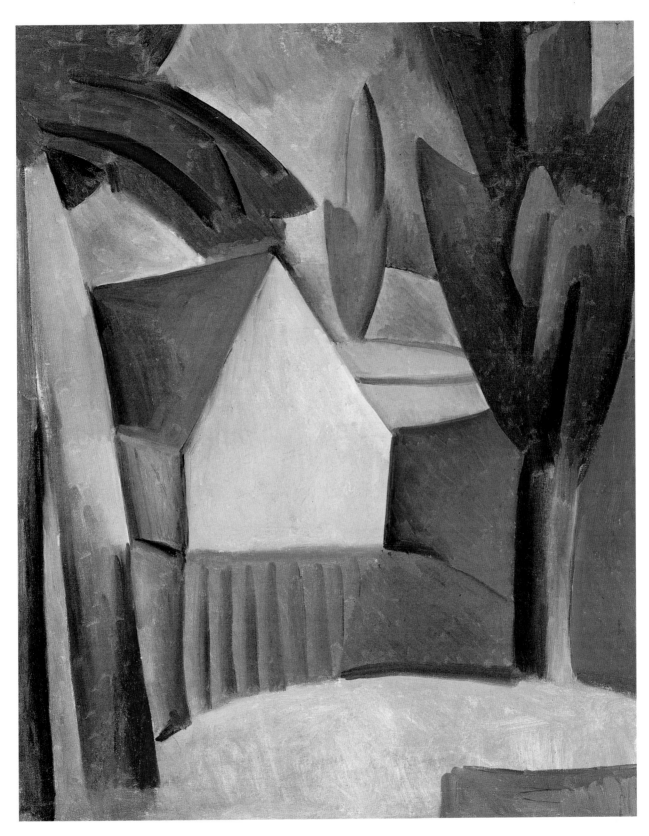

CAT. 54 PABLO PICASSO, *Small House in a Garden*, 1908

FIG. 65 Ivan Morozov, c. 1908

FIG. 66 Mikhail, his brother, c. 1903

FIG. 67 Morozov's house (Academy of Arts)

by masterpieces by Monet, Renoir, Degas, van Gogh, and Toulouse-Lautrec in his gallery.

Despite the eclecticism of his interests as a collector, Mikhail Morozov showed great perceptiveness. He was one of the first outside France to appreciate the Intimiste painting of the Nabis, which on the surface of it was unsuited to his temperament. He discovered Gauguin, apparently before Shchukin. The proportion of Western paintings in his collection was not that large, but the exceptional quality of the works has ensured his prominent place in the history of Russian collecting, the equal of Shchukin.

His brother, Ivan Abramovich (1871-1921), began collecting immediately after Mikhail's sudden death. He bought a huge old house on Prechistenka Street and began restoring its austere interior, which he considered the ideal decor for his future gallery.

During the first years, he bought only Russian paintings – Vrubel, Levitan, Korovin, Serov, Golovin, Benoit, Somov – all of whom Mikhail was already collecting. With time, the list grew to include artists such as Kuznetsov, Mashkov, Larionov, Goncharova, Kuprin, Konchalovsky, and Chagall, but not Kandinsky or Malevich – having gone this far 'left' he stopped. When he ceased buying, the Russian collection comprised three hundred pictures and seven sculptures (most of which are now in the Tretyakov Gallery).[18]

Like his brother, Ivan Abramovich decided to complement his Russian pictures with foreign paintings. In 1903, with the acquisition of a landscape by Sisley, *Frost in Louveciennes* (1873, Pushkin Museum of Fine Arts), he laid the foundation stone for his principal collection: French painting. Initially rather unsure of himself, he sought help from his brother's adviser, Sergei Vinogradov, on whose recommendation he bought Pissarro's *Ploughed Land* (1874, Pushkin Museum of Fine Arts) from Vollard and two pictures by Sisley from Durand-Ruel, one of which he quickly returned. Like Shchukin, he made it a condition that he could return a work if it didn't fit into his collection.

In 1904, Morozov managed to get his hands on a masterpiece, Renoir's *Portrait of the Actress Jeanne Samary* (1877, Pushkin Museum of Fine Art). Ivan Abramovich often said that he was continuing the work of his brother – who had given pride of place in his collection to the full-length portrait of an actress. Was Ivan still heeding the voice of his brother Mikhail? It is certainly true that the circle of Russian and French artists in whom he took an interest had in a way been established for Ivan by his brother. Yet, from the outset, with each new purchase, Ivan Morozov demonstrated that he was no blind imitator.

The first two paintings by Bonnard, together with Maurice Denis's *Sacred Spring at Guidel* (cat. 10), appeared in the Prechistenka Street mansion in 1906. For Morozov, the year was marked by his active participation in the Salon d'Automne, for which Diaghilev organised the 'Two Centuries of Russian Art' exhibition. Morozov lent him a great many pictures and at the exhibition's closure, he was elected an honorary member of the Salon d'Automne and awarded the Légion d'honneur.

The year 1907 was a decisive one for Morozov. The refurbishment of the interior of his house was now complete. The Russian paintings that had hitherto reigned there now had to make room for more. Ivan Abramovich wanted to create a gallery in which French painting would be represented with the same dignity as in the home of Shchukin, and these ambitious intentions can be discerned in the 1907 purchases. Morozov didn't concentrate his attention on the work of a single painter, nor on a particular group. His field of interest encompassed the whole of French painting over the previous three decades. From that moment on, he collected on such a scale that he often outdid Shchukin. Vollard nicknamed him 'the Russian who doesn't barter.' But this unwillingness to haggle did not mean that he acted hastily. On the contrary, he gave great thought to his collecting. 'Hardly had he got off the train', wrote Félix Fénéon, the prominent critic and artistic director of Galerie Bernheim-Jeune, 'than there he was in one of those art

shop armchairs, low and deep enough for the art lover not to get up while canvases were paraded in front of him like scenes from a film. In the evening, Monsieur Morozov, a singularly attentive observer, was too tired even to go to the theatre. After days spent like this, he left for Moscow having seen only paintings, taking several choice purchases with him.'[19]

Morozov's most impressive coups were his Monets. From Durand-Ruel he bought *Boulevard des Capucines* (1873, Pushkin Museum of Fine Arts), *The Pond at Montgeron*, and *A Corner of the Garden at Montgeron* (both 1876, the Hermitage). Around that time, Morozov found an identically sized canvas by Monet rolled up in Vollard's storeroom. He bought it (Vollard charged four times less for this one than Morozov had paid for the others), realising that the pictures were linked (they in fact belonged to the same decorative set). Thus was laid the first foundation stone for this remarkable part of Morozov's collection, the magnificent decorative series by the French master.

The year 1907 brought Morozov canvases by Gauguin and Cézanne. Preferring initially neither one nor the other, he sought their best works, and found them. At that time, Shchukin was well ahead of him and it seemed impossible to outdo him, particularly as far as Gauguin was concerned. Yet a year later, Morozov owned eight major works by him (in all, he acquired eleven). His response to Shchukin's 'iconostasis' was to assemble a group that was less homogeneous but of equally extraordinary quality.[20] Morozov's Gauguins are not only beautiful, but also have a highly particular musicality. Focusing, as Shchukin had, on Gauguin's Tahitian painting, he endeavoured to present its different facets, from the landscapes and genre paintings to the symbolic compositions an still lifes.

Immediately after the Gauguin period came the van Gogh phase. Already at the time their names were often mentioned together, and not solely because they had worked together in Arles in the autumn of 1888. And nowhere was their extraordinary liaison reflected more than in Morozov's collection where,

side by side, hung two pictures of the same subject, Gauguin's *Night Café at Arles* (1888, Pushkin Museum of Fine Arts) and van Gogh's *The Night Café* (1888, Yale University Art Gallery).

It is well known that Cézanne's posthumous exhibition at the 1907 Salon d'Automne exerted a big influence on the future of French art and subsequently on the whole of European art. Ivan Morozov was one of the most attentive visitors to the salon, where he bought his first four Cézannes, including two masterpieces, *Mont Sainte-Victoire* and *Still Life with Drapery* (cat. 12, 55).[21] Although there were quite a few magnificent canvases by the master on the market at the time, Morozov followed his own very particular line of thought, which sometimes led him to search for years for the indispensable work. His favourite picture, *Blue Landscape* (Hermitage), acquired in 1912, is a superb example of this relentless, obstinate quest. 'I remember', wrote Sergei Makovsky, author of the first essay on the Morozov Gallery, 'that during one of my first visits to the gallery I was surprised to see an empty space at the end of a wall entirely devoted to the work of Cézanne. "This space is reserved for a blue Cézanne" (that is, for a work from Cézanne's final period), Morozov explained to me. "I've been keeping an eye on him for a long time, but can't make up my mind." The space reserved for a Cézanne remained vacant for over a year, until only recently, when a magnificent new "blue" landscape, selected from scores of others, took its place next to the preceding chosen ones.'[22]

When it came to the greatest painters, Morozov could take a long time to make up his mind. His eye had become extraordinarily acute yet he remained unsure of himself. He still needed the advice of a painter friend or an art dealer in whom he had confidence and who could give him the extra push he needed. This doesn't mean that he always followed the advice he was given; the advice was indispensable for entering into a dialogue with a painting. 'When Morozov visited Ambroise Vollard,' wrote Matisse, 'he said, "I want to see a really beau-

tiful Cézanne." Shchukin would ask to see all the Cézannes he had on sale and make his own choice.'[23]

Matisse seems to have preferred Shchukin's way of choosing Cézannes to that of Morozov. But in reality one was as good as the other since they corresponded to each collector's personality. In fact, for Cézanne, who demanded particular circumspection, Morozov's method yielded the best results. One could place one's trust in Vollard: wily as he was, he would never have risked proposing the Muscovite collector a Cézanne that wasn't extraordinary. At the beginning of the twentieth century, the Morozov Cézannes – eighteen of the artist's masterpieces – were incontestably the best in the world (fig. 68), even though Auguste Pellerin's collection in Paris contained a larger number of paintings. Ivan Abramovich had every reason to be proud of his Cézannes, and when asked who his favourite painter was, he replied Cézanne.[24]

His Cézannes reflected his nature. In the paintings of Mont Sainte-Victoire, the volumes of the mountain are accentuated. It has the massiveness of the slow and imposing Morozov (Matisse called him 'the bear'). *Large Pine Near Aix-en-Provence* (cat. 13) perfectly illustrates just how constructed Morozov's Cézannes are. Its composition, which from a distance resembles a mosaic, attempts to resolve much more complex problems, bearing witness to the painter's modesty in the face of nature's infinite diversity. *Still Life with Drapery*, one of a group of five very similar compositions, shows just how keen Morozov's eye was: he took the best (at that time, he was still able to choose). The fruit in this still life is a perfect example of the construction of form through colour.

Shchukin wanted to be in the front rank of collectors of French painting, from the Impressionists to Cézanne, van Gogh, and Gauguin, and then from Matisse to Picasso. The Nabis, who were on the fringes of the mainstream, were of little interest to him. Morozov saw things otherwise. He considered that byways could also yield treasures, and so discovered the exceptional qualities of the pictures of Denis,

Bonnard, and Roussel, establishing particularly close relations with the first two.

After his house on Prechistenka Street had been completely refurbished, Morozov became fascinated by the possibilities for novel, contemporary decorative options its interior offered. A painter he considered audacious enough to undertake this was Maurice Denis. In 1907, he commissioned him to paint *The Story of Psyche* (cat. 62-73) for the music room. This ensemble was so well received in Moscow that he decided to decorate the mansion's main staircase. For this, though, he turned to Pierre Bonnard, a painter who apparently lacked the particular qualities required for monumental works. His large triptych *Mediterranean* (cat. 74), however, is a remarkable achievement of monumental decorative painting (see following chapter). When the delighted Morozov commissioned two additional canvases, Bonnard chose themes familiar to him: early spring and the heart of autumn (figs. 93, 94), thereby creating two 'brackets' for the main work – the triptych, bathed in summer light – with the entire ensemble covering the cycle of the seasons.

Fortunately, when Morozov turned not to the 'Old Masters' of the new painting but to young artists, he acted in a more determined fashion. In 1907, no sooner had Matisse put the finishing touches to *The Bouquet* than it appeared in his collection. It was followed by other still lifes by the artist, forming a superb ensemble. Next to arrive were Vlaminck's *Boats* (1907, Pushkin Museum of Fine Arts) and *View of the Seine*, and Derain's *Drying the Sails* (1905, Pushkin Museum of Fine Arts) and *The Mountain Road* (cat. 22). Works such as these were often bought cheaply during exhibitions. *The Mountain Road*, for example, was bought for 250 francs at the 1907 Salon des Indépendants. And Vlaminck's *View of the Seine*, one of the finest Fauve landscapes, Vollard threw in free of charge along with paintings already bought. Vollard, as we know, was anything but selfless, but with Morozov and Shchukin he had forged special ties. For Vollard or Kahnweiler, co-operating with collectors such as these was a *sine qua non* for the success of their own campaign

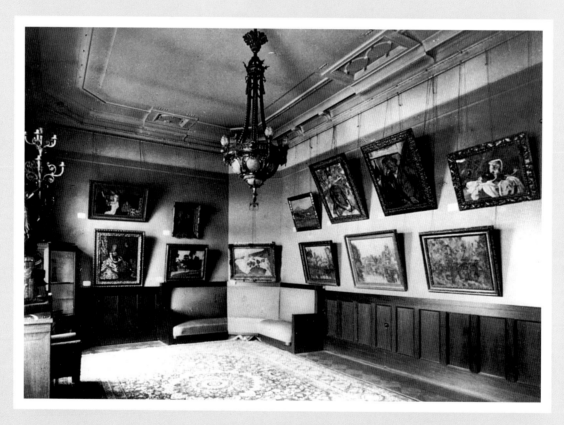

FIG. 68 The Cézanne room at Morozov's house, c. 1923

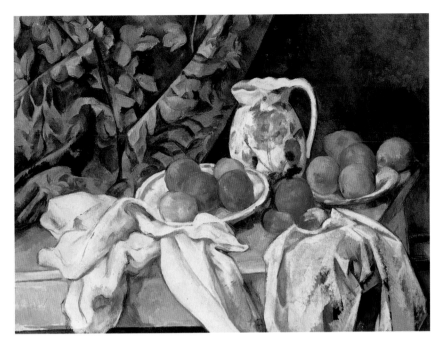

CAT. 55 PAUL CÉZANNE, *Still Life with Drapery*, c. 1894-1895

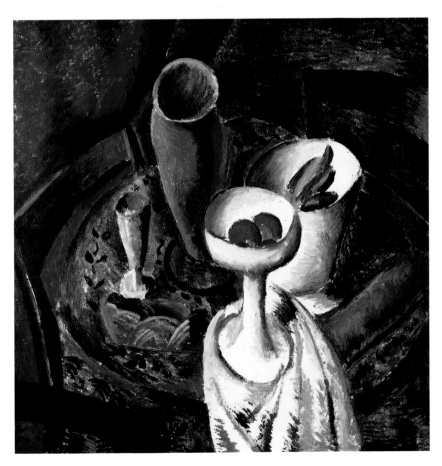

CAT. 56 ANDRÉ DERAIN, *Table and Chairs*, 1912

for the survival of the new art. Since the two Moscow collections were turning into full-blown museums, whose reputations were quickly growing, it was in the interests of top art dealers that they should contain exceptional works.

Morozov was unable to attend the 1905 Salon d'Automne, where *Drying the Sails*, one of the paintings that caused the biggest scandal, marked the birth of Fauvism. But a year and a half or two years later he made up for what he had missed, turning for the most part, as ever, to Vollard. The works by Matisse, Derain, and Vlaminck were joined by canvases by Puy, Marquet, and Valtat, perfect examples of the new trends in French painting striving for the total liberation of colour and brushwork.

Morozov's passion for Louis Valtat's painting (cat. 57), which Shchukin disregarded, is significant. Shchukin always considered Valtat, who lies more or less midway between the Nabis and the Fauves, to be a compromised painter. Morozov, however, bought nine of his works. He also owned five Derains and three Vlamincks, but he couldn't ignore the fact that the most outstanding artist – one who put even painters as brilliant as Derain, Vlaminck, and Marquet in the shade – was of course Matisse, eleven of whose works were in his collection.

Morozov could not rival Shchukin in this respect. Shchukin's selection of Matisses was eventually of such exceptional quality that no other collector could have vied with him. Morozov's Matisses reflected his character and his tastes – they were more peaceful, more obvious, with nothing of the 'all or nothing' that had been Matisse's motto for his problematic canvases.

Clearly, Shchukin was aware of his superiority in this domain. Had it not been he who had taken his young colleague to Matisse's studio, then to Picasso's? He didn't always understand his countryman's hesitations, but he could not but accord him his esteem. Occasionally they would go to exhibitions in Paris together. Their rivalry became manifest in certain specific situations: without the *Story of Psyche* ensemble there may not have been Matisse's *Dance* and *Music* (figs. 63, 64). The success of Denis's painting in Moscow aroused in Shchukin the desire to

show his fellow countrymen what absolutely uncompromising decorative painting could really look like. Nevertheless, this competition between the two played a secondary role: both fully understood that they were serving the same cause. As his early interest in the Fauves demonstrates, Ivan Morozov was undeniably also an audacious collector. It is only when compared to Shchukin that he appears less determined. If he hadn't had a taste for risk, he would never have been able to collect this new type of painting. Nevertheless, Morozov's boldness went hand in hand with a greater prudence, which in fact gave him a certain advantage. When Shchukin took a new step he was already thinking about the next. There came a moment, infatuated as he was both with the present and the future, when he stopped buying Monets and then Gauguins. Morozov made sure he didn't fall behind either: if an opportunity arose to fill a gap in his collection, which was primarily devoted to the 'classics' of the new art, he never let it pass. Whereas for Shchukin, with time, the 'classics' had become people on which the page had been turned once and for all.

Although they shared the same passion, they were two very different personalities. Marguerite Duthuit, Matisse's daughter, remembered Morozov as 'a good fellow, rather coarse (unrefined), sociable, nice.' According to her, Matisse considered Shchukin to be perceptive, refined, and very serious.[25] 'With none of Shchukin's hotheadedness, constantly demonstrating the circumspection and rigour of his choices, fearing extremes, forever undecided, Morozov preferred quietly going through Vollard's storeroom to indulging in Shchukin's adventurousness, which drew him towards unknown shores. Morozov brought clear planning and objective construction to his collecting. Calmly, he threaded together strings of masterpieces, like pearls on a necklace.'[26] 'More expansive, Shchukin liked to "discover" a painter, to "launch" his career. What motivated him was the risk factor. He delighted in stupefying his numerous guests. Prudent and reserved, Morozov, instead of seeking out the latest experiments by innovators, endeav-

oured to build a clear and exhaustive picture of the period we had just lived through.'[27]

Morozov was always drawn to painting with obviously decorative qualities. But not just any type of decorativeness, of course. *Dance* and *Music* remained anathema to him, despite his high esteem for Matisse's art and his readiness to commission him to paint decorative canvases. At the beginning of 1913, Shchukin wrote to Matisse, apparently not without a certain irritation, 'Mr Morozov is still very influenced by other artists who do not understand your latest work. He wanted you to decorate a room for him and now under these people's influence he has bought a large canvas by Bonnard for the room in question.'[28] In this respect, Shchukin was of course wrong in ascribing Morozov's decision to outside influences. Matisse's slowness, which had caused the collector to wait so long for preceding commissions, was also a deciding factor.

In 1913, the gallery was completely installed. That same year Morozov filled several gaps in his collection with the acquisition of two decorative compositions by Roussel and canvases by Renoir, Marquet, and Derain. He was also on the lookout for works by Daumier, Seurat, and Toulouse-Lautrec, but was unable to make the habitual autumn trip to Paris the following year: World War I had just broken out, followed by the Revolution and then civil war.

The spectre of pillage now loomed over the collectors' mansions. In the context of the time, this could have taken place not only in the banal form of out-and-out theft, but also at the behest of a representative of some self-proclaimed power claiming to be taking a 'revolutionary' initiative. Ivan Morozov recounted how an envoy from a provincial district turned up at his house one day to 'requisition' an entire series of pictures, for the simple reason that there were no Cézannes or Derains in that locality. It was only with the help of Grabar, director of the Tretyakov Gallery, who had become, so it is said, comrade Trotsky's wife's right-hand man, that he succeeded in getting rid of the undesirable partisan.[29]

The Soviet authorities soon nationalised both the Morozov and Shchukin collections, renaming them the First and Second Museums of New Western Painting. The Shchukin Gallery began functioning as a museum in November 1918. Six months later the Morozov collection opened to the public. The Board for Museum Affairs and the Protection of Monuments informed Ivan Abramovich that he had been appointed assistant curator of his own museum. The post of political commissar had also been created.

Prior to the Revolution, the Morozov collection had occupied two storeys of his mansion. After October 1917, the first floor passed from hand to hand.[30] Amidst the confusion that reigned at the time, during which the most far-fetched institutions were created and merged, there was always one trying to get hold of the upper floor as well. Ivan Abramovich grew tired of this infighting and the volatile atmosphere and during the summer of 1919 managed to obtain authorisation to go abroad to undergo medical treatment, which he genuinely needed. He more or less settled in Germany, then went to Paris, and later to Karlsbad, where he died soon after.

Sergei Shchukin had taken refuge in the West before Morozov. When the Soviets came to power, the gallery, which he himself intended to transform into a museum open to the public, no longer belonged to him. In accordance with an order that all inhabitants had to 'make room' for others, the collector had to give up the rooms he lived in with his family. The painter Yury Annenkov, who at the time was painting portraits of head revolutionaries one after the other, recalls visiting the Shchukin residence with Trotsky, who happened to be a great admirer of Picasso. 'One day, we popped over to the Shchukin Museum, which was just a stone's throw from the Revolutionary Military Council.[31] The museum had been nationalised and Shchukin himself, who had discovered Picasso, who had discovered Matisse, Shchukin who had created a priceless museum of new European painting in Moscow, the extraordinarily generous

Shchukin, in his own house, had been allotted the servants' room next to the kitchen.'[32] For Shchukin, a member of the upper classes, worse than the daily discomfort was the ever-present threat of arrest that could swoop at any moment. Fearing this, in the summer of 1918, he fled to France where, deprived of his fortune, he was no longer in a position to continue his activity as a collector.

In Russia, after the first phase of museum construction, there followed a period of reconstruction. In 1923, the Shchukin and Morozov collections were amalgamated. Canvases from the nationalised collections – M. and N. Riabushinsky, S. Shcherbatov, M. Tsetlin – and the Western paintings collected by Mikhail Morozov were transferred to the new unified Museum of New Western Art.

In the early 1930s, a number of the works were transferred to the Hermitage following exchanges between Moscow and Leningrad. The period of the first transfers was a tragic one for both cities' museums, which saw some of their finest works secretly sold to the West (a secret only for the Soviet people, obviously). Problems arose from these sales involving immigrants whose collections had been nationalised. 'Also, apparently, Sergei Ivanovich Shchukin was preparing to recover his collection by legal action. I remember when I asked Shchukin about this he got terribly worked up. He had always had a stutter, but this time, he started stuttering even more and said to me, "You know, P. A., I created this collection not only, not principally for myself but for my country and my countrymen. Whatever the events there my collections must remain there."'[33]

The pillagers' main target was the Hermitage, which was shamelessly dispossessed of masterpieces by van Eyck, Raphael, Titian, Perugino, Rubens, van Dyck, Rembrandt, Hals, Poussin, and Watteau. An attempt to remove several works by Cézanne and his contemporaries that had only just arrived from Moscow was foiled, but despite this four masterpieces from the Museum of New European art were still sold.[34]

In the 1930s, darker and darker clouds began gathering over the Museum of New European Art. The Soviet authorities' post-Revolutionary flirt with the avant-garde was long over. There were now enough volunteers to argue that such a museum was detrimental to the workers. If it had not been for the war in 1941, the museum would certainly have been closed earlier. The war necessitated the evacuation of all the pictures to Siberia. The large-format canvases, particularly those by Denis and Bonnard, were hastily rolled up, and remained so for several years.

In 1948, a secret government directive signed by Stalin decreed the museum's liquidation: 'The Council of Ministers of the Soviet Union considers that the State Museum of New European Art, situated in the city of Moscow, contains in its collections works of Western European bourgeois art that are fundamentally apolitical, directed against the people, formalist, and devoid of any progressive educational value for the Soviet people ... Showing the museum's collections to the masses is politically pernicious and favours the spread of foreign bourgeois and formalist views in Soviet art.'[35]

The Museum of New European Art's collection was rapidly shared out between the Hermitage and the Pushkin Museum of Fine Arts. The pictures were divided up in a hasty and ignorant fashion, resulting in the separation of works from the same group. Bonnard's *Mediterranean* triptych left for the Hermitage while the two side panels remained in Moscow, and Denis's *Story of Psyche* was sent to Leningrad without the statues by Maillol.

It is not difficult to reconstruct what happened: the Pushkin Museum, on whose territory the dismantling took place, considering itself master of the situation, made sure the finest paintings remained in Moscow. It kept not only the pictures by Courbet and Manet, but also works in a realist vein by Bastien-Lepage and Dagnan-Bouveret. Most of the Impressionist and Post-Impressionist canvases went to the Pushkin Museum. It was another story for the Matisses, Derains, and Picassos, though, on which the Moscow museum had no particular designs. Shchukin's collection of Picasso's Cubist canvases were

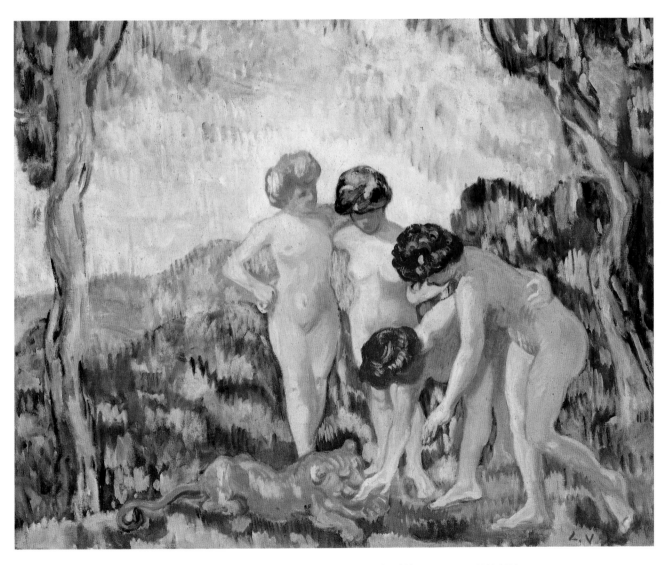

CAT. 57 LOUIS VALTAT, *Little Girls Playing with a Lion Cub (Children's Games)*, c. 1905-1906

happily sent to the Hermitage. However, the fear of being accused of 'ideological negligence' was not the only factor. In Moscow there was a lack not only of exhibition but also of storage space.[36] It was clearly harder to find a home for the large canvases.

Having been enriched in such an extraordinary fashion, the Hermitage kept the Shchukin and Morozov collections hidden away. It wasn't until after Stalin's death that, little by little, art again became accessible to the public – even if in the late 1950s the Matisses and Picassos were still in storage. By the beginning of the next decade, most of the works of the 'New Painting' were on show in the museum. In the Hermitage, they took on new meaning. In this museum containing art from all over the world, these canvases, hanging next to prestigious works from the past, became a vital link in the chain of world culture.

Notes

1 Yakov Tugendkhold, *Pervyj muzej novoj zapadnoj zivopisi* [The First Museum of the New Western Painting] (Moscow: n.p., 1923), p. 12.

2 Alexandre Benois, *Moi vospominaniâ* [My Memories], vol. 1 (Moscow: Nauka., 1990), p. 491.

3 Yakov Tugendkhold, 'Francuskoe sobranie S. L. Sukina' [The French Collection of S. L. Shchukin], *Apollon*, 1914, no. 1-2, p. 6.

4 Leonid Pasternak, *Zapiski raznyh let* [Notes From Different Years], (Moscow, n. p. 1975), p. 63. In fact, Leonid Pasternak was mistaken when he indicated that *The King's Wife*, which he called the Maori Venus, was the first Gauguin painting to enter the Shchukin collection.

5 'Matisse talks to Tériade', *Art News Annual*, no. 21, 1952. Quoted from *Henri Matisse. Écrits et propos sur l'art* (Paris: Hermann, 1972), p. 118.

6 Pavel Muratov, *Sukinskaâ Galereâ* [The Shchukin Gallery], *Russkaâ Mysl* [Russian Thought], no. 8 (1908), p. 116.

7 Judi Freeman, *The Fauve Landscape* (Los Angeles: Los Angeles County Museum of Art and Abbeville Press, 1990), p. 98.

8 Ibid., p. 92.

9 Ilya Ehrenburg, *Lûdi, gody, zizn'* [People, Years, Life], vol. 5 (Moscow: n.p., 1966), p. 427.

10 Beverly Kean, *French Painters, Russian Collectors. The Merchant Patrons of Modern Art in Pre-Revolutionary Russia, 1890-1914* (London: Hodder & Stoughton, 1994), p. 161.

11 Alfred H. Barr, Jr., *Matisse, His Art and His Public* (New York: Museum of Modern Art, 1951), p. 147.

12 Letter by Shchukin to Matisse, dated 20 December 1910. See Albert Kostenevich, 'La Correspondance de Matisse avec les collectionneurs russes', in A. Kostenevich, N. Semionova, *Matisse et la Russie* (Moscow and Paris: n.p., 1993), p. 162.

13 Alexandre Benois, 'Hudozestvennye Pis'ma. Moscovskie vpecatleniâ' [Letters of an Artist. Impressions of Moscow], *Rech* (4-17 February 1911).

14 Tugendkhold, op. cit., p. 30.

15 William Rubin, *Picasso and Braque, Pioneering Cubism* (New York: Museum of Modern Art, 1989), p. 363.

16 'Matisse parle à Tériade', *Art News Annual*, no. 21, 1952. Quoted from *Henri Matisse. Écrits et propos sur l'art*, op. cit., pp. 118-19.

17 We do not know precisely when Morozov began collecting avant-garde French painting.

18 These figures were established by Boris Ternovets, who was in charge of nationalising the Morozov collection. See Boris Ternovets, 'Muzej novogo zapadnogo iskusstva' [The Museum of New Western Painting], in Boris Ternovets, *Pisma. Dnevniki Stati* [Letters, Journals, Articles] (Moscow: n.p., 1977), p. 108. Ivan Morozov himself had indicated a larger number of Russian works – four hundred and thirty (see Félix Fénéon, 'Les Grands collectionneurs. Ivan Morozoff', *Bulletin de la vie artistique*, 1920, p. 355), a figure which may have included the works on paper.

19 Félix Fénéon, ibid.

20 Later, Alfred H. Barr, Jr., founder of the Museum of Modern Art in New York, after visiting the Shchukin and Morozov galleries in Moscow, expressed his preference for the Morozov Gauguins. See Alfred H. Barr, Jr., 'Russian Diary', *Defining Modern Art. Selected Writings of Alfred H. Barr Jr.* (New York: Harry N. Abrams, Inc., 1986), p. 116.

21 The archives of the Pushkin Museum of Fine Arts has a copy of the catalogue of Cézanne's posthumous exhibition annotated by Ivan Morozov.

22 Sergei Makovsky, 'Francuzkie hudozniki iz sobraniâ I. A. Morozova' [The French Paintings in the Ivan Morozov Collection], *Apollon*, no. 3-4 (1912), pp. 5-6.

23 Henri Matisse, *Ecrits et propos sur l'art*, op. cit., p. 119.

24 Fénéon, op. cit., p. 356.

25 Beverly Kean, *All the Empty Palaces. The Merchant Patrons of Modern Art in Pre-Revolutionary Russia*, (London, 1983), p. 102.

26 Boris Ternovets, 'Sobirateli i antikvary proslogo. I. A. Morozov' [Collectors and Antique Dealers of the Past. I. A. Morozov], *Sredi kollecktsionerov* [Among the Collectors], no. 10 (1921), p. 41.

27 Abram Efros, 'Celovek s popravkoj. Pamâti I. A. Morozova' [A Man Who Mended his Ways. In Memory of I. A. Morozov], *Sredi kolleksionerov*, no. 10 (1921), pp. 3-4.

28 Letter from Shchukin to Matisse, 10 January 1913, in Kostenevich, op. cit., 1993, p. 173.

29 Fénéon, op. cit., p. 357.

30 The first floor of the Morozov house was requisitioned as a foyer for collaborators of the military district, after which followed every imaginable kind of institution, including the warehouse of the library of Iaroslavl University, the literature section of the main archives, the Chekhov Museum, and the nationalised D. I. Shchukin collection.

31 This proximity proved to be fatal for the Shchukin mansion. The Revolutionary Military Council, soon to become the People's Committee for Defence, obtained the liquidation of the First Museum of Modern Western Painting, whose pictures were moved to the Morozov mansion, and transformed the building to suit its needs.

32 Yuri Annenkov, *Dnevnik moih vstrec* [Journal of My Encounters] vol. 2 (Leningrad: n.p., 1991), p. 275.

33 Buryshkin, *Moskva kupeceskaâ* [The Moscow of the Merchants] (Moscow: n.p., 1991), p. 148.

34 Decision of the Council of Ministers of the USSR no. 672, 6 March 1948, in the National Archives of the Russian Federation (R-5446. List 1. D. 327), published in the article by M. Aksenenko 'Kak zakryvali Sezanna I Matissa' [How the Cézannes and Matisses were hidden], *Mir Muzeâ* [Museum World], no. 6-7 (November-December 1998), pp. 47-48.

35 This also happened perhaps because the canvases were rolled up on several rolls, whose contents no one had yet looked at.

36 The museum's storerooms were jam-packed. For Stalin's seventieth birthday an exhibition was organised, as absurd as it was pompous, of the gifts the dictator had received. The museum soon filled up with these objects, which remained on exhibit for several years, ousting the permanent exhibition of masterpieces by Old Masters, which were put back in storage. Furthermore, the entire Dresden Gallery, moved from Germany in 1945, was placed in the storerooms of the Pushkin Museum, and there was no longer question of its restitution.

Maurice Denis
and Pierre Bonnard

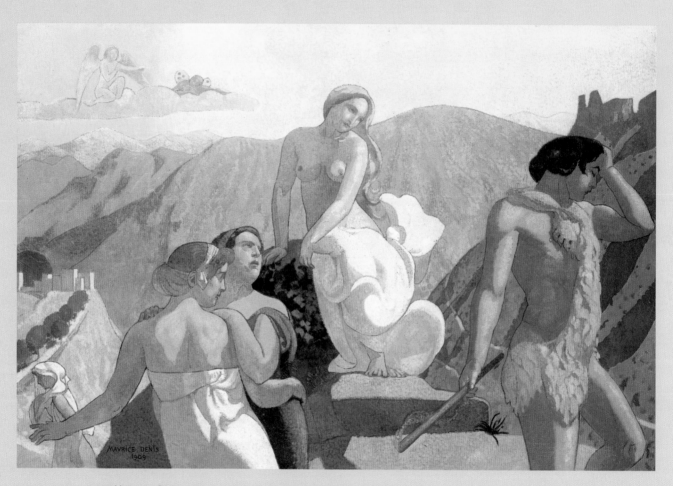

CAT. 58 MAURICE DENIS, *The Story of Psyche*. Sixth panel: *Psyche's Parents Abandon Her on the Summit of the Mountain*, 1909

MAURICE DENIS AND PIERRE BONNARD: THE MOROZOV DECORATIVE PAINTINGS IN THE HERMITAGE COLLECTION

ALBERT KOSTENEVICH

The two unique series of decorative paintings by Maurice Denis and Pierre Bonnard in the Hermitage were both commissioned by the famous Muscovite collector Ivan Morozov. His name is linked to the history of modern art not only because, like Sergei Shchukin, he amassed one of the finest collections of French Impressionist and Post-Impressionist paintings, but also because its contents, collected at the beginning of the twentieth century, had a profound influence on the young painters of the Russian avant-garde.

Ivan Abramovich Morozov had developed a passion for decorative painting long before becoming a collector. During their childhood, the Morozov brothers, Mikhail and Ivan, had studied under the outstanding decorative painter Constantin Korovin. Mikhail, the eldest, frequented the theatre world and in 1893 a group of painters, including Korovin, Mikhail Vrubel, Valentin Serov, and Apollinary Vasnetsov, met in his Moscow mansion. He regularly bought paintings by them and Ivan, who lived most of the time in Tver, where he ran the family's large textile firm, often took part in these gatherings when he was in Moscow.

When he was very young, Mikhail Morozov was already a renowned collector. His collection included works that were decorative in both function and style, such as Vrubel's large *Faust and Marguerite* and his *Judgment of Paris* triptych. At his home, discussion centred around Vrubel's decorative and monumental works (such as the decorations for S. T. Morozov's mansion, the ceramic panel for the façade of the Hotel Metropole, and his set designs for the Mamontov Private Opera in Moscow), and also the numerous projects for the theatre by Constantin Korovin and other artists. In 1895, at Mikhail Morozov's request, Korovin painted a 'set in the style of Corot.' All those who took part in the lively debates at the Morozov residence on Smolensky Boulevard must also have talked about the huge canvases that Korovin and Vrubel had painted for the Russian art and industry exhibition in Nizhni Novgorod in 1896. Mikhail Morozov's taste for decorative art was also to be seen in his appreciation of the work of Paul Gauguin, with its dominant use of flat areas of pure colour. Morozov was the first Russian to have understood the true value of Gauguin's work. Two of his pictures, *The Canoe (Te Vaa)* and *Landscape with Two Goats*

FIG. 69 The decorative cycle *The Story of Psyche*, 1908-1909

(*Tarari Maruru*), today in the Hermitage collection, belonged to Mikhail Morozov.

From 1902-3, Mikhail Morozov undoubtedly also owned pictures by Bonnard, Denis, and Vallotton. It is noteworthy that Morozov, despite his impetuous temperament, was the first in Russia to appreciate the Intimiste art of the Nabis.

Ivan Abramovich Morozov, whose intentions were very modest to begin with, later endeavoured to continue his elder brother's work. He made his first acquisitions immediately after Mikhail's death in 1903 and, following his example, decided not to limit himself to collecting Russian painters. Initially, he was impressed by the paintings of Alfred Sisley, Camille Pissarro, and Auguste Renoir. And in 1906, the first paintings by Bonnard (*Landscape in the Dauphiné* and *Morning in Paris*) and Denis (*Sacred Spring at Guidel*, cat. 10) were shown in his mansion in Prechistenka Street (these works are today in the Hermitage collection). There was a very close bond between Morozov and these two artists.

The year 1907 was a key one for Ivan Abramovich Morozov's collection, because he managed to acquire several magnificent compositions by Claude Monet, Renoir, Gauguin, and Paul Cézanne. After his house was refurbished, the canvases by the Russian painters, hitherto the majority, would occupy a more modest place. Like his brother Mikhail and like Sergei Shchukin, Morozov decided to accord French painting an important place in his collection.

The refurbishment of the mansion provided the collector with unexpected new decorative options. He felt that Maurice Denis, whom he had met in the spring of 1906, was capable of realising his project, and visited the painter that summer at St-Germain-en-Laye on the outskirts of Paris. There, he reserved the unfinished *Bacchus and Ariadne* (today in the Hermitage, cat. 4) and commissioned from its matching work, *Polyphemus*, which Denis painted in 1907 (today in the Pushkin Museum of Fine Arts, Moscow).

In 1907, Ivan Morozov commissioned Maurice Denis to paint *The Story of Psyche* for the music room of his Prechistenka Street home. Never before had such an audacious and ambitious work been commissioned for a Moscow mansion. Having received photographs and the room's measurements, the painter merely had to choose the subjects. In his letter to Moscow dated 21 June, Denis wrote: 'I've already given some thought to the subjects that I would like to choose for the decorative canvases you have commissioned me. And it seems to me that the story of Psyche would be absolutely ideal because of its idyllic quality, full of mystery. I have already composed five scenes totally different to the ones by Raphael in the Farnesina, but nevertheless faithful to Apuleius' story. Before taking my sketches any further, I would like to be sure that you will leave me absolutely free and that you are not against the subject of the story of Psyche*.'

Following Ivan Morozov's final agreement, Denis wrote in a letter from Italy on 14 September 1907: 'I am staying on Lake Maggiore with my family and want to work here on the sketches that I began in Saint-Germain; I brought them with me in order to embellish them with Italian landscapes*.' Denis's stay in Italy enabled him to complement the five initial sketches (today in the Musée d'Orsay, Paris; figs. 73-76, 78) with some eighty drawings and studies. At the beginning of the summer, the compositions in the studies were transposed to large canvases. Denis finished the series of canvases for the 1908 Salon d'Automne, then sent them to Moscow. In his *Journal*, he noted: 'My life in Paris from 30 July to 21 August: every evening I'm at the Grand Palais . . . in this great building that I've been granted the use of for a while.'[1] After the Salon d'Automne and their arrival in Moscow, in December, they were hung on the walls and framed with brocade tape.

For the canvases, Denis used the compositions and colours of the sketches made during his stay at the Villa

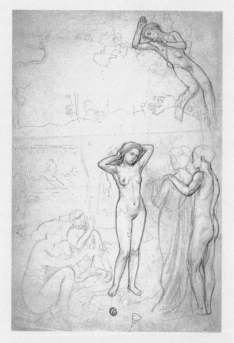

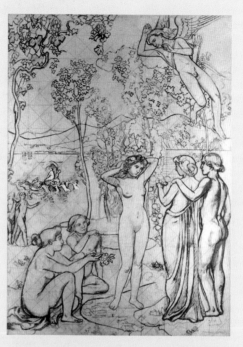

CAT. 73.1 Study for the first panel of
The Story of Psyche, 1908

FIG. 70 MAURICE DENIS, *Psyche at her Toilet,* 1908

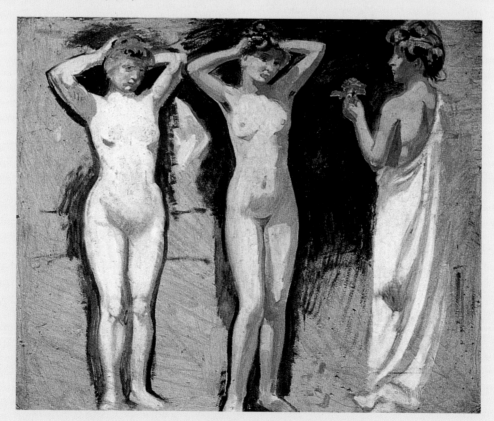

FIG. 71 MAURICE DENIS, *Study for Psyche at her Toilet. Psyche and Woman on the right
[first panel],* c. 1907

Bella Vista in Florence. In *Zephyr – on Cupid's Orders – Carries a Sleeping Psyche to the Island of Bliss* (cat. 62), we see the Isola Bella on Lake Maggiore, and *The Vengeance of Venus; Subjected by Venus to the Harshest Trials, Psyche, to Her Misfortune, Gives In to Curiosity a Second Time and, in this Extremity, Is Aided by Cupid* (cat. 66) is infused with the painter's impressions of the Giusti Gardens in Verona. The drawings for the figures of Psyche and Cupid were done in Rome. The models were a young woman from the Roman countryside, well known at the Academy of Fine Arts in Rome, and a handsome young man from Trastevere. Venus's face was inspired by Denis's wife, Marthe, and the Olympian gods Mars and Bacchus were given the features of his friends Kerr-Xavier Roussel and Aristide Maillol.

The theme of Cupid and Psyche inspired numerous French painters in the nineteenth century, notably Pierre-Paul Prud'hon, Gérard, and William Bouguereau. Bouguereau's academicism had a certain influence on Denis's work, in particular in the treatment of the first and fifth canvases. For the third canvas – perhaps the most accomplished of the series – Denis reused a formula previously used by French artists Simon Vouet and Pierre Subleyras, depicting Psyche contemplating Cupid by lamplight. In January 1909, Maurice Denis, who had gone to Moscow at Ivan Morozov's invitation, wrote in his *Journal*: 'My large decoration is a little isolated in a large, cold room, stone grey with mouse grey furniture. Something is needed to *join* things. But that aspect isn't devoid of grandeur. My colours hold their own, like at the Salon, but in a more harmonious unity.'[2] Denis reworked certain areas, toning down the colours slightly so that they matched the room's architecture better. But the completion of the decorations entailed several additional paintings: two new canvases, the sixth and the seventh, above the doors (cat. 58, 70), and the four narrow canvases, in the form of pilasters, for the west wall, depicting Cupid firing an arrow (cat. 68, 72), and on either side of the central canvas (the third), showing Psyche (cat. 63, 65). He also painted a border on either side of the door (cat. 69, 71). These additional elements were painted on his return to France.

In the music room of the Morozov residence, there were, apart from Denis's paintings, four statues by Maillol, *Pomona*, *Flora*, *Spring* and *Summer*, commissioned by the Muscovite patron of the arts, all of which are today in the Pushkin Museum of Fine Arts. The Hermitage recently succeeded in acquiring a beautiful earlier variation (without arms) of *Spring* (cat. 61). This sculpture has been included in this exhibition to illustrate the very fruitful collaboration between Maillol and Denis – it was in fact on Denis's advice that Morozov commissioned Maillol to sculpt the statues on the theme of the seasons.

The Story of Psyche illustrates several episodes of the myth of *Cupid and Psyche*, as retold in Apuleius' *Golden Ass* or *Metamorphoses*. Venus, filled with wrath by the admiration the young and beautiful Psyche aroused in all, sent her son Cupid to induce the young woman to fall in love with the most despicable man. Instead, he fell in love with her and, aided by Zephyr, hid her in his palace. Upon which, Psyche's elder sisters, jealous, suggested she break her vow to always avoid looking at the face of her mysterious lover. Psyche lit a lamp and inadvertently spilt a few drops of hot oil on Cupid's shoulder. He disappeared and Psyche, condemned to wander the earth in search of him, had to surmount many difficult tasks. When Proserpine entrusted Psyche with a casket destined for Venus, she disobeyed the order not to open it. Out of the casket wafted an otherworldly drowsiness and she fell into a deathly sleep. But all's well that ends well: Cupid sped to Psyche's rescue, snapped her out of her slumber, and, having obtained Jupiter's permission, married her. Apuleius' story is not merely a tale but also an allegory about desire (Psyche) being reunited with love (Cupid).

FIG. 72 MAURICE DENIS, *Psyche, first thoughts*, 1907

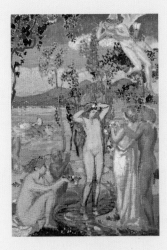

FIG. 73 MAURICE DENIS, *Love Surprising Psyche*, late 1907

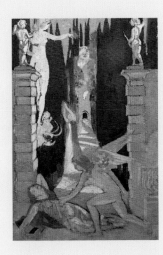

FIG. 76 MAURICE DENIS, *The Punishment of Psyche*, late 1907

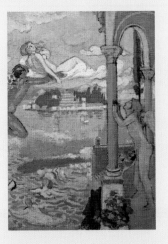

FIG. 74 MAURICE DENIS, *Psyche Being Carried Off by Zephyr*, late 1907

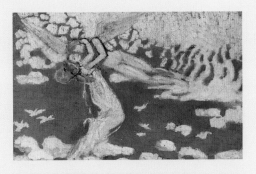

FIG. 77 MAURICE DENIS, *Psyche Being Carried Off*, 2nd version
for one of the overdoors, 1909

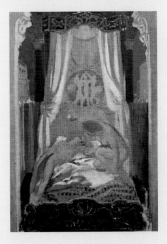

FIG. 75 MAURICE DENIS, *Psyche's Curiosity*, late 1907

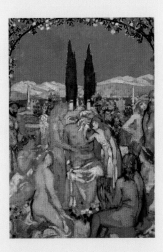

FIG. 78 MAURICE DENIS, *Psyche's Pardon and Marriage*, late 1907

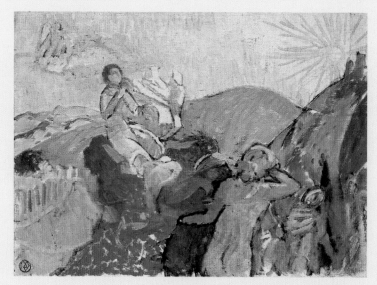

FIG. 79 MAURICE DENIS, *Psyche's Parents Abandon Her on the Summit of the Mountain*, sketch for one of the two overdoors, 1909

FIG. 80 MAURICE DENIS, Russian sketchbooks, p. 23, 1909 (left)

FIG. 81 MAURICE DENIS, 'Brittany 1909' sketchbook, unpaginated, 1909 (centre)

FIG. 82 MAURICE DENIS, Russian sketchbooks, p. 26, 1909 (right)

FIG. 83 MAURICE DENIS, Russian sketchbooks, p. 4, 1909

CAT. 59 MAURICE DENIS, *Painted Vase [Seated Female Bather]*, 1909 **CAT. 60** MAURICE DENIS, *Painted Vase [Crouched Female Bather]*, 1909

 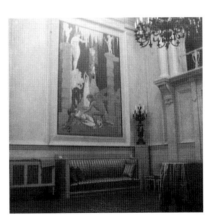

FIGS. 84, 85, 86 Photographs by Maurice Denis of the interior of Morozov's house, 1909

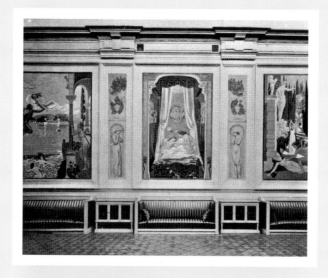

FIGS. 87, 88, 89 Morozov's music room, c. 1912

FIG. 90 Morozov's music room, c. 1912

CAT. 61 ARISTIDE MAILLOL, *Spring (without Arms)*, 1910-1911

159

Denis focused particularly on this second aspect, which had already been accentuated by Renaissance humanists. The artist preferred to see Psyche as a personification of the human soul, as was customary in ancient Greece, rather than concentrate on the story's sensual temptations. His reading consciously countered former interpretations of the theme by Raphael, Giulio Romano, and Rubens. At the same time, he showed no interest in the dramatic conflicts in Apuleius' story, in the episodes involving Psyche's sisters and her mis-adventures after the night she recognised Cupid.

In his old age, reminiscing about his major works in his *Journal*, Denis described *The Story of Psyche* series as one of 'facility and formula.' The series does reflect a certain ease, albeit a studied ease, that of modern art's formulae artfully executed. In the context of the refined architecture of the Morozov music room, with its applied arts, sculpture, and paintings, it was the latter that set the tone. *The Story of Psyche* carried the hopes of Art Nouveau, a style that had developed at the turning point between two centuries and which represented an attempt to embody the idea of the monumental and decorative ensemble. At that time, it seemed that everything – from architecture to jewellery – could be endowed with the serpentine lines of this style born out of a search for synthesis and elegance. Stemming from the same principles, the thirteen canvases and the exquisite objects, ceramic vases, and furniture made from Denis's designs complemented each other in Ivan Morozov's mansion.

The five largest canvases are the most important for our understanding of the theme and of Denis's artistic vision. The painter adopted certain simple yet effective measures to give the elements of the series unity: same format, same proportions for the figures, same importance accorded to flat surfaces, and same offsetting of one colour by another. The combinations of blue and pink planes perfectly illustrate the situations described in the story whilst conforming to the aesthetic premises of Art Nouveau. The third canvas, *Psyche Discovers That Her Secret Lover is Cupid* (cat. 64), is the most impressive. In this work, the lamplight transforms the bright pink of the naked body into a pink-ochre, which gives the composition, whose background is dark, more unity.

The heavenly landscapes that make up the backgrounds of the *Story of Psyche* canvases evoke a dreamlike, tourist's vision of Italy, embellished here and there with exotic architecture. Every element, whether taken from reality or invented, is painted following general decorative principles. Denis, not wanting to limit himself to solving decorative problems, felt compelled to emphasise the symbolic content of the series; nevertheless, it was the happy marriage of painting and architecture that gave the ensemble its full impact.

The Story of Psyche was so admired by Morozov's guests that he decided to ask Pierre Bonnard (1867-1947) to deco-rate the mansion's main staircase. In January 1910, via the intermediary of the Galerie Bernheim-Jeune in Paris, Morozov commissioned Bonnard to paint a large triptych. The collector sent the artist a photograph of the staircase and information concerning its dimensions. In his overall project, Bonnard had to take into account the fact that the triptych's parts would be separated by half-columns. The triptych was exhibited at the Salon d'Automne in 1911 under the title *Mediterranean. Panels between Columns*.

In June 1909, Bonnard was Henri Manguin's guest at the Villa Demière in Saint-Tropez. There, he painted *View of Saint-Tropez* or *The Alley* (Hahnloser Collection, Bern), the picture that would later inspire the central part of the triptych. However, when he painted the large canvas, Bonnard modi-fied the composition of the study. Not only did he eliminate several details but, by setting the view of the sea further back in the distance, he also achieved a lighter and airier tonality. When he began the triptych, Bonnard probably

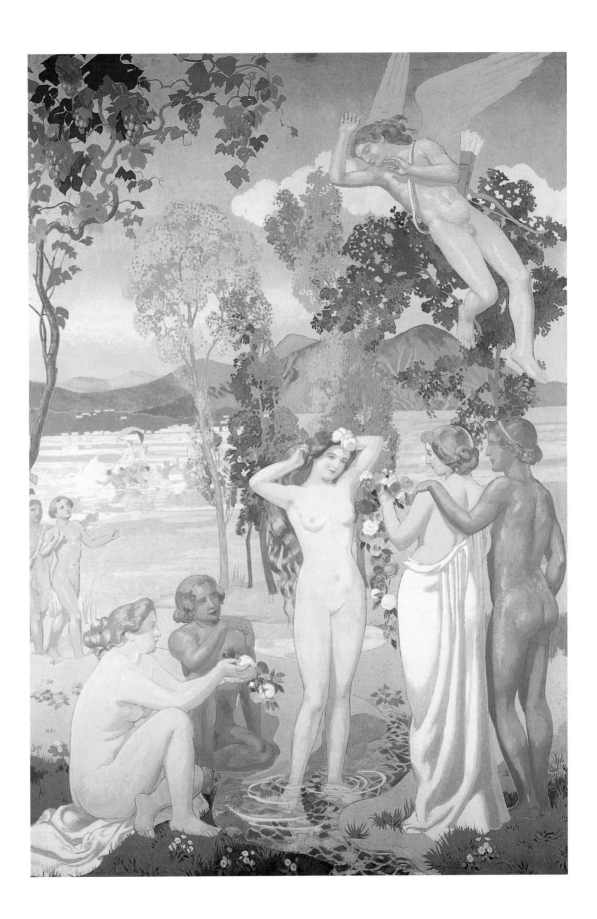

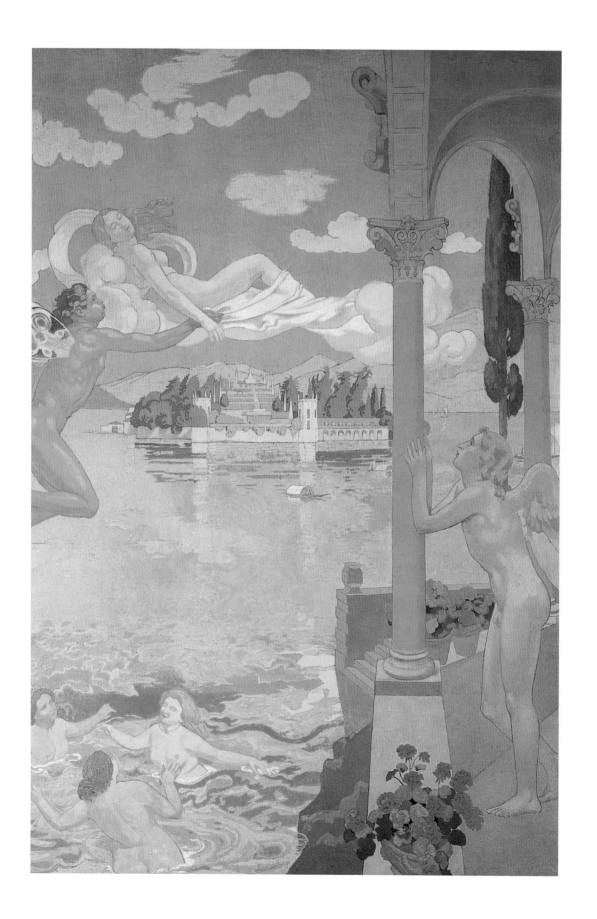

MAURICE DENIS

The Story of Psyche

From left to right

CAT. 67 Fifth panel: *In the Presence of the Gods, Jupiter grants Psyche Immortality and Celebrates Her Marriage with Cupid*, 1908

CAT. 68 Eighth panel: |*Cupid*| (in the form of a pilaster)

CAT. 69 Twelfth panel: border

CAT. 70 Seventh panel: *Cupid Carries Psyche to the Heavens*, 1909

CAT. 71 Thirteenth panel: border

CAT. 72 Ninth panel: |*Cupid*| (in the form of a pilaster)

CAT. 73 First panel: *Cupid is Struck by the Beauty of Psyche, an Innocent Object of the Worship of Mortals and the Jealousy of Venus*, 1908

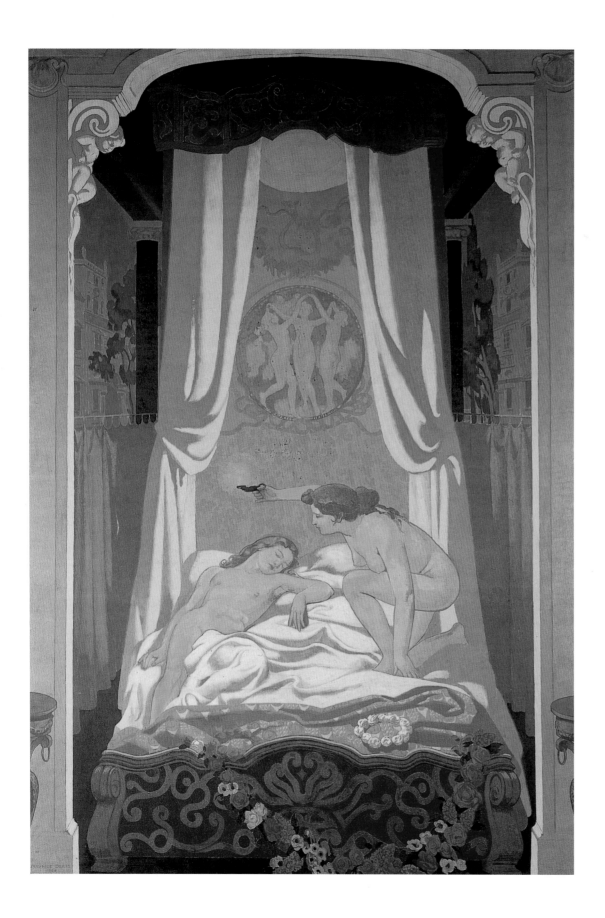

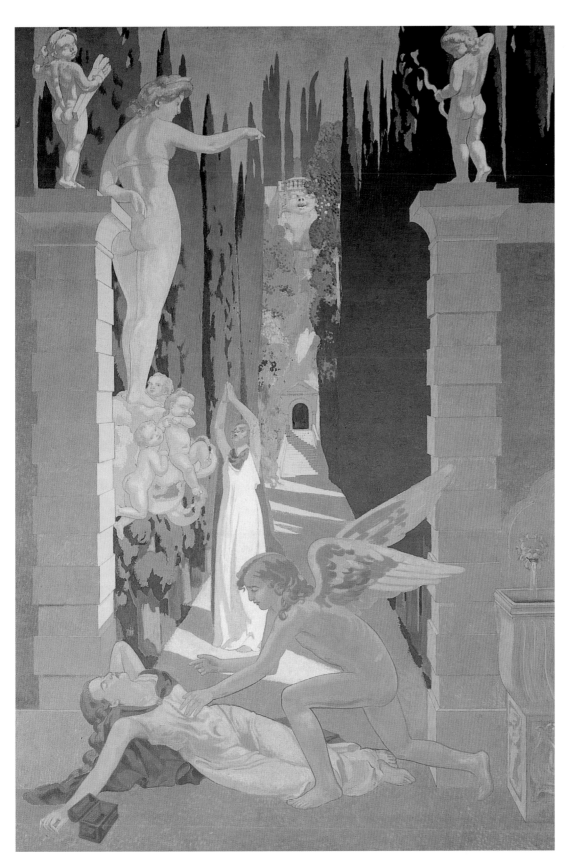

MAURICE DENIS
The Story of Psyche

From left to right
CAT. 62 Second panel: *Zephyr, - on Cupid's
Orders - Carries a Sleeping Psyche to
the Island of Bliss,* 1908
CAT. 63 Tenth panel: *[Psyche],* 1909
(in the form of a pilaster)
CAT. 64 Third panel: *Psyche Discovers that Her
Secret Lover is Cupid,* 1908
CAT. 65 Eleventh panel: *[Psyche],* 1909
(in the form of a pilaster)
CAT. 66 Fourth panel: *The Vengeance of Venus;
Subjected by Venus to the Harshest Trials, Psyche,
to Her Misfortune, Gives In to Curiosity a Second
Time and, in this Extremity, Is Aided by Cupid,* 1908

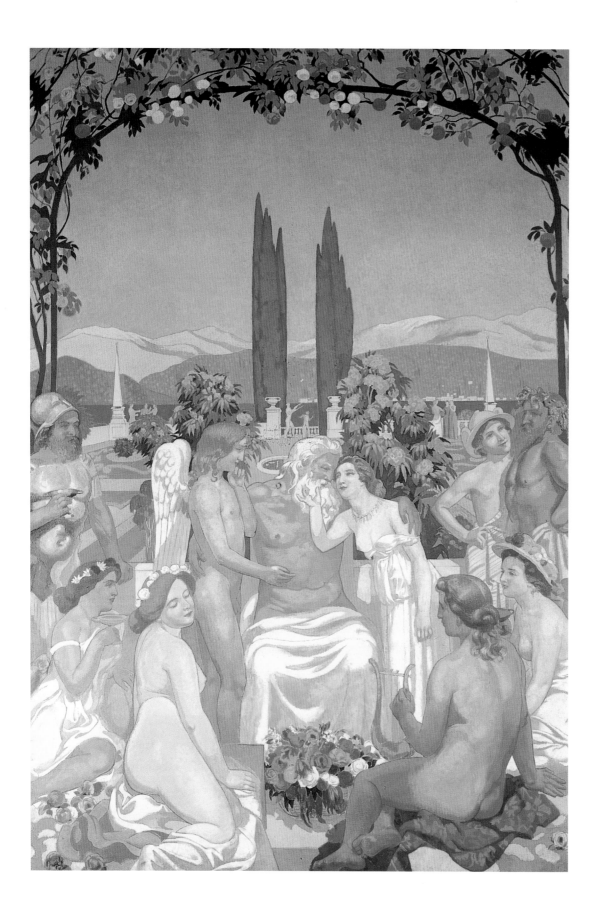

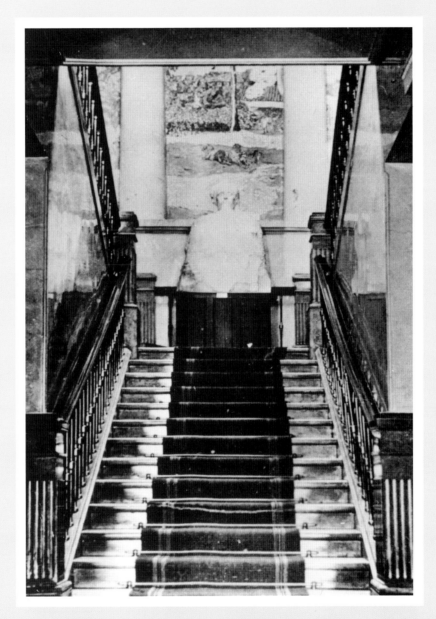

FIG. 91 The staircase in Morozov's house leading to Bonnard's *Mediterranean*, c. 1912

re-created the landscape from memory since the Bernheims had already bought *View of Saint-Tropez* in 1910. In September 1910, again in Saint-Tropez, the painter wrote to his mother that the South filled him with wonder, like a picture from A *Thousand and One Nights*. The impression this brief stay left on him no doubt influenced the triptych, which depicts autumn rather than summer. In the same letter, Bonnard recalls meeting a dark-haired girl with an enormous blue parrot, adding that he has just discovered the delights of pebbles, low walls, olive trees, and oaks. The upper part of the right-hand panel is taken up by an oak tree, with the girl and the parrot below. The bird, however, is not blue, as Bonnard had originally seen it and painted it in *Woman with a Parrot*, but green, the colour change having been dictated by the demands of the mural composition.

The triptych was finished around May 1911. After being exhibited at the Galerie Bernheim-Jeune and the Salon d'Automne, it was sent to Moscow. There, the canvases were placed directly on the walls between the half-columns of the second storey of the main staircase. Their top corners were trimmed slightly to follow the outline of the volutes of the columns' capitals. In 1948, after the closure of the New Museum of Western Art, housed in Morozov's mansion, the triptych and *The Story of Psyche* were moved to the Hermitage, where the triptych's missing elements were reconstituted and the canvases reinforced and mounted on stretchers. Although the triptych forms a single picture, it was mounted on three separate stretchers. The landscape continues over the three sections of identical proportions, yet each part is an autonomous and accomplished composition in its own right. For this reason, each canvas needs its own space around it – it needs to 'breathe'.

The theme of the triptych is a garden with a view over the Mediterranean. In the middle, small children play happily; in the corner of both side panels, a young woman anchors the composition. The figures are shaded by trees. The triptych

would lose much without the gentle charm of Bonnard's women and his lively, comical little children. Yet these figures are less important than the nature that surrounds them, which is neither wild nor primitive but cultivated, a nature that took centuries of Mediterranean civilisation to create. The garden's trees occupy large areas of the canvases. Their joyful, theatrical arabesques provide the overall decorative movement and create the impression of a superb, humanised nature. In the background of this flat theatre set, we see the captivating blue of the Mediterranean. The painter discarded several elements in the study he did from nature at Saint-Tropez to arrive at this calm and majestic composition. It is no longer a view but an idea of the Mediterranean.

It is the Mediterranean light that gives the Morozov triptych its soul. In this respect, it marked a new development in Bonnard's work, even if the conventional, decorative treatment of the trees dates back to his experiments in the 1890s. The triptych's lush vegetation is reminiscent of ancient tapestries, and also of Oriental art.

Bonnard seems not to have had a particular gift for monumental painting, yet his *Mediterranean* triptych (cat. 74) is a remarkable contribution to monumental decorative art. He never went to Moscow and the photograph of the staircase probably didn't give him a very precise idea of the architectural space his huge three-part 'picture' had to adorn. One can therefore but marvel at how perfectly fitting his solution was. This was not the result of some kind of clairvoyance, but rather the fact that he had no intention of subordinating his painting to architecture. Painting as joyous and free as this would not be out of place in any architectural context.

When Morozov, who was delighted with the triptych, commissioned Bonnard to paint two additional canvases for the side walls, the artist chose two recurrent themes in his work: early spring and the depths of autumn (*Early Spring in the Country* [fig. 93] and *Autumn. Fruit Picking* [fig. 94]; the two

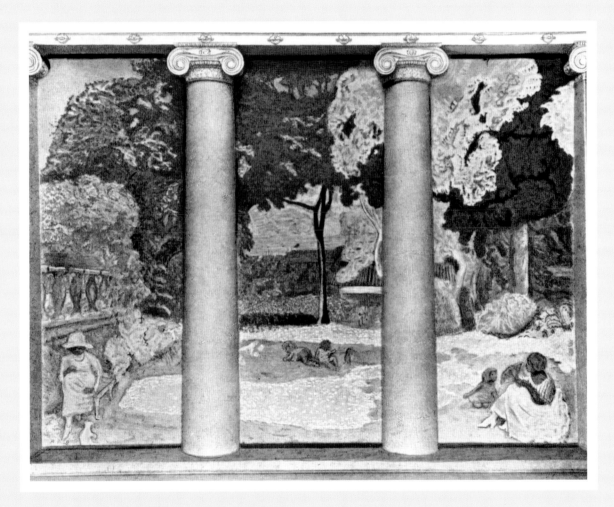

FIG. 92 PIERRE BONNARD, *Mediterranean* (triptych), Morozov's house, c. 1912

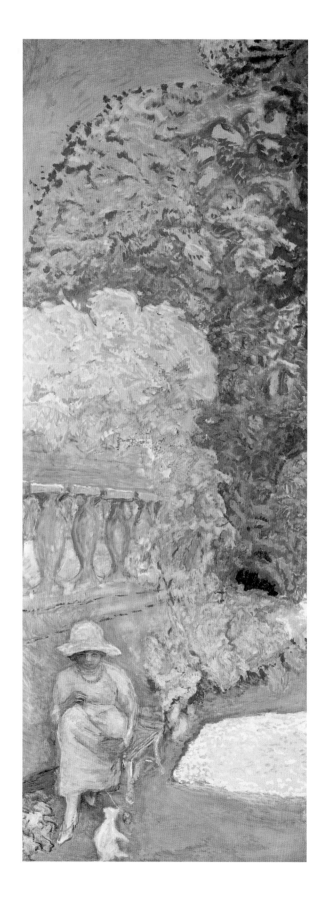

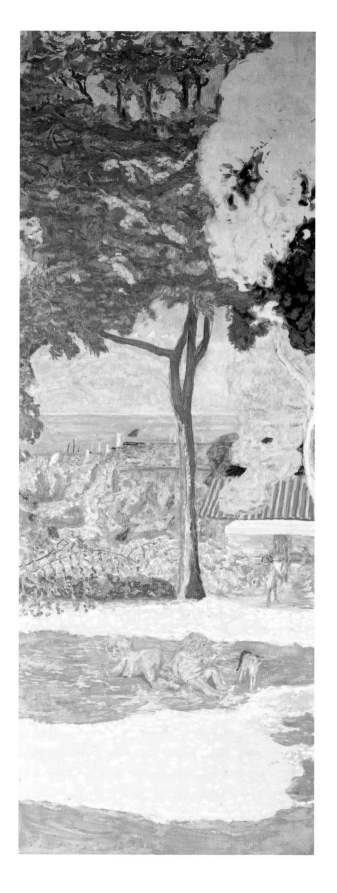

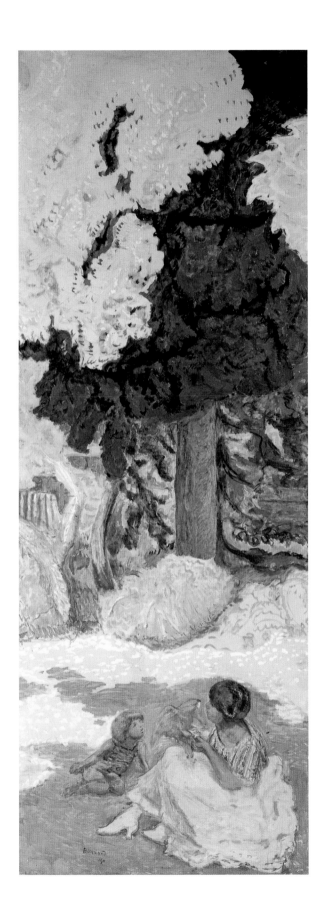

CAT. 74 PIERRE BONNARD, *Mediterranean* (triptych), 1911

canvases, painted in 1912, are today in the Pushkin Museum of Fine Arts. So the painter added his 'inverted commas' for the central work, the triptych itself, basking in summer light, and the passing of the seasons became the main theme of the ensemble. The triptych bathed the staircase of the Morozov mansion in its glow, and must have created an illusion of depth and great luminosity, whereas the two canvases on the landing's side walls were flatter and less colourful.

For many years, the monumental decorative works by Bonnard and Denis remained in storage in the Hermitage. They were too large for the French painting gallery on the third floor of the Winter Palace, so they were only shown at certain exhibitions. When the first rooms of the old General Staff Building, recently acquired by the Hermitage, were restored and began to be used for exhibitions, a host of new possibilities opened up[3]. The presentation of the decorative paintings by Bonnard and Denis is merely the first stage in the redevelopment of this building, which will probably eventually house the Hermitage's entire collection of French painting.

Notes

* Source, State Hermitage Museum

1 Maurice Denis, *Journal*, vol. 2, 1905–1920 (Paris: Vieux Colombier, 1957), p. 94.

2 Maurice Denis, op. cit., p. 100.

3 This text was written at the time of the reinstallation of the decorative cycles by Maurice Denis and Pierre Bonnard in September 1999.

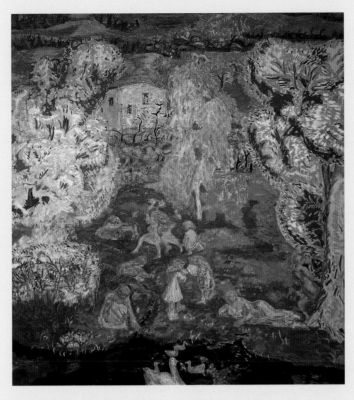

FIG. 93 PIERRE BONNARD, *Early Spring in the Country*, 1912

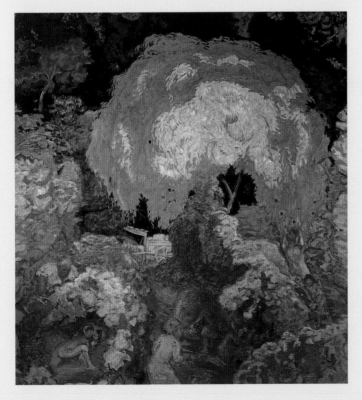

FIG. 94 PIERRE BONNARD, *Autumn. Fruit Picking*, 1912

167

Catalogue

In this catalogue of the works displayed, the works appear in chronological order and are grouped by artist. The artists are arranged in alphabetical order. The abbreviations 'N. B.' and 'M. P.-T.' correspond to Nathalie Bondil and Michael Parke-Taylor respectively. All the commentaries were written by Albert Kostenevich.

EXPLANATORY NOTE ON THE PROVENANCE OF THE WORKS
The First Museum of Modern Western Painting, Moscow (1918-1923), was previously the collection of Sergei Shchukin.
The Second Museum of Modern Western Painting, Moscow (1918-1923), was previously the collection of Ivan Morozov.
In 1923, the two collections were combined and became part of the collections of the State Museum of Modern Western Art, Moscow.

Pierre Bonnard (1867-1947)

⊷⊶⊶⊶⊷

After first studying law at his father's insistence, Pierre Bonnard attended the Académie Julian, where he met the Nabis painters. Inspired by Japanese prints and by the work of Gauguin, he became known as the 'Japanese Nabi.' Throughout his career he oscillated between a decorative style and an Intimist idiom, centred around his favourite model, his wife Marthe.

The turn of the century was a transitional period for Bonnard, during which he abandoned the homogeneity of the Nabis for a more personal style. He went on a series of trips: in 1899 he visited Milan and Venice with Vuillard and Roussel; two years later, he went to Spain with Vuillard and the princes Antoine and Emmanuel Bibesco; in 1905 and 1906 he travelled to Holland on the yacht of Misia Natanson, wife of the co-founder of La Revue blanche; and in 1908 he went to Tunisia and Algeria. However, it was his discovery of Saint-Tropez in 1909 that made the most profound impact on him: in his words, it cast an 'Arabian Nights spell' on him. Signac, Cross, and Matisse were already regular visitors to the small fishing village. Bonnard's discovery of the Mediterranean vegetation and light was a decisive step towards greater freedom and colour in his paintings. He stayed on the Côte d'Azur repeatedly before acquiring a villa at Le Cannet, near Cannes, in 1926. He eventually moved there definitively and, in his endless

search for new landscapes, made a rare concession to modernity by buying a car.

Far from the bustle of northern urban life, Bonnard's radiant, timeless visions of the South, wavering between dream and reality, are like tapestries woven by the forces of nature. There he found the spirit of the golden age of Antiquity, to which he paid tribute all his life, particularly in his large decorative paintings for the Muscovite collector Ivan Morozov and for the family of his dealers, Josse and Gaston Bernheim.

N. B.

CAT. 2 *Early Spring (The Little Fauns)*
1909
Oil on canvas
102.5 x 125 cm

Provenance: Galerie Bernheim-Jeune, Paris, 1909; the Bernstein Collection, Paris, from 28 June 1909; the Galerie Bernheim-Jeune again from 1911; collection of I. A. Morozov, Moscow, (acquired from the Galerie Bernheim-Jeune for 5,000 francs) from 1912; Second Museum of Modern Western Painting, Moscow, 1918; State Museum of Modern Western Art, Moscow, from 1923; the State Hermitage Museum, St. Petersburg, from 1948.

Bonnard first turned his hand to pastoral motifs in 1902 in the illustrations commissioned by Vollard on the theme of Longus's *Daphnis et Chloé*. In 1907, he painted a small canvas, known as either *Faun*, *Pan and Nymph* or *L'Après-midi d'un faune*,[1] then, around 1910, the picture *Fauns* (private collection, Switzerland),[2] which the Daubervilles date at 1905. Only these two canvases and the Hermitage picture depict the mythological characters in Dionysos's entourage. In *Fauns*, which is more decorative in treatment, Bonnard also developed the subject of the Hermitage composition: in the bottom left

corner, a being with goat's hooves plays music exactly like here.

Among the works heralding *Early Spring* is a pair of small canvases, *Mother and Child* and *Father and Daughter* (Lambert Collection, Brussels), each showing two figures against a landscape background. The figures in these pictures were later brought together in the Hermitage composition. The flute-playing faun, in particular, has the same pose as the mother in the Brussels picture.

Early Spring was also preceded by another *Early Spring* (1908, Phillips Collection, Washington, DC) which, with a few minimal changes, shows a Vernouillet landscape that can be seen in *Storm at Vernouillet* (1908, private collection, Switzerland),[3] which shows two children fleeing a storm – a subject genre sometimes used in late-nineteenth-century Salon painting.

Bonnard replaced the 1908 canvas's real children with mythological figures, and substituted the background of shapeless wilderness for the Vernouillet landscape with its contemporary architectural elements, thereby imbuing *Early Spring* with a completely unexpected counterpoint.

Bonnard's stay at Vernouillet in the spring of 1909 proved very productive. Among the canvases he painted there, one can cite *Rainy Landscape* (Athenium Museum, Helsinki), which partly reuses the landscape of *Early Spring*. The date written on this work – 1909 – tends to confirm that of the Hermitage painting.

[1] Jean and Henry Dauberville, *Bonnard, Catalogue raisonné de l'œuvre peint*, vol. 2 (Paris: J. and H. Bernheim-Jeune, 1967), no. 471.
[2] Ibid., no. 329.
[3] Ibid., no. 509.

Cat. 74 *Mediterranean (Triptych)*
1911
Oil on canvas
Left panel: 407 x 152 cm; centre panel: 407 x 152 cm; right panel: 407 x 149 cm

Provenance: Collection of I. A. Morozov (commissioned for 2,500 francs) from 1911; Second Museum of Modern Western Painting, Moscow, from 1918; State Museum of Modern Western Art, Moscow, from 1923; the State Hermitage Museum, St. Petersburg, from 1948.

This triptych is in fact a single picture extending over three enormous stretchers. The sections all have the same scale and landscape, but each separate part is a self-sufficient work in its own right. This is why each canvas demands its own surrounding space, its own 'air'. Bonnard knew that the staircase of the Morozov mansion, for which the triptych was intended, had three half-columns, which served to break up the composition, and which he used as 'framing' elements and as motifs within the scene itself. The triptych's theme is a garden overlooking the Mediterranean. The figures – the group of comical little children playing in the middle and the two young women on either side – are all placed in the shade of the trees. Without the nonchalant grace of the women, typical of Bonnard, and without the children's exuberance, the triptych would lose much of its charm. But it is nature that is all-important here, not untouched wilderness but cultivated nature, the culmination of long centuries of European civilisation nourished by the Mediterranean.

The trees in the garden take up half of the total picture area. Their theatrical arabesques form a festive décor epitomising the ensemble's decorative bias and at the same time create a sense of a magnificent, humanised nature. In the background – serving as a flat, close, accessible stage backdrop subjected to the laws of this realm – we see the beckoning blue of the Mediterranean. And it is the Mediterranean light that gives the Morozov triptych its genuine spirituality. In this respect, the picture represented a real breakthrough for Bonnard, even if the conventional decorative treatment of the trees harked back to his experiments in the 1890s. The painting's ornamental quality is akin to ancient scenic wallpapers. One can also see points in common with Eastern art. The English critic Clive Bell declared one day, not without a hint of humour: 'Bonnard's pictures as a rule grow not as trees; they float as water lilies. European pictures, as a rule, spring upwards, masonry-wise, from their foundations; the design of a picture by Bonnard, like that of many Chinese pictures and Persian textiles, seems to have been laid on the canvas as one might lay cautiously on dry grass some infinitely precious figured gauze.'[1]

In January 1910, Ivan Morozov, through the intermediary of the Galerie Bernheim-Jeune, commissioned Bonnard to paint a large triptych for the staircase of his mansion on Prechistenka Street (the building today belongs to the Russian Academy of Fine Arts). The collector sent the artist a photograph of the staircase and its dimensions. The triptych's parts were to be separated by half-columns, which Bonnard integrated into his overall composition. At the 1911 Salon d'Automne, the triptych was exhibited under the title *Mediterranean. Panels Between Columns*.

The following year, to complete it, Bonnard painted two more large canvases: *The First Days of Spring in the Country* and *Autumn. Fruit Picking* (Pushkin Museum of Fine Arts).

The triptych's principal motifs refer back to the pictures of the 1890s, particularly the series of decorative paintings *Women in a Garden* (1890–91, Kunsthaus, Zurich), one of which represents a woman with a cat. The central motif of the children playing is a common one in Bonnard's work, but there is no similar picture that one can compare it to. The right-hand figure had previously appeared in the painting *Woman with a Parrot* (1910, Wildenstein & Co., Inc.).

In June 1909 Manguin invited Bonnard to stay at his villa in Saint-Tropez. It was there that he painted *View of Saint-Tropez (The Path)* (Hahnloser Collection, Bern), which became the inspiration for the triptych's central canvas. However, he modified the study's composition when he transposed it onto canvas. He opted for a view further from the sea, opening onto the distance, thereby obtaining a remarkable, airy lightness of tone. Departing from the study from nature, he arrived at a composition full of serenity and grandeur: no longer a view but an idea of the Mediterranean.

When he painted the triptych, Bonnard was probably painting from memory and not from the study since *View of Saint-Tropez* had already been sold to the Bernheims in 1910.

Bonnard painted several landscapes in Saint-Tropez in 1910 and in March 1911 when he stayed there again, but only one, *Palm Tree* (1910),[2] is related to *View of Saint-Tropez* and consequently to the triptych's central panel. When the painter stayed with Paul Simon in Saint-Tropez in September 1910, he wrote to his mother that the Mediterranean was like a spectacle out of *A Thousand and One Nights*. The impressions from his stay there undoubtedly made themselves felt in the creation of the triptych, which shows an autumn landscape and not a summer one. In the same letter Bonnard describes how, when he went with Simon to visit some neighbours, he saw a young woman with an enormous blue parrot, adding that he had discovered pebbles, stone walls, olive trees, and oaks. The upper part of the right-hand canvas is taken up by an oak tree. In the lower part there is the young woman with the parrot, but not a blue one like the one Bonnard had seen and as he had painted it for the first time in *Woman with a Parrot*, but green.

The triptych was finished in May 1911. After it was shown at the Galerie Bernheim-Jeune and the Salon d'Automne it was sent to Moscow in

November. There, the canvases were fixed directly onto the walls between the half-columns on the first floor of the main staircase and the corners were trimmed slightly to accommodate the capitals. When the triptych arrived at the Hermitage in 1948, the small missing pieces had to be reconstituted and the canvases were reinforced and mounted on stretchers.

1 Quoted in James Thrall Soby, James Elliott and Monroe Wheeler, *Bonnard and his Environment* (New York: The Museum of Modern Art, 1964), p. 11.
2 Dauberville, op. cit., no. 621.

Paul Cézanne (1839-1906)

>+++-0-+++<

After receiving a classical education, Paul Cézanne left his native Aix-en-Provence for Paris to become a painter. Disappointed by the teaching at the Académie Suisse, he spent his time in the Louvre copying Venetian Renaissance painters, Michelangelo, Rubens, and, later, Poussin. Although Cézanne never went to Italy, he constantly returned to the Louvre to study the Old Masters.

The works of his first period, which he described as 'oversexed', show a dark, intense romanticism, influenced by the Caravaggist paintings he had seen in churches in Provence during his youth and the paintings of Delacroix. With the future Impressionist painters, he took part in the lively discussions at the Café Guerbois and in the Salon des Refusés scandal. But it was at Auvers-sur-Oise and then at Pontoise, painting alongside the 'humble and colossal' Pissarro, that he found his true path and devoted himself to landscape. But his style and personality remained impediments to success at the Impressionist exhibitions, where he showed from 1874.

Unlike the other Impressionists,[1] Cézanne did not travel. Instead, he returned to the Provence of his childhood, to the nature he loved and whose motifs and secrets he relentlessly explored. He even turned his back on L'Estaque, near Marseilles, which had become too industrialised for his taste, retreating with his wife and son to his hometown, Aix. There he pursued the task he had set himself, one that he would always find difficult and laborious, 'to do Poussin again after nature', an ambition frequently commented on by his young followers in search of a new classical order, Maurice Denis and Émile Bernard. Yet his influence spread far beyond the circle of the upholders of tradition, opening the way for the radical new modernity of Cubism.

N. B.

1 Manet and Degas made the traditional trip to Italy in their youth, whereas Renoir and Monet went later on in their lives. Manet also went to Spain and Renoir to Algeria. Pissarro, Sisley, and Monet visited England, and Monet travelled in Holland.

Cat. 55 *Still Life with Drapery*
c. 1894–95
Oil on canvas
55 x 74.5 cm

Provenance: Collection of I. A. Morozov, Moscow, from 1907 (purchased from Galerie Vollard, Paris, for 17,000 francs); Second Museum of Modern Western Painting, Moscow, from 1918; State Museum of Modern Western Art, from 1923; the State Hermitage Museum, St. Petersburg, from 1930.

The picture is a magnificent example of Cézanne's conception of perspective, which is even more strikingly apparent in his paintings of objects seen from close up than in his landscapes. To plunge into the universe of Cézanne's painting is to journey through the multidimensional space of his pictures, in which each object is not only beautiful but also retains its own individuality, unaffected by its surroundings. It is no coincidence that Evmarie Schmitt takes the Hermitage still life as an example of the painter's habit of incorporating different viewpoints into the same composition. 'Table edges, interrupted by a draped cloth, continue on the other side at a different height; jugs and glasses are frequently depicted simultaneously from a frontal and an elevated point of view; and tabletops almost invariably appear tilted upward, toward the viewer. This disregard of traditional perspective reflected Cézanne's extreme concentration on each individual object, which he attempted to depict as

exhaustively as possible. In still lifes, as in landscapes and figure compositions, then, Cézanne eschewed the principles of visible reality in favour of principles intrinsic to art.'[1] In all likelihood, the picture was altered at a later date. The table napkin on the right was definitely added some time after the painting was finished and the paint, applied on a completely dry surface, became slightly transparent, allowing the image of the table to show through.

From a compositional point of view, *Still Life with Drapery* can be regarded as a more accomplished version of *Still Life* (Barnes Foundation, Merion), a work which has been given several dates but which certainly cannot have been painted after the Hermitage picture. Rewald dates it 1892–94.[2] It is unlikely that these two works were far apart. Although far more detailed than the Barnes Foundation still life, *Still Life with Drapery* is just as unfinished, particularly the napkin on the right. However, many of Cézanne's works previously considered unfinished are today thought to be finished. Consciously or not, the painter stopped at the point when any additional brushstrokes for superficial finishing, particularly in the napkin area, would have compromised the work's structure.

There are widely differing opinions as to the date of the Hermitage still life. An annotation by the artist's son found in Vollard's archives mentions c. 1888–89. Venturi first stuck to 1895, then re-examined this date and opted for 1900–5. Sterling suggested an equally broad but earlier date span: 1895–1900. Lawrence Gowing, then John Rewald, opted for 1899.[3] This is based on the hypothesis that the still life was not painted in Paris, where Cézanne was then living. True, the flower-patterned curtain was part of the furnishings in the artist's Paris apartment and it figures in the famous *Mardi Gras* (1888, Pushkin Museum of Fine Arts), which was painted in Paris. But this is not enough to determine when the picture was painted. It would not have been difficult for him to transport such a piece of fabric, or any other object. And this is what in fact happened: we know, for example, that the china milk jug that

appears in a whole series of pictures from the 1890s on, including *Still Life with Drapery*, was among the objects in the Aix studio.

[1] Evmarie Schmitt, *Cézanne in Provence* (Munich, London, New York: Prestel, 1994), pp. 57–58.
[2] Rewald, op. cit., no. 844.
[3] Ibid., no. 846.

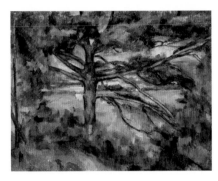

Cat. 13 *Large Pine Near Aix-en-Provence*
c. 1895–97
Oil on canvas
72 x 91 cm

Provenance: Collection of I. A. Morozov, Moscow, from 1908 (purchased from Galerie Vollard, Paris, for 15,000 francs); Second Museum of Modern Western Painting, Moscow, from 1918; State Museum of Modern Western Art, Moscow, from 1923; the State Hermitage Museum, St. Petersburg, from 1948.

Cézanne had been irresistibly drawn to this great pine almost from childhood. On 9 April 1858, he wrote to Émile Zola: 'Do you remember the pine perched on the cliff over the Arc valley, spreading its hairy head out over the gulf stretching below us, whose foliage protected our bodies from the ardour of the sun? Ah! may the gods preserve it from the deadly blow of the woodcutter's axe!'[1]

The majestic conifer began to take centre stage in his paintings thirty years later, in *Large Pine* (c. 1889, Museu de Arte, São Paulo), and even a little earlier in several works showing the same pine from the same angle. Clearly, the tree must have fascinated the painter for very personal reasons.

This series of works represents the village of Montbriant, in the Arc valley near Aix, where the artist's sister and her husband Maxime Conil

had bought a property in 1886. Montbriant was next to the village of Bellevue. Traditionally, the pine in the Hermitage painting is considered to have been situated in the commune of Montbriant – in certain publications, the canvas is entitled *Large Pine at Montbriant*. Rewald demonstrated that the land on which it was situated in fact belongs to the *commune* of Bellevue (whose houses can be seen in the distance). Consequently, he titled two pictures of this tree *Large Pine and Red Land. Bellevue*.[2]

The first of these canvases (Yoshii Gallery, Tokyo) was painted some time before the Hermitage *Large Pine Near Aix-en-Provence*. Lionello Venturi dates it 1886–87, John Rewald and Douglas Cooper 1885. The Hermitage landscape was undoubtedly painted several years later, at the same time as the two watercolours *Large Pine, Study* (Metropolitan Museum of Art, New York, and Kunsthaus, Zurich), for which Rewald gives the same dates as the Hermitage picture: 1890–95. For his part, Venturi thinks that the two canvases of the great pine at Bellevue were painted around the same time, but that is clearly erroneous. To begin with, the simple fact that the Hermitage pine's trunk is thicker and the undergrowth higher plead in favour of a later date. In the past, the curator of the State Museum of Modern Western Art, Nina Yavorskaya, had suggested 1895–97, a date span which Theodore Reff later accepted.

Furthermore, the treatment of the Hermitage picture is infinitely more architectural in style than the one in the Yoshii Gallery. Cézanne had left the first version unfinished, and the picture was to pay dearly for this later when it was subjected to 'improvements' by an unknown artist. Schuffenecker, who probably bought it for a song, later sold it to Vollard for a considerable sum, but since unfinished works then had little value, he had it 'finished' beforehand. He admitted that a third of the picture surface had been painted over and this 'improvement' to the Cézanne original wasn't discovered until the late 1930s. Although Schuffenecker insisted that he did not do this for financial gain, it was precisely the 'incomplete' state of Cézanne's

paintings that kept their price down. The 'completed' version of *Large Pine* fetched the record sum of 550,000 francs when the Gagnat Collection was auctioned.

[1] Paul Cézanne, *Correspondance*, ed. John Rewald (Paris: Grasset, 1978), p. 19.
[2] John Rewald, *The Paintings of Paul Cézanne. A Catalogue Raisonné* (New York: Harry N. Abrams, Inc., 1996), nos. 537, 761.

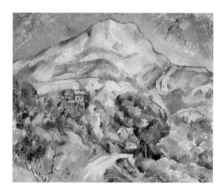

Cat. 12 *Mont Sainte-Victoire*
c. 1896–98
Oil on canvas
78.5 x 98.5 cm

Provenance: Collection of I. A. Morozov, Moscow, from 1907 (purchased from Galerie Vollard, Paris, for 20,000 francs); Second Museum of Modern Western Painting, Moscow, from 1918; State Museum of Modern Western Art, Moscow, from 1923; the State Hermitage Museum, St. Petersburg, from 1948.

The Mont Sainte-Victoire, venerated since time immemorial in Cézanne's native Provence, just as Mount Olympus was by the ancient Greeks and Mount Sinai by the Jews, became an obsessive motif in his work. It embodied for him nature's indestructible grandeur and his work outdoors 'from the motif' often took him on pilgrimages there. In this motif Cézanne sought certainty, and what more immutable certainty could there be in the region where he lived and worked than the Mont Sainte-Victoire? He devoted some thirty oil paintings and forty-five watercolours to the sacred mountain.

In the Hermitage picture, the mountain is such a powerfully sculptural central form that the whole landscape, responding to its rhythms, appears to swell and rear up. Cézanne's aim here was not to transcribe precisely an optical impression. Deliberately transgressing atmospheric and linear perspective, he made the mountain bigger than it was in reality, bringing it closer. Yet small details have been left out. The relief of the real landscape has been replaced by a sculptural, formal relief.

The famous German collector Karl Ernst Osthaus, after visiting Cézanne in 1906, recalled how the artist, taking as examples the few paintings he still had at his home (as soon as he finished them Vollard took them to Paris), most of them mountain landscapes, explained to him how he approached the problems of perspective. "'The principal thing in painting," he said, "is finding the correct distance. It is colour that expresses all changes in depth. That's how to recognise talent in a painter.'"[1]

The colours in *Mont Sainte-Victoire* – the grey of the mountain's bare rock summit, the green expanse of meadows and woods at its foot and, closer, the red of the earth – are nature's. This natural gradation of tones from warm in the foreground to cool in the distance is designed to fully render the landscape's depth. When the old masters endeavoured to represent space they usually divided it into three separate planes, the nearest warm and dark, with the most distant being pushed further back with the use of cooler and lighter colours. This 'recipe' did not suit Cézanne, despite his reverence for the great masters of the past. His beloved Mont Sainte-Victoire was not just any old landscape to be reproduced as faithfully as possible. And if the Mont Sainte-Victoire's mass seems to stand there in the light of day with deceptive closeness, Cézanne further accentuates this by introducing warm tones into the mountain and cold tones at the foot of the picture. The light expresses not only differences in depth: by destroying the age-old three-plane formula, it also brings about a new pictorial structure, characterised by its unity and totally novel dynamism.

What distinguishes the Hermitage picture from other paintings of the Mont Sainte-Victoire is its particularly 'energetic' perspective, which attempts to render in full the power of light. In this respect the picture has a certain ambiguity: the distant mountain seems to 'come closer' than traditional perspective criteria would allow it to. The Hermitage landscape's unusual spatiality becomes particularly apparent when compared with the version in the Cleveland Museum of Art, in which the mountain, seen from almost the same angle, recedes much further into the painting's depth.

The artist's son believed the Hermitage landscape was painted around 1890. Venturi dates it at 1894–1900, as he did the Cleveland picture. Rewald, who calls the latter the 'second version', believes it to have been executed much later (1904), and pushes the Hermitage *Mont Sainte-Victoire* forwards to 1896–1898.[2] He emphasises that Cézanne painted the landscape from the Tholonet road (in his catalogue raisonné, he entitles it *The Mont Saint-Victoire from above the Tholonet Road*). Château Noir, where the artist rented a room to work in (in the picture, the house is hidden by trees), is halfway between Tholonet and the Mont Sainte-Victoire. The road has now been widened and modified, but if one compares the picture with the photograph of the motif taken by Rewald in 1935 one sees that, although exactly reproducing real-life details, Cézanne greatly altered the perspective, which brought the mountain markedly closer.

Upper and lower areas of the picture are quite badly damaged, due to it being unframed before arrival at the Morozov mansion and later having been rolled up for preservation – we know that Vollard managed to obtain a significant number of Cézanne's paintings rolled up like this.

[1] Karl Ernst Osthaus, 'A Visit to Paul Cézanne', in *Conversations with Cézanne*, ed. Michael Doran (Berkeley, Los Angeles, and London: University Press of California, 2001), p. 96.
[2] Rewald, op. cit., no. 899.

Sonia Delaunay (1885-1979)

In 1890 Sonia Delaunay was adopted
by her wealthy uncle Henri Terk, a prominent
lawyer in St. Petersburg. There she learned
about art through his collection of paintings
and reproductions. From 1903 to 1905
she studied drawing at the university in
Karlsruhe. Then she moved to Paris to study
at the Académie de la Palette, where she
met Amédée Ozenfant and André Dunoyer
de Segonzac. By 1907 she was familiar
with the latest artistic developments in Paris
and was producing figurative paintings
influenced by van Gogh, Gauguin, and the
Fauves. In order to avoid returning home
to her family, Delaunay married the art critic
and dealer Wilhelm Uhde in 1908.
The same year she held her first solo
exhibition at his Galerie Notre-Dame-des-
Champs. Through Uhde she became friends
with Picasso, Braque, Vlaminck,
and Robert Delaunay.

Her shared artistic interests with
Robert Delaunay led to an amicable divorce
from Uhde and marriage to Delaunay in
1910. Pioneers in abstract art, the Delaunays
together developed a lyrical approach
towards pure colour abstraction and music
that led the poet Guillaume Apollinaire to
define a movement called Orphism. After
1917 Sonia Delaunay devoted more time
to her work as a decorative artist, adapting
'Orphic' colour principles equally to
paintings, bookbindings, applied arts,
and fabrics. When World War I broke out,
the Delaunays moved to Spain and then
Portugal, where they remained until 1920.
Sonia drew upon her husband's research into
the laws of contrasts and of simultaneity
(the creation of light and movement by
contrasting circles of colour). 'These laws,'

she wrote, 'methodically discovered by
Chevreul . . . were observed by Robert and
me in nature. In Spain and Portugal, where
the light is purer, less misty than in France.'[1]
It was in fact during her time in the Iberian
peninsula that she fully discovered
the dynamic of the circle proposed by
Robert in 1912–13.

M. P.-T.

[1] Danielle Molinari, R. et Sonia Delaunay (Paris: Nouvelles
Éditions Françaises, 1987), p. 89.

CAT. 31 *The Prose of the Trans-Siberian and Little
Jehanne of France* (detail)
1913
Watercolour stencils on paper
198 x 36.5 cm

Provenance: Collection of A. A. Smirnov,
St. Petersburg; the State Hermitage Museum,
St. Petersburg, from 1966.

The action of Blaise Cendrars' poem, which he
wrote under the influence of his travels in Russia
in 1903–7, takes place during the 1904–5 Russo-
Japanese War and the ensuing 1905–7 Revolution.

The aim of Cendrars' and Sonia Delaunay's
collaboration on this work was to create a
'simultaneous book' whose text and pictorial
accompaniment could both occupy the same
surface. The painted part has nothing to do with
book illustration, though. Sonia Delaunay
created her own coloured rhythmic structure,
which had to be at one with the text, and did
not consider her work as a mere decorative
arrangement: her aim was to render the
movement of light through the play of coloured
forms. The printed text comprised six different
typefaces, which in itself was an unusual
typographical experiment. It is thought that the
overall composition owes its form to the Eiffel
Tower, whose image haunted Robert Delaunay.
The tower is effectively represented opposite the
last lines of Cendrars' poem.

The first 'simultaneous book' was published
in November 1913 and made a major impact in
Parisian artistic circles. Favourable and hostile

articles and letters appeared in *Paris-Journal*, *Gil Blas*, and *Soirées de Paris*. Originally, it was to be published in a limited edition of one hundred and fifty, but the print run was in fact much smaller. In Robert Delaunay's original project, the total length of all the books in the print run initially planned, placed end-to-end – each book when open measured two metres – was to be the same as the height of the Eiffel Tower.

The first owner of the book in the Hermitage was A. Smirnov (1883–1962), a friend of Cendrars and Robert and Sonia Delaunay. This important Russian literary critic was a lecturer at St. Petersburg University before and after World War I. We know that he also lectured in St. Petersburg, notably in the cellar of a literary and artistic cabaret called *The Wandering Dog*. During his lectures, he demonstrated the poem and the 'synchronous disc' mentioned in the dedication. The disc, like the poem, was intended to present the 'abstracted spectacle of light and movement.'

Maurice Denis (1870-1943)

Maurice Denis first wrote about his vocation as a painter in his diary at the age of fourteen. Later, during his adolescence, moved by the *Coronation of the Virgin* by Fra Angelico in the Louvre, he wanted to become a painter-monk. He was a devout Catholic and religion would play an important role in his work throughout his life. At the Lycée Condorcet in Paris he became friends with fellow pupils Édouard Vuillard and Kerr-Xavier Roussel.

In 1888, at the Académie Julian, the trio met Paul-Élie Ranson, Pierre Bonnard, and Paul Sérusier. These artists, all preoccupied by the same Synthetist and Idealist aesthetic theories, created the Nabis group, and Denis, who was nicknamed the 'Nabi of the beautiful icons', became their spokesman and theoretician. The painter Henri Lerolle, after discovering Denis's work at the 1891 Salon des Indépendants, became his friend and often invited him to his home, where Denis met other artists (Edgar Degas and Auguste Renoir), men of letters (Stéphane Mallarmé, Paul Claudel, André Gide, and Paul Valéry), and composers (Vincent d'Indy, Claude Debussy, and Ernest Chausson). Thanks to this network, with its links with the Parisian avant-garde and bourgeoisie, Denis began to receive commissions for large decorative ensembles.

With Marthe, whom he married in 1893, Denis made his first trip to Italy in 1895. His second stay there was decisive. In late 1897, invited by Chausson, he went to Fiesole and was captivated by the Tuscan landscape. It was a moment of great personal and artistic happiness for him. At the beginning of the following year, Gide revealed the beauties of Rome to him, saying: 'We will become classicists together.'[1] A new concern for order and discipline appeared in his work. Following his conversion to classicism, Denis returned again and again to the Renaissance masters, and to Italy, his love of which would be eclipsed by none of the other countries he visited: Germany (1903), Spain (1904), Russia (1909), Algeria and Tunisia (1921), Holland (1926), the United States and Canada (1927), and the Holy Land and Greece (1929). Italy, his future home-cum-museum at Saint-Germain-en-Laye near Paris, and his house at Perros-Guirec in Brittany, remained his three favourite places.

N. B.

[1] Maurice Denis, letter to Vuillard, 15 February 1898, *Journal* I (Paris: Vieux Colombier, 1957), p. 134.

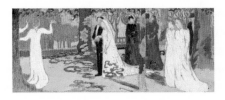

CAT. 7 *Wedding Procession*
c. 1892
Oil on canvas
26 x 63 cm

Provenance: The State Hermitage Museum,
St. Petersburg (acquired in 1939).

This picture has a closely matching counterpart, *Procession Under Trees* (1892, Altschul Collection, New York). Some of the figures and the landscape background in the latter are the same, but its subject has a more abstract quality and the procession of young women in white clothes is not necessarily part of a marriage ceremony. Quite clearly, *Wedding Procession* was painted just before *Procession Under Trees*, in which the analogous details are hardly sketched out.

Certain researchers have given the Hermitage picture the slightly later date of 1893, basing this on the autobiographical aspect of the painter's early work: he had married Marthe Mercier on 12 June 1893. *The Wedding of Marthe and Maurice Denis* (formerly in the Dominique Denis Collection, Saint-Germain-en-Laye), a faithful portrait of the newlyweds, nevertheless has an entirely different feeling. Moreover, one cannot unreservedly assimilate the Denis couple to the fiancés in the Hermitage painting, in which the bridegroom has black hair, whereas Maurice Denis's was brown.

The scene has a more imaginary than real feeling about it. Since 1890, the year Denis met Marthe, he had dreamed of marrying her but had had to overcome his own father's hostility to this. They became engaged in autumn 1892 and it was undoubtedly then that he painted *Wedding Procession* and *Procession Under Trees*. The autumn landscape in the background of both pictures would support this dating.

Apart from a few minor details, the picture's composition follows that of the pencil sketch,[1]

in which only the man wearing a top hat on the right is missing. It is also possible that *Wedding Procession* was in fact a sketch for a picture never painted.

[1] Ursula Perucchi-Petri, *Die Nabis und Japan* (Munich: Prestel, 1976), p. 176, no. 122.

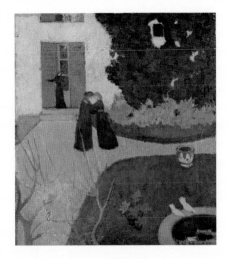

CAT. 11 *The Meeting (The Visitation)*
c. 1892
Oil on cardboard
37.5 x 33 cm

Provenance: Collection of M. A. Morozov (brother of I. A. Morozov), Moscow; collection of M. K. Morozova, Moscow, from 1903; Tretyakov Gallery, Moscow, from 1910 (donated by M. K. Morozova); State Museum of Modern Western Art, Moscow, from 1925; the State Hermitage Museum, St. Petersburg, from 1934.

The picture's traditional title has remained since its stay in Mikhail Morozov's collection, even though what is depicted here is not a scene from everyday life but a passage of the New Testament, Mary's visitation to Elizabeth (Luke 1:36–56). Unlike the later painting, which takes another approach to the theme, in *The Meeting*, Denis's first picture on this theme, the painter re-uses the Renaissance schema of the two cousins embracing. Since that period, the scene had been represented against a landscape background, often in front of the house of Zachary, Elizabeth's husband.

The holy and the mundane mingle in this picture, to the extent that the scene depicted,

one of the most popular in the New Testament, is not perceived as a religious one: hence its title. Denis's representation of the architecture and clothing avoids the historical aspect and proceeds as though he were re-creating the motif from life. The symbolic resonance of the detail is muted. In Christian art, the image of the dove had manifold symbolic meanings. Usually, it personified the Holy Spirit and consequently was linked to the Immaculate Conception. It was also common to represent union and concord in the form of a couple of doves. They figured in this sense even in paintings unconcerned with Christian themes. The urn in the garden and the small fountain at which the doves are drinking are an allusion to the dish of John the Baptist, Elizabeth's son (whom she is waiting to bring into this world). Furthermore, the urn and the fountain with the doves are brought to the fore in the picture and correlated on a formal level through the dialogue between black and white.

The picture, most probably painted around 1892, is close to *Breton Women in Large Shawls* (1892, private collection, Saint-Germain-en-Laye) and *Red Roofs* (c. 1892, Musée du Prieuré, Saint-Germain-en-Laye). The system Denis employed in these two canvases, consisting in inserting large areas without clear contours, is stylistically comparable to *The Meeting*.

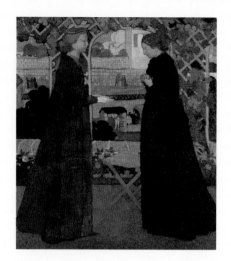

CAT. 46 *The Visitation*
1894
Oil on canvas
103 x 93 cm

Provenance: Collection of S. I. Shchukin, Moscow, from 1899; First Museum of Modern Western Painting, Moscow, from 1918; State Museum of Modern Western Art, Moscow, from 1923; the State Hermitage Museum, St. Petersburg, from 1934.

The theme of Mary's visit to Elizabeth (Luke 1:36–56) is one that Denis returned to on several occasions in his early work, after having painted it for the first time in *The Meeting* (see cat. 11). In the notes the painter made on his honeymoon in 1893, he set out a whole programme of religious compositions for himself, which included two *Visitations*. That year, he painted *Visitation with a Dovecote* (private collection), in which Elizabeth and Mary are shown in front of a small trellised house (whose structure heralded the future leafy arbour). In the lithograph *Mary's Visitation to Elizabeth* (1894), the composition is simplified and the little house is replaced by a trellised fence. In the Hermitage picture, this motif undergoes further modification: the plain rectangular grid has become an openwork arcade made out of diagonal latticework and crowned with autumn leaves. The grid motif, borrowed from the masters of the Japanese print, was popular with all the Nabis.

Visitation with a Dovecote has a horse-drawn cab and cabman in the foreground. With this detail, Denis in a certain manner pushed back the subject's limits by evoking the journey Mary has

made. In the Hermitage canvas, the cab, placed in the background, is hardly visible and the background landscape has changed from Perros-Guirec to Saint-Germain-en-Laye. The proportions between figures and background have been radically modified. Mary, on the left, and Elizabeth, on the right, occupy almost the entire height of the picture and have a much more imposing air than beforehand.

In the picture, personal meanings mingle with motifs from traditional iconography. The roses Marthe Denis loved so much are the symbols of the Virgin Mary, who from the Middle Ages was known as the 'rose without thorns'. As in other works from the 1890s, the picture's two heroines still greatly resemble the painter's wife. Denis shows little orthodoxy, however, with regard to the season. In the Catholic calendar, the Visitation is celebrated on 2 July, whereas the scene depicted here is undoubtedly taking place in the autumn. This can probably be explained by the fact that the picture was painted shortly before the birth of Maurice Denis's first child, Jean-Paul, who was born in October 1894 and died in February 1895. It was standard practice for the painter to include events in his private life in traditional subjects. The scene is distinguished by one specifically turn-of-the-century detail: Elizabeth is bareheaded – she is at home – whereas Mary, who has come to visit her, is wearing a fashionable hat. The pink colour of her small hat echoes the pink tints of the women's faces and hands and the heightened pink cloud between them. This cloud alludes to the celestial qualities of the Virgin Mary, who is also called Gate of Heaven, and was far from being an unimportant detail for Denis – he wouldn't have devoted a preparatory drawing to it otherwise.

There are two surviving sketches for the Hermitage picture, one horizontal, the other vertical. In the end, the painter opted for an almost square format, a shape symbolising perfection.

The figure of Mary is almost the same as the woman holding the plate in Denis's large programmatic composition *The Pilgrims of Emmaus* (1894, Musée du Prieuré, Saint-Germain-en-Laye).

The picture was praised for its *mise-en-scène* by the famous critic Gustave Geffroy when it was shown at the Salon International des Arts Décoratifs in 1895.[1]

[1] Gustave Geffroy, *La Vie artistique* (Paris: Deutu, 1895), p. 254.

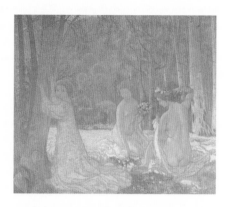

CAT. 6 *Figures in a Spring Landscape (The Sacred Grove)*
1897
Oil on canvas
156.3 x 178.5 cm

Provenance: Galerie Vollard, Paris (purchased from the artist for 1,000 francs), from February 1899; collection of P. I. Shchukin (brother of S. I. Shchukin), Moscow, from 1899 or 1900; collection of S. I. Shchukin, Moscow, from 1912; First Museum of Modern Western Painting, Moscow, from 1918; State Museum of Modern Western Art, Moscow, from 1923; the State Hermitage Museum, St. Petersburg, from 1948.

Although the picture contains many personal elements – not uncommon in Denis's work – it also contains an entire symbolic programme that demands a degree of erudition on the viewer's part. Iconographically, it is related to the theme of the Three Graces – the Charities – but the subject itself is treated in a totally novel fashion. Two of the women are shown in the nude – the third, in a white gown, stands apart. Completely ignoring her friends, she is writing the painter's signature on a tree trunk, an allusion with an evidently playful side to it. Denis probably had in mind an old custom consisting in guessing the name of one's future spouse and then carving it on a tree trunk. The daisies evoke divination and in rituals the crown is often a symbol of destiny. Since time immemorial in certain regions of France and Germany, the arrival of spring was

symbolised by a young woman dressed in white, the 'Rose of May'. In the picture, the artist associates, as fancy takes him, the themes of spring, love and their forthcoming blossoming. The stag and the hind in the distance embody spring, renewal, and growth (because of the annual regrowth of their antlers). The stag is the messenger of the gods and sacred animal of the goddess Diana, the antique protector of young women when they married. It also personifies hearing. In pagan times, one went into the woods to meet the gods, hoping to hear a voice from on high, and the three women seem to be listening to something.

Influenced by the Renaissance painters during his trips to Italy, Denis's work began to gravitate away from his previous, characteristically flat style. It is extraordinary how many heterogeneous elements blend together in *Figures in a Spring Landscape*, everything from scenic wallpaper to the Neo-Impressionists, Raphael, and Puvis de Chavannes. The composition's overall design seems to have been reduced to a common denominator, so that the outlines of the figures of the naked young women, of the young woman dressed in a sumptuous white gown, whose fabric falls in complex folds, as well as those of the trees, echo one another.

The picture was probably called *Sacred Grove* at the Galerie Vollard. The title given to it by Denis, *Figures in a Spring Landscape*, is written on the back of the canvas. In January 1909, Denis referred to it in his journal as *Spring in the Forest*. The title *Sacred Grove* reflected the work's debt – perceived by contemporaries – to Puvis de Chavannes's picture of the same name (1884, Musée des Beaux-Arts, Lyon), which was hugely popular at the turn of the century. Maurice Denis would also have been familiar with Sérusier's picture *The Sacred Grove* or *The Incantation* (1891, Musée des Beaux-Arts, Quimper). Nevertheless, although painting the same subject – three figures in a sacred grove – his approach diverged from the Synthetist principles that Sérusier had developed following Gauguin's example. Similar themes had also been taken up on several occasions by certain French academic painters. Denis clearly knew P. Franc-Lamy's *Le Renouveau*

(The Renewal), which was shown at the 1892 Salon and praised by public and critics alike.

The picture's conception had been prepared by works painted in the early 1890s, notably *Le Soir trinitaire* (1891, Dejean Collection, Mas-de-Januq) and *Des Jeunes Filles que l'on pourrait appeler des anges* (1892). At that time, Denis had already adopted the practice of continuously reorganising the same image. The association of pagan, profane, and Christian motifs is evident in these works when one compares them to several others whose influence can be felt in the Hermitage picture: *Triple Portrait de Marthe en fiancée* (1892, Musée du Prieuré, Saint-Germain-en-Laye), *Trois Jeunes Princesses* (1893, private collection, Saint-Germain-en-Laye) and *Le Jardin des vierges sages* (1893, Lerolle Collection, Paris). The link between the latter and *Figures in a Spring Landscape* is undeniable. The picture's title itself contains an allusion to the New Testament parable of the wise and foolish virgins (Matthew 25:1–13). One must also mention the sketch *Printemps virginal* (1894, Musée du Prieuré, Saint-Germain-en-Laye), presumably for a mural painting, in which young women in a wood embody the theme of nature's reawakening.

Figures in a Spring Landscape was preceded by two sketches, one of which is in mixed media, donated to the Hermitage by the artist's family. In the latter, the painter's first attempt to formulate his idea for the composition, the motif of the young woman writing her fiancé's name on a tree is already present. Nevertheless, there are not three but five figures, although it is possible that two of them were conceived from the outset as alternatives.

According to Alexandre Benois's testimony, it was in fact on his initiative that Sergei Shchukin advised his brother Piotr to buy the painting from Vollard.[1]

[1] Aleksandr Benua (Alexandre Benois), *Moi vospominaniâ* [My Memories], vol. 2, book 4 (Moscow: Nauka, 1990), p. 151.

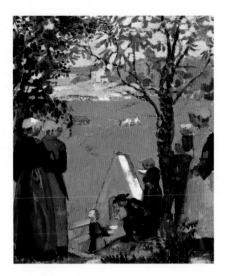

Cᴀᴛ. 10 *Sacred Spring at Guidel*
c. 1905
Oil on canvas
39 x 34.5 cm

Provenance: Collection of I. A. Morozov, Moscow, from 1906 (purchased at the Salon des Indépendants, Paris, from the artist for 850 francs); Second Museum of Modern Western Painting, Moscow, from 1918; State Museum of Modern Western Art, Moscow, from 1923; the State Hermitage Museum, St. Petersburg, from 1934.

Guidel is first mentioned in Denis's journal in a note he made in August 1905 at Pouldu. Then in Brittany, the painter and his wife Marthe made several excursions in the Quimper area to see the religious festivals and processions that took place in Pont-Aven, Clohars, and Guidel, situated in a 'valley, always cool and such a beautiful green.'[1]

It was probably then, in August 1905, that Denis painted the picture, which differs from his other works by the freshness of its greens. *Religious Procession at Guidel*, which the artist gave to Sérusier's wife (private collection, Lausanne), was clearly painted a little later.

Morozov's relations with Denis date from his acquisition of the painting at the Salon des Indépendants.

[1] Denis, op. cit., vol. 2, p. 20.

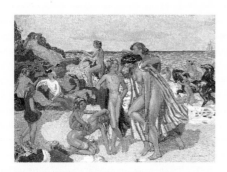

CAT. 4 *Bacchus and Ariadne*
1907
Oil on canvas
81 x 116 cm

Provenance: Collection of I. A. Morozov, Moscow,
(purchased from the artist in 1906 for 4,000 francs)
from 1907; Second Museum of Modern Western
Painting, Moscow, 1918; State Museum of Modern
Western Art, Moscow, from 1923; the State
Hermitage Museum, St. Petersburg, from 1931.

During the summer of 1906, Ivan Morozov paid
Denis a visit at his studio in Saint-Germain-en-
Laye while he was working on *Bacchus and Ariadne*.
Although the picture was not yet finished, the
collector bought it and came to an agreement
with the painter that he should paint a matching
canvas (*Polyphemus*, Pushkin Museum of Fine
Arts). Both works date from 1907 and in all
likelihood Denis worked on the painting again
after *Polyphemus* was finished. When he visited
Denis, Morozov would have seen *Beach with Small
Temple* (1906, Musée Cantonal des Beaux-Arts,
Lausanne), which, like *Large Beach* (subsequently
destroyed), represented the Brittany coast with
young women bathing in the nude in the
foreground. All these pictures were in fact very
similar from a compositional point of view. In
them, one can already see the motifs later
developed in *Bacchus and Ariadne*. In *Beach with
Small Temple*, a young woman sits enthroned on a
rock, and in the versions of *Beach with a Spaniel*
(1903, private collection and Chinchong
Collection, Tahiti), in the background, as later in
the Hermitage picture, there is a young man on
horseback riding into the water. In *Bathing* (1906,
private collection), on the rock on the left there
is a young woman in a white blouse, and on the
horizon on the right, a sailing ship.

Denis set the antique myth of Bacchus and
Ariadne on the beach of a seaside resort dear to

him since childhood, the typical Brittany beach
of Trestignel and Sept-Îles at Perros-Guirec.

The picture also reflects his impressions of
Italy, particularly his recollections of an antique
sculpture he had seen in the Museo Nazionale
in Naples in 1904. The pose of the nude bather
in the foreground is that of *Venus Lacing her
Sandal*, a marble statuette discovered at
Pompeii. The figure of Ariadne reclined on the
rock recalls *Ariadne Asleep*, a sculpture widely
known from Roman copies of the third-century
BC Greek original.

At that precise time, in January 1904, Denis,
then in Rome, wrote in his journal: 'Bacchus and
Ariadne (subject of beach painting), interpretation
by Poussin after Titian at the Academy of Saint
Luke.'[1] It was probably at that time that the idea
for the Hermitage composition took shape in
the painter's mind, one which he took up again
in 1913 in *Ariadne in the Last Light of Dusk* (private
collection).

[1] Denis, op. cit., vol. 1, p. 204.

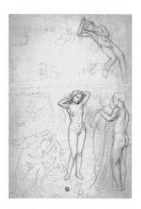

CAT. 73.1 *Study for the first panel of* The Story of
Psyche
1908
Pencil on paper
72.5 x 50.2 cm

Provenance: Acquired in 1992
(gift of Dominique Denis).

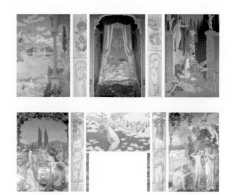

The Story of Psyche

Provenance: Collection of I. A. Morozov, Moscow,
from 1908 (all five panels commissioned
for 50,000 francs); Second Museum of Modern
Western Painting, Moscow, from 1918;
State Museum of Modern Western Art; Moscow,
from 1923; the State Hermitage Museum,
St. Petersburg, from 1948.

In the spring of 1907, Ivan Morozov commissioned
Denis to paint a decorative ensemble for the
music room of his mansion on Prechistenka
Street. The initial commission was for five large
canvases, for each of which Denis had produced a
sketch (all now in the Musée d'Orsay, Paris) by
summer 1907. From the outset, Denis had a very
clear picture of the ensemble, so much so that
when transposing from sketch to painting, he
merely had to follow the original compositions
and their colour indications. The modifications
are minimal: in the first canvas, the figures of the
young boys on the far left have been brought
forwards and the young man sitting has his wrist
bent. In the second canvas, the bathers are
represented slightly differently and in the fifth,
Mars has been changed.

The oil sketches were followed by numerous
preparatory drawings, the best of which is a
pencil sketch for the first panel, donated to the
Hermitage by the painter's son, Dominique
Denis, in 1992.

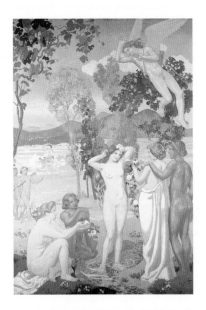

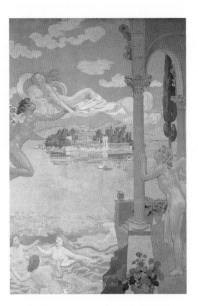

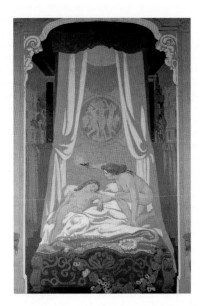

CAT. 73 First panel: *Cupid is Struck by the Beauty of Psyche, an Innocent Object of the Worship of Mortals and the Jealousy of Venus*
1908
Oil on canvas
394 x 269.5 cm

CAT. 62 Second panel: *Zephyr, - on Cupid's Orders -, Carries a Sleeping Psyche to the Island of Bliss*
1908
Oil on canvas
395 x 267.5 cm

CAT. 64 Third panel: *Psyche Discovers that Her Secret Lover is Cupid*
1908
Oil on canvas
395 x 274.5 cm

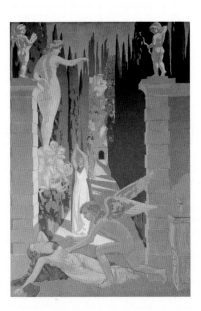

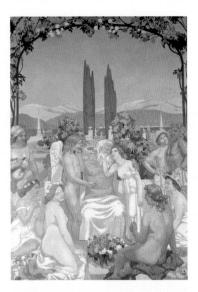

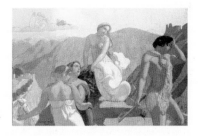

CAT. 58 Sixth panel: *Psyche's Parents Abandon Her on the Summit of the Mountain*
1909
Oil on canvas
200 x 275 cm

CAT. 66 Fourth panel: *The Vengeance of Venus. Subjected by Venus to the Harshest Trials, Psyche, to Her Misfortune, Gives In to Curiosity a Second Time and, in this Extremity, is Aided by Cupid*
1908
Oil on canvas
395 x 272 cm

CAT. 67 Fifth panel: *In the Presence of the Gods, Jupiter grants Psyche Immortality and Celebrates Her Marriage with Cupid*
1908
Oil on canvas
399 x 272 cm

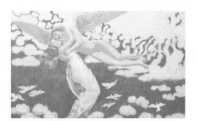

Cat. 70 Seventh panel: *Cupid Carries Psyche to the Heavens*
1909
Oil on canvas
180 x 265 cm

Cat. 68 and Cat. 72 Eighth and ninth panels:
Cupid Drawing a Bow
1909
Oil on canvas
390 x 74 cm

Cat. 63 and Cat. 65 Tenth and eleventh panels: *Psyche*
1909
Oil on canvas
390 x 74 cm

Cat. 69 Twelfth panel: *Border*
1909
Oil on canvas
228.5 x 19.6 cm

Cat. 71 Thirteenth panel: *Border*
1909
Oil on canvas
229 x 19 cm

Provenance: Collection of I. A. Morozov, Moscow, from 1909 (commissioned for 20,000 francs); Second Museum of Modern Western Painting, Moscow, 1918; State Museum of Modern Western Art; Moscow, from 1923; the State Hermitage Museum, St. Petersburg, from 1948.

The Story of Psyche. Complementary canvases
(above, from top to bottom, Cat. 70, 68, 72, 63, 65, 69, 71)

Denis worked on the complementary canvases in France after his trip to Moscow in January 1909. As before, he did preparatory sketches and drawings for the panels. There is a small oil sketch for the seventh panel in the Musée d'Orsay in Paris. There were also five large drawings using various media (pencil, charcoal, chalk, and gouache), today in the Musée du Prieuré in Saint-Germain-en-Laye. One drawing for the sixth canvas shows Psyche seated, another her sisters. The drawings for the seventh canvas depict Psyche and Cupid. All the complementary canvases were finished by autumn 1909.

In a letter to Ivan Morozov dated 23 October 1909, Émile Druet wrote that he had exhibited two canvases by Maurice Denis which met with an enthusiastic reception, and that he had just sent them to be packed for transport to Moscow.

At the outbreak of war with Nazi Germany in 1941, the complementary canvases, along with the initial panels, were taken down from the walls, rolled up, and evacuated to Siberia. When they were unwrapped again in 1951, after their donation to the Hermitage, it was discovered that some of them were missing and that the paint on others, particularly the seventh, had been badly damaged.

Cat. 59 *Painted Vase [Seated Female Bather]*
1909
Ceramic
Height 54 cm; diameter 35.5 cm;
diameter at base: 20 cm

Cat. 60 *Painted Vase [Crouched Female Bather]*
1909
Ceramic
Height 53 cm; diameter 35.5 cm;
diameter at base: 20 cm

Figures on the large canvases appear again as 'bathers' on the vases – not Psyche herself but her retinue, particularly the seated nude with white roses and the two other nudes sitting with her in the foreground of the fifth canvas. The stout heroines in the monumental mural painting seem here to be teasing each other, thus introducing a humorous touch to the ensemble.

Ivan Morozov had already begun acquiring vases by Maurice Denis – in the end he bought eight – before he commissioned *The Story of Psyche*. In 1909, during the second stage of work on this ensemble, he felt it necessary to add complementary pieces, and Denis agreed to paint four vases. When the Museum of Modern Western Art's collection was divided up in 1948, these remained in Moscow. For the Hermitage's bicentenary in 1964, the Pushkin Museum of Fine Arts donated two of these vases to the Leningrad museum.

André Derain (1880-1954)

Derain, born in Chatou, turned to painting at an early age. From 1898–99 he attended painting classes at the Académie Camillo under Eugène Carrière. Through his artist friend Georges Linaret, who was making copies in the Louvre in a proto-Fauve manner, he met Henri Matisse, who was studying at that time in Gustave Moreau's atelier. Derain also frequented the Louvre, where he made copies of Old Master paintings, as well as of ancient Egyptian and Greek sculpture. Following demobilisation from military service in 1904, Derain painted landscapes at Chatou, near Paris, with Maurice de Vlaminck. During that period he developed an interest in the work of Gauguin and Cézanne through his friendship with Matisse.

Derain made his first visit to the South of France during the summer of 1905, when he painted with Matisse in the small fishing village of Collioure near the French/Spanish border. Together they gained notoriety for their landscape paintings and were dubbed *fauves* ('wild beasts') at the 1905 Salon d'Automne. An inveterate traveller, Derain continued to visit the South of France in subsequent summers, painting at L'Estaque (1906), Cassis (1907), and Martigues (1908). In 1907 he became friends with Picasso. Picasso's influence and a mutual admiration for Cézanne changed Derain's palette from high-keyed contrasting colours to more restrained earth tones that emphasised geometrical compositions. In 1909 he worked at Montreuil and Carrières-sur-Seine, and in 1910 at Villeneuve-Loubet and Cagnes-sur-Mer, followed by a stint with Picasso at Cadaquès in Spain. Before serving in World War I, he painted in 1913 with Vlaminck in Marseilles and Martigues. After the war, Derain returned to a more classical style of painting associated with the 'call to order' that informed the work of many artists who reinterpreted avant-garde classicism.

M. P.-T.

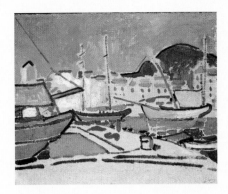

Cat. 21 *Harbour*
c. 1905
Oil on canvas
62 x 73 cm
Provenance: Galerie Kahnweiler, Paris; collection of S. I. Shchukin, Moscow, from 1913; First Museum of Modern Western Painting, Moscow, from 1918; State Museum of Modern Western Art, Moscow, from 1923; the State Hermitage Museum, St. Petersburg, from 1948.

Harbour's simplicity and chromatic purity are reminiscent of children's drawings: only a child proceeds in this way, spontaneously choosing the brightest colours, not bothering with details. Another similarity with children's art is the absence of shadow, a strategy that Derain had deliberately adopted to render the Mediterranean light in a new way: 'A new conception of light consists in eliminating shadow. Here the light is very bright and the shadows very light. Shadow reveals a world of clarity and luminosity that pits itself against sunlight.'[1] Derain made no attempt to give the viewer the impression of a real world. He proposed not a representation but a metaphor for light. Which is why, leaving more than a third of the picture empty, he refrained from painting the ground, whose colour, considered as equal to the others, becomes the incarnation of the light drenching the quayside and the walls of the houses. In relation to the primary colours, the ground is perceived as a kind of chromatic chord composed of several nuances. Endeavouring to give his colour a joyful tonality, Derain allowed each hue to radiate completely freely, with its own zone of influence.

Until quite recently, the picture was thought to be a view of the port of Le Havre and is listed as such in old catalogues. But the mountain on the right contradicts this. Douglas Cooper and John Rewald separately suggested that it was a Mediterranean port: Collioure, L'Estaque, or Cassis. The latter location is unlikely since the works painted at Cassis are very different in style. *Harbour*, on the other hand, is close to the landscapes painted at Collioure.

From a stylistic point of view, the picture belongs with the works painted in 1905, when Derain and Matisse were working together at Collioure. Derain visited L'Estaque several times, but painted above all in Collioure. The locality represented in *Harbour* is similar to that of *Sailing Boats at Collioure* (Engelhardt Collection, New Jersey), in which a green mountain overlooks the sea. *Harbour* was possibly one of the complete series of Collioure landscapes exhibited at the Salon d'Automne in 1905.

Kellermann calls the picture *Bateaux au port* (*Boats in Port*) and dates it to around 1906.[2]

[1] Letter to Vlaminck sent from Collioure on 28 July 1905; André Derain, *Lettres à Vlaminck* (Paris: Flammarion, 1955), p. 155.
[2] Kellermann, op. cit., no. 116.

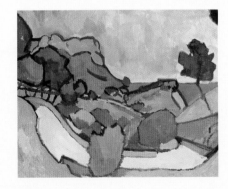

Cat. 22 *The Mountain Road*
1907
Oil on canvas
81 x 100 cm
Provenance: Collection of I. A. Morozov, Moscow, from 1908 (purchased at the Salon des Indépendants, Paris, for 250 francs); Second Museum of Modern Western Painting, Moscow, from 1918; State Museum of Modern Western Art, Moscow, from 1923; the State Hermitage Museum, St. Petersburg, from 1948.

This picture is one of the series of works Derain painted in 1907 at Cassis on the Mediterranean

coast, which includes notably *Near Cassis* (Duvivier Collection, Ostend) and *Cassis* (Musée d'Art Moderne de Troyes).[1] Kellermann titles the Hermitage picture *Paysage aux environs de Cassis* (*Landscape near Cassis*; no. 121). The series constitutes the final, so-called 'stained glass' phase of Derain's Fauve period.

The picture really does resemble a stained-glass window, due to the lines separating the areas of colour. But despite the conventionality of the devices used, the canvas's style is determined by nature – in this case, by the harsh colour and clarity of light of the South of France. Even though Derain completely shuns atmospheric perspective and muted background colour, he succeeds to a certain extent in rendering the landscape's depth using a skilful alternation of tones. The aim was to enclose the colour in large zones, each with its own unity, and to obtain a serene yet dynamic equilibrium. Derain, a painter of the Latin world, who on the Mediterranean coast had found a nature he considered ideal, always tended towards an ordered and clear universe.

Only a few minor modifications to the composition differentiate the painting from the study called *Landscape Near Cassis* (Kunstmuseum, Bern). Another *Landscape Near Cassis* (1907, Museum of Modern Art, New York) – smaller and undoubtedly later – can be linked to it. Here the overall composition was kept, but Derain slightly changed the motif from nature and abandoned its flat treatment. In the New York landscape, we already sense the transition from the 'stained glass' period to a style clearly influenced by Cézanne.

[1] Kellermann, op. cit., no. 127.

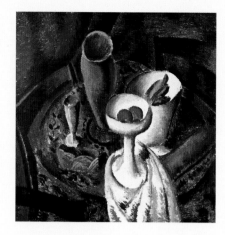

Cat. 56 *Table and Chairs*
1912
Oil on canvas
88 x 86.5 cm

Provenance: Collection of I. A. Morozov, Moscow, from 1913 (purchased from Galerie Kahnweiler, Paris, for 1,600 francs); Second Museum of Modern Western Painting, Moscow, from 1918; State Museum of Modern Western Art, Moscow, from 1923; the State Hermitage Museum, St. Petersburg, from 1948.

The glass is not transparent and the fruit dish, judging by its white colour, could be porcelain, but the picture does not tell us so, nor is there any textural difference between the dish and the tablecloth. Derain has no qualms about eliminating the individual treatment and colour nuances that differentiate objects from one another. They have been reduced to mere forms, a procedure which, although intrinsically Cézanne-inspired, would probably not have met with the master's approval.

The work was definitely painted in the second half of 1912 and had arrived at the Morozov mansion by the beginning of 1913. The Galerie Kahnweiler (no. 2044) gave it the date of 1912. The works from this period have a characteristic concentric structure. The dish in the foreground of this still life occupies the same central position in *The Game Bag* (1913, Musée de l'Orangerie, Paris). The composition of *Still Life with Dish* (National Gallery, Prague) is also similar to that of the Hermitage. In Kellermann's catalogue raisonné, the picture is dated 1912 and entitled *Still Life with Fruit Dish*.[1]

[1] Michel Kellermann, *André Derain. Catalogue raisonné de l'œuvre peint*, vol. 1, 1895–1914 (Paris: Galerie Schmit, 1992), no. 294.

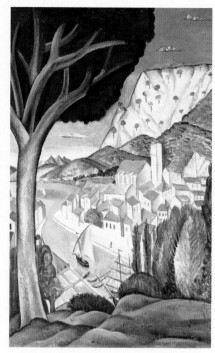

Cat. 30 *Martigues (Harbour in Provence)*
1913
Oil on canvas
141 x 90 cm

Provenance: Collection of S. I. Shchukin, Moscow, from 1914; First Museum of Modern Western Painting, Moscow, from 1918; State Museum of Modern Western Art, Moscow, from 1923; the State Hermitage Museum, St. Petersburg, from 1948.

Derain visited the Mediterranean port of Martigues several times. In 1908 he painted a panoramic view (Kunsthaus, Zurich) from more or less the same viewpoint, in a style close to that of *The Mountain Road*. But in this picture, painted in the summer of 1913, he is already paying much more attention to details and spatial depth.

If one compares the picture with photographs of Martigues, one sees how the architecture of this small Provençal town with its tiny cube-like houses suggested the painting's geometric style, whose resemblance to Cubism is only superficial. The geometric treatment extracts the quintessence of this landscape painted from nature. Unimportant details of the Chapel of the Annunciation have been omitted and the top of the bell tower has been slightly modified to give it a more unitary, crystalline form.

The deliberate archaism and Gothic style of *Martigues* are the result of Derain's radical reassessment of the values governing his art. Refusing the flatness and pure colour of the Fauves, he displaced the central concern from colour to form. Derain's constant urge to simplify is compounded here by his interest in naive art. The conventionally decorative forms of the trees on the mountainside are reminiscent of children's drawings, and the branches of the tree in the foreground recall the vegetation in paintings by Le Douanier Rousseau, with whom Derain was on friendly terms. One can also see that he has not forgotten the landscape backgrounds of fifteenth-century masters. But far from seeking medieval stylisation, Derain's prime aim, at least in the pre-World War I years, was to assimilate the Italian Primitives. Kellermann, who titled the painting *View of the Port of Martigues*, mentions the existence of another, smaller variation.[1]

[1] Kellermann, op. cit., no. 242.

Kees van Dongen (1877-1968)

From 1894 to 1896, Kees van Dongen studied drawing at the Royal Academy of Painting in Rotterdam. In 1899, he moved to Paris. The critic Félix Fénéon introduced him to anarchist and bohemian circles, and he contributed humorous and satirical illustrations in the manner of Steinlen and Toulouse-Lautrec to popular journals. In his one-man show at Vollard's in 1904, van Dongen exhibited Impressionist works, but he soon abandoned this style to embark on a short-lived Neo-Impressionist phase influenced by van Gogh. Although he contributed only two paintings to the famous 1905 Salon d'Automne's 'cage aux fauves', van Dongen occupied a special place in Fauvism. Rather than following the predominant Fauve practice of painting landscape, his iconography centred on portraiture and night life. His figures, isolated against an empty background, regain a solidity emphasised by outline. Van Dongen moved to the Bateau Lavoir in Paris, where he met Picasso, Vlaminck, and Derain. His violent and flamboyant Fauvism made an immediate impression abroad, where his work was soon exhibited, exerting a particular influence on German Expressionism.

Thanks to the funding provided by his contract with the Galerie Bernheim-Jeune in 1909, he began to travel, first in Spain and Morocco (winter 1910–11). His discovery of the South enriched his colours even more. In March 1913 he went to Egypt: the colours of the country brought out the Fauve in him once more.

Between the two World Wars, van Dongen painted mainly society portraits. Although he frequented fashionable Parisian circles, he continued to pursue his quest for a caustic style allying rigour with humour.

M. P.-T.

Cat. 14 *Spring*
1908
Oil on canvas
81 x 100.5 cm

Provenance: Galerie Bernheim-Jeune, Paris, from 1908; collection of S. I. Shchukin, Moscow; First Museum of Modern Western Painting, Moscow, from 1918; State Museum of Modern Western Art, Moscow, from 1923; the State Hermitage Museum, St. Petersburg, from 1948.

One finds echoes of *Spring*, undoubtedly van Dongen's best Fauve landscape, only in a few paintings by Matisse and Derain. His approach to nature here is so direct it is almost aggressive. The 'point blank' viewpoint he chose for the landscape did not prevent him from summarily sacrificing details for the unity of the areas of colour. The horizon line has been deliberately lowered so that the corollas of the white flowers stand out against the azure sky. Van Dongen had a gift for inventing powerful new painterly effects. The apple blossom is painted with a palette knife to achieve an enamel-like density. Everywhere else he used a brush, in particular for the areas necessitating transparent coats, and he deliberately left several areas of the ground unpainted to allow the colour to 'breathe' and not be suffocated by neighbouring vivid tones.

Although one senses here the influence of Matisse, the picture was certainly not painted before 1908. Nor can it have been painted before his then-close friend Picasso's first Cubist landscapes. In a 1909 photograph of him in his studio, there is a painting with the same cube-like house in the middle. The picture entitled *Spring* in the late-1908 exhibition at the Galerie Bernheim-Jeune was probably the Hermitage canvas. No other painting of the same name figures in any of van Dongen's exhibition catalogues.

Henri Fantin-Latour (1836-1904)

>-+→-0-+→+-<

Henri Fantin-Latour received his initial artistic
training from his father, a portraitist. He went
on to study at the Petite École Spéciale de
Dessin et de Mathématiques, founded by
Horace Lecoq de Boisbaudran, whose teaching
methods were based on memorisation. He also
copied the Old Masters in the Louvre. At the
Café Guerbois and the Salon des Refusés,
he played a part in the emergence of a new
type of painting, led by Édouard Manet. But
his singular style, appreciated by only a few,
and his innate reserve kept him on the margins
of the Impressionist movement. Tending more
towards Romanticism, a generation ahead
of his time, he is considered one of the
forerunners of Symbolism.

Fantin-Latour disliked travelling. When
he went to England and Germany it wasn't for
a change of scenery. He was an anglophile and a
friend of the American James McNeill Whistler
who, with his student companion Alphonse
Legros, had both settled in England. Through
the intermediary of the Edwards family, he
sold chiefly to English collectors. He was
also a Germanophile and Wagner enthusiast:
he attended the first performance of *The Ring*
at the newly built opera house in Bayreuth,
after which he visited Munich, where he
was impressed by Hans Thoma's sea sirens.

In the peace of his studio, with his wife,
also a painter, Fantin-Latour painted flowers,
group portraits, and, increasingly, vaporous
and mysterious allegories fleeing the world
of appearances. A prodigious lithographer,
he created enchanted visions peopled with
figures from a mythological world inspired by
music and opera, particularly *The Ring*, creating
an art in perfect keeping with Baudelaire's
Correspondances.

N. B.

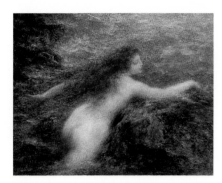

Cat. 36 *Naiad*
c. 1896
Oil on canvas
41.5 x 55 cm

Provenance: Sale of the Kerchner collection
(Vente Kerchner), Paris (sold for 5,600 francs);
Galerie Durand-Ruel, Paris; private collection,
Moscow; Russian Historical Museum, Moscow;
Pushkin Museum, Moscow, from 1926; State
Museum of Modern Western Art, Moscow, from
1930; the State Hermitage Museum, St.
Petersburg, from 1948.

This picture belongs to the painter's 'musical
fantasies'. A nymph similar to the one in the
Hermitage painting, but the opposite way
round, had already figured in the 1878 drawing
Rinaldo (Rhode Island School of Design,
Providence, Rhode Island), inspired by the
Brahms cantata of the same name. It depicts
Rinaldo's friends freeing him from Armida's
charms. The nymph borne through the waves by
a magical force became a recurrent image in
Fantin-Latour's 'musical' works, and crops up
several times in his lithographs and paintings
on Wagnerian themes.

The artist may well have been inspired by a
specific piece of music, possibly the Romantic
composer E. Hoffmann's opera *Ondine* or Pugni's
ballet *Ondine*. The picture was exhibited in
Durand-Ruel's gallery under this name and was
probably preceded by the pastel *Ondine*[1] (1896
Salon) and the sketch for it (no. 1619). In *Naiad*
the composition is the opposite way round to
the pastel. The corresponding lithograph was
published on 31 March 1896. Fantin-Latour
frequently returned to the themes of the water
sprite and the naiad. In the catalogue of his
complete works there is a detailed description,
accompanied with its dimensions, which
correspond exactly to those of the Hermitage

painting: 'No. 1629. A sea sprite, seen frontally,
bathes in the sea at the foot of a tall cliff, her
right arm outstretched, her left arm curved back
and gathering in her long blond hair streaming
behind her head.[2]'

[1] *Catalogue de l'œuvre de Fantin-Latour*, 1849-1904, compiled
and edited by Mme Fantin-Latour (Paris: Floury, 1911),
nos. 1614 and 1629.
[2] Ibid., no. 1629.

Émile-Othon Friesz (1879-1949)

The son and grandson of sailors, Émile-Othon Friesz was to retain a lifelong attachment to the international atmosphere of his home town, Le Havre, France's main port for the Americas. His unusual Creole first name came from his mother's parents, who had settled in Martinique. Friesz began his art training at the École Municipale des Beaux-Arts at Le Havre. With funds from a municipal scholarship, he entered the École des Beaux-Arts in Paris. Like the students in Gustave Moreau's atelier (Matisse, Marquet, and Manguin) and the Académie Carrière (Derain), Friesz visited the Louvre where he made copies after Old Master paintings. Trips to museums in Brussels and Antwerp in 1900 further advanced his knowledge of the art of the past.

During this period he became friends with Raoul Dufy. Calling themselves the 'Le Havre School', Friesz, Dufy, and Braque showed their works there from 1902. Although Friesz participated in the 1905 Salon d'Automne and thus was associated with Fauvism, his real Fauve work was initiated during his second trip to Antwerp with Braque during the summer of 1906. There he adopted a bright palette and composed his harbour scenes in a manner similar to Braque. Friesz's close association with Braque continued in 1906 when he made his first trip to the South of France in the company of his friend. Together they travelled to L'Estaque and in 1907 painted in La Ciotat, where they were visited by Matisse. The same year, Friesz met Derain, who was painting at Cassis, and they travelled to Munich together in 1909. That same year he discovered Italy and, even more importantly, Portugal, bringing back a series of outstanding canvases. By World War I, Friesz was working conservatively with subdued colours and linear compositions in a semi-Cubist manner.

M. P.-T.

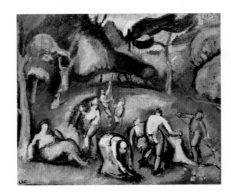

Cat. 27 *Autumn Work*
1907
Oil on canvas
54 x 65 cm

Provenance: Collection of S. I. Shchukin, Moscow, from 1909; First Museum of Modern Western Painting, Moscow, from 1918; State Museum of Modern Western Art, Moscow, from 1923; the State Hermitage Museum, St. Petersburg, from 1948.

The painting is a sketch for the picture of the same name (1907–8, Nasjonalgalleriet, Oslo), which marked a turning point in Friesz's work – he later explained that it was precisely in this work that he had embarked on a return to structure and had abandoned pure colour. This is not yet the case in the sketch, though, which is reminiscent of the 1907 La Ciotat landscapes.

The landscape in the background is a variation of *Autumn Landscape* (1907, former Chrysler Collection, United States), in which the harvest motifs which were to be developed in the Hermitage sketch were already sketched out. Never before had Friesz drawn so heavily on classical art. The pose of the man naked to the waist, on the right, was inspired by the Michelangelo *Slave* in the Louvre, and the leaning woman is reminiscent of Raphael's cartoon for *The Miraculous Draught of Fishes* (1515–16, Victoria and Albert Museum, London). These reminiscences, and others besides, are more clearly perceptible in the Oslo picture than in the sketch, which is less detailed.

The preparatory drawings for the picture are in the Statens Museum for Kunst in Copenhagen.

The sketch for *Autumn Work* was shown at the second 'Golden Fleece' exhibition in Moscow at the beginning of 1909 and was probably very quickly bought by Sergei Shchukin.

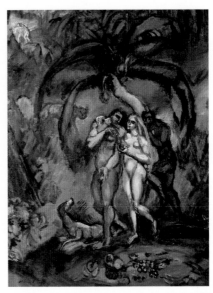

Cat. 9 *Temptation (Adam and Eve)*
c. 1910
Oil on canvas
73 x 60 cm

Provenance: Collection of I. A. Morozov, Moscow, from 1911 (purchased from Galerie Druet, Paris, for 500 francs); Second Museum of Modern Western Painting, Moscow, from 1918; State Museum of Modern Western Art, Moscow, from 1923; the State Hermitage Museum, St. Petersburg, from 1948.

The painting is a sketch for the *Adam and Eve* (1910, whereabouts unknown) Friesz exhibited at the 1910 Salon des Indépendants (no. 1969), which Apollinaire acclaimed as one of Friesz's major works. The sketch was painted on an old canvas cut out of a large-format picture.

Three preparatory drawings entitled *Adam and Eve* (pastel, pen, and pencil) are today in the Statens Museum for Kunst in Copenhagen. Around that time, Friesz painted another picture entitled *Adam and Eve* (dated 1910),[1] in which he developed a large decorative motif representing a fantastic garden filled with all manner of trees, flowers, and animals. Although placed in the foreground, Adam and Eve take up only a modest part of it. *Temptation* belongs to the 1910 cycle of pictures on the theme of the Garden of Eden: *Paradise, The Creation of Adam, The Birth of Eve,* and *The Original Sin.*

[1] Maximilien Gauthier, *Othon Friesz* (Geneva: P. Cailler, 1957), no. 62.

Paul Gauguin (1848-1903)

'I have two natures in me – the Indian and the sensitive. The sensitive has disappeared, enabling the Indian to walk straight and true.'[1] Drawing on the theories of biological determinism popular at the time, Paul Gauguin attributed his 'wildness, despite himself' to Inca and conquistador ancestry in Peru, where he had spent five years of his childhood.

A self-taught painter, Gauguin turned his back on his stock exchange career and his family, and spent the rest of his life fleeing the corruption, duplicity, and vice of civilisation. He went first of all to Brittany, where the mystery of ancient superstitions went hand in hand with an authentic yet already disappearing ruggedness. Next, the mirage of a school of artists working together in the tropics took him three times to the Caribbean. In 1887, he stayed in Panama and Martinique with Charles Laval. In 1891, still penniless, he left for the French colony of Tahiti, where he spent the remainder of his life, apart from a stay in France from 1893 to 1895. But the 'New Cythera' of Bougainville was now nothing but a myth: lacking a written culture, decimated by European diseases, the indigenous people had been colonised and converted to Christianity. Gauguin, a defender of the islanders and an anticlerical provocateur, soon found himself at loggerheads with civilisation's local Punch and Judy-style triumvirate of the missionary, the gendarme, and the public prosecutor. The penniless, misanthropic painter moved on to his last port of call, the Marquesas Islands.

Gauguin was the first artist to have completely shared the life of the 'primitives'. He identified with them and appreciated and assimilated their art. For all that, his pictorial references are often eclectic, and his barbarically coloured pantheistic visions reflect his nostalgia for a lost paradise.

N. B.

[1] Letter to his wife Mette (22 January–6 February 1888), in *Paul Gauguin, Lettres à sa femme et à ses amis*, ed. Maurice Malingue (Paris: Grasset, 1946).

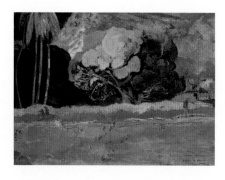

CAT. 15 *Fatata te Mouà (At the Foot of the Mountain)*
1892
Oil on canvas
68 x 92 cm

Provenance: Collection of I. A. Morozov, Moscow, from 1908 (purchased from Galerie Vollard, Paris, for 800 francs); Second Museum of Modern Western Painting, Moscow, from 1918; State Museum of Modern Western Art, Moscow, from 1923; the State Hermitage Museum, St. Petersburg, from 1948.

The Swedish anthropologist Bengt Danielsson, ex-governor of Tahiti and a great connoisseur of Tahitian art, pointed out that this landscape was painted on the island's south coast, where Gauguin lived in the village of Mataiea from late 1891 to mid-1893.

The enormous mango tree was one of the main attractions of the place where Gauguin had settled. On the right we see the painter's hut, but this is no reason to assume that the painting is topographically accurate. He later transposed the huge tree he had fallen in love with into an altogether different environment. It figures in two other 1892 paintings,[1] *Women on a River Bank* and *Matamua (In the Past)*, and then in *Hina Maruru (Festivities at Hina)* (1893)[2] and *Nave Nave Moe (Sacred Spring / Sweet Dreams)* (Hermitage; see cat. 8). The first links in this chain were the small study *Woman on a River Bank* and *Fatata te Mouà*, which did not yet carry the symbolic and religious baggage of *Matamua* and the later works, in which the motif of the large tree is linked in the artist's mind to the Tahitian moon goddess Hina.

The figure of the horseman galloping across the expanse of bare red ground bordered by majestic trees adds a discreetly Romantic note. According to Danielsson, at that time 'the population had diminished so much that huts were rare. And, as in this picture, one rarely saw

more than a single horseman or passer-by at a time.'[3] The raison d'être of the tiny figures of the horseman and the solitary walker, which one barely notices at first glance, was above all to emphasize the grandiose scale of nature. Yet at the same time, these figures also allude to a subject Gauguin was content merely to suggest. In a recent biography of the painter, David Sweetman postulates that the two figures are representations of Jotefa, an androgynous Tahitian adolescent whose image in two hypostases – horseman and woodcutter – could explain Gauguin's predilection for him, also expressed in *Noa Noa*.[4] Yet, if one can possibly admit that the horseman is Jotefa, there is no reason to apply this hypothesis to the right-hand figure, whom one is more inclined to see as a self-portrait of the artist. For a long time the painting was known as *The Large Tree*, under which title, having been bought by Morozov from Vollard, it arrived at his Moscow mansion. Yet, as Charles Sterling has pointed out, the Tahitian title means something else entirely, and the artist himself had given the title *Large Tree* to two other canvases painted a year earlier.[5] The picture was shown at the 1893 exhibition at the Galerie Durand-Ruel,[6] and is mentioned in a letter by Gauguin concerning the 1895 sale: 'Exceptionally, for the friends who have been faithful to me during these times, I'll maintain the catalogue prices for a few days: *Fatata te moua* . . . 400.'[7]

[1] Georges Wildenstein, *Gauguin*, vol. 1 (Paris: Beaux-Arts, 1964), nos. 462, 467.

[2] Ibid., no. 500.

[3] Bengt Danielsson, *Gauguin in the South Seas* (translation of *Gauguin Sönderhavsar*) (New York: Doubleday, 1965), no. 13.

[4] David Sweetman, *Paul Gauguin, A Life* (New York: Simon & Schuster, 1995), p. 338.

[5] Wildenstein, op. cit., nos. 437, 439.

[6] *Exposition d'œuvres récentes de Paul Gauguin* (Paris: Galerie Durand-Ruel, n.d.), no. 26.

[7] Published in *Gauguin*, catalogue of the exhibition at the Orangerie, Paris, 1949, appendix III.

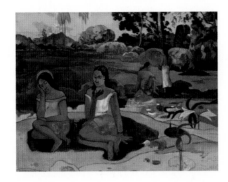

Cat. 8 *Nave Nave Moe (Sacred Spring / Sweet Dreams)*
1894
Oil on canvas
74 x 100 cm

Provenance: Sale of Gauguin's work at the Hôtel Drouot (no. 23), Paris, on 18 February 1895, auctioned to Emile Schuffenecker for 340 francs; Dosbourg sale (no. 16), Paris, on 10 November 1897 for 160 francs; collection of Prince Wagram, Paris; Galerie Vollard, Paris; collection of I. A. Morozov, Moscow, from 1908 (purchased from Vollard for 8,000 francs); Second Museum of Western Painting, Moscow, from 1918; State Museum of Modern Western Art, Moscow, from 1923; the State Hermitage Museum, St. Petersburg, from 1931.

The picture's second title, *Sacred Spring / Sweet Dreams*, originated in the catalogue of the exhibition/sale Gauguin organised in 1895 (which he probably compiled himself), in which it is called *Eau délicieuse*. However, the Tahitian title written on the canvas doesn't mean this. Georges Wildenstein takes it to mean 'Joy of resting'. Bouge and Danielsson propose more exact versions: *Sweet Reveries* or *Sweet Dreams*.

The picture dates from the period between Gauguin's two stays in Tahiti. It was painted at the beginning of 1894, after the two stained-glass windows he made at the end of the previous year for his Parisian studio: *Nave Nave* and *Tahitian Woman in a Landscape* (Musée d'Orsay, Paris), which feature the lotus flower that was later transposed in *Nave Nave Moe*. The picture was painted in Paris as a souvenir of Oceania and consists entirely of images from the first Tahitian period. Gauguin's studio in Paris was full of canvases that he had brought back from the South Seas. The figures in the foreground are also to be seen in *Te Fare Maorie (Maori House)* (1891),[1] the naked woman sitting in the centre in *Aha oe Feii (Are You Jealous?)* (1892,

Pushkin Museum of Fine Arts), and the Tahitian standing on one side in three 1892 paintings.[2] The Tahitian double divinity is also represented in *Vairaoumati Tei Oa (Her Name is Vairaoumati)* (1892, Pushkin Museum of Fine Arts). Richard Field presumes that this sculpture represented the supreme god Taaroa and one of his wives.[3] Other details are also re-uses.

Gauguin essentially based *Nave Nave Moe* on the picture entitled *Woman on the Beach* (private collection, Paris).[4] Wildenstein wrongly dates it 1898, whereas, in all likelihood, the artist had brought it back to Paris from Tahiti. This canvas, which also depicts the subject of the right-hand and central part of *Nave Nave Moe*, was painted, if not directly from life, then from quite impressionistic sketches from life, which the artist then abandoned for stylised generalisations and a synthetic composition steeped in rather odd religious ideas. It was to express these ideas that he incorporated the double idol into the landscape (absent from the picture *Women on the River Bank*) and placed the Virgin Mary and Eve with the apple, portrayed as Tahitian women, in the foreground.

One by no means insignificant detail of *Sacred Spring* eloquently reveals how Gauguin's symbolism functions: the common denominator of the similarly coloured skirts, with the same golden flower motif, worn by the Virgin Mary and Eve sitting next to one another like sisters, is a simple and effective symbolic device. By virtue of the picture's subtle formal orchestration, symbolism plays an important role here. We are made aware of this by the red marks outlined in the Cloisonnist manner, echoing one another: water, the fruit raised to the mouth, and the clothes of the main protagonists.

[1] Wildenstein, op. cit., no. 436.
[2] Wildenstein, op. cit., nos. 472–74.
[3] Richard S. Field, *Paul Gauguin, The Paintings of the First Voyage to Tahiti* (New York: Garland Publishing, 1977), p. 95.
[4] Wildenstein, op. cit., no. 574.

Cat. 47 *Man Picking Fruit in a Yellow Landscape*
1897
Oil on canvas
92.5 x 73.3 cm

Provenance: Sent by Gauguin from Tahiti to the Galerie Vollard, Paris, on 9 December 1898; Galerie Vollard; collection of S. I. Shchukin, Moscow; First Museum of Modern Western Painting, Moscow, from 1918; State Museum of Modern Western Art, Moscow, from 1923; the State Hermitage Museum, St. Petersburg, from 1948.

This picture is related to the large-scale composition *Where Do We Come From? What Are We? Where Are We Going?* (Museum of Fine Arts, Boston). The central figure of the man reaching up to pick a fruit from a tree is shown wearing only a loincloth, as in the preparatory canvas for the panel, which the painter entitled *Tahiti: Characters from What Are We?* (1897, private collection, New York).[1] The figure has an important symbolic role in the *What Are We?* panel. The allusion to the tree of knowledge is absolutely clear. In *Man Picking Fruit from a Tree*, the philosophical content is still vague: the picture resembles more a scene from everyday life. One can therefore assume that it was painted before the panel.

The figure in the Hermitage picture reappears later in *Faa Ara (The Awakening)* (1898, Ny Carlsberg Glyptotek, Copenhagen).

[1] Wildenstein, op. cit., no. 560.

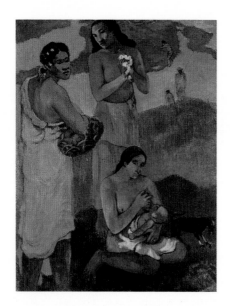

Cat. 39 *Women by the Sea (Maternity)*
1899
Oil on canvas
95.5 x 73.5 cm

Provenance: Galerie Vollard, Paris, from 1900; collection of S. I. Shchukin, Moscow, from 1903 or 1904; First Museum of Modern Western Painting, Moscow, from 1918; State Museum of Modern Western Art, Moscow, from 1923; the State Hermitage Museum, St. Petersburg, from 1948.

In March 1899, Pau'ura gave birth to a baby boy, whom Gauguin named Émile (like the son he had with Mette, who had stayed in Copenhagen). Danielsson and other researchers have associated this event with the painting of two pictures. Following Wildenstein's example, they were habitually called *Maternity I* (Hermitage) and *Maternity II* (David Rockefeller Collection, New York). The second canvas differs by its vivid colour and decorative style and the absence of the dog and the figures in the background. It isn't dated but, in all likelihood, it was also painted in 1899, probably after *Women by the Sea*. The Hermitage painting was one of some ten canvases sent to Vollard in January 1900 with the following description: '8) Three figures. In the foreground, woman crouching, breastfeeding a child. On the right, small black dog. On the left, standing woman, in red dress with a basket. Behind, woman in green dress holding flowers. Background of blue lagoons on red-orange sand.'[1] When he painted *Women by the Sea*, Gauguin mixed real-life observation, the iconography of scenes of the

adoration of the Infant Jesus by the Old Masters and Puvis de Chavannes's compositional devices. Gauguin undoubtedly knew his decorative canvases *Young Women at the Seaside* and *Sweet Country* (1882). At the same time, while working on the painting the artist would have recalled his own *Three Tahitian Women* (1897, National Gallery of Scotland, Edinburgh). The figure of the woman with flowers standing in the centre is one of the most recurrent images in Gauguin's painting. It appears in three other 1899 pictures, *Two Tahitian Women with Mango Blossoms* (Metropolitan Museum, New York), *Rupe Rupe* (Pushkin Museum of Fine Arts), and *Te Avae No Maria* (*The Month of Mary*) (see cat. 38), as well as in several other works.

The picture was shown at the Gauguin exhibition at Vollard's gallery in 1903.

[1] Jean de Rotonchamp, *Paul Gauguin* (Paris: Crès, 1925), p. 221.

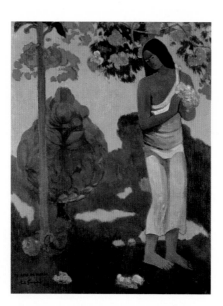

Cat. 38 *Te Avae No Maria* (*The Month of Mary*)
1899
Oil on canvas
96 x 74.5 cm

Provenance: Galerie Vollard, Paris, from 1903 (sent by Gauguin from Atuona); collection of S. I. Shchukin, Moscow (acquired before 1910); First Museum of Modern Western Painting, Moscow, from 1918; State Museum of Modern Western Art, Moscow, from 1923; the State Hermitage Museum, St. Petersburg, from 1930.

The picture is also known as *Woman with Flowers in Her Arms*, a title which came from the list of

canvases that Gauguin sent Vollard in 1903: '9) Te avae no Maria. A woman with flowers in her arms on a yellow-green background. On the left, a fruit tree and a tropical plant.'[1] The picture's Tahitian title means 'the month of Mary', that is, the month in the Roman Catholic calendar devoted to the worship of the Virgin Mary (the May masses), during which there falls a festival of pagan origin that in Europe has celebrated the awakening of nature since the dawn of time. Nature in bloom, therefore, becomes the central subject of Gauguin's picture, and this is emphasised by the yellow ground and the figure of the woman, whose pose is taken from a bas-relief from the Javanese temple of Borobudur, *The Ablutions of Bodhisattva* (c. AD 800). Gauguin took a photograph of it with him to Tahiti and, in 1898–99, re-used the pose of this stone figure. He also found the prototype for the 'tropical plant' in the Borobudur relief. The picture's principal elements were already in *Faa Iheihe* (*Tahitian Pastorale*) (1898, Tate Gallery, London). The far right-hand part of this picture comes, with a few changes, from *Rupe Rupe* (1899, Pushkin Museum of Fine Arts). It became an independent motif in *The Month of Mary*. The heroine's pose appears again in other 1899 canvases: *Three Tahitian Women against a Yellow Background*, the two versions of *Maternity* (see cat. 39) and in *Te Tiai Na Oe Ite Rata*[2] (*Are You Waiting For a Letter?*).

[1] Rotonchamp, op. cit., p. 221.
[2] Wildenstein, op. cit., no. 587.

Henri Le Fauconnier (1881-1946)

A painter and theoretician, Le Fauconnier initially studied law at the Université de Paris, but decided to become an artist instead, entering the studio of Jean-Paul Laurens. In 1902 he enrolled at the Académie Julian, where he came into contact with Roger de La Fresnaye and André Dunoyer de Segonzac. He exhibited at the Salon des Indépendants from 1905. Le Fauconnier was impressed by the Fauves at the 1905 Salon d'Automne, but never joined their ranks. Like many artists of his generation, Le Fauconnier was profoundly affected by Cézanne, an influence that led him down the Cubist path. In Ploumanac'h, on the coast of Brittany, where he spent every summer from 1907 to 1913, Le Fauconnier created a 'Breton Cubism' using large shapes, minimal detail, and a dark palette to capture the omnipresence of granite in the grey light of the seashore. He felt confirmed in this direction through contact from 1909 to 1913 with the Montparnasse Cubists, who included Delaunay, Gleizes, Metzinger, and Léger.

In 1910 he became a member of Kandinsky's Neue Künstlervereinigung (New Association of Artists) in Munich and his work was published in 1912 in the Blaue Reiter (Blue Rider) almanac in Munich. Le Fauconnier established a link between French artists and the German Expressionists in this quest for 'the spiritual in art'. In 1912 he became director of the La Palette academy, where Chagall and Gromaire were among his pupils.

Around 1913 he turned from Cubism towards a kind of visionary Expressionism. On moving to Holland, where he lived from 1914 to 1920, he became a important figure in the art world. His work was widely popular in Russia, Germany, and Austria. On returning to France, Le Fauconnier reverted to a realistic and skilfully constructed style.

M. P.-T.

CAT. 29 *The Lake*
1911
Oil on canvas
92 x 72.5 cm

Provenance: Collection of S. A. Poliakov, Moscow (purchased at the 'Jack of Diamonds' exhibition in Moscow, no. 211, for 100 roubles), from 1912; State Tretyakov Gallery, Moscow, from 1919; State Museum of Modern Western Art, Moscow, from 1925; the State Hermitage Museum, St. Petersburg, from 1948.

This picture was very favourably reviewed by Apollinaire when it was exhibited at the 1911 Salon d'Automne under the title *Lakeside Trees* along with two other landscapes painted on the banks of Lake Annecy. The poet acknowledged Le Fauconnier's mastery of colour and it is noteworthy that Marc, Macke, and Klee all visited his studio as soon as they arrived in Paris. Roger Allard, one of the most influential art critics of the time, wrote an article entitled 'The Blaue Reiter Almanac' accompanied by two reproductions, Matisse's *Dance* and Le Fauconnier's *Lake*, in which he noted that Le Fauconnier had put 'all the noble reserve of his northern character into the delicate architecture of his space creations'.[1]

Allard saw Le Fauconnier's work as an example of Cubism, but today he is considered as a painter in the Cézanne tradition, hardly influenced by Cubism at all. And despite the fact that the picture's central motif is the ancient castle of Duingt on the banks of Lake Annecy, which Cézanne himself had painted fifteen years earlier, there is nothing imitative about the work.

[1] Roger Allard, 'Signs of Renewal in Painting', in *The Blaue Reiter Almanac*, ed. Wassily Kandinsky and Franz Marc, rev. ed. (London: Thames and Hudson, 1974), p. 109.

Aristide Maillol (1861-1944)

In the fall of 1882 Maillol moved to Paris from his birthplace at Banyuls-sur-Mer in the South of France in order to study painting with Jean-Léon Gérôme. But Gérôme advised him to study at the École Nationale des Arts Décoratifs, where he enrolled in January 1883 to study sculpture. He then attended the École des Beaux-Arts, where he studied in the atelier of Alexandre Cabanel from 1885. Upon the death of Cabanel in 1889, he worked in the atelier of the painter Jean-Paul Laurens until 1893. Although his early work shows the influence of Puvis de Chavannes, Gauguin, and the Nabis, he gave up painting in 1893 to establish a tapestry workshop at Banyuls-sur-Mer. At the turn of the century, Maillol was forced to abandon tapestry due to failing eyesight. He turned to sculpture, which he exhibited for the first time at Ambroise Vollard's in 1902.

At the 1905 Salon d'Automne, where the Fauve artists exhibited landscapes, Maillol was represented with a plaster known as *La Méditerranée* depicting his wife as a bather. Rodin introduced Maillol to Count Harry Kessler, who became his patron and commissioned a version of *La Méditerranée* in marble. In 1904, Count Kessler invited Maillol to London to see the sculptures from the Parthenon on display at the British Museum. Subsequently, Kessler invited Maillol to accompany him and the poet Hugo von Hofmannsthal on a trip to Greece in the spring of 1908. This journey encouraged Maillol to continue to make sculpture in the idiom of a contemporary Mediterranean classicism. But he travelled little in the ordered course of a life spent in Marly-le-Roy in the summer and Banyuls-sur-Mer in winter. At the invitation of Kessler, Maillol travelled to Germany in 1928 and to Florence in 1934.

M. P.-T.

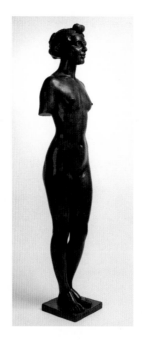

Cat. 61 *Spring (without Arms)*
1910–11
Bronze
169 x 42 x 20 cm; base: 27.5 x 27.5 cm

Provenance: Collection of the sculptor; Gallery of Dina Vierny, Paris; private collection, Paris, from 1982; the State Hermitage Museum, St. Petersburg, from 1996.

This work is related to the group of sculptures that Ivan Morozov commissioned for his music room. Among the group's four statues, which symbolise the seasons, there is another *Spring* (1910–11, Pushkin Museum of Fine Arts). At the outset, the figure had no arms and no head (1910). In Morozov's final version, *Spring* is a naked woman trying out a garland of flowers on her breast. Her head raised and her neck slightly craned forward, she seems to be looking at herself in a mirror. In the 'without arms' version, which Maillol worked on at the same time, the gesture was eliminated to obtain a more unified outline.

There are six casts of this sculpture, of which the Hermitage's is the second. According to Dina Vierny, Maillol's model, assistant and dealer, the light patina is the work of Maillol himself.

Henri Manguin (1874-1949)

In 1894 Manguin began artistic studies under the tutelage of Gustave Moreau at the École des Beaux-Arts in Paris. There he made friends with the future Fauve artists Henri Matisse, Albert Marquet, Jean Puy, and Charles Camoin. Like his contemporaries in Moreau's atelier, he visited the Louvre to make copies of Old Master paintings, thereby gaining a thorough grounding in pictorial lessons from artists such as Poussin, Titian, Delacroix, Velázquez, Rembrandt, and Chardin. Manguin's artistic debut took place in 1902, when he contributed to the Salon des Indépendants. By 1903 he was painting in a proto-Fauve manner with heightened non-naturalistic colours and broken brushstrokes. Manguin made his first trip to the South of France in September 1904, when he stayed with Paul Signac at Saint-Tropez. Shortly thereafter he rented the Villa Demière at Malleribes near Saint-Tropez, where he stayed with his family until September 1905. That summer, on a bicycle trip with his wife and Signac, the latter acting as tour guide, he discovered the Côte d'Azur. He responded to the light of the Mediterranean coast by painting with a bright, colourful palette. His reputation was enhanced when he exhibited at the famous 1905 Salon d'Automne, where Fauvism was christened. In 1908 he renewed his friendship with Marquet at the Académie Ranson and later that year travelled with him to Naples. From 1909 until the end of his career, Manguin continued to apply Fauve colours to his naturalistic renderings of the landscapes he encountered during his extensive trips to Italy, Normandy, and the South of France.

M. P.-T.

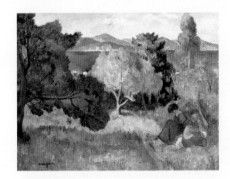

Cat. 24 *Path in Saint-Tropez*
1905
Oil on canvas
73 x 91.5 cm

Provenance: Galerie Vollard, Paris (purchased from the artist), from 1905; collection of G. E. Haasen, St. Petersburg, from March 1906; the State Hermitage Museum, St. Petersburg, from 1921.

Manguin, who since the beginning of the Fauve period had spent his summers on the Côte d'Azur, in the 'beautiful region of Saint-Tropez', painted picture after picture in a state of rapturous awe of Mediterranean nature. In June 1905, he declared to Matisse: 'I am filled with wonder by this land and particularly by the place where we are now. It is absolutely extraordinary, and I would like to use that, since I know I will never find anything the same again. [...] I must tell you how happy I am here, in this wonderful region where we have the sea, plains, and mountains, infinitely varied, in a totally restricted space, not to mention the sun, which has already shone enough for two months.'[1] The chromatic range of Manguin's paintings is not very broad. His happy vision of the world incited him to seek joyous colour harmonies, to intensify and lighten tones. Most of his Fauve period canvases were executed in the same palette of scarlet tints, light blue, light violet, and tones of green.

Path in Saint-Tropez was painted at the Villa Demière near Saint-Tropez in the summer of 1905. Manguin also painted *The Meadow, Villa Demière* (1905, private collection) from the same viewpoint at about the same time. The figures on the right of the picture are the painter's wife and their sons. In the catalogue of Manguin's complete works, the picture is called *Saint-Tropez. Jeanne and her Sons.*[2]

[1] *Henri Manguin 1874–1949* (Paris: Musée Marmottan, 1989), p. 129.
[2] Lucile and Claude Manguin, eds., *Henri Manguin. Catalogue raisonné de l'œuvre peint* (Neuchâtel: Ides et Calendes, 1980).

Albert Marquet (1875-1947)

Albert Marquet's life was deeply marked by his childhood and youth in Bordeaux. He loved the lively atmosphere of the port, where he lingered between home and school. He entered the École Nationale des Arts Décoratifs, then worked under Gustave Moreau at the École des Beaux-Arts. There he was encouraged to visit the Louvre and make copies after Old Master paintings. While in Moreau's atelier, he painted nudes in a Fauve manner alongside Matisse. The most important journey of his early career took place in May 1905 when he visited Marseilles and Saint-Tropez. With Charles Camoin, he painted scenic spots along the Côte d'Azur. Later that summer he travelled alone to Nice and Menton. He exhibited at the famous 1905 Salon d'Automne, when the term 'fauve' was coined, although his style was generally more understated and conservative than that of Matisse and Derain.

For the remainder of his career Marquet continued to paint landscapes that are site specific. A confirmed traveller, Marquet visited Le Havre (with Dufy) and Sainte-Adresse in 1906 and then London in 1907 in the company of Camoin and Friesz. In 1908 he discovered Italy with Manguin. His time in Naples contributed to a new perspective. Thereafter he preferred to paint seascapes rather than cityscapes. In 1913, Marquet went to Morocco with Matisse. While Paris and Algeria were favourite locales, Marquet travelled widely between 1920 and 1939, visiting Tunisia, Norway, Egypt, Spain, Roumania, the USSR, Morocco (again), Italy, Switzerland, Holland, and Sweden.

M. P.-T.

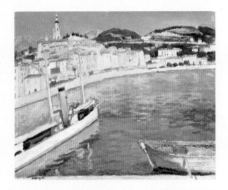

Cat. 19 *Menton Harbour*
1905
Oil on canvas
50.5 x 61 cm

Provenance: Galerie Bernheim-Jeune, Paris; collection of G. E. Haasen, St. Petersburg; the State Hermitage Museum, St. Petersburg, from 1921.

In the summer of 1905, Marquet worked first in Saint-Tropez, then went along the Côte d'Azur to Menton. The whole series of landscapes he painted there, mostly seascapes, are characteristically vividly coloured. Apart from the Hermitage picture, there is another view of the port of Menton (Hessel Collection), which was shown in February-March 1906 at the 'Libre Esthétique' exhibition in Brussels (no. 153). One of the two Menton landscapes was shown at the famous 1905 Salon d'Automne (no. 1044), but since the catalogue mentions neither the work's dimensions or other characteristics, one does not know which. The picture shows the Promenade du Midi in Menton with, on the left, beyond the houses, the town's principal monument, the seventeenth-century Cathedral of Saint-Michel.

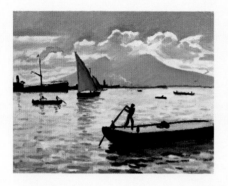

CAT. 18 *Bay of Naples*
1909
Oil on canvas
62 x 80.3 cm

Provenance: Collection of I. A. Morozov, Moscow, from 1913 (purchased from Galerie Druet, Paris, for 3,750 francs); Second Museum of Modern Western Painting, Moscow, from 1918; State Museum of Modern Western Art, Moscow, from 1923; the State Hermitage Museum, St. Petersburg, from 1948.

The extreme terseness of Marquet's style was close to that of the Fauves, and even enabled him to exhibit with them, but whereas his great friend Matisse allowed his imagination free rein, he remained faithful to the impression from nature. He addressed the same problem the Impressionists posed themselves: that of rendering the sensation of atmosphere saturated with light. However, the simplicity with which he achieved this, using few marks and colours, was not Impressionist in manner. Steeped in a fresh, limpid, luminous marine light, *Bay of Naples* is one of his greatest landscapes. The use of white, blue, and black allows the picture to 'breathe'. There is no vibration in the atmosphere; there can be none. Nature, in Marquet's work, is light and serene, an invitation to meditate. The landscape opens onto a beckoning depth, free of all constraint. Only the vessels sailing on this liquid mirror enable one to perceive the serene succession of planes.

After discovering Naples in 1908, Marquet spent most of the next summer there. At the exhibition at the Galerie Druet in May 1910, he showed eleven landscapes brought back from Naples some months earlier. For the most part, the works in this series show the Bay of Naples against the backdrop of Vesuvius, sprinkled with rowing boats, ships under sail, and small steam vessels. The closest to the Hermitage painting in their structure and treatment are *Naples. The Sailing Ship* (1909, Musée des Beaux-Arts, Bordeaux) and *Naples. The Rower* (1909, private collection, Paris). *Vesuvius* (1909, Pushkin Museum of Fine Arts, Moscow) was painted from the same viewpoint.

Henri Matisse (1869-1954)

In 1891, after abandoning plans for a career in law, Matisse became a student of the academic artist William Bouguereau at the Académie Julian. A year later he was invited to join Gustave Moreau's studio at the École des Beaux-Arts, where he stayed until 1898. Matisse learnt important lessons from Moreau, who stressed the primacy of imagination and feeling, advised his students to go into the streets to observe life, and encouraged them to visit the Louvre to copy the Old Masters. While studying under Moreau, Matisse became friends with Marquet, Manguin, and Puy, and became acquainted with Derain, who was studying in Eugène Carrière's studio. In 1898 he discovered the Mediterranean in Corsica: 'It was at Ajaccio that I experienced the great wonder of the South.'[1] From 1904, Matisse was to spend most of his summers in the South of France. In 1904 he stayed at Saint-Tropez in the company of Paul Signac and Henri-Edmond Cross and experimented with Neo-Impressionism. In the summer of 1905, in the fishing village of Collioure, he worked with Derain on a new conception of light and colour in painting. These pictures established Fauvism when shown at the 1905 Salon d'Automne. The following year Matisse met Moscow merchant Sergei Shchukin, who commissioned him in 1909 to make decorative panels on the themes of dance and music for the stairwell of his home. In 1911 Matisse was invited by his Russian patron to study icons in Moscow.

An inveterate traveller to exotic locations, Matisse visited Tangier in 1911. He returned to Morocco in 1912–13 with his friend Camoin and once again met Marquet and the Canadian painter J. W. Morrice. Matisse

settled in Nice after 1920. En route to Tahiti in 1930, he visited the United States, where he met his future patron, Dr. Albert Barnes, at his home in Merion, Pennsylvania.

<div align="right">M. P.-T.</div>

[1] Pierre Schneider, ed., *Henri Matisse: exposition du centenaire* (Paris: RMN, 1970), p. 52.

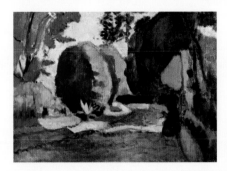

CAT. 16 *The Luxembourg Gardens*
c. 1901
Oil on canvas
59.5 x 81.5 cm

Provenance: Galerie Druet, Paris; collection of S. I. Shchukin, Moscow, from 1907; First Museum of Modern Western Painting, Moscow, from 1918; State Museum of Modern Western Art, Moscow, from 1923; the State Hermitage Museum, St. Petersburg, from 1948.

The colours, although extremely dense, are based on observations from nature. The trees have an early autumn feel about them, due to the cool shadows and unexpected proximity of the glowing purple and the yellowing but still green vegetation in the clearings. In *The Luxembourg Gardens* and in other Paris views from the same period, Matisse's painting has certain traits in common with Gauguin's. This affinity with Gauguin, one of whose works Matisse had bought in 1899, was partly due to the coarse-grained canvas he chose to paint on, similar to hessian, which was Gauguin's favourite surface. The latter's influence can be felt in the more subdued approach. Following Gauguin's example, Matisse eliminated details and built the landscape out of a few large, powerful areas of colour. Although he did not draw his inspiration from the colours of the tropics, he has used more vivid colours than Gauguin. To appreciate their similarities and

differences, one merely has to compare *The Luxembourg Gardens* with Gauguin's *Fatata te Moùa (At the Foot of the Mountain)* (cat. 15). Matisse probably knew this canvas, as it was on view at the Galerie Vollard, which the young painter often visited.

There are other pictures of the Luxembourg Gardens, small studies, including *On the Edge of the Path. The Luxembourg Gardens* (c. 1901, private collection, New York).

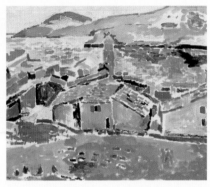

CAT. 23 *View of Collioure*
c. 1905
Oil on canvas
59.5 x 73 cm

Provenance: Galerie Bernheim-Jeune, Paris (purchased from the artist), from 15 February 1908; collection of S. I. Shchukin, Moscow (purchased for 1,000 francs), from 9 January 1909; First Museum of Modern Western Painting, Moscow, from 1918; State Museum of Modern Western Art, Moscow, from 1923; the State Hermitage Museum, St. Petersburg, from 1948.

Matisse worked at Collioure during the summer of 1905, then again in the spring and summer of 1906. *View of Collioure* (also called *The Roofs of Collioure*) has been given both dates. The date 1905, written in pencil on the stretcher, perhaps by the Galerie Bernheim-Jeune, was changed to 1906. The original date is more plausible, though, given the work's style: the work fits comfortably into the 1905 group of Collioure works – *Seascape* (Museum of Fine Arts, San Francisco), *Street in Collioure* (private collection), and *Red Beach* (Luddington Collection, Santa Barbara), which is particularly close to the Hermitage painting. And it was in 1905 that Matisse introduced large, flat areas of pure colour into the Divisionist language of separate, isolated brushstrokes.

The vivid colours and the way in which they are applied to the canvas were intended to be decorative, but also to enable a simple, even naive expression of the feeling of nature. However, the total liberation of colour did not resolve all the problems posed by the painting of a picture. The colours had to be harmonised, but not evened out, and it was precisely during the summer of 1905 that Matisse found the solution to the problem. He recalled later: 'At that time, at Collioure, I pursued a theory or an odd habit I had heard Vuillard talk about, who used the notion of "decisive touch" ... Which helped me a lot because it made me feel how the object was coloured: I applied that colour and it was the first colour on the canvas. Then I added a second one but as it didn't go with the first, instead of removing it I added a third, which reconciled them. I then had to continue in this vein until I felt that I had created an absolutely harmonious canvas and that I had discharged the emotion that had spurred me to begin it.'[1] In *View of Collioure*, the two first colours were dictated by the orange-red of the roofs and the blue of the sea. The role of the third colour fell to green. The other hue contributing to this reconciliation is pink. Infrared photography shows the picture's very clear linear composition. The impression the picture gives of a spontaneously executed study is misleading: Matisse began applying paint only after having first drawn on the canvas.

View of Collioure includes one of the main landmarks of this town at the foot of the Pyrenees, the Chapel of Saint Vincent. During 1905, Matisse painted the chapel's rounded bell tower in *View of Collioure with the Chapel* (Museum of Modern Art, New York), *Collioure* (Bridgestone Gallery, Tokyo), *The Port of Collioure* (The Baltimore Museum of Art), and also in *The Port of Collioure and Nets Drying. Collioure* (private collections).

[1] Jean Guichard-Meili, *Matisse* (Paris: Hazan, 1967), p. 48.

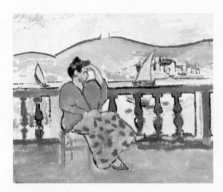

Cat. 20 *Lady on a Terrace*
1907
Oil on canvas
65 x 80.5 cm

Provenance: Galerie Druet, Paris; collection of S. I. Shchukin, Moscow, from 1908; First Museum of Modern Western Painting, Moscow, from 1918; State Museum of Modern Western Art, Moscow, from 1923; the State Hermitage Museum, St. Petersburg, from 1948.

This picture is characterised by the use of coloured outlines, indicative of the artist's refocusing on the organisational role of drawing, which had been eclipsed for a while by the Fauvist 'explosion' of colour. The end of Fauvism was drawing nigh. Here, true, the outlines are less frontiers than distinct areas in themselves. Which is why, within the picture's colour structure, the outline is given a concrete tone, complementary to and heightening the dynamism of the area it encloses. Furthermore, Matisse does not content himself with delimiting areas of colour, but reconciles juxtaposed hues. He ostensibly uses a formal device already employed by van Gogh. The thick, negligently drawn lines, the flat treatment and choice of details – a bright green mountain, a seaside house, sailing boats – evoke children's drawings. Matisse may have been interested and amused by his own sons' drawings of their mother, since the woman on the terrace is the painter's wife, Amélie.

The picture was painted at Collioure in the summer of 1907. The date 1906, proposed by several researchers, seems early. Although, as in his 1906 works, the painter used extremely bright colours, whose resonance he further accentuated by introducing coloured outlines, the lines provided a framework or linear skeleton that is absolutely characteristic of his 1907

works and which one finds in the most important painting of that period, *Luxe* (Statens Museum for Kunst, Copenhagen), in which the mountains at Collioure also appear in the background. The balustrade overlooking the sea against a backdrop of mountains appears again in *Interior at Collioure. Siesta* (c. 1905, private collection, Ancona).

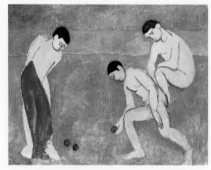

Cat. 41 *Game of Bowls*
1908
Oil on canvas
115 x 147 cm

Provenance: Galerie Bernheim-Jeune, Paris; collection S. I. Shchukin, Moscow, from 1909; First Museum of Modern Western Painting, Moscow, from 1918; State Museum of Modern Western Art, Moscow, from 1923; the State Hermitage Museum, St. Petersburg, from 1948.

It can be said of the protagonists of *Game of Bowls*, and of those of *Dance* and *Music*, painted subsequently, that they both do and do not look like real people. With their passion for games that all adolescents of the time had, these youths really do seem to be playing the popular French game of *pétanque*, but at the same time their gestures and poses are almost ritualistic. Matisse's figures are not having fun, they are engaged in the 'game of life'. The extremely simplified landscape is the only appropriate place for the action, and perfectly matches the scene's austere, mysterious symbolism. The stretch of water visible on the horizon – the sea or a river – is less a component of a landscape than a symbolic element: since time immemorial, the river, like the sea, has been a metaphor for the dialectic unity of life and

death. The more symbolic such a painting is, the more it is steeped in primitivism.

In the picture, the painter designates a subject, but the absence of explanatory detail and the overall simplification of formal means turn it into an allegory. The number of figures is itself symbolic (in popular tradition, three is the favourite number). And it is no coincidence that there are also three *boules*: the whole scene can be perceived as a divination ceremony. That the picture's chromatic range should have nothing joyful about it could at first seem surprising, but on reflection reveals itself to be entirely justified. In part, the green of the meadow embodies the Earth's vital forces, but also, in ancient Egypt, green was the colour of Osiris, the god of the productive forces of nature and sovereign of the sepulchral world. The symbolism of the colour has not one but two meanings, because it is of an intuitive and not a literary order.

The picture was painted very quickly early in the summer of 1908 and by midsummer was already in Moscow. It is not known whether Matisse did preparatory drawings. *Game of Bowls* belongs to the cycle of works linked to the theme of the 'golden age' that began with *The Joy of Living* (1905–6, Barnes Foundation, Merion) and continued with the two versions of *Luxe* (1907, Centre Georges Pompidou, Paris; Statens Museum for Kunst, Copenhagen). The next stage was *Bathers with a Turtle* (1908, Saint Louis Art Museum), a composition with three figures, and *Game of Bowls*. The poses of the figures in *Luxe* and *Game of Bowls* have a lot in common. The Hermitage painting is just as close to *Bathers*, both in terms of the surrounding landscape and the placement of the figures.

The symbolic environment of *Game of Bowls*, a boundless green meadow with an expanse of blue water, comes from *Bathers with a Turtle*, a canvas the same size as *The Joy of Living*, and after it, *The Red Room*. The symbolism of *Bathers* and *Game of Bowls* is inherent in every component of style and content: the simplification of the landscape, and the number of figures and their nudity, which harks back to man's primitive state.

By making *Game of Bowls* the masculine counterpart to *Bathers*, Matisse was wilfully engaging in a deliberate primitivism. According to Picasso, with whom he was on good terms during

this period, he developed this style at a time when his sons, Pierre and Jean, had only just begun drawing. With his perfectly attuned eye, Matisse had understood, by observing their approximate contours and the clumsiness of their infantile daubing, how to simplify down to the essential.

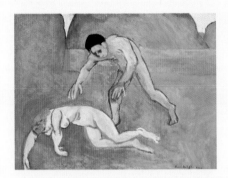

Cat. 40 *Nymph and Satyr*
1908–9
Oil on canvas
89 x 116.5 cm

Provenance: Collection S. I. Shchukin, Moscow (purchased through the mediation of the Galerie Bernheim-Jeune for 3,000 francs), from 12 January 1909; First Museum of Modern Western Painting, Moscow, from 1918; State Museum of Modern Western Art, Moscow, from 1923; the State Hermitage Museum, St. Petersburg, from 1948.

In the spring of 1907, Matisse completed a ceramic triptych, for the Osthaus villa in Hagen, whose side sections represent a dancing nymph and whose central part depicts a satyr and a nymph. Unlike the later Hermitage version, the satyr in the ceramic panel is covered with hair and has goat's legs. The legs of the nymph are half-hidden by a cloth. The painting that served as a prototype for the ceramic was Correggio's *Jupiter and Antiope* in the Louvre. But Matisse would certainly have been familiar with other versions of the subject, in particular Watteau's *Nymph and Faun* (Musée du Louvre, Paris).

When Matisse first addressed this theme in a painting commissioned by Sergei Shchukin, who clearly knew the Hagen triptych, he discarded all allusion to mythology and modified the figures' poses. The canvas is not only larger than its ceramic counterpart but also infinitely more effective due to its exceptionally vivid colours. Its Expressionist hues and overt sensuality are unique in Matisse's work. Flam attributes this particularity to Matisse's passion for his Russian pupil Olga Meerson.[1] The red-haired nymph, despite her exaggerated features, does strongly resemble the model of the *Portrait of Olga Meerson* (Museum of Fine Arts, Houston).

The picture was painted at Cassis, at the Hôtel Cendrillon, in January 1909. On 7 February, Matisse announced to Fénéon: 'I've finished, as you must have been told, the picture that you sold to Mr. Shchukin, *Faun Surprising a Nymph*. I think it's probably dry, but as the paint can't yet have hardened, please don't have it photographed until it has been framed . . . Allow me to remind you that Mr Shchukin is impatiently awaiting the picture, and that he made me promise to have it sent as soon as possible, express, to Moscow.'[2] Matisse had begun the picture in 1908 (he mentioned it in a letter to Fénéon dated 26 November). It was probably then that the photograph of the composition in its first state was taken. Today, without even resorting to X-ray photography, one can make out the previous outlines beneath the coat of green paint, and one senses that in their initial state, the movements of the figures were even more dynamic.

[1] Jack Flam, *Matisse: The Man and his Art* (Ithaca: Cornell University Press, 1986), p. 248.
[2] *Henri Matisse* (Paris: Galerie Bernheim-Jeune, 1977).

Painting, Moscow, from 1918; State Museum of Modern Western Art, Moscow, from 1923; the State Hermitage Museum, St. Petersburg, from 1931.

The picture is a kind of postscript to *The Red Room* (Hermitage). The departure point for both works was a canvas by Jouy, which Matisse had reproduced three years before in *Vase, Bottle and Fruit* (Hermitage) and in 1908 in *Harmony in Blue*, which, after he reworked it, became *The Red Room*. As in the 'canvas for Monsieur C's dining room', the painter simplified the drawing of the ornamentation and gave it much more dynamism. He also opted for brighter colours than the original Jouy picture. His earlier representations of this motif, before *Harmony in Blue*, were less terse. The chocolate pot on the left appeared in other pictures, including *Crockery on a Table* (Hermitage), but here Matisse painted it in ochre hues to provide exactly the right contrast with the blue of the tablecloth.

Matisse finished the picture in January 1909. In a letter he wrote to Fénéon on 7 February 1909, it is clear that the picture was already dry. He asked Fénéon to have it taken to Druet to be photographed before being urgently sent to Shchukin along with *Nymph and Satyr*: 'Would you mind also having collected from me the still life he commissioned and which will leave in the same shipment?'[1]

[1] *Henri Matisse* (Paris: Galerie Bernheim-Jeune, 1977).

Cat. 48 *Still Life with Blue Tablecloth*
1909
Oil on canvas
88.5 x 116 cm

Provenance: Collection of S. I. Shchukin, Moscow (acquired from the artist for 3,000 francs), from 1909; First Museum of Modern Western

crockery. But in every detail – the ornate bronze top of the chest of drawers, the jugs and climbing plants – one sees echoes of the same motif: the languorous, bewitching curves of the nymph's body, an ancestral symbol of an ideal world.

Cat. 51 *Fruit, Flowers, and the panel 'Dance'*
1909
Oil on canvas
89.5 x 117.5 cm

Provenance: Collection of I. A. Morozov, Moscow (purchased from the artist for 5,000 francs), from 1910; Second Museum of Modern Western Painting, Moscow, from 1918; State Museum of Modern Western Art, Moscow, from 1923; the State Hermitage Museum, St. Petersburg, from 1948.

Cat. 49 *Pink Statuette and Pitcher on a Red Chest of Drawers*
1910
Oil on canvas
90 x 117 cm

Provenance: Collection of S. I. Shchukin, Moscow, from 1910; First Museum of Modern Western Painting, Moscow, from 1918; State Museum of Modern Western Art, Moscow, from 1923; the State Hermitage Museum, St. Petersburg, from 1930.

In this picture, also known as *Still Life with 'Dance'*, Matisse again took up the genre of the still life and the studio interior he had already tackled in *Studio Corner* (private collection, Paris), but here he introduces one of his own works into the picture – the first version of *Dance* (1909, Museum of Modern Art, New York). Certain critical works have erroneously indicated that the work reproduced is the one Matisse painted for Sergei Shchukin.

When Shchukin wrote to the painter to tell him how enthusiastic he was about the *Dance* panel, he was talking about the first version, which can be seen only just begun in a photograph of Matisse in his studio taken by the great American photographer Edward Steichen. The outlines of the figures have barely been sketched in. Later, Matisse worked on both canvases at the same time. Consequently, the picture shows not the Issy-les-Moulineaux studio, as has sometimes been indicated, but the one in Boulevard des Invalides, where Shchukin visited him before 31 March 1909, the date of his letter confirming the commission for the new *Dance*.

The picture, also known as *Still Life with Pewter Pot*, was painted at Issy-les-Moulineaux: the plank wall also figures in *Pink Studio* (1911, Pushkin Museum of Fine Arts), and the same chest of drawers is in *Red Studio* (1911, Museum of Modern Art, New York). Matisse painted the terracotta statuette of the reclining woman several times between 1908 and 1912: it appears in *Sculpture and Persian Vase* (1908, Nasjonalgalleriet, Oslo), *The Goldfish* (1909-10, Statens Museum for Kunst, Copenhagen), *Goldfish and Sculpture* (1911, Museum of Modern Art, New York), and *Goldfish. Interior* (1912, Barnes Foundation, Merion). This work by Matisse, known above all from several bronze casts, was sculpted in 1907. It reproduces the pose of one of the nudes in *The Joy of Living* (1905–6, Barnes Foundation, Merion). The statuette was also the origin of the painting *Blue Nude: souvenir of Biskra* (1907, The Baltimore Museum of Arts).

That Matisse should have used this statuette more often than any other object in the construction of his still lifes is hardly surprising. Each ensemble of objects takes on a particular meaning when juxtaposed with it. In *Pink Statuette*, the little figure is not immediately 'legible'. Its form is less distinct than that of the surrounding

Cat. 50 *Standing Moroccan in Green (The Standing Riffian)*
1913
Oil on canvas
146.6 x 97.7 cm

Provenance: Collection of S. I. Shchukin, Moscow, from 1913 (purchased from the artist); First Museum of Modern Western Painting, Moscow, from 1918; State Museum of Modern Western Art, Moscow, from 1923; the State Hermitage Museum, St. Petersburg, from 1948.

On the back of this picture there is a label on which has been written 'M. Henri Matisse, Hôtel de France, Tanger'.

Matisse stayed at the Villa de France Hotel from October 1912 to mid-February 1913. At the beginning of November, he wrote to his family that he was preparing to paint a picture of a Riffian and, on 21 November, announced to Marguerite that he had begun 'a canvas the same size as Shchukin's *Goldfish*. It's the portrait of a Riffian [*sic*], a kind of mountain dweller, magnificent and as wild as a jackal' (Archives Matisse, Paris).

The allusion to *The Goldfish* was of course not merely to indicate the picture's dimensions, but also implied the possibility that the two canvases might go together. Shchukin was undoubtedly also counting on the effect the pairing of the paintings would produce.

Matisse met a representative of the Riffians, a warrior people, in Tangier. He drew him frenetically (private collection, nos. 46–51 of the exhibition 'Matisse in Morocco')[1] and painted two pictures. One, *Seated Riffian* (1912–13, Barnes Foundation, Merion), is very large (200 by 160 cm) and the figure has been given heroic, larger-than-life proportions. The other *Standing Moroccan* – which at the Hermitage has kept its traditional title of *Standing Moroccan in Green* – is smaller but its colour is more vibrant. It has been suggested that *Standing Moroccan* could well be a preparatory study,[2] but this is clearly not so. From a compositional point of view, the pictures are different in design and, even if they are somewhat akin in colour, this does not mask their important differences on the emotional level. It is significant that Shchukin, who had the choice of the two, preferred the smaller picture.

One can take the drawing *Moroccan, three-quarter length* (no. 47 of the exhibition 'Matisse in Morocco', Washington, DC, New York, Moscow, and Leningrad, 1990) to be a preparatory study for *Standing Moroccan*.

On 10 January 1913, Matisse sent his son Jean a postcard of Tangier with the caption 'Tipo de la Kabila de Raisili': 'Here's a character from the village of Raisuli, a famous brigand who held travellers to ransom in the Tangier area a few years ago. To appease him, the sultan appointed him governor of a province. And so he became an official thief, intimidating his citizens.'[3] The painter probably sent this postcard because of the brigand's striking resemblance to the Riffian who had posed for him.

[1] Jack Cowart, Albert Kostenevich et al., *Matisse in Morocco, The Paintings and Drawings*, 1912–1913 (Washington, DC and New York: National Gallery of Art and Harry N. Abrams Inc., 1990).

[2] Commentary by Agnès Humbert in Gaston Diehl, *Henri Matisse* (Paris: Tisné, 1954), p. 140.

[3] The postcard is in the Archives Matisse, Paris. It is reproduced in J. Cowart, A. Kostenevich et al., op. cit.

Pablo Picasso (1881-1973)

In his youth, Picasso demonstrated extraordinary talent. At the age of eleven he took classes in ornamental drawing from his father at the School of Art in Corunna. In 1895 he began a course in classical art and still life at the Escuela de Bellas Artes in Barcelona. This was followed in 1897 by a brief stint at the Academia Real de San Fernando in Madrid. Picasso gained a prodigious knowledge of the history of art by studying a wide range of Old Master paintings at the Prado.

The years 1901 to 1904 are known as his Blue Period. During this time, he worked primarily in Barcelona and his iconography was centered on the tragic outcasts of life. By 1904 Picasso had settled in Paris, where his friends included poets and writers such as Guillaume Apollinaire, Max Jacob, and André Salmon. The Blue Period was followed by the Rose Period (1904–6), during which he depicted actors and circus performers. In the summer of 1906, in Gósol, an isolated Catalan village in the Pyrenees, he absorbed influences from Iberian sculpture and discovered how distortion might be deployed for expressive purposes. Along with African and Oceanic works seen in the Musée d'Ethnographie du Trocadéro, the Cézanne retrospective at the 1906 Salon d'Automne provided the necessary impetus to advance his work in 1907 towards Cubism. He spent the summer of 1909 at Horta de Ebro in southern Spain. There he painted landscapes in a Cubist vocabulary of geometric forms that betray his debt to Cézanne's analysis of structure. In 1910, Picasso visited Derain at Cadaqués on the Spanish coast near the French border. For the remainder of his career, Picasso enjoyed a close association with the South of France and the Mediterranean coast.

M. P.-T.

CAT. 42 *Naked Youth*
1906
Gouache on cardboard
67.5 x 52 cm

Provenance: Collection of S. I. Shchukin, Moscow, from 1914; First Museum of Modern Western Painting, Moscow, from 1918; State Museum of Modern Western Art, Moscow, from 1923; the State Hermitage Museum, St. Petersburg, from 1934.

In early 1906, Picasso worked on an idea for a large picture – which he never painted – on the theme of the watering place. Inspired by Gauguin's *Riders on the Beach* (Stavros Niarchos Collection), it was to represent several naked young people and horses. In the sketches in gouache[1] and crayon,[2] there is a young man with a horse in the middle, a motif Picasso developed separately in the major canvas *Boy Leading a Horse* (1906, Museum of Modern Art, New York), with the figure's pose slightly modified. One can assume that *Naked Youth*, painted in spring 1906, heralded the group of works with young riders. It is also related to the travelling performer theme, as the box of circus accessories on which the figure is leaning reminds us.

At the same time, *Naked Youth* reflects the neo-classical tendencies manifesting themselves in Picasso's work at precisely this time. He had obviously studied the antique sculptures in the Louvre closely. Everything about the 'boy', whom Richardson calls the *Ephebe*, is reminiscent of statues such as the kouros from Paros (mid-sixth

century BC, Musée du Louvre, Paris). Richardson suggests another, hitherto unrevealed source for the Hermitage gouache: a Javanese bas-relief representing a standing figure, whose pose is exactly the same as the naked youth's.[3] There was a plaster copy of this bas-relief in the Paris cabaret Au Lapin Agile, which Picasso regularly frequented. In a photograph of the cabaret's interior (1905),[4] one can clearly see the Javanese bas-relief (plaster casts of which were sold at the 1900 Exposition Universelle) and also Picasso's painting, inspired by his visits to Au Lapin Agile (1905, private collection),[5] in which he portrays himself as a harlequin.

On the back of Naked Youth, there is another, undoubtedly earlier gouache and charcoal composition, Reclining Woman and Naked Youth, but horizontal instead of vertical. This sketch, which was never transposed into a painting, is linked to the vast Rose Period cycle devoted to travelling performers. The other study on the theme of resting performers, The Acrobat's Family (1905, private collection, Germany), a gouache representing a woman lying and a man sitting on a bed, was probably executed at the same time.[6] The sleeping woman in the Hermitage drawing is clearly Fernande Olivier, Picasso's companion at that time. Picasso met this artist's model, who claimed to have posed for Cormon, Carolus-Duran, Boldini, and Degas, in 1904. In September of the following year she moved in with him at the Bateau Lavoir. However, she very rarely appears in Picasso's 1904–5 work. It is interesting to note that in two other works painted at the end of 1904, Sleeping Nude (whereabouts unknown)[7] and Meditation (private collection),[8] the artist portrays his companion asleep.

The most plausible date for the gouache is late 1904. The same characters are represented in the watercolour Saltimbanques (Ludwig Collection, Aquisgran), dated 1904 by the painter himself, in which a young man sitting on a bunk listens to a naked girl who has already got up and is brushing her hair.

[1] Christian Zervos, Pablo Picasso, vol. 1 (Paris: Cahiers d'Art, 1932), no. 265.
[2] Pierre Daix and Georges Boudaille, Pablo Picasso, 1900–1906. Catalogue raisonné de l'œuvre peint (Neuchâtel: Ides et Calendes, 1966), no. 14.

[3] John Richardson and Marilyn McCully, A Life of Picasso, vol. 1, 1881–1906 (New York: Random House, 1991), p. 427.
[4] Ibid., 1991, p. 373.
[5] Zervos, op. cit., vol. 1, no. 275.
[6] Zervos, op. cit., vol. 1, no. 289.
[7] Zervos, op. cit., vol. 1, no. 234.
[8] Zervos, op. cit., vol. 1, no. 235.

CAT. 43 Dryad
1908
Oil on canvas
185 x 108 cm

Provenance: Kahnweiler Gallery, Paris; collection of S. I. Shchukin, Moscow; First Museum of Modern Western Painting, Moscow, from 1918; State Museum of Modern Western Art, Moscow, from 1923; the State Hermitage Museum, St. Petersburg, from 1934.

Dryad or Nude in a Forest occupies a place totally on its own in Picasso's 1907–8 bather cycle, which owed much to Cézanne. This in itself already poses a problem as much psychological as it is chronological: when exactly was it painted? It has been dated spring, summer and even autumn 1908. It is significant that a connoisseur as eminent as William Rubin should have indicated 'spring-autumn 1908'.[1]

One can consider the pencil drawing in sketchbook 15 (36R) Woman in an Armchair (1908, Musée Picasso, Paris) to have been one of the first expressions of the impulse that led to Dryad. The woman's pose in the drawing, in which she seems to be slipping out of the armchair, was retained in the painting without being really explicit. Steinberg[2] has seen the presence of the armchair as a link with Les Demoiselles d'Avignon, in which the action takes place in an interior. Such a link, as much thematic as formal, can be better perceived when one considers, instead of Les Demoiselles d'Avignon, the studies for it. Steinberg also cites other, earlier sources for Dryad: the canvas entitled Nudes Embracing or Nudes Kissing (1905, Statens Museum for Kunst, Copenhagen), in which the female figure's pose already has all the characteristics of the 1908 picture, and also the drawing Female Figure (1905, Musée Picasso, Paris), whose pose constitutes an invitation and on which the painter wrote the letters 'S.V.P.' ('s'il vous plaît').

Nonetheless, one cannot claim that Dryad is in the same vein as the sarcastic drawing of the Rose Period. The unprecedented parody of the eternal feminine, with its blend of invitation and menace, has here become a frightening vision of an idol of some unknown cult. The feeling of terror emanating from the painting stems to a large extent from the work's initial source, recently brought to light by Richardson: the Dryad's pose is absolutely identical to that of the corpse hanging by the neck in an engraving from the second book by Andrea Vesalius, the famous sixteenth-century naturalist, On the Construction of the Human Body.[3] It is entirely possible that the artist may have been shown this engraving by Guillaume Apollinaire, a great lover of antiquarian books.

Picasso had the idea for a painting of a standing female nude as early as 1907. He carried this out for the first time in Dance of the Veils (Hermitage) and in the numerous studies he did for this painting, which nevertheless do not explore all the subject's possibilities. He clearly wanted to paint a nude that would defy convention. It was precisely at this time that figures with indecent gestures first appeared, in the two preparatory drawings for Dryad (June-July 1907, Musée Picasso, Paris): one a pen drawing

on the back of a watercolour study for *Les Demoiselles d'Avignon*,[4] the other in pencil.[5] There ensued a series of sketches, which Zervos dated 1907.[6] Just before beginning this canvas, Picasso executed a gouache sketch,[7] which includes yet another female figure in the background. The sketch has a more concrete, more 'natural' side to it. When one compares it to the picture, one comes to the conclusion that the 'hatched', lapidary, and energetic aspect of the forms did not appear immediately but while working on the painting, as was the case for *Woman with a Fan*.

[1] William Rubin, *Picasso and Braque. Pioneering Cubism* (New York: The Museum of Modern Art, 1989), p. 103.
[2] Leo Steinberg, 'The Philosophical Brothel', in *Art News*, September 1972.
[3] Andreas Vesalius, *De humani corporis fabrica*, 1543; see Richardson, op. cit., vol. 2, p. 89.
[4] Zervos, op. cit., vol. 6, no. 992.
[5] Zervos, op. cit., vol. 6, no. 912.
[6] Zervos, op. cit., vol. 26, nos. 163–65, 180.
[7] Zervos, op. cit., vol. 2, no. 112.

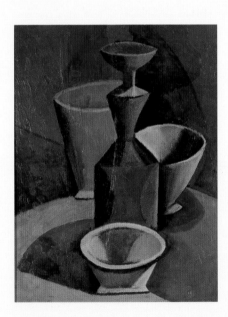

CAT. 52 *Carafe and Three Bowls*
1908
Oil on cardboard
66 x 50.5 cm

Provenance: Kahnweiler Gallery, Paris; collection of S. I. Shchukin, Moscow; First Museum of Modern Western Painting, Moscow, from 1918; State Museum of Modern Western Art, Moscow, from 1923; the State Hermitage Museum, St. Petersburg, from 1948.

After the Cézanne retrospective in 1907 and the first publication of the now-famous letter he sent to Émile Bernard from Aix, in which he advises him to consider nature in terms of the cylinder, sphere, and cone, the young avant-garde painters became increasingly fascinated by geometricising tendencies. Furthermore, Picasso chose objects whose fundamental cylindrical or conical structure needed no revealing through analysis, since these were obviously inherent properties of the objects themselves. Elements comprising all three forms are partially present in the carafe in *Carafe and Three Bowls*, one of his most 'sculptural' compositions. Yet one can talk of a Cézanne influence only rather cautiously, since Picasso's insistence on emphasising geometrical principles borders on parody. There is absolutely no question of mockery here, though. Picasso had immense respect for Cézanne, and one can but feel how serious he was about this painting. This still life is an act of profound faith. Contemplating it, one finds oneself in front of an immanent presence of objects, in which the valueless things of everyday life take on a vital and hieratic meaning.

The picture was probably painted in Paris during the summer of 1908, although one cannot entirely discount it having been executed at a later date in La Rue-des-Bois. It is reminiscent of *Jug, Bowl and Fruit Dish* (1908, Philadelphia Museum of Art), which is usually considered to be one of the La Rue-des-Bois works. On the other hand, although details of the still life can be more easily linked to real aspects of this village than Paris, the fact that Picasso was merely developing here a motif of an earlier composition – *Carafe, Bowl and Lemon* (Galerie Beyeler, Basel) – tends to favour Paris. The preparatory sketch for this still life, executed in ink, is in one of the sketchbooks in the Marina Picasso Collection (43R); Picasso completed this sketchbook in May-June 1907. The principles on which the *Carafe and Three Bowls* composition is based also point to the sketch. Picasso might have painted the picture before he left for La Rue-des-Bois. But from a stylistic point of view it could not have been painted before spring 1908.

A radiograph shows that the picture was painted over a landscape by Picasso that, judging by certain stylistic details, probably dates back to 1901.

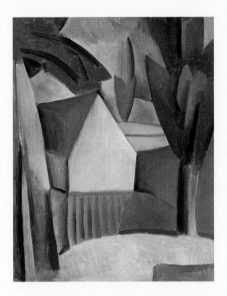

CAT. 54 *Small House in a Garden*
1908
Oil on canvas
73 x 61 cm

Provenance: Kahnweiler Gallery, Paris; collection of S. I. Shchukin, Moscow; First Museum of Modern Western Painting, Moscow, from 1918; State Museum of Modern Western Art, Moscow, from 1923; the State Hermitage Museum, St. Petersburg, from 1930.

The picture was painted near Creil, in La Rue-des-Bois. In August 1908, Picasso retired to this tiny village sixty kilometres north of Paris to escape the city heat and the stress of work. Situated on a road alongside the River Oise near the forest of Halatte, it consisted of no more than ten small houses. But when it came to finding nature in tune with the Cubist manner, it was a good choice. Although he had intended to stay longer, Picasso only stayed there for what proved to be a very productive month. It is hard to believe that *Small House in a Garden* represents the nature of Île-de-France, the cradle of Impressionism. Picasso did not paint it from nature, – in general, he maintained he never painted landscapes from nature – but *Small House in a Garden* is nevertheless quite a concrete representation of the place where he was staying. The generalisations in the treatment do not mask the landscape's specific details, such as the species of the trees. We immediately grasp that the sky looming over this region, gloomy as it may be, is very green (a few similar examples

even provided a pretext for certain authors to speak of a 'green period' in Picasso's work). And other features of reality remain, such as the modest village's tiny houses. Yet, unlike the Impressionist landscapes, who could remember ever seeing countryside quite like Picasso's enchanted land? *Small House in a Garden* is the product of an anti-Impressionist conception of the world, a negation of what Picasso called 'painting which depends on the weather'.

Of the five landscapes painted at La Rue-des-Bois, the closest to the Hermitage picture is the canvas with the same title in the Pushkin Museum of Fine Arts.[1] Both were probably painted shortly after he arrived in the village.

[1] Zervos, op. cit., vol. 2, no. 81.

CAT. 37 Bathing
1908
Oil on canvas
38.5 x 62.5 cm

Provenance: Kahnweiler Gallery, Paris;
collection of S. I. Shchukin, Moscow; First
Museum of Modern Western Painting, Moscow,
from 1918; State Museum of Modern Western Art,
Moscow, from 1923; the State Hermitage Museum,
St. Petersburg, from 1948.

The picture was inspired by Cézanne's *Bathers* and belongs to the cycle of works representing naked women in the open air: *Three Nude Women*,[1] *Friendship* (Hermitage), and *Bathers in the Forest*.[2] Picasso may possibly have had a monumental composition in mind since the picture appears to be a sketch.

Bathing was clearly preceded by the drawing *Bathers* (1908, Musée Picasso, Paris), which is more naturalistic in style: on the left there is a woman lying down, on the right a woman standing holding drapery (the same as in *Dance of the Veils* in the Hermitage). In both style and motif, the picture is close to the pen drawing *Nude Woman* (1908, Musée Picasso, Paris).

In February 1908, Picasso filled a little sketchbook with nine drawings.[3] Brigitte Léal, who published this album, considers that all three drawings are sketches and studies for *Three Women* (Hermitage). However, only one sheet corresponds to this work.[4] All the others are, in a certain manner, the initial sketches for the figures, in *Bathing*. The first sheet (4R) contains only the date 8 February ('8 febrero'), which enables one to precisely determine the starting point of the work on *Bathing*. Next (6V) comes a standing nude figure which one finds again – greatly modified – on the right-hand side of the painting. The two drawings on the following sheet (7R and 7V) represent the heads of the reclining figures in *Bathing*. Sheet 8V is the first sketch for *Three Women*: Picasso chose an almost square format for this composition, which also includes three bathers. The other sheets, consisting of five drawings (9–12), are again related to the idea of *Bathing*. Clearly, Picasso then had a large composition in mind, which he originally wanted to be in the spirit of *Bathers* but which never got beyond the sketch stage.

[1] Zervos, op. cit., vol. 2, no. 53.
[2] Ibid; no. 66.
[3] Brigitte Léal, *Carnets. Catalogue des dessins de Picasso*, vol. 1 (Paris: RMN, 1996), pp. 199–201.
[4] Sheet 8V, ibid., p. 200.

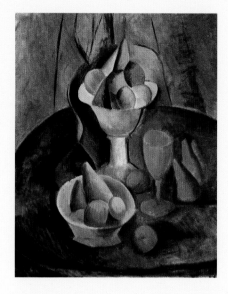

CAT. 53 *Vase with Fruit*
1909
Oil on canvas
91 x 72.5 cm

Provenance: Kahnweiler Gallery, Paris; collection of S. I. Shchukin, Moscow; First Museum of Modern Western Painting, Moscow, from 1918; State Museum of Modern Western Art, Moscow, from 1923; the State Hermitage Museum, St. Petersburg, from 1948.

The picture, also known as *Fruit Dish with Pears* and *Vase, Fruit and Glass*, was painted in Paris early in 1909. At that time, Picasso was also painting a series of still lifes that differ from those of the summer and autumn of 1908 in that they are less monumental and more complex in rhythm.

Of the works in this group, the closest to the Hermitage composition are *Fruit Dish* (Museum of Modern Art, New York) and *Vase, Gourd and Fruit on a Table* (Whitney Collection, New York), painted at the beginning of 1909. The Musée de Grenoble has a small watercolour also entitled *Fruit Dish*, clearly painted at the same time as the Hermitage picture. In it, one recognises, despite it being presented less distinctly, a fruit dish the same as this one containing apples and pears. This rather curious dish, evoking the corolla of a flower, was an Art Nouveau design dating from the 1890s. It belonged to Picasso, who painted it in three works, either literally or, as in the Hermitage picture, in a simplified form. It also figures, with pears, in the background of *Queen Isabeau* (1909, Pushkin Museum of Fine Arts).

In *Vase with Fruit*, one feels the distinct influence of Cézanne. The picture differs from the still lifes painted in the summer of 1908 in the moderation of its hues and by its precise construction. The objects are seen from different, although similar, points of view, and are drawn less stiffly, and the space that surrounds them is condensed. The picture's overall tonality is more polyphonic, although the treatment of texture – the glass and the flesh of the fruit – is evened out, as was already the case. The composition is very studied and ordered: the large fruit dish reigns centre frame, while the pears, apples, and melon that constitute its 'retinue' stand respectfully at its sides.

As far as possible, each object is placed in such a way as to not hide the others and not disturb the overall balance.

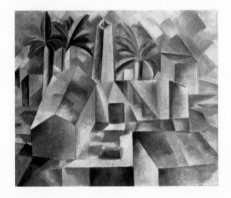

Cat. 28 *Brick Factory at Tortosa*
1909
Oil on canvas
50.7 x 60.2 cm

Provenance: Collection of Haviland, Paris, from 1909; collection of S. I. Shchukin, Moscow; First Museum of Modern Western Painting, Moscow, from 1918; State Museum of Modern Western Art, Moscow, from 1923; the State Hermitage Museum, St. Petersburg, from 1948.

Until quite recently, the picture was called *Factory at Horta de Ebro*.

From June to September 1909, Picasso stayed at Horta de Ebro (present-day Horta de San Juan). Formerly, everything Picasso had brought back from Spain was considered to have been painted at Horta. Daix established that a few works were executed during a stopover in Barcelona. *Brick Factory* does not in fact depict Horta, even though it was undoubtedly painted there.

Palau i Fabre pointed out that there are palm trees in the picture, which do not grow at Horta de Ebro. Subsequent researchers have generally repeated his view that Picasso invented this feature of the landscape, but this explanation is unsatisfactory since Picasso's deformations were always made from reality. The 'crystallising' tendency, which reached its culmination in the landscapes of summer 1909, was a result of the nature of the locations and the architecture of the Tarragona region. In photographs taken by Picasso, which he sent to the Steins in Paris, we can see clearly the 'cubist' structure of these landscapes, dotted with cube-like whitewashed dwellings. Comparison with these photographs shows that Picasso did not represent the village of Horta in a precise fashion, nor even by simplifying or geometricising certain details. Like El Greco, whom he greatly admired and who, in his pictures of Toledo, displaced or left out houses at will, he followed not the exact topography but the demands of rhythm and composition. But the character of the place was nonetheless very faithfully rendered. Picasso himself pointed this out by the simple fact of sending photographs.

He didn't need to invent the palm trees because they grow at Tortosa, the region's administrative centre. Tortosa and Horta de Ebro are on the same river, the Ebro, and at the beginning of June, Picasso stopped off there on his way to Horta. On 5 June, he sent a postcard from Tortosa, a view of the town, and he may well have returned there later.

It was Maria Luisa Borras, from Barcelona, who (verbally) recognised Tortosa as the place represented in the Hermitage canvas. Today, Tortosa is still renowned for its brickworks, which traditionally have a main building like a barn, canopies to shelter the bricks, and a usually rectangular chimney. It is a brickworks of this type that is represented in the Hermitage picture.

The landscapes of the village of Horta de Ebro, treated in the same way as *Brick Factory at Tortosa*, differ in the mountainous aspect of the site. The two landscapes *Houses on a Hill* (Museum of Modern Art, New York) and *Reservoir. Horta* (David Rockefeller Collection, New York) once belonged to Gertrude Stein, who in her memoirs does not assign them a precise location.

Pierre Puvis de Chavannes
(1824-1898)

Born in Lyons, Pierre Puvis de Chavannes was originally destined for a career as an engineer, like his father, but a serious illness forced him to abandon this plan. In 1846, he developed an interest in art during a trip to Italy. On his return to Paris, he studied in the studios of Henry Scheffer, Eugène Delacroix (shortly before it closed), and Thomas Couture. During this period, in 1848, 'I left for Italy, where I got seriously down to work. For a year, alone, I worked from the model, drawing and painting non-stop. My schooling was my free search for my taste, and my study my heeding only my instincts . . . I've never been a great traveller either. I've seen a little of Italy, Florence, a bit of Spain, San Sebastian, and that's about it. I adore Provence, its light, its horizons and sea views.'[1]

From 1850, Puvis de Chavannes showed regularly at the Salon. He proved particularly adept at decorative painting and developed a style well suited to murals, with simplified forms, a respect for the flatness of the picture surface, pale colours, and clear, well-ordered compositions. He received his first public commission, for the Musée Napoléon, in 1864. This was followed by many others for public monuments in Paris, in the provinces, and even abroad (Boston), all of which helped spread his fame and his sphere of influence.

Puvis de Chavannes had little taste for travelling, however, as he explained to a friend: 'The countries you have visited are unknown to me, but, from what you say about them, I have seen analogous ones, and they've made me slightly sick. Man must keep an awareness of his power in creation, and doing much with little is an altogether greater pleasure than wandering around in search of certain beauties which are not human in scale . . . I, dear child,

know exactly where my place is . . . and I draw my sustenance now from France alone. . . It's like chamber music compared to the powerful harmonies which you have been struck by, but it has its grandeur, and its calm gracefulness is very pervasive.'[2]

N. B.

[1] Paul Guigou, 'Puvis de Chavannes', *La Revue du siècle*, no. 56 (January 1892), p. 3.
[2] Letters from 1877 and 1878 quoted in Ary Renan, 'Puvis de Chavannes', in *La Revue de Paris*, vol. 1 (15 January 1895), p. 444.

CAT. 32 *Woman by the Sea*
1887
Oil on paper pasted on canvas
75.3 x 74.5 cm

Provenance: Collection of I. S. Ostroukhov, Moscow; I. S. Ostroukhov Museum of Icon-Painting and Art, from 1918; State Museum of Modern Western Art, Moscow, from 1929; the State Hermitage Museum, St. Petersburg, from 1931.

The picture was once known as *Madwoman by the Sea*, a title given to it in Russia. On the back of the canvas there is an old French label, on which the artist wrote 'Woman by the Sea'. Several attempts were made to link the painting to Félix Pyat's short story *La Folle d'Ostende* (written in 1858, but not published until 1886 in the collection of the same name), which may have inspired *Woman by the Sea*'s melodramatic conception. Pyat's story is about the wife of a fisherman reported missing at sea, who goes mad searching for him along a deserted stretch of coastline. Puvis de Chavannes

may indeed have read the story, especially since he had always been very drawn to the theme of the poor fisherman. But there is absolutely nothing directly illustrative about his work. The heroine of the Hermitage picture shows no visible signs of madness.

Two works comparable to *Woman by the Sea* were shown in the exhibition 'Puvis de Chavannes' in Ottawa in 1976–77:[1] a watercolour of a woman on a deserted beach (no. 181), in which the figure is the opposite way round to the Hermitage picture, and a red chalk drawing (no. 182) bearing the title *La Fée aux blés* (*The Corn Fairy*), written by the painter himself. In the drawing the woman is holding a corn wreath. There is also an oil sketch, *Fée sur la plage de sable* (*Fairy on a Sandy Beach*; private collection, Paris). Clearly Puvis de Chavannes was hesitating between several still quite abstract projects, for which he reused the same figure. Two years earlier he had painted a woman in the same pose in the background of *Ancient Vision* (Carnegie Institute, Museum of Art, Pittsburgh).

[1] Louise d'Argencourt, *Puvis de Chavannes*, exh. cat. (Paris: Éditions des Musées Nationaux, 1976).

Jean Puy (1876-1960)

'I had a vocation. I was captivated by the novels of Jules Verne, which I reread incessantly. I knew all there was to know about storms, savage cannibals, and crocodiles. I would be a sailor.'[1] But his father had different ideas and Jean Puy began his training as an architect at the École des Beaux-Arts in Lyon. He then switched to painting, continuing his training in Paris at the Académie Julian. Dissatisfaction with the academic approach led him to transfer to the Académie Carrière, where he came into contact with Derain. He soon became friends with the future Fauve artists taught by Gustave Moreau. By 1904 he was working frequently in Manguin's studio in the company of Matisse, who became his friend.

In 1904 and 1906 Puy made visits to the South of France, staying at Saint-Tropez and Collioure. Although his favourite bedside reading was Homer's *Odyssey*, Puy found the rough coast of Brittany preferable to the Mediterranean. He was deeply attached to the region, and was one of the few who remained faithful to it during the Fauve period: 'Why travel? The subjects I know I see with new eyes.'[2] His participation in the 1905 Salon d'Automne assured him a place in art history as a Fauve, since his painting was located in the 'cage aux fauves' (wild beasts' cage). Eschewing explosive Fauve colours, Puy adopted a more restrained approach to landscape painting than Matisse, Derain, and Vlaminck. In his interest in domestic scenes, concern for atmosphere, and merging of Fauvism and Impressionism, he remained closer to Bonnard. Always on the fringe of the avant-garde, Puy retired to his home town of Roanne in 1927 and thereafter made only brief appearances in Parisian art circles.

M. P.-T.

[1] Letter to Charles Camoin, 14 May 1944, Charles Camoin Archives, Paris. Quoted in Marion Chatillon-Limouzi, 'Jean Puy: l'homme et sa vie', *Un fauve en Bretagne, Jean Puy*, exh. cat. (Paris: ADAGP, 1995).

[2] Jean Puy, *Souvenirs, Archives familiales*, quoted in Chatillon-Limouzi, op. cit.

Cat. 25 *Summer*
1906
Oil on canvas
76.6 x 112.5 cm

Provenance: Galerie Vollard, Paris; collection of I. A. Morozov, Moscow, from 1908; Second Museum of Modern Western Painting, Moscow, from 1918; State Museum of Modern Western Art, Moscow, from 1923; the State Hermitage Museum, St. Petersburg, from 1934.

Guillaume Apollinaire considered that the singularity of Jean Puy's art lay in the fact that it was 'absolutely free of sadness and has a witty and exquisitely delightful charm, so rare in our time'.[1] The poet's words come to mind especially when one considers *Summer*, which is characterised by an overall tonality full of nobility and freshness, and by a decorative aspect of great freedom. With its magnificent landscape setting and its skilfully animated *mise en scène*, it could easily have served as a sketch for a theatre set. But turn-of-the-century stage design had no need for Puy's talent. Besides, he was above all interested in easel painting. One can assume that Puy drew his inspiration from existing pictures on the Shakespearean theme of A *Midsummer Night's Dream*. In late-nineteenth-century England and France, pictures of the inhabitants of Titania's and Oberon's realm were often a pretext for depicting erotically charged subjects. Puy certainly knew the painting by Henri Camille Danger, *Elves* (1896), in which the forest in the background bears some resemblance to the landscape in *Summer*, but, discreetly parodying his predecessors, he deliberately gave the scene a real, contemporary tonality.

[1] 'Compte rendu de l'exposition "Jean Puy"', *L'Intransigeant*, 12 January 1911; reprinted in *Apollinaire on Art: Essays and Reviews 1902–1918* (New York: Viking Press, 1972), p. 130.

Odilon Redon (1840-1916)

Odilon Redon was a frail child (he may also
have been epileptic). He spent his childhood
on his family's estate at Peyrelebade, near
Bordeaux. He remained profoundly attached
to this austere region between the vineyards
and the ocean and, when he moved to Paris after
the war of 1870, he returned there every summer,
until the property had to be sold in 1897.

Attracted by drawing, writing, and music,
Redon took lessons with a local painter, then
studied architecture to please his father. He
eventually entered the free class of the academic
painter Jean-Léon Gérôme at the École des
Beaux-Arts, an experience that he found
disappointing. Largely self-taught, he was
more influenced by his meetings with others.
In Bordeaux, the botanist Armand Clavaud
introduced him to natural history and the
literature of his time, while the engraver Rodolphe
Bresdin taught him the techniques of etching and
lithography. Drawing, as he himself emphasised,
on tradition, nature, and the imagination, Redon
created nightmarish and dreamlike visions.
Until the 1890s he was famous for his charcoal
drawings and lithographs in black and white.
He subsequently used pastels and coloured oils,
and was hailed as a master of Symbolism.

Redon made several trips that were to have
a lasting influence on his work. In 1859 he went
to the Pyrenees for the first time and in 1878 he
travelled to Holland, where he marvelled at the
Rembrandts, and to Belgium, where he exhibited
at the Salon des XX in Brussels, returning to
France with his friend Stéphane Mallarmé. He
discovered Italy later, in 1900 and in 1908 (Venice).
Nevertheless, he remained deeply attached to
the region where he grew up and wrote, 'The day
Rembrandt advised his pupils not to travel, and
especially not to Italy, I think he became the
herald of profound art.'[1]

N. B.

[1] Odilon Redon, À soi-même – Journal 1867–1915 (Paris:
Librairie José Corti, 1961), p. 117.

CAT. 44 *Woman Lying Under a Tree (The Dream)*
1900–1
Tempera on canvas
27 x 35 cm

Provenance: Collection of S. I. Shchukin, Moscow;
First Museum of Modern Western Painting,
Moscow, from 1918; State Museum of Modern
Western Art, Moscow, from 1923; the State
Hermitage Museum, St. Petersburg, from 1948.

The intrigue which forms the theme of this
canvas was already present in Redon's early
work, notably in *Woman Sitting Under a Tree in a
Forest* (c. 1875, private collection, Paris), a study
in the Corot manner. The charcoal drawing *Tree*
(about 1875, Art Institute of Chicago), also
dating from this period, is a prototype for the
picture's central detail. And much earlier, in the
early 1860s, the artist executed a series of
solitary oak trees (Musée du Louvre, Paris).

The tree, which has an important role in the
Hermitage picture, is one of the most recurrent
images in Redon's work, beginning with his
adolescent drawings. Sturdy trees such as
this figure systematically in his symbolic
works (*Centaur*, 1883, Boston Museum of
Fine Arts; *Caliban Asleep*, c. 1900, Musée d'Orsay,
Paris; *The Buddha*, 1904, Bonger Collection,
Almen, France; *Saint Sebastian*, 1910,
Kunstmuseum, Basel, and Musée d'Orsay,
Paris). In each of these examples, this recurrent
detail is highly meaningful both in compositional
and symbolic terms. Redon was deeply moved
by the ancient symbolism of the tree, which
was considered both as a sign of eternal nature
and as a sort of axis linking earth and sky, but
the motif has yet other symbolic meanings in
his work. In the lithograph, *Day*, published in
the album *Dreams* (1891), the green sapling not
only embodies awakening nature and spring

but also light and day. Conversely, in the
Hermitage picture, which shows a night scene,
the tree has lost its leaves. Another close
variation dating from the same period is *Caliban
Asleep*, in which the Shakespearean character
lies under a tree like the one in the Hermitage
picture. Around that time, Redon undertook
several decorative projects and his painting
became fuller in colour. A little later, on 21 July
1902, he wrote in a letter to M. Fabre: 'I have
espoused Colour.'[1]

[1] Roseline Bacou, *Odilon Redon*, vol. 1 (Geneva: Cailler,
1956), p.142.

Auguste Rodin (1840-1917)

Rodin's genius as a sculptor revealed itself relatively belatedly. Despite having enrolled at the Petite École Spéciale de Dessin et de Mathématiques when he was thirteen, he failed the entry exam to the École des Beaux-Arts three times. To support himself, he worked as an assistant and sculpted decorative stonework in the workshops of other sculptors, notably Albert-Ernest Carrier-Belleuse, then at the height of his fame. In 1870, fleeing the Franco-Prussian war, he stayed in Belgium, where he worked with the Belgian sculptor Antoine van Rasbourgh.

His stay in Italy in 1875–76 was a turning point in his career. Although he had set off with the intention of discovering the 'secrets' of Michelangelo, he also discovered Raphael, Donatello, and classical art. On his return to Brussels, he channelled his new ideas into a single sculpture, L'Âge d'Airain (The Age of Bronze). It was the first of his works to be acclaimed. Exhibited initially in Brussels and then in Paris, this nude exuded such vitality that Rodin was accused of having moulded it from the live model. But his reputation was now secure and he emerged from the scandal with increased stature.

From then until his death, the 'master', now settled in Paris, created a prodigious œuvre in a series of scandals, masterpieces, major technical innovations, and public and private commissions. By the turn of the century, his reputation had spread abroad. His numerous exhibitions took him to Europe's main capitals, but his favourite destination remained Italy, whose architecture, landscapes, inhabitants, and museums inspired in him a vision of beauty in which he perceived the Antiquity he so venerated.

N. B.

Cat. 33 *Eternal Springtime*
c. 1900
Marble
77 cm

Provenance: Collection of P. S. and V. S. Eliseyev, St. Petersburg, from January 1906 to 1917 (purchased by V. S. Eliseyev from the artist for 10,000 francs); the State Hermitage Museum, St. Petersburg, from 1923.

The conception of *Eternal Springtime* is linked to the first phase of work on *The Gates of Hell*. A photograph (c. 1881) shows the clay sculpture unfinished with the bas-relief of *The Gates of Hell*, the ensemble for which it was intended, in the background. Rodin himself emphasised the importance of the theme of love in *The Gates of Hell*: 'Look at these lovers condemned to eternal suffering: they gave me the inspiration to represent love in different phases and poses, such as it appears in our imagination. I mean passion because, above all, the work must be full of life.'[1] The model who posed for the woman also posed for *Adèle's Torso* (1882), which Rodin used in his work on *The Gates of Hell* and later in *The Fall of an Angel* (1895).

The first version was cast in plaster (1884, Philadelphia Art Museum). At this stage, Rodin had entitled the sculpture *Zephyr and the Earth*. But when he showed the sculpture (the bronze version) for the first time at the 1897 Salon, it was under another title, *Cupid and Psyche*, which explains the traces of wings on the man's back. When V. Eliseyev bought *Eternal Springtime* from Rodin, it was called *Love Victorious*.

The sculpture's transposition into marble and bronze necessitated extensive changes to the right-hand side, where the base was enlarged to support the man's arm and leg. The other marble copies of the sculpture are in the Szepmuveszeti Muzeum, Budapest, the Ny Carlsberg Glyptotek, Copenhagen, the Museo Nacional de Arte Decorativo, Buenos Aires, and the Metropolitan Museum, New York.

The bronze version of the sculpture that belonged to Ivan Morozov is now in the Pushkin Museum of Fine Arts. In the nineteenth century alone, more than 140 bronzes were cast – the contract Rodin signed with the Leblanc-Barbedienne foundry did not mention any limit in the number.

[1] W. G. C. Byvanck, *Un hollandais à Paris en 1891* (Paris: Perrin, 1892), p. 8.

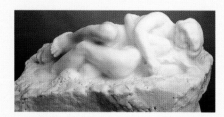

Cat. 35 *Cupid and Psyche*
1905
Marble
26 x 52 cm

Provenance: Collection of S. P. and V. S. Eliseyev,
St. Petersburg (commissioned in 1905), from 1906
to 1917; the State Hermitage Museum, St.
Petersburg, from 1923.

For his treatment of one of French art's most
popular subjects, Rodin had no intention of
following established iconographic formulae as,
for example, Denis did (see cat. 64). Cupid and
Psyche were habitually represented naked in a
scene with a lamp in which Psyche suddenly
discovers that her lover is none other than the
god of love himself. Rodin, however, was loath to
illustrate this scene from Apuleius' version of the
legend. Nor was he in the habit of engraving the
title directly on a work. But the scene's eroticism
had to be dressed up in a literary pretext, hence
his recourse to an inscription. There was another,
marble version, *Amour et Psyché*[1] (whereabouts
unknown).

[1] Rainer Crone and Siegfried Salzmann, ed., *Rodin. Eros and
Creativity* (Munich: Prestel, 1992), p. 206.

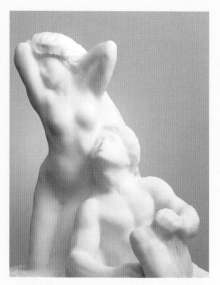

Cat. 34 *The Poet and The Muse*
c. 1905
Marble
63 x 77 cm

Provenance: Collection of S. P. and V. S. Eliseyev,
St. Petersburg (commissioned in 1905), from 1906
to 1917; the State Hermitage Museum,
St. Petersburg, from 1923.

In tackling the theme of the poet and the
muse, Rodin explored two different approaches.
The first was a direct portrayal of Victor Hugo,
whom he knew and greatly admired. In the
second, the work, stripped of all concrete
references, became an expression of a sentiment
of a higher order. The first was for the
monument to Victor Hugo, commissioned in
1889, the second was to be a 'chamber' piece,
destined for private rather than public
appreciation. The monument for the Panthéon
posed the sculptor a problem that he did not
want to resolve with recourse to banal
attributes, as for example Dalou had done in
his bas-relief *The Apotheosis of Victor Hugo* (1886),
in which the muse blesses the Olympian poet,
wearing a toga and a laurel crown, with her
lyre. In his first sketch, Rodin, intent on
avoiding the commonplace, portrays the great
Romantic poet in the nude, surrounded by
three muses (1889–90, Musée Rodin,
Meudon). Rilke likened them to thoughts that
rendered the poet's solitude acutely visible.
Rodin, however, was not in the least bit
satisfied with them. His group sculpture

clearly lacked unity. In the second version
(1890, Musée Rodin, Meudon), the idealised
hero has been replaced by an old man in
modern dress. Gradually, the image of the
thinker was materialising, even if he did still
have naked muses over his head. The overall
configuration is reminiscent of the two-tier
compositions of the artist's former employer,
Carrier-Belleuse. Other versions followed, in
which the muses were reduced to two, yet
despite all these changes the monument to
Victor Hugo remained an ensemble of superb
yet heterogeneous details.

Unlike the various versions of *Monument
to Victor Hugo*, Rodin's *Dreams* (as the Hermitage
sculpture was originally called) had remark-
able unity, in terms of both form and meaning.
This was no longer a historical figure –
panegyrical concerns had been cast aside.
What was now being represented was the very
idea of poetry and its maturation, shown at
the moment when the poet dreams side by
side with his inspirer.

For Rodin, the power of love, which he called
'the world's axis', created 'everything –
including art and religion'. Rodin, an extremely
passionate person, did not have an abstract,
metaphysical conception of love. In one way or
another, the love he depicts is always erotic,
even if his sculpture did comply with
nineteenth-century ethical and aesthetic
norms – unlike his hundreds of overtly erotic
drawings, which were not intended for public
consumption. For Rodin, a regular reader
of Ovid's E*legies*, depicting the poet in the
academic, neo-classical manner, both
protagonists draped in antique or pseudo-
antique robes, with attributes such as the
lyre and laurel crown, would have been
unthinkable. He represented the young couple
as naked lovers.

The sculpture is known under several titles.
Apart from the principal ones, *Dreams* and *The
Poet and the Muse*, there was also *The Awakening*
and *Ideal Love*. It was as the latter that S. Eliseyev
ordered the sculpture from Rodin in 1905.

On 6 October 1906, the secretary of the firm
Zebaume & S. Blanc Réunies, who looked after

Rodin's affairs, wrote to the artist that S. Eliseyev would have liked to have seen work on *Ideal Love* progressing and wrote again a month and a half later, informing Rodin of the Russian collector's growing impatience and asking whether, if the sculpture was finished, it could be packed for transport (Archives du Musée Rodin, Paris).

Henri 'Le Douanier' Rousseau
(1844-1910)

⊢•◦•◦•⊣

A sort of artistic Candide, Henri Rousseau took up painting as a hobby when he was about 40. Self-taught, he copied the Old Masters in the Louvre and admired academic painters such as Jean-Léon Gérôme and William Bouguereau. He exhibited regularly at the Salon des Indépendants, where his work was regularly mocked. Despite this, the strangeness and apparent clumsiness of his works attracted the attention, and admiration even, of the avant-garde. It was Alfred Jarry who coined the name 'Le Douanier' ('customs officer'). In 1908, Picasso and his friends at the Bateau Lavoir held a banquet in honour of the aging, penniless painter. Guillaume Apollinaire wrote a quatrain for the occasion, furthering the myth that Rousseau had been to Mexico:

Tu te souviens, Rousseau, du paysage astèque [*sic*]
Des forêts où poussaient la mangue et l'ananas
Des singes répandant tout le sang des pastèques
Et du blond empereur qu'on fusilla là-bas
Les tableaux que tu peins tu les vis au Mexique … [1]

Yet Rousseau hardly travelled at all. He found his inspiration in Paris, on the banks of the Seine or in the city's parks, painting a life of bucolic charm. From 1891, inspired by visits to the zoos and publications such as *Le Journal des voyages*, he fuelled his childlike imagination with exotic scenes of fighting animals inherited from the Romantic tradition or Orphic paintings with an unspoilt and distant nature. He transformed the tropical greenhouses in the Jardin des Plantes into impenetrable virgin forests and found his wild beasts in popular photo albums and illustrated magazines. Rousseau's magical realism was acclaimed by the Surrealists. His dreamlike jungles influenced in particular Max Ernst, Paul Delvaux, and Victor Brauner.

N. B.

[1] Guillaume Apollinaire, quoted in *Le Douanier Rousseau*, exh. cat. (Paris: Éditions de la Réunion des Musées Nationaux, 1984), p. 106.

Cat. 45 *Combat of a Tiger and a Bull (In a Tropical Forest)*
1908
Oil on canvas
46 x 55.5 cm

Provenance: Galerie Vollard, Paris, from 1909; collection of S. I. Shchukin, Moscow, from 1912; First Museum of Modern Western Painting, Moscow, from 1918; State Museum of Modern Western Art, Moscow, from 1923; the State Hermitage Museum, St. Petersburg, from 1930.

The picture mentioned by the artist in the inscription on the back of the painting is now in the Cleveland Art Museum. Despite what Rousseau himself maintained, the Hermitage canvas is a variation and not a reproduction. The landscape in the Cleveland picture is more exotic: the plants are much larger in relation to the animals. Most researchers consider that the Hermitage variation was painted in 1908, but a slightly later date cannot be discounted: Vollard bought it on 5 August 1909.

Henri Rousseau had prepared the imagery of *Combat of a Tiger and a Bull* in a whole series of previous works, notably the motif of the attacking tiger in two large canvases, *Tropical Storm with a Tiger* (1891, National Gallery, London) and *Scout Attacked by a Tiger* (1904, Barnes Foundation, Merion). The specific source of the Cleveland picture, and consequently the Hermitage canvas, is an etching by Eugène Pirodon after a picture by the Belgian painter Charles Verlat, *Tigre royal*

attaquant un buffle.[1] The etching was published for the first time in 1883 and appeared again in 1906 in the review *L'Art*. It was clearly in this second publication that it caught Rousseau's attention, since the following year he began painting the Cleveland *Combat of a Tiger and a Bull*. In the etching, Verlat's composition is reproduced the other way round, and it was perhaps to avoid being accused of plagiarism that Rousseau put it back the 'right way round'. Verlat's picture and Pirodon's etching both belong to the animal painting genre: the figures of the animals occupy most of the space. Rousseau shifts the focus to the view of the jungle, as he imagined it, and in Russia the established title of the work was *In a Tropical Forest*.

[1] Henri Certigny, 'Une source inconnue du Douanier Rousseau', *L'œil* (October 1979), pp. 74–75.

Kerr-Xavier Roussel (1867-1944)

Kerr-Xavier Roussel's decisive meeting with Édouard Vuillard took place when they were pupils at the Lycée Condorcet in Paris. It was the beginning of a long friendship. Spurred on by Vuillard, they studied painting together at the Académie Julian. While there, Roussel joined the Nabis, whose pictorial style and Intimiste subjects he espoused. In 1893, he married Vuillard's sister.

After 1900, Roussel gravitated increasingly towards bucolic subjects. He found his elegiac inspiration in the Île-de-France countryside and travelled little, although there was one trip that made a lasting impression on him: in 1906 he went first to Aix-en-Provence with Maurice Denis to meet Cézanne, one of the forerunners of the return to classical values, then to the Côte d'Azur to visit Signac and Cross. His discovery there of the timeless beauty of the Mediterranean of Antiquity confirmed the new direction his art was taking. He began freely reinterpreting the myths of Greco-Roman and Arcadian Antiquity. The fauns, nymphs, naiads, and satyrs that people his paintings and pastels are pretexts for shimmering, hedonist works. Like his old friends the Nabis and like Monet, whom he admired, Roussel excelled at large-format decorative works. Examples are his *Cortège de Bacchus* (1912), a monumental stage curtain for the new Théâtre des Champs-Élysées, and his commissions for the Kunstmuseum, Winterthur, the Palais des Nations in Geneva, and the Palais de Chaillot in Paris.

Active during a period when Poussin, Claude, and Watteau were the emblematic figures of a certain type of French art, Roussel is considered one of the principal proponents of the return to classicism in the arts.

N. B.

Cat. 3 *Mythological Scene*
c. 1903
Oil on canvas
47 x 62 cm

Provenance: Galerie Bernheim-Jeune, Paris; Nekrasov collection, Moscow (purchased from Bernheim-Jeune through the mediation of P. P. Muratov), from 1911; S. A. Poliakov collection, Moscow; Tretyakov Gallery, Moscow, from 1917; State Museum of Modern Western Art, Moscow, from 1925; the State Hermitage Museum, St. Petersburg, from 1948.

The picture's other title is *The Goat* (under which it was listed in the Galerie Bernheim-Jeune's inventory).

The painting, one of several variations on the theme of Arcadia, illustrates no myth in particular. By depicting these naked figures in the middle of nature, the painter was willingly letting himself 'drift' into the mythological level of consciousness, something he was readily inclined to do, given his predilection for seventeenth-century painting, which inspired the figures' poses.

In this scene of play with animals, Roussel takes up a Dionysian motif. When the god Dionysius was worshipped in Athens, he was dressed in a black goatskin and called the 'kid'. In the context of the picture, the naked women can be considered as bacchantes.

In 1900, the painter began gravitating towards mythological motifs. Beforehand, his representations of figures with animals were simply treated as scenes from everyday contemporary life (*Infant Jesus with Goat*, c. 1890, private collection, Paris). In his pictures in a mythological style, probably inspired by Cross, Roussel incorporated small details fashionable at the time, wry nods that were a hallmark of the Nabis' distinctive sense of humour. In this

picture, we can see this sign language at work in the women's hairstyles, typical of the early years of the twentieth century.

The antique subject of the picture suggests that Roussel was representing the Mediterranean coast. The picture has sometimes been dated about 1906, which would link it to Roussel's trip to Provence with Denis. This journey took place in winter, whereas the landscape in the background of *Mythological Scene* has definite autumnal tints. The painter had already discovered the Mediterranean coast in 1899, when he went to Cannes, from where he left for Venice with Vuillard. Both in its formal characteristics and in the treatment of the female figures, the work is similar to the picture entitled *At the Seaside* (c. 1903, Musée du Petit Palais, Paris) and *Bathers* (1903, Bernheim-Jeune Collection, Paris), as well as the studies that preceded that painting. This kinship enables *Mythological Scene* to be dated to about 1903.

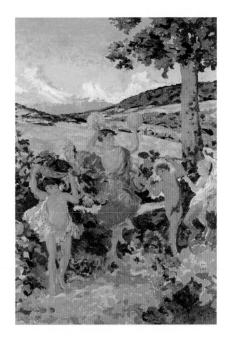

Cat. 5 *The Triumph of Bacchus (Rural Festival)*
1911–13
Oil on canvas
166.5 x 119.5 cm

Provenance: Galerie Vollard, Paris, from 1911; collection I. A. Morozov, Moscow, from 1913 (purchased from Galerie Vollard for 10,000 francs); Second Museum of Modern Western Painting, Moscow, from 1918; State Museum of Modern Western Art, Moscow, from 1923; the State Hermitage Museum, St. Petersburg, from 1948.

Like its counterpart, *The Triumph of Ceres* (Pushkin Museum of Fine Arts), *The Triumph of Bacchus* was painted in 1911 and exhibited at the Salon d'Automne that year under the title *Mythological Scene*. Such Bacchic scenes in the antique manner, ranging from Salon paintings to photographic *tableaux vivants* and drawing on a stock repertory of poses, were not rare at the turn of the century. A photograph entitled *Bacchic Joy*, reminiscent of the Hermitage picture, had appeared in Édouard Daelen's *La Moralité du nu*, published in Paris in 1905. Bouguereau's picture *The Education of Bacchus* (1884) was far better known. Roussel's can be seen as both the artist's personal reaction to the paragon of Salon art and as the anti-academic response of the dawning twentieth century to the already closed nineteenth. Among the artists in the anti-academic camp, Roussel's immediate

predecessor for decorative compositions in this genre was Adolphe Willette, who, several years earlier, had decorated the Bal Tabarin cabaret with his *The Games of Eve* frescoes (1904), with their figures joyfully dancing in the open air.

Roussel in turn took up the theme a little later, an experience that would serve him for his works of the 1910s. The central figure in *The Triumph of Bacchus* is reminiscent of the figure dancing next to the herm of Pan in *Love and Little Dog* (1905, private collection, Paris). Also in this work there is a figure identical to the one on the right.

In 1913, Roussel's two *Triumphs*, which had already been bought by Ivan Morozov, were 'retouched' by the painter and given a more decorative look. One can link Roussel's 'forcing' of the colour to his work on the stage curtain for the Théatre des Champs-Élysées in Paris. On an iconographic level, the two canvases herald in many ways this curtain and his preparatory sketches for it, executed in 1913. The curtain's theme, suggested by the architect Auguste Perret, was also Bacchic dances in the open air. According to B. Ternovets, curator of the Museum of Modern Western Art in Moscow, Roussel began reworking the two pictures when he heard that they were to be hung next to works by Matisse, although Morozov didn't appreciate the changes. Traces of the initial, grey-brown tonality remain around the edges of *The Triumph of Bacchus*.

It is not clear how the two canvases were hung in Morozov's mansion. From a compositional point of view, neither contains any definite criteria suggesting they should have the left- or right-hand place. The pictures, which had already been transported to Moscow, were not mentioned in the catalogue of the Morozov collection published in 1912. We do not even know what title their first owner had given them. The Pushkin Museum of Fine Arts and the Hermitage kept the title given them by the Museum of Modern Western Art, *Rural Festival*, which reflects the early Soviet tendency towards demythologisation.

Paul Signac (1863-1935)

It was after a visit to an exhibition of paintings by Monet at the Galerie Georges Charpentier in 1880 that Paul Signac decided to become a painter. And it was the work of Monet and Alfred Sisley that influenced his early style rather than the lessons he took with the minor Prix de Rome winner Jean-Baptiste Bin. A founder member of the Salon des Indépendants, where he met Georges Seurat, the inventor of Divisionism, a painting technique which, contrary to the subjectivity of Impressionism, aspired towards scientific objectivity. The publication of his *D'Eugène Delacroix au néo-impressionnisme* in 1899 established him as the new technique's theoretician. After the deaths of Seurat and Cross, and long after Pissarro and the young Matisse had distanced themselves from Divisionism, he remained steadfastly faithful to its principles. Although he is seen as a survivor, the liberation of colour Signac ceaselessly advocated was decisive not only for the Fauves and the Futurists, but also in Belgium, where he maintained a network of friendships in the arts and in left-wing political circles.

In 1892, Signac, at the helm of his yacht, was dazzled by his discovery of Saint-Tropez. Up until 1913, when he moved to Antibes, his house in the fishing village was a meeting place for the colony of artists and visitors that gathered there: Luce and Cross, Denis and Roussel, the future Fauve painters Camoin, Manguin, Marquet, Valtat, Puy, and of course Matisse, among others. He was a tireless painter of seascapes and, following the example of Joseph Vernet, began a series on the great ports, travelling abroad to paint the ports of Rotterdam, Antwerp, Genoa, Venice, London, and even Istanbul.

N. B.

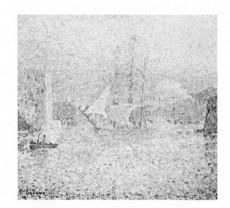

Cat. 17 *Port of Marseilles*
1906–7
Oil on canvas
46 x 55.2 cm

Provenance: Collection of I. A. Morozov, Moscow, from 1907 (purchased at the Salon des Indépendants for 500 francs); Second Museum of Modern Western Painting, Moscow, from 1918; State Museum of Modern Western Art, Moscow, from 1923; the State Hermitage Museum, St. Petersburg, from 1930.

This is a repeat of the landscape of the same name and size (1898, Kröller-Müller Museum, Otterlo). The Otterlo *Port* was not painted from nature but from Signac's memories of his trip to Marseilles. However, this does not necessarily mean that in reproducing his previous composition the painter mechanically copied every detail of the whole painting. In the Hermitage picture, the brushstrokes are wider and the colour purer, evoking a mosaic. One also notices a few differences in the details, particularly in the sailing ship in the centre.

'The canvas which works best,' Signac wrote in his journal on 18 October 1898, 'and which seems right, is indeed the one I painted from imagination, with only a vague outline at the entrance to the port. One evening, at the hotel, I took some crayons and coloured a botched sketch I had done during the day. Unconcerned with veracity, I coloured sea and sky in yellow, red and mauve, attenuating the colour from the centre, occupied by the boats, towards the edges. And lo and behold this completely invented effect seemed more real than the two other watercolour pictures painted from nature.'[1]

In 1911, Signac painted another *Port of Marseilles* (Musée d'Orsay, Paris), much larger in size, with additional details – clouds, boats, another sailing ship – and drier in treatment. The Hermitage landscape is usually dated 1907, the year it was exhibited at the Salon des Indépendants. Françoise Cachin, the painter's granddaughter and a specialist on his work, thinks it is more likely to have been painted in 1906.

[1] Extract from Paul Signac's unpublished journal, 1897–98, 1898–99, introduction and notes by John Rewald, *Arts de France*, nos. 11–12, 1947.

Félix Vallotton (1865-1925)

The Swiss-born Félix Vallotton left Lausanne in 1882 for Paris, where he enrolled at the Académie Julian. From 1893, he exhibited with the Nabis, but the 'foreign Nabi', as he was known, always kept a certain distance from the group. He soon became famous for his dark woodcuts, some of which painted an austere, bitter picture of married life. With the same biting irony, he wrote a novel, *La Vie meurtrière*. A disillusioned and solitary person, his paintings coldly analysed figures in interiors, female nudes, and other Intimiste scenes.

Next Vallotton turned to landscape. The beaches of Brittany, then the bucolic Normandy countryside, infused his work with a new serenity. Travelling around on foot or by bicycle, he noted down motifs in his sketchbooks before painting them from memory in his studio. On the canvas, topographical description was transformed by a cold, unreal light. His original use of areas of colour and rigorous lines rendered a landscape that had become 'cosa mentale'. And at the beginning of the century, when Poussin's classicism had again become a model for certain avant-garde tendencies, Vallotton made explicit reference to the master of the historical landscape, a tradition that he wanted to revive with his 'paysages composés'. He discarded the fashionable imagery of mythological fauns and nymphs, except in two instances, where the barbarism of Antiquity got the upper hand over the joyous bacchanal. For Vallotton, Arcadia, if it existed, was uninhabited, silent, and still.

In 1913, he agreed to accompany a depressive artist friend on a trip to Russia where, apart form the art galleries, the Neva in St. Petersburg, and the Kremlin in Moscow, which he found 'pretty astonishing, wild, barbarous and a little comic,'[1] he found little to interest him.

N. B.

[1] Hedy Hahnloser-Bühler, *Félix Vallotton et ses amis* (Paris: A. Sedrowsky, 1936), p. 213.

CAT. 1 *Landscape, Arques-la-Bataille*
1903
Oil on cardboard
67 x 103.5 cm

Provenance: Collection of G. E. Haasen, St. Petersburg; the State Hermitage Museum, St. Petersburg, from 1921.

The picture belongs to a series of landscapes painted in the summer of 1903 in the vicinity of the town of Arques-la-Bataille, some ten kilometres from Dieppe. In Vallotton's catalogue raisonné,[1] the series of seventeen landscapes is listed under number 508. The Hermitage landscape – the most remarkable of the series – was not painted from nature but in the artist's studio, from a pencil drawing (private collection, Paris).[2]

Another preparatory drawing was reproduced by the same author in his article 'Vallotton's Rediscovery of the Classic Landscape'.[3]

This work, like other Japanese-influenced decorative landscapes that Denis and the Nabis were already painting in the 1890s, is clearly a stylisation of a view from nature. In Hokusai's landscape prints, Vallotton would have found the device he used to depict the whirlpool and the outlines of the trees. The harmonious interplay of the lines of the swirling current and the shapes of the trees and shadows is emphasised by the narrow gilded frame with rounded corners (the painter trimmed the corners of the cardboard to fit it into the frame).

Classical harmonies also resonate in the picture, as Rudolf Koella found in his comparison of the Hermitage painting to Poussin's landscape *Spring* (1660–64, Musée du Louvre, Paris). The work was shown under the title *Stream, Normandie* at Vallotton's one-man exhibition at the Galerie Bernheim-Jeune in 1906, as attested by the gallery's partially intact wax seal on the back. It was definitely the Hermitage picture the painter was alluding to in a letter sent to his brother in Paris on 21 March 1911, in which he recounts how Haasen, during his trip from Russia to Switzerland, bought a landscape from him.[4]

[1] Maxime Vallotton and Charles Goerg, *Félix Vallotton. Catalogue raisonné de l'œuvre gravé et lithographié* (Geneva: Éditions de Bonvent, 1972), no. 508.

[2] Rudolf Koella, 'Le Retour au paysage historique. Zur Entstehung und Bedeutung von Vallottons später Landschaftsmalerei', *Jahrbuch des Schweizerischen Instituts für Wissenschaft*, Zurich (1968–69), pp. 36–37, note 5.

[3] In Sasha Newman, *Félix Vallotton* (New Haven: Yale University Art Gallery, 1991), p. 177.

[4] Félix Vallotton, *Documents pour une biographie et pour l'histoire d'une œuvre*, vol. 2 (Paris: Bibliothèques des Arts, 1973–74), letter 250.

Louis Valtat (1869-1952)

From 1887 to 1891 Valtat studied at the École des Beaux-Arts in Paris, where he spent time in the studio of Henri Harpignies and, possibly, Gustave Moreau. Following military service, he entered the Académie Julian in 1891, where he worked under Jules Dupré and met the Nabis Bonnard, Denis, and Vuillard. By 1894 or early 1895, Valtat was in the South of France for health reasons, staying at Collioure and Banyuls-sur-Mer, where he assisted Maillol with his early sculpture. Valtat's travels to the Midi anticipated those of the Fauves. In 1897 he made his first trip to Agay, a small fishing village to the east of Saint-Raphaël that was to become a future painting place for Derain. At nearby Anthéor, Valtat constructed a villa in 1899 called Roucas Rou, where he lived and painted until World War I. He visited Renoir on several occasions between 1900 and 1905 at Magagnosc, near Grasse. In 1902 Valtat travelled to Venice and Florence, then in 1903–4 he visited Signac in Saint-Tropez; in 1906 he spent time in Algiers.

In 1905 Valtat exhibited at the Salon d'Automne. His work was not included in the same room as that of the Fauves. Nonetheless, his marine painting was reproduced by the art critic Louis Vauxcelles in his famous review of the exhibition in L'Illustration, sealing Valtat's association with Fauvism forever. Even though he worked with a bright palette, Valtat did not deploy colour with the same boldness as Matisse or Derain. Until about 1914 he produced powerful, decorative canvases in a style which he was progressively to perfect.

M. P.-T.

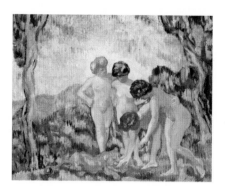

Cat. 57 *Little Girls Playing with a Lion Cub (Children's Games)*
c. 1905–6
Oil on canvas
81.5 x 100.5 cm

Provenance: Collection of I. A. Morozov, Moscow, from 1908 (purchased from Galerie Vollard, Paris, for 800 francs); Second Museum of Modern Western Painting, Moscow, from 1918; State Museum of Modern Western Art, Moscow, from 1923; the State Hermitage Museum, St. Petersburg, from 1931.

The second title, *Children's Games*, tinged with mischievousness, written in pencil on the stretcher, was probably the painter's. The motif is closely related to a group of compositions with four bathers painted in 1906.[1] The most important of these compositions is a large canvas entitled *Bathers* (1906, Musée du Petit Palais, Geneva). Furthermore, the treatment of the background of *Children's Games* is comparable to the landscapes painted at Agay and Estérel in 1905.

[1] Jean Valtat, *Louis Valtat. Catalogue de l'œuvre peint, 1869-1952*, vol. 1 (Neuchâtel: Ides et Calendes, 1977), nos. 603–5.

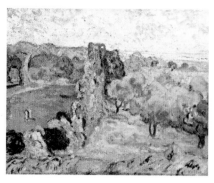

Cat. 26 *Landscape in the South of France*
c. 1908
Oil on canvas
60 x 73.5 cm

Provenance: Collection of I. A. Morozov, Moscow, from 1909 (purchased from Galerie Vollard, Paris, for 1000 francs); Second Museum of Modern Western Painting, Moscow, from 1918; State Museum of Modern Western Art, Moscow, from 1923; the State Hermitage Museum, St. Petersburg, from 1934.

Valtat revealed himself as one of Fauvism's precursors as early as 1900 and there was a reproduction of one of his paintings on the famous page of L'Illustration that sparked the Fauvist scandal at the 1905 Salon d'Automne. But later on, unlike Matisse and Derain, he did not seek to force colour any further but endeavoured above all to give the picture's overall formal structure unity. In canvases such as *Landscape in the South of France*, the painter arrives at a neo-baroque form that subjugates each of the composition's elements to his elegant, confident, dancing brushstrokes.

The picture has traditionally been dated 1909, the year it was shown at the Salon d'Automne, but it was probably painted a year earlier while Valtat was working in Provence. During the summer of 1909, Valtat was in Normandy. In addition, stylistically the work is closer to those painted in 1908.

Marquesas Islands

Tahiti

Map: Edigraphie, Rouen

Selected Bibliography

General Works

BANHAM, Reyner, *Theory and Design in the First Machine Age*, New York, Praeger, 1960.

BENJAMIN, Roger, *Matisse's 'Notes of a painter': Criticism, Theory, and Context 1891-1908*, Ann Arbor, UMI Research Press, 1987.

BLUME, Mary, *Côte d'Azur: Inventing the French Riviera*, London, Thames and Hudson, 1992.

BOUILLON, Jean-Paul, *Maurice Denis*, Geneva, Skira, 1993.

CAHN, Isabelle, *Gauguin et le mythe du sauvage*, Paris, Flammarion / Arthaud, 1988.

COGEVAL, Guy, *Bonnard, les chefs-d'œuvre*, Paris, Hazan, 1993.

COUSTURIER, Lucie, *K. X. Roussel*, Paris, Bernheim-Jeune, 1927.

DRISKEL, Michael Paul, *Representing Belief: Religion, Art, and Society in Nineteenth-Century France*, University Park, The Pennsylvania State University Press, 1992.

DUVIGNAUD, Françoise, *Terre mythique, terre fantasmée: l'Arcadie*, Paris, L'Harmattan, 1994.

FERRIER, Jean-Louis, *Les fauves: le règne de la couleur*, Paris, Terrail, 1992.

FLAM, Jack, *Matisse on Art*, rev. ed., Berkeley and Los Angeles, University of California Press, 1995.

GANDIN, Éliane, *Le voyage dans le Pacifique de Bougainville à Giraudoux*, Paris, L'Harmattan, 1998.

HERBERT, James D., *Fauve Painting: The Making of Cultural Politics*, New Haven and London, Yale University Press, 1992.

HERBERT, Robert L. (ed.), *Modern Artists on Art*, Englewood Cliffs, Prentice Hall, 1964.

Le fauvisme, texts by painters, writers, and journalists selected by Philippe Dagen, Paris, Somogy, 1994.

MAYEUR, Jean, *Les Débuts de la IIIᵉ République, 1871–1898*, Paris, Seuil, 1973.

OPPLER, Ellen, *Fauvism Reexamined*, New York, Garland Publishing, 1976.

PALAU I FABRE, Josep, *Picasso: Life and Work of the Early Years 1881–1907*, Oxford, 1981.

REY, Robert, *La Renaissance du sentiment classique: La peinture française à la fin du XIXᵉ siècle*, Paris, Les Beaux-Arts, 1931.

SCHNEIDER, Pierre, *Matisse*, London, Thames and Hudson, 1984.

SHIFF, Richard, *Cézanne and the End of Impressionism: A Study in the Theory, Technique and Critical Evaluation of Modern Art*, Chicago, The University of Chicago Press, 1984.

SILVER, Kenneth E., *Esprit de Corps: the Art of the Parisian Avant-Garde and the First World War: 1914-1925*, Princeton, Princeton University Press, 1989.

SILVER, Kenneth E., *Making Paradise: Art, Modernity, and the Myth of the French Riviera*, Cambridge and London, The MIT Press, 2001.

SILVERMAN, Debora, *Art Nouveau in Fin-de-Siècle France*, Berkeley, University of California Press, 1989.

SILVERMAN, Debora, *Van Gogh and Gauguin: The Search for Sacred Art*, New York, Farrar, Straus and Giroux, 2000.

WEBER, Eugen, *France, Fin-de-Siècle*, Cambridge, The Belknap Press, 1986.

WERTH, Margaret, *Le Bonheur de Vivre: The Idyllic Image in French Art, 1891-1906*, PhD thesis, Harvard University, Ann Arbor, UMI, 1994.

WHITNEY KEAN, Beverly, *French Painters, Russian Collectors: Shchukin, Morozov and Modern French Art 1890-1914*, rev. ed., London, Hodder and Stoughton Ltd, 1994.

Exhibition Catalogues

1918–1958 : la Côte d'Azur et la modernité, Paris, RMN, 1997.

1894–1908 : le Roussillon à l'origine de l'art moderne, Montpellier, Indigène, 1998.

ANDRAL, Jean-Louis, and Yona FISCHER, *Peindre dans la lumière de la Méditerranée*, Jerusalem, The Israel Museum, 1987.

BIASS-FABIANI, Sophie (ed.), *Peintres de la couleur en Provence, 1875-1920*, Marseilles, Office de la Région Provence-Alpes-Côte d'Azur, Paris, RMN, 1995.

BOEHM, Gottfried, Ulrich MOSCH, and Katharina SCHMIDT, *Canto d'Amore: Classicism in Modern Art and Music 1914–1935*, Basel, Kunstmuseum, 1996.

BRETTELL, Richard, et al., *The Art of Paul Gauguin*, Paris, RMN, 1989.

CACHIN, Françoise (ed.), *Cézanne*, Paris, RMN, 1995.

CACHIN, Françoise, and Monique NONNE, *Méditerranée: de Courbet à Matisse*, Paris, RMN, 2000.

CAFRITZ, Robert, Lawrence GOWING, and David ROSAND, *Places of Delight: The Pastoral Landscape*, Washington, DC, The Phillips Collection, 1988.

CLAIR, Jean, and Guy COGEVAL, *Lost Paradise: Symbolist Europe*, Montreal, Montreal Museum of Fine Arts, 1995.

COGEVAL Guy (ed.), *Maurice Denis: 1870–1943*, Lyon, Musée des Beaux-Arts, 1994.

COWART, Jack, Albert KOSTENEVICH, et al., *Matisse in Morocco: The Paintings and Drawings, 1912-1913*, Washington, DC, National Gallery of Art, New York, Harry N. Abrams, Inc., 1990.

COWLING, Elizabeth, and Jennifer MUNDY, *On Classic Ground: Picasso, Léger, de Chirico and the New Classicism 1910–1930*, London, Tate Gallery, 1990.

DRUICK, Douglas, and Peter ZEGERS, *Van Gogh and Gauguin: The Studio of the South*, Chicago, The Art Institute of Chicago, and New York, Thames and Hudson, 2001.

ELDERFIELD, John, *The "Wild Beasts": Fauvism and Its Affinities*, New York, The Museum of Modern Art, 1976.

ELDERFIELD, John, *Henri Matisse: A Retrospective*, New York, The Museum of Modern Art and Harry N. Abrams, Inc., 1992.

FERRETTI-BOCQUILLON, Marina, Anne DISTEL, John LEIGHTON, and Susan Alyson STEIN, *Signac 1863–1935*, New York, The Metropolitan Museum of Art, New Haven, and London, Yale University Press, 2001.

FOURCADE, Dominique, and Isabelle MONOD-FONTAINE, *Henri Matisse, 1904–1917*, Paris, Centre Georges Pompidou, 1993.

FREEMAN, Judi (ed.), *The Fauve Landscape*, Los Angeles, Los Angeles County Museum of Art, and New York, Abbeville Press, 1990.

GROOM, Gloria, *Beyond the Easel: Decorative Painting by Bonnard, Vuillard, Denis, and Roussel, 1890-1930*, Chicago, The Art Institute of Chicago, New Haven, and London, Yale University Press, 2001.

KÖLTZSCH, Georg-W., Albert KOSTENEVICH, et al., *Morozov, Shchukin: The Collectors : Monet to Picasso: 120 Masterpieces from the Hermitage, St. Petersburg, and the Pushkin Museum, Moscow*, Bonn, Bild-Kunst, 1993.

KOSTENEVICH, Albert, *Bonnard et les Nabis*, St. Petersburg, Aurora, Bournemouth, Parkstone, 1996.

KOSTENEVICH, Albert, *French Art Treasures at the Hermitage: Splendid Masterpieces, New Discoveries*, New York, Harry N. Abrams, Inc., 1999.

LEMOINE, Serge (ed.), *De Puvis de Chavannes à Matisse et Picasso: vers l'art moderne*, Paris, Flammarion, 2002.

LE NORMAND-ROMAIN, Antoinette (ed.), *Rodin et l'Italie*, Rome, Edizioni de Luca, 2001.

MALOON, Terence, et al., *Classic Cézanne*, Sydney, Art Gallery of New South Wales, 1998.

MARTIN-MÉRY, Gilberte, et al., *Les années fauves: 1904–1908*, Paris, Somogy, and Barcelona, Fundació Caixa Catalunya, 2000.

MONOD-FONTAINE, Isabelle, RUBIN, William, et al., *L'Estaque: naissance du paysage moderne, 1870–1910*, Marseilles, Musées de Marseille, and Paris, RMN, 1994.

NEWMAN, Sasha M. (ed.), *Bonnard: The Late Paintings*, Washington, DC, The Phillips Collection, 1984.

PAGÉ, Suzanne, *André Derain: le peintre du trouble moderne*, Paris, Musée d'Art Moderne de la Ville de Paris, 1994.

Picasso, 1905–1906: From the Rose Period to the Ochres of Gósol, Barcelona, Electa, 1992.

ROSENBLUM, Robert, Maryanne STEVENS, and Ann DUMAS, *1900: Art at the Crossroads*, New York, Harry N. Abrams, Inc., 2000.

RUBIN, William (ed.), *Cézanne: The Late Work*, New York, Museum of Modern Art, 1977.

RUBIN, William, *Pablo Picasso, Retrospective*, New York, Museum of Modern Art, 1980.

RUBIN, William (ed.), *Primitivism in 20th Century Art: Affinity of the Tribal and the Modern*, New York, Museum of Modern Art, 1984.

THIÉBAUT, Philippe, *1900*, Paris, RMN, 2000.

THOMSON, Richard, *Monet to Matisse: Landscape Painting in France 1874–1914*, Edinburgh, National Gallery of Scotland, 1994.

VERDI, Richard, *Cézanne and Poussin: The Classical Vision of Landscape*, London, Lund Humphries, Edinburgh, National Gallery of Scotland, 1990.

WAYNE, Kenneth, John HOUSE, and Kenneth E. SILVER, *Impressions of the Riviera: Monet, Renoir, Matisse and their Contemporaries*, Portland, Portland Museum of Art, 1998.

Index of Artists

* Throughout this catalogue, the spelling 'Kerr' (in Kerr-Xavier Roussel) is employed, based on information provided by the heir and administrator of the artist's estate, Antoine Salomon. The spelling 'Ker' is also correct.

List of Illustrations

Photographic Credits